DONATELLO

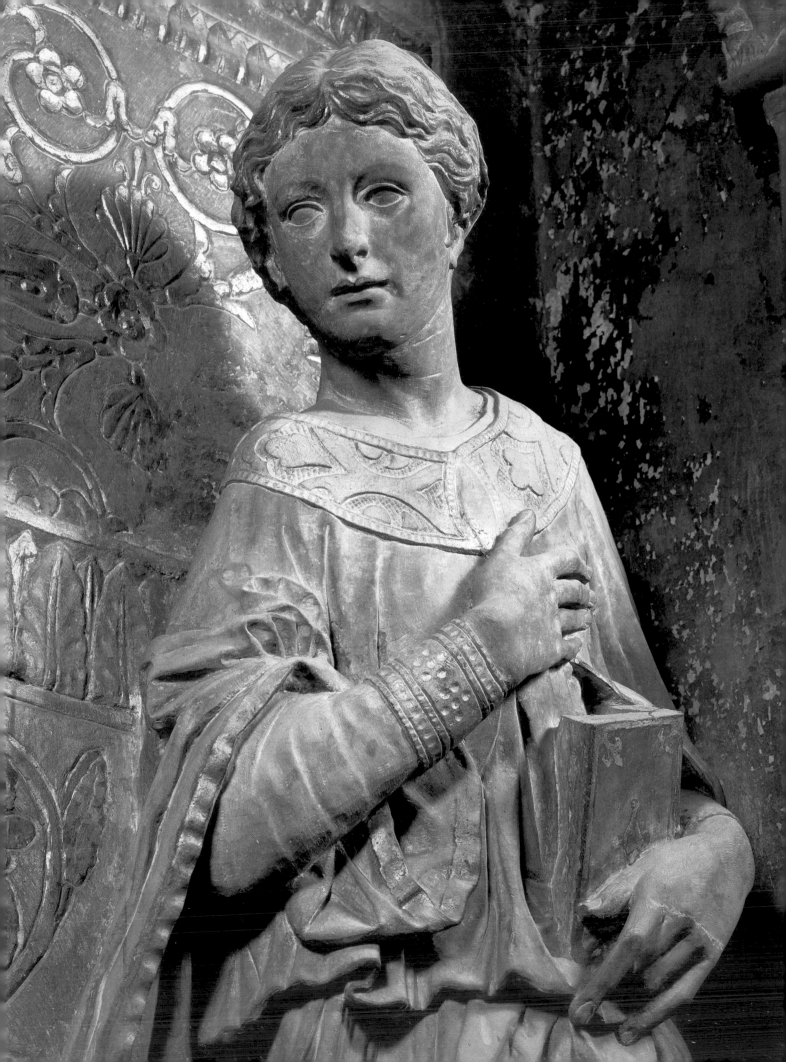

DONATELLO

Bonnie A. Bennett & David G. Wilkins

Moyer Bell Limited · Mt. Kisco, New York

Published by Moyer Bell Limited, Colonial Hill/RFD 1, Mt. Kisco, NY 10549

First published 1984
© Phaidon Press Limited 1984

Library of Congress Cataloging in Publication Data

Bennett, Bonnie A. (Bonnie Apgar)
 Donatello.

 Bibliography: p. 239
 Includes index.
 1. Donatello, 1386?-1466. I. Wilkins, David G.
II. Title.
NB623.D7B38 1985 730′.92′4 84-29473

Typeset in Monophoto Garamond by Keyspools Limited, Golborne, Lancs.
Printed in England by Jolly and Barber Limited, Rugby, Warks.

The publishers are grateful to all museums and institutions who have given permission for the works of art in their possession to be reproduced. They have endeavoured to credit all known persons holding copyright or reproduction rights to the illustrations in this book.

Alinari, Florence, Figs. 1–4, 7, 9–15, 20, 22–8, 30–1, 35–9, 42, 45–8, 50–4, 57–64, 66, 71–3, 75, 79, 81–9, 93–9, 102–5, 107–10, 112, 115–7, 122–8, 131–5, 138–141; Scala, Florence, frontispiece, Pls. I, II, III; Gabinetto Fotografico della Soprintendenza ai Beni Artistici e Storici, Florence, Figs. 5, 8, 21, 29, 49, 67, 74, 77, 80, 88, 100, 111, 119–20, 122, 129, 130, 136–7; Reproduced by courtesy of the Trustees, The National Gallery, London, Fig. 41; Crown Copyright Victoria and Albert Museum, London, Figs. 56, 68–70, 76; Osvaldo Bohm, Venice, Figs. 113, 114.

Frontispiece. The Virgin. Detail of the *Cavalcanti Annunciation* (Fig. 84).
1430s. Sandstone, with gilding

CONTENTS

For
Bruce, Evan, and Millicent
and
Ann, Rebecca, and Katherine

INTRODUCTION

Vasari's introduction to the Life of Donato in the 1550 edition of the *Vite* included an effusive description of Donatello's talent and good character, contrasting him with the 'old, but not antique' sculptors who preceded him. This description was dropped in the 1568 edition, but it seems appropriate to revive it – at least in part – since the judgements are closer in time to their subject than ours are, and it restores a certain aura to an artist often forced into art-historical moulds. Vasari wrote:

> Nature justly was offended to see herself ridiculed by the strange figures that those people left to the world, deciding to have one born who, in working, would lead back to the best form, with good grace and proportion, the badly conceived bronzes and poor marbles. . . . By her will and decision she overwhelmed Donatello with marvellous gifts at his birth; and she herself sent him down among mortals, full of goodness, judgement, and love.

It is probably a measure of Vasari's good sense that he modified his admiration, but his awe at Donatello's genius and his need to explain the source of such a gift are certainly familiar; Vasari turned to a personification of nature for an explanation, and we have turned to history.

The traditional format for an art-historical monograph is a chronological presentation of the life and works of an artist in order to elucidate both the development of an individual style and the relationship of creative production to historical events. It is valuable for its directness and for the clarity of its overview of an artist's *œuvre*. General artistic trends and historical concerns are usually considered only to the extent that they may be reflected in the artist's biography; otherwise they are likely to be treated in a more general text. For a lesser talent than Donatello's, the traditional monograph, with its basic assumptions about stylistic development, presents few problems, since style and activity will more or less conform to the preconceived model of experimentation, synthesis and mature style, all related to the period as a whole. An artist as innovative as Donatello, however, generates ideas, rather than reflects them; his conceptions, alone or with those of a small number of his peers, create the artistic trends of his time. He does not turn from one borrowed concept to the next, but allows ideas to mature and intermingle, enriching rather than changing his art; he is only partly revealed by a chronological study.

It seemed best, therefore, to organize this book not chronologically, but according to general themes or problems raised by Donatello's *œuvre*, or those basic to a study of Renaissance art. The chapter on relief sculpture is prompted by Donatello's interest in the form, as well as by his invention of *rilievo schiacciato* and application of linear perspective, and the chapter on figural sculpture by his revival

7

of the free-standing bronze statue and interest in sculpture-in-the-round. Some works appear, therefore, in several different contexts, so that sculptures as important as the *St. Louis of Toulouse*, the bronze *David* and the *Judith and Holofernes* are discussed as statuary, in terms of technique, politics, and the artist's sources, and again in the final interpretative chapter; even less pivotal works are likely to appear in two or three contexts. The first chapter is an introduction to Donatello's artistic personality, to those attitudes, innovations, and concerns that, when taken together, define the individual; as Donatello's last known works, the San Lorenzo pulpit panels aptly indicate his complexity. Chapter two provides a historical framework and documented life of Donatello, which should make the material more accessible to beginning students. The concluding chapter attempts, in a frankly subjective discussion, to elucidate, or at least to recognize, the quality of Donatello's vision and understanding that has made his sculpture a timeless expression of the nature and meaning of human experience.

This unorthodox organization is possible only because of the scholarship that preceded it, in particular H. W. Janson's monumental work *The Sculpture of Donatello*, conceived as a *catalogue raisonné* that treats the sculptures individually and comprehensively. The debt to Janson's book is overwhelming, and it remains the source for the basic documentation. Some of his conclusions have proved inaccurate as new information has been found, and others have been countered with new arguments, but the value of his critical views has not been diminished. Among other books on Donatello, Giorgio Castelfranco's has provided a well-illustrated interpretative overview, Luigi Grassi's a much needed documented chronology, and Ludwig Goldscheider's a wealth of visual comparisons and intriguing possibilities and connections. Because of the ease with which information can be found in Janson's book, we have not given individual references to it; the same is true of John Pope-Hennessy's *Italian Renaissance Sculpture* and Frederick Hartt's *Donatello, Prophet of Modern Vision*, which offer alternative interpretations and new insights, again primarily organized as catalogues. The latter is particularly useful for the sensitive photographs by David Finn, often taken from the correct viewing position and essential to a desk-bound student. The most complete documentation on Donatello is 'Regesti donatelliani' by Volker Herzner; it is a remarkable compilation of payments and notices occasionally quoted in their entirety. Both the introductory text to Pope-Hennessy's *Italian Renaissance Sculpture* and Charles Seymour's *Sculpture in Italy 1400–1500* are important general works on Renaissance sculpture, indispensable as guides to cultural, typological, and stylistic trends and change; they have been more influential than the few notes quoting them would indicate. We have included a bibliography of material on Donatello since 1960, or essentially since Janson's *Sculpture of Donatello*; the number of entries attests to the scholarly interest and activity in Donatello problems.

Yet virtually every major work by Donatello still presents significant and generally unresolved questions of patronage, placement, iconography, dating, or style. In some cases we have taken a firm position on these issues, in others we have reiterated the most convincing arguments, and in those cases where it does not seem that all the evidence is available, we have stated the problem and presented the bibliography. Our intent has been to make suggestions, to reopen questions, and to maintain possibilities, with the consequence that both chronology and attributions are less rigid than they usually are in a monograph. Stylistic chronology, that standard art-historical problem-solver, has proven less than reliable for Donatello; Francis Ames-Lewis has argued the uselessness of style in dating the bronze *David*, and the notion that style becomes more emotional with the advancing age of the artist is certainly belied by the surprisingly early date recently found on the wooden *St. John the Baptist*. None the less, Donatello's chronology remains important and

many more facts have come to light in recent years; it is hoped that the biography in chapter two, supplemented with contemporary literary references, will prove particularly useful. Janson undertook the careful and selective elimination of unimportant or questionable works of art, which was necessary to establish the core of Donatello's *œuvre*; coming full circle, with the wealth of scholarship generated by his book, we have reconsidered several mundane, useful objects, works in less prestigious materials, and the attributions of Vasari and other early writers, in an attempt to re-establish the richness of his working environment – the broadest definition of art in context.

Our collaboration on this book has at times resembled that of Donatello and Brunelleschi in the Sacristy at San Lorenzo; we have taken turns complaining like Brunelleschi about intrusions by the other. At the end of the endeavour, however, we have come to appreciate the relationship between Donatello and Michelozzo, whose partnership is documented but whose specific roles remain elusive. The book was jointly conceived, and, even though we are individually responsible for the basic design of separate chapters, the execution, the refinement, and the mutual tempering of ideas have by now made the book as integrated as that original conception. We brought different scholarly strengths to the task, but we have ultimately shared equally in the partnership.

This book has been written over a long period of time and the assistance we have received, both together and separately, has been as often indirect as direct, as often in casual conversation as in consultation. We wish to thank our colleagues and students at the University of Pittsburgh, the University of Rochester, and the Sarah Lawrence–University of Michigan Summer Session in Florence for their valuable comments and criticism. Our tasks were made considerably easier by the librarians and collections of the libraries at the Universities of Pittsburgh and Rochester, and the Kunsthistorisches Institut in Florence. We express particular gratitude to Alfredo di Marino, Sheila Edmunds, Stephanie Frontz, Kahren Hellerstedt, Archibald Miller, Piero Morselli, Peggy Pinner, John and Barbara Reich, Deborah Strom, and David Summers, and recognize that it is impossible to acknowledge our full debt to scholars, family, and friends. At Phaidon Press we received invaluable assistance from Dr. I. Grafe, Simon Haviland and Penelope Marcus. It is our hope that our efforts will prove valuable to those who already share Vasari's admiration for Donatello, as well as to those encountering his genius for the first time.

Dates that are not qualified are supported by documents or other evidence. Locations are in Florence unless indicated otherwise.

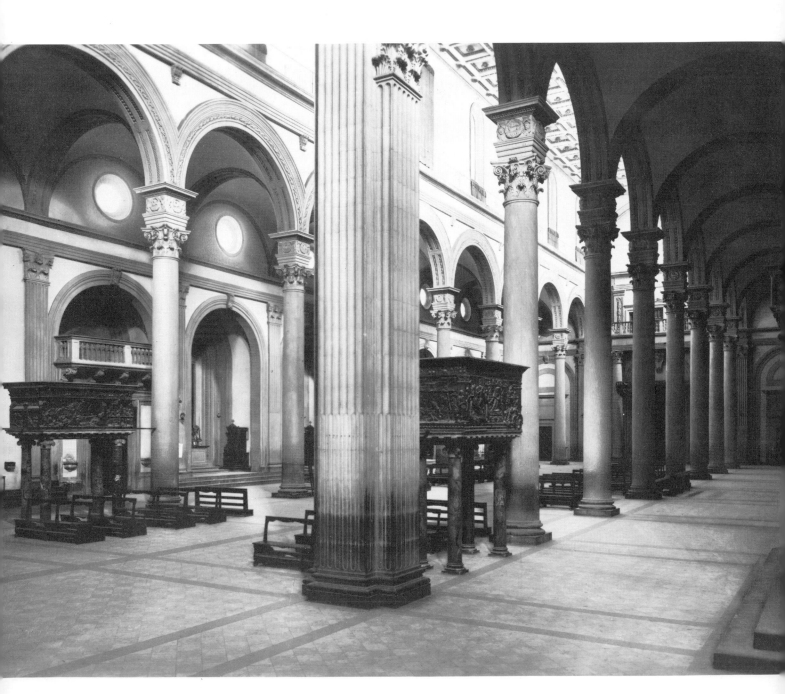

Donatello the Sculptor:
the San Lorenzo Pulpit Reliefs

[At San Lorenzo] he also designed the bronze pulpits that contain the Passion of Christ, producing a work of great strength, design and invention with abundant figures and buildings. However he was prevented by old age from completing these, and they were brought to perfection by his pupil, Bertoldo.

Vasari, *Life of Donato*, 1568[1]

An aged artist is often forgiven his last works. But Donatello's eleven bronze narrative reliefs for San Lorenzo (Figs. 1–4, 7, 9, 12, 14, 64),[2] the octogenarian's last works before his death in 1466, are praised by Vasari for their strength, design, and invention, qualities he admires in the sculptor's earlier works as well. He views the reliefs as yet another example of Donatello's innovative genius – nothing more and, oddly enough in light of their completion by a follower, nothing less. Vasari's assessment of Donatello's works is not only consistent, but quite different from his praise of works by Donatello's contemporaries (Ghiberti, Nanni di Banco, Luca della Robbia, the Rossellino brothers, Desiderio da Settignano), which he prefers to judge as 'graceful' or 'executed with great diligence', or of those by Jacopo della Quercia, which he praises primarily for their closeness to nature.

Innovation implies constant change, and Donatello selectively built, but never relied, on past endeavours, whether they were his own or those of others; his career never culminated in a single masterwork and he never developed a 'mature style'. The forcefulness of an image such as the Risen Christ from the San Lorenzo *Resurrection* (Fig. 7) is very much akin to that of the haunting *St. John the Baptist* (Fig. 113) of nearly thirty years earlier, or to the *Penitent Magdalene* (Fig. 131). The unique composition of the *Resurrection*, and the intended locations for the San Lorenzo reliefs are manifestations of his interest in space – an interest that resulted in his invention of *rilievo schiacciato* and his use of linear perspective, and in his revival of sculpture-in-the-round. No one work can be taken as typical of his *œuvre*, yet each is aptly characterized by Vasari's general comments on the San Lorenzo reliefs. The sculptor was an unpredictable genius whose work does not demonstrate a consistent evolution within a narrowly defined personal style.

Although Vasari may have treated the San Lorenzo reliefs as being equal to Donatello's other work, modern scholarship has until recently largely ignored them. Yet appreciating the breadth of their artistic scope, the power of their imagery, and the complexity of reconstructing them historically and art-historically provides a comprehensive background and a critical apparatus for a study of the

1. Filippo Brunelleschi: Church of San Lorenzo, Florence. *c.*1421–50. Interior, showing Donatello's reliefs mounted as a pair of pulpits. (See also Figs. 2–4, 7, 9, 12, 14, 64.)

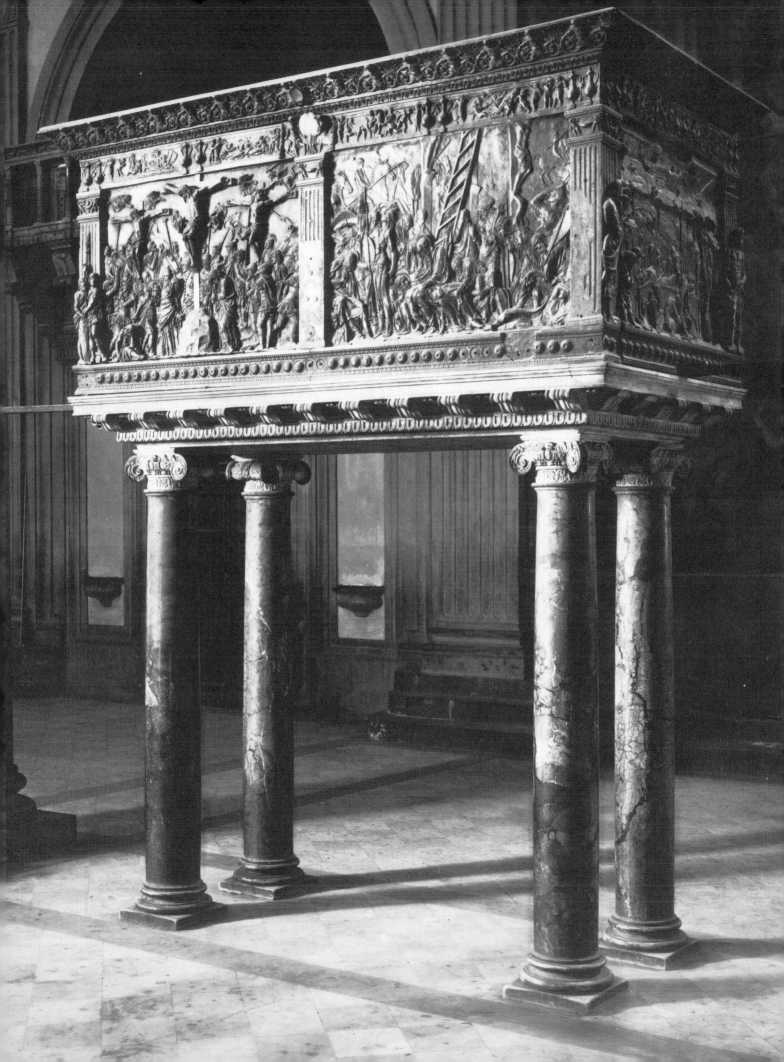

artist. In this monograph the San Lorenzo reliefs introduce Donatello's life and work because they reveal clearly many of the qualities found throughout his art. Foremost among these qualities is his profound and moving reinterpretation of traditional subject-matter, an innovation that seems to grow from his interest in human behaviour. The reliefs also demonstrate how he uses such formal elements as composition, framing, architectural setting, and illusionistic space to emphasize the new human content of his narratives. The expressive use of his medium, in this case bronze, and the revitalization and transformation of sources drawn from earlier art are also readily apparent in these reliefs. Comparisons with works by contemporary sculptors and painters show both that Donatello's reliefs are typical of the Renaissance and at the same time how they stand apart from what other Florentine artists were producing.

Understanding the patronage, function, and location is as important for appreciating these bronze reliefs in San Lorenzo as for any Renaissance work of art. Although no document refers explicitly to the reliefs, it has always been assumed that they were originally intended for the church of San Lorenzo, Florence, and that they were commissioned by a member of the Medici family, most likely Cosimo de'Medici himself.[3] Although the reliefs are now mounted on two large, sarcophagus-shaped pulpits (Figs. 1, 2), and earlier scholars have examined Cosimo's motive for reviving the Early Christian custom of having a pair of pulpits from which to read the Gospel and Epistle, recent investigations suggest that such an arrangement may not have been intended for these reliefs. In fact, the present pulpits make a poor pair: the narrative reliefs are not the same height, the main face of one pulpit offers two narratives while the other has three, and the framing elements have little in common.

Taking these disparities into account and working from the research of Volker Herzner, Luisa Becherucci has proposed that while the pulpit with Passion scenes (Fig. 2) may well have been intended to be the pulpit for San Lorenzo, the narrative reliefs now on the second pulpit (Figs. 7, 9, 14) might have been meant to form part of a monumental tomb for Cosimo de'Medici.[4] She also suggests that the large and handsome entablature with rampant horses (Fig. 3), which now caps the second pulpit, was conceived by Donatello as the cornice for a free-standing high altar for San Lorenzo. This interpretation of the reliefs is supported by a little-known passage in Vasari, which explicitly mentions a model Donatello made for the high altar of San Lorenzo with 'the *Tomb of Cosimo de'Medici* at its foot' ('il modello dell'altar maggiore con la sepultura di Cosimo a' piedi').[5] The passage implies that the tomb was intended to be a free-standing floor tomb, like that of Cosimo's parents in the Old Sacristy, placed under the crossing of the church, that is directly above the present tomb in the crypt. Donatello's ensemble would thus have included a single pulpit, an open altar table, and a free-standing floor tomb. Iconographically and formally Becherucci's proposals are compelling, and she has rightly suggested that the next step should be the dismantling of the pulpits to ascertain what internal evidence the reliefs might offer about their original function and position.

Even without this investigation, however, the iconography of the panels supports Becherucci's theory. With the exception of a single panel dedicated to the Martyrdom of San Lorenzo, the reliefs constitute a sequential cycle of Passion and Post-Passion narrative scenes. Those reliefs that are assumed to have been intended for the pulpit for San Lorenzo include the *Agony in the Garden* (Fig. 12), *Christ before Herod and Caiaphas*, and the *Crucifixion*, *Lamentation*, and *Entombment* (Figs. 2, 4). The reliefs for the tomb of Cosimo would be the *Holy Women at the Tomb* (Fig. 14), the *Descent into Limbo*, the *Resurrection* (Fig. 7), the *Ascension*, and the *Pentecost* (Fig. 9). The positioning of the central Christian theme of the Crucifixion on the pulpit is

2. *The Crucifixion, the Lamentation, and the Entombment.* 1460s. Bronze, height with frieze 137 cm. Florence, San Lorenzo

appropriate, as is the concentration of Resurrection imagery on the tomb.[6] That the scenes intended for the tomb are designed to be seen from above, rather than from below as is now required, adds significant support to Becherucci's theory (Figs. 7, 9, 14).

The power and inventiveness of these late reliefs is well illustrated by the dramatic *Lamentation*, which would have been part of the main face of the San Lorenzo pulpit (Figs. 2, 4). The subject, a traditional one by Donatello's time, presents the moment after Christ has been taken down from the cross, when his mother and his followers gather to mourn his death. Donatello's emphasis on the drama and emotion inherent in this particular narrative is most immediately apparent in the women who are depicted as running, raising their arms, screaming, moaning, and covering their eyes. Their long hair is wild and dishevelled, their movements tense and jerky; in these figures Donatello has effectively expressed a mood of hysteria. Yet there are no fewer than twelve other mourners, figures that reveal how well Donatello understood the varied expressions of grief that can result from a tragic event. The saint seated to the extreme left, for example, has his head bowed and his hands clenched, signalling a retreat into a completely private world of sorrow. The corresponding

3. Detail of the cornice for the Altar Table for San Lorenzo. 1460s. Bronze. Florence, San Lorenzo

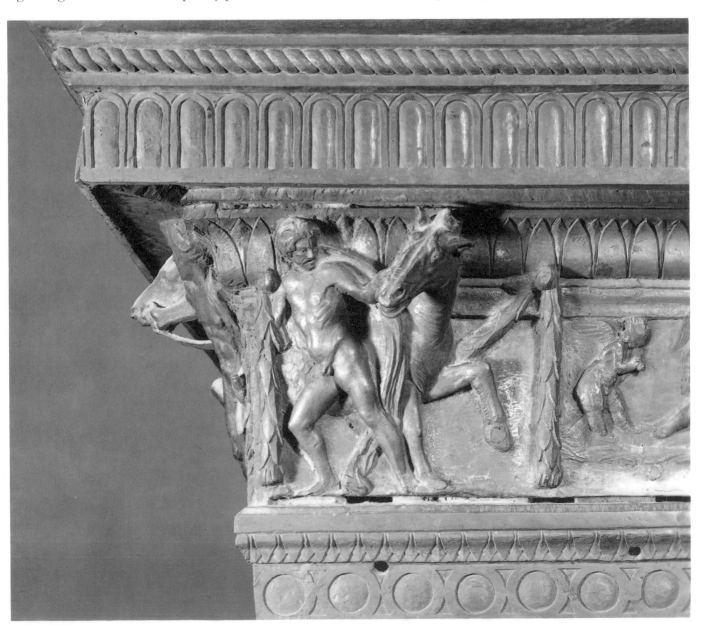

figure with lowered head on the extreme right suffers from exhaustion; his emotional energies are spent. To the right of the ladder is an old, bearded figure whose stare is riveted on the huge nails just removed from Christ's hands and feet. Directly behind the ladder a figure of indeterminate age and sex, the face masked by fallen hair, weeps inconsolably. In direct contrast is the woman immediately to the left of the Virgin, who is depicted in quiet prayer.

The centre of the composition, the core of this *Lamentation*, is an island of stillness within the waves of grief. The rigid body of Christ forms a stabilizing horizontal, and the seated Virgin provides a corresponding vertical. She lowers her head while raising Christ's until their faces are almost parallel and she can stare directly into the visage of her dead Son. Donatello has intentionally made the Virgin's veil substantially more three-dimensional than the rest of the relief so that the light coming through the high windows of San Lorenzo creates a shadow, veiling her expression from us. At this tragic moment Donatello guarantees Mary the dignity of privacy.

These individual emotions are in sharp contrast to the reaction expressed in Fra Angelico's *Deposition*, a sightly earlier work (Fig. 5). Here the response to Christ's

4. *The Lamentation.* 1460s. Bronze, height with frieze 137 cm. Florence, San Lorenzo

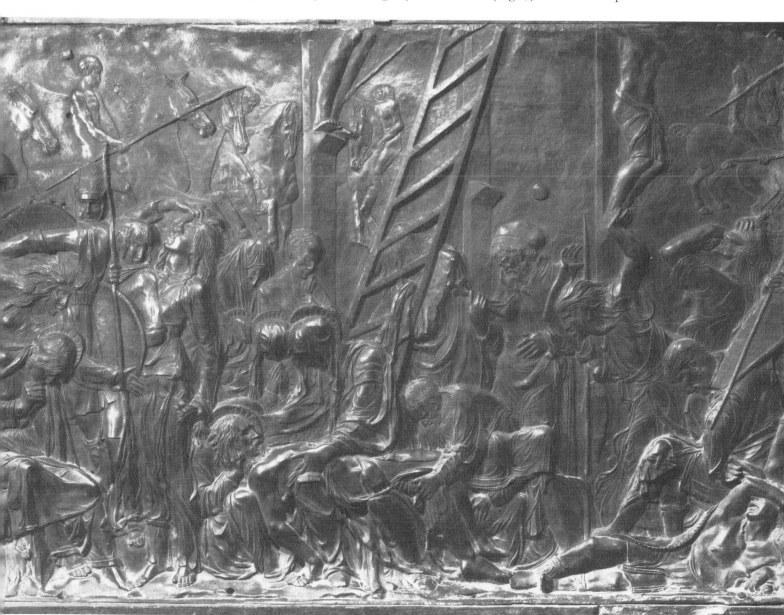

5. Fra Angelico: *The Deposition*. Early 1430s. Tempera on wooden panel, 176 × 185 cm. Florence, Museo di San Marco

death does not vary from figure to figure. The mood of the group of followers who receive the body lowered from the cross is one of gentleness and quiet reverie; not one of the figures loses self-control. The effect is that of a Greek chorus, where individuality is submerged in the expression of common feeling.

Fra Angelico's *Deposition*, however, does not represent the same moment in Christ's Passion as Donatello's *Lamentation*. Although the biblical texts never mention the emotional response aroused by Christ's death in his mother and his followers, by the later middle ages the expression of mourning dominated representations of the Crucifixion, Deposition, Lamentation, and Entombment. The Lamentation, however, is the only subject that does not incorporate a specific action; it seems to have been chosen when an artist or his patron wished to stop all action, to put a pronounced emphasis on the emotion of grief. In light of this it should be noted that Donatello's *Lamentation* is preceded by the *Crucifixion* and followed by the *Entombment* (Fig. 2). Such a sequence of Passion scenes is rare, and Donatello's iconographic choice suggests he wished to emphasize the continuing despair of Christ's followers and of the Virgin Mary.

The comparison of Donatello's *Lamentation* with Fra Angelico's *Deposition* reveals how Angelico has chosen to circumscribe his representation to remove it from an historical context. He has eliminated, for example, the two thieves and their crosses, as well as the soldiers of Pilate, while Donatello's representation includes the thieves and the Roman soldiers.[7] The soldier to the left with his arm raised even adds an air of violence unusual in Lamentation scenes. In addition, the manner in which Donatello has truncated the figures to either side and the thieves on their crosses suggests that we are glimpsing a segment of a much greater reality; he has used the relationship of figure to frame to heighten both the drama and the realism of the narrative. Especially effective is the awkward cropping of the thieves, one at

the knees and the other at the neck. In addition, the random and crowded composition evokes the effect of a real experience, in sharp contrast to the clear, harmonious, and self-contained composition constructed by Angelico.

Throughout Donatello's career the particular story, figure, moment, or attitude that he is representing seems to have played a crucial role in his creative process. Although he was surely aware of earlier artistic representations of his subject and of the biblical and other texts related to it, his own meditation on his theme's human content seems often to have provided the most important impetus for his reinterpretation. In the case of the *Lamentation*, his understanding of individualized emotions would seem to have been the most important single factor.

Comparing Donatello's *Lamentation* and Fra Angelico's *Deposition* also reveals other important differences. While Donatello's relief cannot be called beautiful in the traditional sense, Angelico's painting reveals a determined effort to create a pleasing object: the colours are rich and varied, the carefully studied natural light creates broad and regular patterns of modelling, and the drapery falls in flowing, rhythmic patterns. Whereas Fra Angelico's forms are smooth and geometric in their definition, Donatello's are angular and irregular, creating patterns that are hectic and unpredictable. And the distant hills, clouds, and sky in the painting offer an escape from the misery of the event; Donatello's crowded composition provides no such opportunity for release.

There is, however, one aspect of the *Lamentation* that might be termed traditionally beautiful; this is the muscular body of Christ, which is reminiscent of ancient heroic sculpture in its type and which is created by subtle and finely polished undulations of the bronze surface. This surface treatment, which is pleasing for its own sake, helps create the quiet and soothing peace found at the core of this composition. A comparison of the figure of Christ with the more vigorously plastic surface of the reclining figure in the lower right corner reveals how Donatello manipulated the material to heighten expressive content. In general, a harsh and even violent treatment of the bronze distinguishes the *Lamentation*, and technique becomes another significant means to express the tortured emotions of the witnesses. Fra Angelico's *Deposition*, in contrast, displays the consummate and careful craftsmanship so important to most fifteenth-century Florentine artists and patrons; the forms are finely finished and the effect is of elegance and refinement. Donatello's harshness might be interpreted as a reaction to the decorative, emotionally restrained work created by most of his contemporaries.

The *Lamentation* at San Lorenzo raises another issue important for Donatello's art, for it provides evidence of the inspiration from ancient art, which is so important for the Renaissance. Although the hysterical women hardly seem classical, they are a significant example of antique revival: what inspired Donatello were ancient representations of Maenads, those ecstatic maidens who were shown convulsed with hysterical abandon in representations of the Dionysiac revelries (Fig. 6).[8] Donatello obviously recognized that their poses and expressions could be transformed to express tragedy. Another possible example of classical inspiration is the reclining male figure in the lower right; both his pose and the manner in which he fits into the corner suggest those ancient figures, such as river-gods, who functioned as allegorical references to the setting of their narrative. Donatello may here have been citing an antique source without knowledge of its meaning, attracted to its possibilities as a generic classical reference, which could also function to close the composition; he had previously used such river-god types in the narrative reliefs on the Padua Altar (Fig. 97). In any case, what is remarkable is that Donatello has also forced the figure to participate dramatically in the *Lamentation*.

An additional example of the influence of antiquity is the veiling of the face of the figure directly behind the ladder, but in this case the influence is literary, not visual.

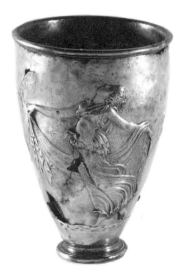

6. *Dancing Maenad* from the '*Vicarello*' *Goblet*. Roman, late first century BC – early first century AD. Silver repoussé, height 11 cm. Cleveland Museum of Art, purchase from the J. H. Wade Fund.

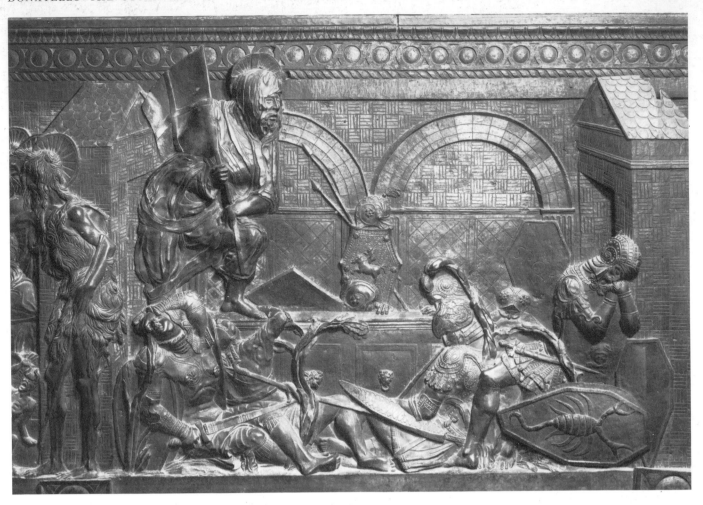

7. *The Resurrection*. 1460s. Bronze, with traces of partial gilding, height with frieze 123 cm. Florence, San Lorenzo

As Moshe Barasch has pointed out, the source is a description of a famous ancient painting by Timanthes, which is described by Quintilian, Cicero, and Pliny. Most relevant here, however, is the reference to it by Donatello's contemporary, Leon Battista Alberti, in *Della pittura*:

> They praise Timanthes of Cyprus for the painting in which he surpassed Colotes, because, when he had made Calchas sad and Ulysses even sadder at the sacrifice of Iphigenia, and employed all his art and skill on the grief-stricken Menelaus, he could find no way to represent the expression of her disconsolate father; so he covered his head with a veil, and thus left more for the onlooker to imagine about his grief than he could see with the eye.[9]

The *Lamentation* breaks with iconographic tradition only in the extremity and variety of emotion depicted; other reliefs from the San Lorenzo Pulpits, however, such as the *Resurrection* (Fig. 7), reveal bolder iconographic experimentation. There seems to be no source for Donatello's interpretation of this central Christian mystery, and nothing in traditional Christian art prepares us for its joylessness.[10] This is Easter morning, when Christ rises from the dead; it is a triumphant and inspiring moment. Donatello's Christ, however, drags himself upward; he is weary, as if still suffering the effects of his human death. That this *Resurrection* offers so little hope is a clear statement of the pessimism, rare in the Renaissance, sensed in much of Donatello's art. This unusual representation of the Resurrection allows him to express not only the completely unexpected nature of the miracle, but also the physical and emotional strain Christ endured at the Crucifixion. Furthermore, the immediately preceding relief in the cycle is the *Descent into Limbo*, the episode of

Plate I. Herod Being Presented with the Head of St. John the Baptist. Detail of the *Feast of Herod* (Fig. 95). 1423–7. Gilded bronze.

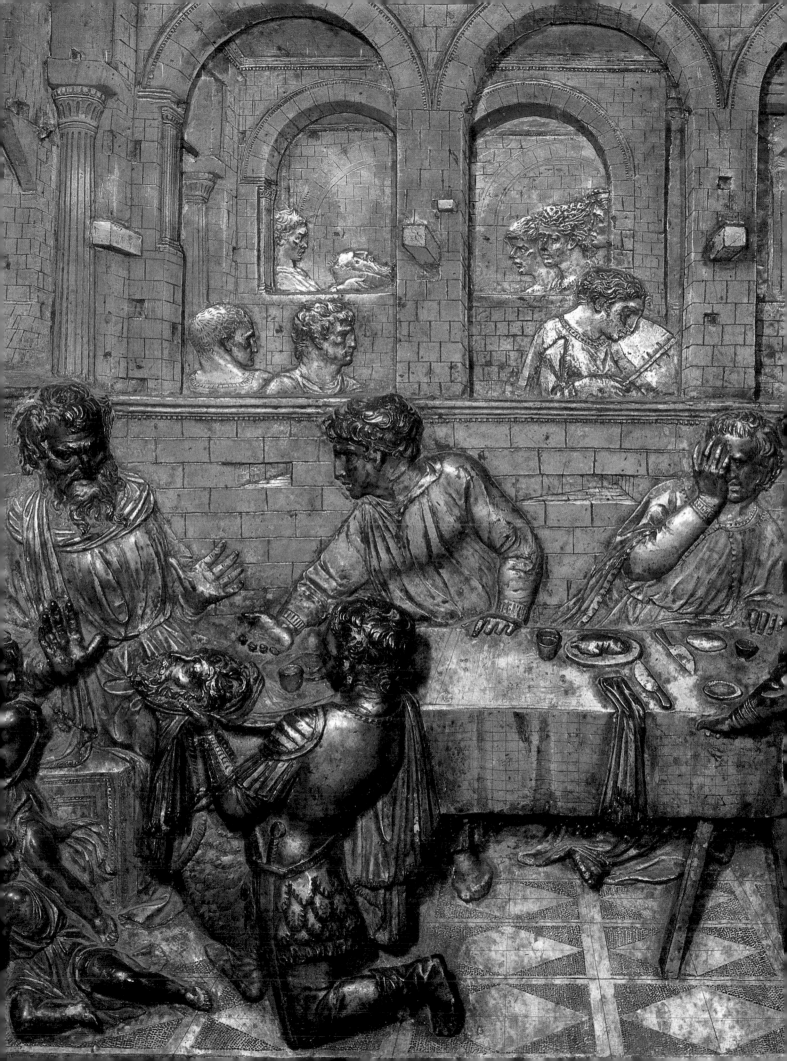

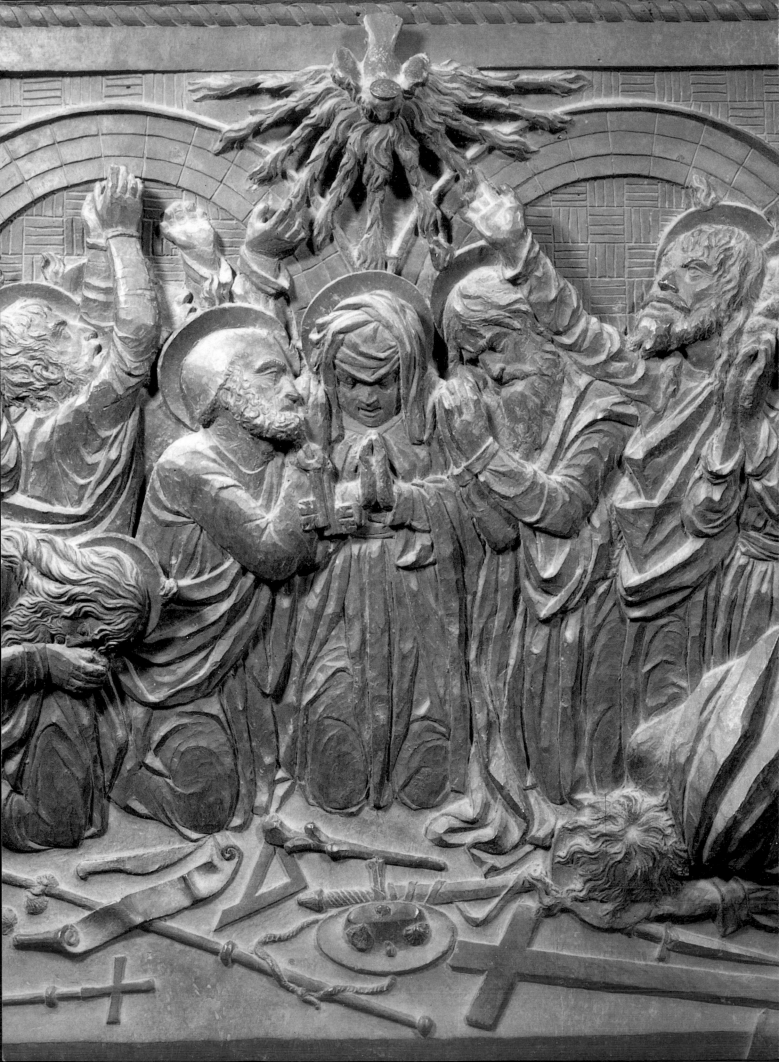

how Christ, after the Entombment and before the Resurrection, broke down the Gates of Hell in order to rescue those holy souls, including King David and John the Baptist, who had died before him; the physical toll of this dramatic action may further explain Donatello's unusual representation of the Risen Christ. This Christ is shocking because he is not a hero; rather than urge us to exult in Christ's victory, Donatello forces us to empathize with his struggle.

In contrast, Andrea del Castagno's almost contemporary fresco represents the Resurrection in a more typical Renaissance fashion: the emphasis is on new life, and there is a stirring youthfulness in Castagno's beardless Christ who, holding the requisite banner, stands triumphant on top of his open sarcophagus (Fig. 8). His figure is almost Apollonian in its physical beauty and heroic composure; his muscles are firm and his white garment is fresh. In startling contrast is Donatello's Christ, who is still encumbered by the burial clothes that St. John (20:5) says were left behind when he rose from the dead. Eyes barely open, Donatello's Christ lacks the energy needed for striking a pose such as that assumed by Castagno's figure. In the fresco Christ is in the centre, with flanking soldiers below to form the stable triangular compositional pattern so popular in the Quattrocento. Donatello, as if in defiance of the norms of Renaissance balance, has placed Christ far to the left, suggesting that his journey after death has barely begun. Castagno's landscape background, like that of Fra Angelico's in the *Deposition*, allows the viewer's eye to wander and escape; Donatello's complexly patterned architectural background eliminates any such possibility. Whereas Castagno offers a single witness to the miracle, a soldier behind the sarcophagus who looks up in wonder, the Roman guards of Donatello's panel all sleep as if drugged, suggesting that they will not share in the Redemption, made possible by the Resurrection. The prominent scorpion on the soldier's shield in the right foreground is unlikely to be merely a decorative motif. In the context of Christ's victory the insect's treacherous sting probably refers to both sin and death: 'O death, where is thy sting? O grave, where is thy victory? The sting of death is sin.' (I Corinthians 15:55–6). Despite this symbolic reference to victory, the pervasive mood of Donatello's *Resurrection* is pessimistic.

The Christological cycle at San Lorenzo closes with the *Pentecost* (Fig. 9), which represents the fulfilment of Christ's promise made at the Ascension to send the Holy Spirit to succour the Apostles. Like the Resurrection, this relief would have been part of the tomb planned by Donatello for Cosimo de'Medici. Technically it is among the least finished at San Lorenzo; the chasing is crude, suggesting that it was unfinished at the time of Donatello's death. The conception is so remarkable, however, that there seems no doubt it originated in the mind of the master. The dove of the Holy Spirit descends at the top, surrounded by tongues of flame, which stretch toward the Apostles and the Virgin. The responses to this surge of divine power are varied. Two Apostles swoon, and one actually falls face down on the floor, 'as if blinded by the divine radiance' wrote Francesco Bocchi in 1591. Others reach out excitedly to welcome the Holy Spirit. In their ecstasy they have let their attributes fall to the floor, and the foreground is littered with knives, staffs, scrolls, and a cross. The composition, in which the floor plays an unusually important role, would be even more satisfactory if viewed from above, as part of the tomb of Cosimo. The central grouping of Peter, the Virgin, and another Apostle provides a foil to the other figures; by responding to the gift of the Holy Spirit with a simple bowing of their heads, they demonstrate their inner strength and stability. Again Donatello's profound awareness of human individuality forms his interpretation of the narrative; the appropriateness of his insight might be verified at a twentieth-century pentecostal prayer meeting.

Donatello's *Pentecost*, however, is more than unusual, for it pointedly ignores the

8. Andrea del Castagno: *The Resurrection*. c.1447. Fresco, 401 × 180 cm. Florence, Refectory of Sant'Apollonia

Detail of Fig. 9

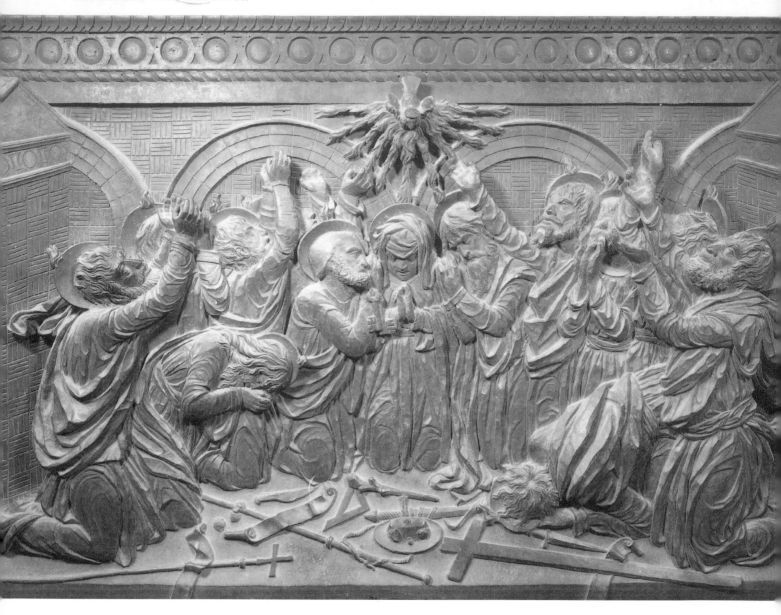

9. *Pentecost*. 1460s. Bronze, height with frieze 123 cm. Florence, San Lorenzo

standard Florentine pattern for depictions of this subject: the Virgin and Apostles were always shown gathered on a balcony, while below, listening at closed doors, were the members of other races who heard the Apostles speaking miraculously in tongues (Fig. 10).[11] Donatello avoids this traditional scheme and demonstrates no interest in the newly acquired linguistic abilities of the Apostles; it is the ecstasy and inspiration of the individual experience that dominates his interpretation.

Donatello's grouping of the Apostles in a semicircle demonstrates the popularity of this geometrically conceived compositional type in the Early Renaissance;[12] yet another example is Luca della Robbia's *Ascension*, an enamelled terracotta relief over one of the sacristy doors in the Duomo (Fig. 11). Luca's Apostles, however, are grouped into a flowing and harmonious ring, with the individuals unified into the larger compositional entity, while in Donatello's work they form only half a circle, and all the figures face the viewer so as to emphasize the variety of their responses. Again Donatello's awareness of human individuality underlies his interpretation of the narrative.

The wisdom of Donatello's insight can perhaps best be seen in the relief of the *Agony in the Garden*, here compared with Ghiberti's relief of the same subject from the North Doors (Figs. 12, 13). The moment represented is early in the Passion

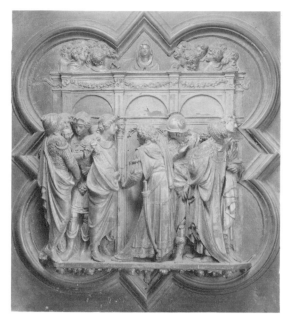

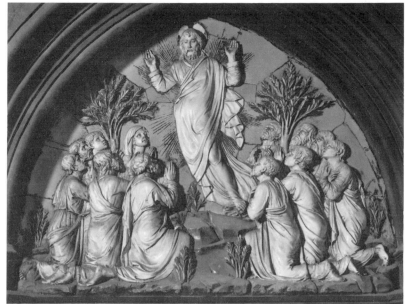

10. Lorenzo Ghiberti: *Pentecost.*
Detail from the North Doors.
1407–24. Bronze, with partial
gilding, 65 × 57.5 cm. Florence,
Baptistry

11. Luca della Robbia: *The Ascension.*
1446–51. Enamelled terracotta,
200 × 260 cm. Florence, Duomo

cycle when, after the Last Supper, Christ and eleven of the Apostles go to the
Garden of Gethsemane:

> Then cometh Jesus with them unto a place called Gethsemane, and saith unto the
> disciples, 'Sit ye here, while I go and pray yonder.' And he took with him Peter
> and the two sons of Zebedee, and began to be sorrowful and very heavy. Then
> saith he unto them, 'My soul is exceeding sorrowful, even unto death: tarry ye
> here, and watch with me.' And he went a little further, and fell on his face, and
> prayed, saying, 'O my Father, if it be possible, let this cup pass from me:
> nevertheless not as I will, but as thou wilt.' And he cometh unto the disciples, and
> findeth them asleep, and saith unto Peter, 'What, could ye not watch with me one
> hour? Watch and pray, that ye enter not into temptation: the spirit indeed is
> willing, but the flesh is weak.' He went away again the second time, and prayed,
> saying, 'O my Father, if this cup may not pass away from me, except I drink it, thy
> will be done.' And he came and found them asleep again: for their eyes were
> heavy. And he left them, and went away again, and prayed the third time, saying
> the same words.
>
> Matthew 26:36–44

Both Donatello and Ghiberti represent Christ's vision as an angel, although no
such figure is mentioned in the biblical text. Ghiberti's angel is surprisingly empty-
handed and the chalice, that portent of Christ's death explicitly mentioned by
Matthew, does not appear; this permits a rather prosaic interpretation of the theme,
with Christ and the angel having the same crossed-arms gesture as they stare into
each other's eyes. In Donatello's relief the angel thrusts forward a large chalice, and
Christ's response is to raise his hands high in a pathetic gesture of supplication;
Donatello has clearly been inspired by Christ's plea: 'O my Father, if it be possible,
let this cup pass from me.' While Ghiberti suggests communication between the
two figures, Donatello has represented a dramatic, personal experience. He forces
Christ to confront death, and by thrusting him so far back into the illusionistic space
he becomes truly alone, forsaken at exactly that moment when he most needs the
succour of his followers.

Ghiberti, working in a smaller scale, limited his group to Christ, the angel, and
Peter and the sons of Zebedee; all are carefully encompassed by the Gothic quat-
refoil frame. Donatello chose a rectangular format framed by pilasters in the
classicizing style consistent with its later date, but he does not allow his frame to

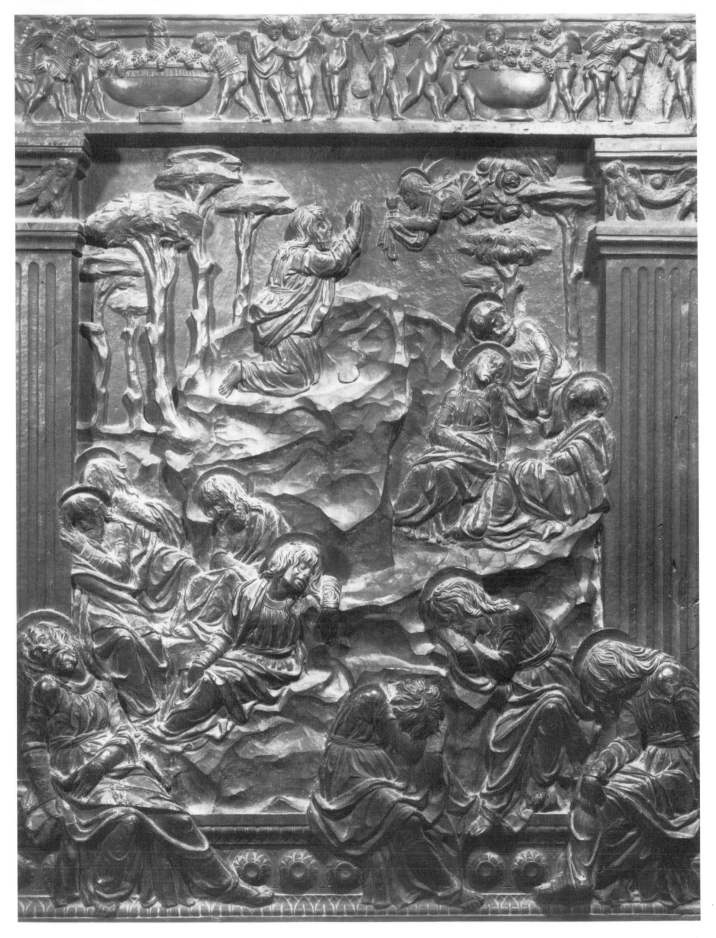

delineate and enclose; he treats it as something to be overlapped, defied. The foremost Disciples cascade out of the enframed space of the relief, thrust forward toward the world of the spectator. The union of these Apostles with the spectator is almost certainly intentional; it may be compared to traditional Florentine representations of the Last Supper, in which Judas is placed on 'our' side of the table.[13] Here Donatello has decisively broken the traditional boundaries, both physical and psychological, between life and art.

This conscious overlapping of the frame is significant, since Donatello's work frequently defies traditional or expected limitations not only of framing, but of expression, iconography, and technique as well. This struggle against traditional boundaries has already been demonstrated in his composition of the *Resurrection*, his reinterpretation of the Pentecost theme, and the new iconographic content he created for the *Resurrection*. His disregard for accepted norms offers an insight into his character and creative process that is crucial for understanding his art.

The *Holy Women at the Tomb* is perhaps the most startling of the reliefs in terms of spatial manipulation (Fig. 14). The traditional climax of this biblical narrative comes when the three women discover that their Lord has risen:

> And when the sabbath was past, Mary Magdalene, and Mary the mother of James, and Salome, had bought sweet spices, that they might come and anoint him. And very early in the morning the first day of the week, they came unto the sepulchre at the rising of the sun. And they said among themselves, 'Who shall roll us away the stone from the door of the sepulchre?' And when they looked, they saw that the stone was rolled away: for it was very great. And entering into the sepulchre, they saw a young man sitting on the right side, clothed in a long white garment; and they were affrighted. And he saith unto them, 'Be not affrighted: Ye seek Jesus of Nazareth, which was crucified: he is risen; he is not here: behold the place where they laid him. But go your way, tell his disciples and Peter that he goeth before you into Galilee: there shall ye see him, as he said unto you.' And they went out quickly, and fled from the sepulchre; for they trembled and were amazed: neither said they any thing to any man; for they were afraid.
>
> Mark 16:1–8

Donatello's conception of this subject is remarkable, for he has created an actual three-dimensional structure to define the space of Christ's tomb-chamber. It is this

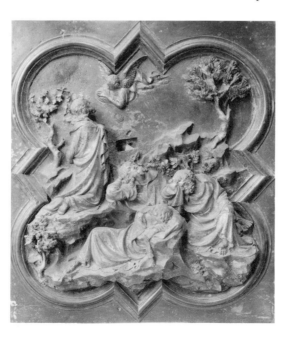

12. *The Agony in the Garden.* 1460s. Bronze, height with frieze 137 cm. Florence, San Lorenzo

13. Lorenzo Ghiberti: *The Agony in the Garden.* Detail from the North Doors. 1407–24. Bronze, with partial gilding, 65 × 57.5 cm. Florence, Baptistry

device that most evocatively conveys the meaning of the narrative: Christ has risen, and the tomb is empty.

Donatello's representation conveys none of the spirit of 'alleluia' normally associated with Easter morning; rather he emphasizes the disorientation and fear of the women expressed in the biblical text. The one to the right, for example, looks hysterically into the empty sarcophagus, while the middle figure stares uncomprehendingly at the gesticulating angel, who points upward in an attempt to convince her that the 'sweet spices' she thrusts forward will not be needed. She is so perturbed that she clutches at one of the piers for support. In the right half of the composition is the other part of the tomb chamber, where the second angel (mentioned by Luke and John) and some sleeping soldiers are glimpsed. The presence of these latter reminds us that some are not allowed to partake of the miracle. The fact that all the important action takes place only in half the architectural setting, which thereby creates a drastically asymmetrical narrative, again demonstrates Donatello's disregard for the tradition of the Renaissance centralized composition.

The extent to which Donatello deviated from the norm in the *Holy Women at the*

14. *The Holy Women at the Tomb*. 1460s. Bronze, height with frieze 123 cm. Florence, San Lorenzo

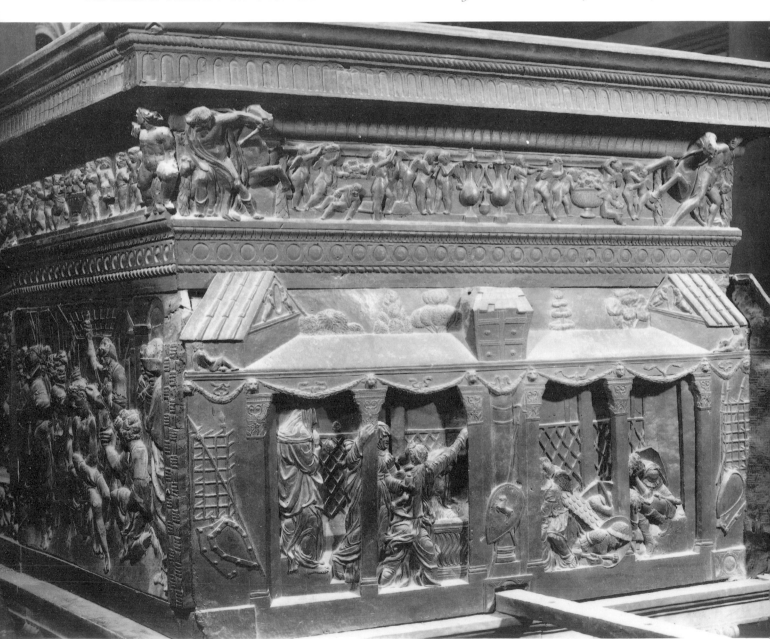

15. Lorenzo Ghiberti: *The Story of Jacob and Esau*. Detail from the Gates of Paradise. 1429–37. Gilded bronze, 79.5 cm. square. Florence, Baptistry

Tomb is obvious in a comparison with Ghiberti's *Jacob and Esau* from the Gates of Paradise (Fig. 15). The latter is not only an example of conventional Renaissance compositional practices, but virtually a visual equivalent of the written formula for a good narrative composition as invented by Alberti, a contemporary of Donatello and Ghiberti. Ghiberti has placed his architectural structure in the middle ground, so that it exists as an independent unit within the illusionistic space, and while some episodes of the narrative take place within this structure, others occur in front of it, to the side, and even on its roof. Since the sculptor's most prominent figures are the larger, high relief figures who stand in front of the building, there is the unavoidable impression that architecture's primary function is as a backdrop. In Donatello's work on the other hand, the architectural construction encompasses both relief figures and real space, thereby pushing the sculptural type beyond the definition of relief sculpture. The unreality of a stage setting, which Ghiberti's architecture suggests, is not simply the result of its position in the middle ground; its cavernous heights and the illogical notion that the mother's confinement took place in a monumental open loggia further suggest that it functions primarily as an aesthetic device. Serene and harmonious, it provides an elegant setting for the seven episodes of Ghiberti's narrative. In contrast, Donatello's structure is more reasonably scaled to the figures and, although both buildings are essentially classical in inspiration, Donatello's has the randomness, even the incompleteness, of an actual construction or an ancient Roman ruin; the unfinished buttress in the centre juts forward to incorporate the viewer's space, and therefore the viewer, into the composition.

Ghiberti's architectural invention is closer to the finest early Renaissance architecture, the great monuments of Brunelleschi, than is Donatello's. When we compare Ghiberti's setting with the interior of Brunelleschi's San Lorenzo, the church for which Donatello's reliefs were created (Fig. 1), it is clear that Ghiberti's sculptural creation and the church share the same lofty proportions, simple decoration, and measured and regular definition of repeated units; both are controlled and predictable. Donatello's creation, on the other hand, offers a complex rhythmic relationship of solids and voids, as well as of decorative membering, establishing a seemingly deliberate contrast between his sculpted reliefs and the physical environment they were to adorn.

The tenuous relationship between architecture and narrative in Ghiberti's *Jacob*

and Esau panel also exists between the cast of characters and narrative; he delighted in elaborating his compositions by adding extraneous figures and additional decorative details. In this case, for example, the four beautiful women to the left play no role in the development of the story; though they may ornament the relief, they also distract from the given narrative. Ghiberti's description of his work reveals his interest in the ornamental aspect of his sculptures:

> I was commissioned . . . [to do] the third door of S. Giovanni, and I was given a free hand to execute it in whatever way I thought would turn out most perfect and most ornate and richest. . . . These stories, very abundant in figures, were from the Old Testament: in them I strove to observe with all the scale and proportion [*misura*], and to endeavour to imitate Nature in them as much as I might be capable; and with all the principles [*liniamenti*] which I could lay bare in it and with excellent compositions and rich with many figures. In some stories I placed a hundred figures, in some less and in some more. I conducted this work with the greatest diligence and with the greatest love.[14]

Ghiberti's attitude toward the treatment of narrative is consistent with that of the most important theorist of the Quattrocento, Alberti, who described the qualities essential to a significant narrative composition as the concept *istoria*:

> The first thing that gives pleasure in a 'historia' is a plentiful variety. Just as with food and music novel and extraordinary things delight us for various reasons but especially because they are different from the old ones we are used to, so with everything the mind takes great pleasure in variety and abundance. So in painting variety of bodies and colours is pleasing. I would say a picture was richly varied if it contained a properly arranged mixture of old men, youths, boys, matrons, maidens, children, domestic animals, dogs, birds, horses, sheep, buildings and provinces; and I would praise any great variety, provided it is appropriate to what is going on in the picture.[15]

In a comparison between Donatello and his great rival Ghiberti, then, it is the former who is out of step with Renaissance attitudes and the latter who best fulfils the theorist's expectations. But while Ghiberti may offer variety and abundance in his number of figures, it is Donatello who represents a wider range of emotions. Ghiberti demonstrates little interest in the treachery and deceit inherent in the Jacob and Esau narrative, and while he enchants us with his beautiful figures, melodious drapery folds, well organized composition, and exquisitely rendered details, we remain emotionally uninvolved in the characters and their drama.

Ghiberti's relief is finely finished, while Donatello's is rough, with some parts hardly chased at all. Although we cannot be sure what further work Donatello might have undertaken on this and the other reliefs had he lived longer, the reliefs as a whole suggest that in his later period he was little interested in the consummate craftsmanship that so concerned Ghiberti and other Quattrocento artists; once again, his attitude is in direct contrast to that prevailing among his contemporaries.

The universal appeal of Donatello's art is based on the convincing emotion evident in these reinterpretations of traditional biblical narratives. He has used virtually every means available to him – space, architectural setting and decoration, technique, surface treatment, composition, framing, classical sources – to express the humanity he perceived in his subjects. Comparisons with the work of his Florentine contemporaries underscore his individuality; whatever he did contains more than a little of the unexpected. Clearly, Donatello was an artist who did not feel constrained by either traditional or contemporary artistic solutions and who took full advantage of the freedom allowed by Quattrocento Florentine culture, and in this case an enlightened patron, to be boldly inventive.

CHAPTER TWO

Donato di Niccolò di Betto Bardi, the Florentine

'He laughed at me, and I at him.' And this saying too originated with Donatello who, after a young disciple with whom he had quarrelled fled to Ferrara, asked Cosimo de'Medici to provide him with letters to the Marchese of Ferrara so that he could follow the youth and murder him. Now as Cosimo knew Donatello's nature, he gave him the letters he had requested and, by another means, informed the Marchese what kind of man this Donatello was. The Marchese granted Donatello the permission to kill the boy wherever he found him, but when Donatello encountered the apprentice face to face, the boy began to laugh as soon as he saw him and Donatello found himself laughing in spite of himself. Later, when the Marchese asked if he had killed the apprentice, Donatello responded: 'No, in the name of the devil, for he laughed at me, and I at him.'

Anonymous Florentine Diarist, *c*.1477–9[1]

The artist whose work is appreciated only after his death is a modern phenomenon; in the Renaissance, quality and success often went hand-in-hand. It is no surprise to find Donatello included with Brunelleschi, Ghiberti, Luca della Robbia, and Masaccio in the prologue to Alberti's 1435/6 treatise *On Painting*, but unlike these other prominent Early Renaissance artists Donatello worked in or for a large number of important centres throughout the Italian peninsula (Fig. 16). In 1452 Alfonso of Aragon, King of Naples, wrote to the Doge of Venice: 'We have heard of the skill and subtlety of the master Donatello in making both bronze and marble statues. There has come upon us a great wish to have him at our court and in our service for some time.' The praise for Donatello is sometimes even more lavish than we might expect: Vasari, Michelangelo's pupil and ardent admirer, claimed that Donatello was so proficient in relief sculpture that 'in our own age no one has equalled him'. Alamanno Rinuccini wrote in 1473 that Donatello was almost the only sculptor to count, since he so surpassed all the others. In the late 1470s a Florentine writer asserted that Lorenzo Ghiberti 'was a small star beside that sun', meaning Donatello. Clearly his reputation for quality did not need much time to grow.[2]

Modern information about the artist includes not only a number of historical references, such as these, but a great number of documents as well. For a single work, the Prato Pulpit (Fig. 103), there are more than 150 documents concerning the commission, the materials, and the execution. Between 1406, the date of the first document referring to a sculpture by Donatello, and his death sixty years later, there are few years for which there is no information on his whereabouts or activity. These notices offer hints about his relationships with other artists, the relative worth of his sculpture, his travels, and the conditions under which he worked.

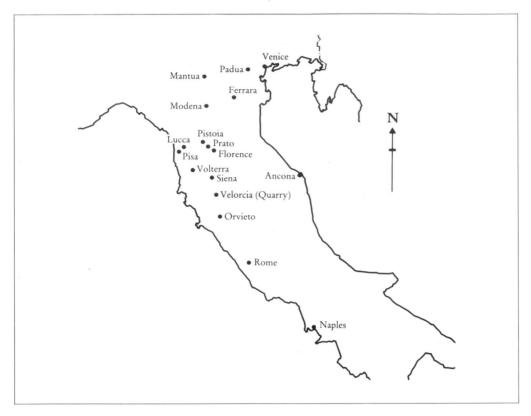

Fig. 16. Italian cities in which Donatello lived and worked, or which he visited, or from which he received commissions; based on fifteenth-century evidence.

1. ANCONA. In 1423 Donatello received the commission for a statuette of *St. John the Baptist* (lost or never completed) for the Baptistry.

2. FERRARA. In January 1451 Donatello received a payment from the Bishop of Ferrara for unknown work.

3. FLORENCE. Here Donatello was born, spent most of his life, and died; see Figs. 18, 19.

4. LUCCA. In 1430 Brunelleschi, Michelozzo, Donatello, and Ghiberti were employed by the Florentine government on engineering projects related to the siege of Lucca. Letters of 1428 and 1430 mention two ancient sarcophagi 'between Lucca and Pisa' that Donatello had seen and praised (see Fig. 102).

5. MANTUA. In 1450 Donatello visited Mantua, where he accepted a commission from Lodovico Gonzaga, Marchese of Mantua, to make a bronze reliquary called the *Arca di Sant' Anselmo* (never completed). In 1452 and 1458 Gonzaga tried to persuade Donatello to return to Mantua to complete the work, and in 1458 Donatello, then resident in Siena, assured Gonzaga's agent that he would return. As far as is known, he did not.

6. MODENA. Donatello visited the city in 1451 and received the commission to execute a gilded bronze statue of Borso d'Este. Although he received payments during 1452, an agent who was sent to him in Padua in 1453 to urge him to return and finish the work was not successful.

7. NAPLES. The *Tomb of Cardinal Rainaldo Brancaccio* by Donatello and Michelozzo was made in Pisa and shipped to Naples, where it was erected in the Chapel of the Hospital of Sant'Andrea (see Fig. 63).

8. ORVIETO. In 1423 Donatello received the commission to execute a gilded bronze figure of *St. John the Baptist* (lost or never completed) for the Baptismal Font of the Duomo of Orvieto.

9. PADUA. Donatello is documented as living in Padua by 1444 and he was still there as late as October 1453. His works there include a bronze *Crucifix* (visible in Fig. 127), the Padua Altar in the Santo (Figs. 127, 128), and the *Equestrian Monument of Gattamelata* (Fig. 52).

10. PISA. Donatello and Michelozzo had a studio in Pisa from 1426 until at least 1429; it was here that they executed the *Brancaccio Tomb*, which was then shipped to Naples (see Fig. 63). The documents suggest that Donatello was in charge of the Pisan workshop. For the exact location of the workshop see Lightbown, *Donatello and Michelozzo*, 88.

11. PISTOIA. The earliest documentary notice of Donatello records a fight that he had in Pistoia in 1401.

12. PRATO. Between 1428 and 1438 Donatello and Michelozzo worked on the outside *Pulpit* for the Cathedral of Prato (Fig. 103). In 1455 they wrote a joint letter to the Cathedral authorities asking if they might be rehired to finish the still incomplete project.

13. ROME. It is often reported that Donatello and Brunelleschi visited Rome *c*.1402–4, shortly after Brunelleschi lost the competition for the Baptistry Doors to Ghiberti, but this trip is not documented; a more probable date for Donatello's first trip to Rome is 1413–15 (see p. 38). By October 1432 Donatello was in Rome and had been there for some time, judging from the demands of the patrons of the *Prato Pulpit* that he return; he was back in Florence by May 1433. Donatello's surviving works in Rome are the *St. Peter's Tabernacle* and the *Tomb of Giovanni Crivelli*.

14. SIENA. Donatello executed several gilded bronze works for the Sienese Baptismal Font (Fig. 35) between 1423 and 1434 (Figs. 36, 95, 138, 140), but he did not live in Siena during this period. He was there on 27 April 1429, when he served as godfather to a child born to a Sienese goldsmith. In 1457 the bronze *St. John the Baptist* (Fig. 65), which had been fabricated in Florence, was delivered to its Sienese patrons, albeit minus an arm. Late in the same year Donatello moved to Siena and declared his intention to 'live and die' there. He was there between 1457 and 1459; during this period he received commissions for a set of Bronze Doors for the Duomo (the models were completed and the Victoria and Albert *Lamentation* (Fig. 56) may be related to this project) and for a marble figure of San Bernardino (never completed) for the Loggia di San Paolo.

15. VELORCIA. In 1458 Donatello and Urbano da Cortona visited the alabaster quarry at Velorcia.

16. VENICE. The wooden *St. John the Baptist* of 1438 (Fig. 113), commissioned by the Florentine citizens resident in Venice for their chapel in Santa Maria Gloriosa dei Frari, was most likely executed in Florence and shipped to Venice.

17. VOLTERRA. Recently discovered documentation reveals that Donatello made a trip to Volterra in 1455 to transact some business for Giovanni de'Medici.

Perhaps most fascinating is the fact that Donatello's name appears where it is least expected, with the result that a more personal image of him emerges than of any other fifteenth-century artist. Vespasiano da Bisticci, writing about 1485, does not include sculptors among his 'Illustrious Men', but he notes that Donatello had been on intimate terms with Niccolò Niccoli, the prominent humanist. Vasari, writing *On Sculpture*, most often cites Donatello's work as examples in his discussion of technique. He is even one of the characters in a novella, the 'Grasso Legnaiuolo,' written in the 1480s but set in 1409; Donatello, who is here involved with his friend Brunelleschi in a farce of mistaken identity, is introduced as 'Donatello, a carver of such quality that it is noted by everyone'.[3] As Janson has pointed out, his popularity is also suggested by his appearance as a character in the religious drama *Nabucodonosor, Re di Babilonia*, of about 1450. A diary containing a collection of witticisms and quips compiled in the late 1470s often mentions well-known people or uses them in anecdotes; Donatello is the only artist mentioned more than once. Although the stories may not be true, the fact that Donatello is the subject, or the object, in seven stories is indicative of his fame and of the familiarity of his name. One of these anecdotes begins this chapter; the others read as follows:

1 The Patriarch sent out a call for Donatello several times, and after many urgings he sent back this answer: 'Tell the Patriarch I don't want to go to him, and that I am just as much the Patriarch in my art as he is in his.'

2 There is a saying: 'Not for the love of God, but because you need it.' This was said by Donatello to a poor man, who asked him for alms for the love of God.

3 Donatello did a bronze statue of the Captain Gattamelata, and as he was being pressed too hard for it he took a hammer and smashed its head. When the Signoria of Venice heard this, they summoned the artist and told him, among other threats, that his own head was going to be smashed, like that of the statue. And Donatello replied, 'That's all right with me, provided you can restore my head as I shall restore that of your Captain.'

4 In the time of Donatello, the outstanding sculptor, there was also another sculptor in Florence, called Lorenzo di Bartoluccio Ghiberti, who was a small star beside that sun. Lorenzo had sold some land of his, called Lepricino, from which he was receiving little income. Donatello was asked what was the best thing – meaning in sculpture – Lorenzo had ever done; Donatello answered: 'Selling Lepricino.'

5 'The less long will he stay with me!' This phrase has already become proverbial, and this is its origin: the sculptor Donatello took particular delight in having beautiful apprentices. Once someone brought him a boy that had been praised as particularly beautiful, but when the same person then showed Donatello the boy's brother and claimed he was even prettier, the artist replied, 'The less long will he stay with me!'

6 Donatello used to keep his assistants poorly ('tigneva'), so that they would not be pleasing to others.[4]

These anecdotes provide hints of Donatello's character that are sometimes corroborated in other fifteenth-century sources. That he had a sharp and sometimes biting wit, for example, is further suggested by the role he plays in the 'Grasso Legnaiuolo', while his violent temper is revealed in a document of 1401, which implies that Donatello was the instigator in a bloody fight. His quarrelsome, or perhaps critical, nature is shown in a poem, addressed to Donato and probably written by Brunelleschi, in which Donatello is chided for voicing his opinion in critical matters outside his field. He may have been well-known for his competitiveness, since Vasari gives a similar image of him in the story about Donatello having made a *Crucifix* (Fig. 74) that Brunelleschi criticized; Donatello's answer, 'Take

some wood and make one yourself', survives in the Italian version of *Familiar Quotations*. This testiness is as typically Florentine as it might have been typical of Donatello, so that it is evidence of Donatello's birthright when Vasari claims the sculptor was happy to return to Florence, where his art would profit from criticism, after his long stay in Padua, where it was too much praised. A letter of 1458 implies that it was difficult to negotiate with Donatello; he is described as being 'molto intricato'. But at the same time the generosity of his almsgiving is reiterated in Vasari's anecdote that Donatello hung a basket filled with money from the work-shop ceiling and all his workmen and friends could take some without asking. A later story, which suggests either a certain amount of modesty or a strong dose of republican spirit, is told by Vespasiano da Bisticci (*c.*1485): Cosimo de'Medici, evidently embarrassed by Donatello's usual manner of dress, gave him a new cloak, cowl, and red mantle. After a day or two Donatello 'put them aside, saying that he would not wear them again as they were too fine for him'. That he was either not a good financial manager or had trouble making ends meet on the amount he earned as a sculptor – the former seems more likely, given the documents of payment that have survived – is revealed by the fact that he often owed back rent. In his 1427 tax return he states that he owes two years' rent (thirty florins) to his landlord, and when he died in 1466 he still owed thirty-four florins back rent on a former house.[5]

Janson, citing the last two anecdotes quoted above and the one at the beginning of the chapter as evidence of Donatello's 'emotional involvements with appren-tices', introduced into the literature the suggestion that Donatello may have been homosexual. These private anecdotes from a diary – especially 'The less long will he stay with me!' – certainly encourage such an intepretation. The only other evidence for this theory, the psychoanalytic interpretation of Donatello's character through an analysis of the works of art he created, is controversial. The fact that there is no other fifteenth-century evidence that supports Janson's theory is not, however, surprising, since homosexual acts were severely punished in Renaissance Florence. In 1429 a confessed offender was burned at the stake, and in 1432 a magistracy founded to extirpate sodomy in the city – a civic act revealing that homosexuality was considered a problem – levied severe fines and a penalty of death by fire after five offences.[6]

We have no certain portrait that represents the features of Donatello, but the traditional type used by Vasari as an illustration for his *Life of Donato* in the *Vite* (Fig. 40) is based on a famous, if ruined, fifteenth-century painting in the Louvre, which depicts the *Founders of Florentine Art* (Giotto, Uccello, Donatello, Manetti, and Brunelleschi). Donatello is also supposedly represented among several other

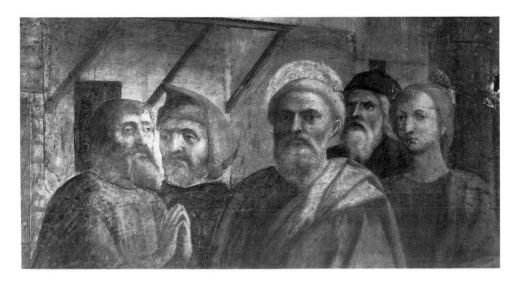

17. Masaccio and Masolino: Portrait of Donatello? Detail from *St. Peter Healing with his Shadow*. *c.*1425–*c.*1427. Fresco. Florence, Santa Maria del Carmine, Brancacci Chapel

Fig. 18. Locations of Donatello's domiciles and studios in Florence, based on fifteenth-century documentation.

1. The Duomo, site of the chapels where Donatello is documented as having carved the *St. John the Evangelist* (1408–15) and the *Cantoria* (1433–9); see Figs. 61, 93.[1]

2. Piazza Frescobaldi, on the southern side of the Arno, across Ponte Santa Trinita, where Donatello and a certain Gherardo rented a house for living quarters from 1 May 1421 to 30 April 1426.[2]

3. The house of Guglielmo Adimari, in Corso degli Adimari (now Via Calzaiuoli), where Donatello was sharing living quarters with his mother, sister, and crippled nephew in 1427.[3] Between 1424/5 and 1425/7 he and his partner Michelozzo were also renting a *bottega* at this site.[4] Given the dates, it is likely that the two sculptors were working on the *Tomb of Baldassare Cossa* and on some of the sculptures for the Sienese Baptismal Font in this studio (Figs. 46, 35). The present building is decorated with a plaque which reads: 'In these walls Donatello and Michelozzo like brothers practised and refined the art of sculpture.'[5]

4. The two *botteghe* at the corner of Via di Santa Reparata (now Via dei Servi) and Piazza del Duomo, which Donatello and Michelozzo had rented by July 1427; they continued to rent these shops until 1433.[6] Here they most likely began work on the *Prato Pulpit* (Fig. 103). This site is now decorated with a nineteenth-century bust of Donatello (by Professor Mancini) and a commemorative plaque erected by the Circolo Fiorentino degli Artisti in 1886; the plaque makes no mention of Michelozzo.

5 The location of the Hospital of Santa Maria Nuova, near which Donatello was renting a house for living quarters in 1431 and 1433.[7] Caplow suggests that he continued to live here until the early 1440s when he left Florence for Padua.[8]

6 The site of three buildings (a former inn and adjacent buildings) owned by the Medici, which were rented out to Donatello in 1433 as a studio. By 1446 these buildings and others had been demolished and the new Medici Palace was being erected on the site.[9]

7. The location of a house with a *bottega*, garden, and other buildings, which Donatello rented for a period of two years and eleven months beginning 1 December 1454.[10] There is evidence he still rented the property in 1458 and 1462; later occupants included Andrea del Verrocchio and Lorenzo di Credi.[11]

8. The corner of Via del Cocomero ('Watermelon Street', now Via Ricasoli) and Via degli Alfani. Vasari tells us that Donatello died in a 'poor little house' on the Via del Cocomero near the Nunnery of San Niccolo; the nunnery was located near the northeast corner of the intersection.[12]

9. The Church of San Lorenzo, where Donatello was buried in the crypt, near the tomb of Cosimo de'Medici.[13]

1. Janson, 13, 119.
2. Herzner doc. 64; Donatello apparently still lived here on 18 March 1426; see Herzner doc. 90.
3. From Donatello's *portata al Catasto* (tax return) for 1427; published by Rufus Mather in *Rivista d'arte* 19, 1937, 186–9.
4. Caplow, 'Sculptors' Partnerships', 154.
5. 'In queste mura Donatello e Michelozzo come fratelli la scultura esercitavano [ed] ingentilivano.'
6. Caplow, 'Sculptors' Partnerships', 154.
7. From Donatello's *portate* for 1430 and 1433; see n. 3 above.
8. Caplow, 'Sculptors' Partnerships', 156.
9. Hyman, 64–74.
10. Caplow, 'Sculptors' Partnerships', 157.
11. See Iodoco del Badia, 'Le Botteghe di Donatello', *Miscellanea fiorentina di erudizione e storia* 1, 1902, 60–2.
12. Vasari, *Life of Donato*.
13. Vasari, *Life of Donato*. For new information on the location of Donatello's burial place see Lightbown, *Donatello and Michelozzo*, II, 327–8.

portraits (including that of Masaccio as St. John the Evangelist on the far right) in Masaccio and Masolino's *St. Peter Healing with his Shadow* (Fig. 17). There is, however, disagreement over which figure might be Donatello; Peter Meller has championed the standing figure to the left, with hands raised in prayer and wearing what he calls a short sculptor's smock, while Luciano Berti has argued for the white-bearded figure next to Masaccio on the right.[7] Anita Moskowitz has recently proposed that the *Reliquary Bust of San Rossore* might be a self-portrait of Donatello in the 1420s (Fig. 110); the suggestion is tantalizing, if unprovable.

Although we do not know what he looked like, the documents give us a great deal of information about Donatello's life. We can reconstruct, for example, where

19. Florence, the location of Donatello's works during the Renaissance. (See opposite page for caption)

he lived in Florence and where his several workshops were located (Fig. 18), and we also know the original location of many of his works (Fig. 19), and can document some, but most likely not all, of the trips he made outside Florence (Fig. 16).

Donatello's birthdate is uncertain, but not because of a lack of records. On his successive tax declarations (*portate al Catasto*) for 1427, 1431, 1433, and 1458, he listed his age, respectively, as 41, 42, 47, and 75. Depending on his actual day of birth relative to the date of the *portata*, the statistics for 1427 yield a birth date of either 1386 or 1387, while those of 1431 offer 1389 or 1390 and those of 1443 give 1386 or 1387. The ages given in these declarations were, it seems, only guesswork, for Donatello lists his mother's age as 84 in both 1431 and 1433. By 1458, when the figures yield a birth date of 1383 or 1384, the artist may have forgotten his exact age, since it was probably not very important, or he may have wished to exaggerate it for some reason. The evidence of the three earliest *portate*, suggesting a birth year ranging from 1386 to 1390, seems reasonable, since the earliest references in documents to Donatello as an artist are in 1404 and 1406–8, when he would have been at the normal age to begin his career.[8]

Who were Donatello's contemporaries? It is clear that he was younger than Niccolò di Pietro Lamberti (born *c*.1370), Jacopo della Quercia (1374?), Brunelleschi (1377), and Lorenzo Ghiberti (1378), about the same age as Nanni di Banco (*c*.1384–5), and older than Michelozzo (1396), Paolo Uccello (1397), Luca della

This view of Florence is taken from a manuscript of Ptolemy's *Geografia*, which may be dated between 1469 and 1472 (Rome, Vatican, Library Cod. Urb. 277).

1. The Baptistry (Fig. 22). This is the site of Donatello's *Tomb of Baldassare Cossa* (Fig. 46). The first mention of Donatello's *Penitent Magdalene* (Fig. 131) is a record that it was in the Baptistry by 1510.

2. The Campanile of the Duomo (Fig. 22). For the niches of this bell tower Donatello executed five marble statues of *Prophets* (see Figs. 122–126); one of these, *Abraham and Isaac*, is a collaborative work with Nanni di Bartolo (Fig. 126).

3. The Florentine Duomo, also known as the Cathedral of Santa Maria del Fiore (Figs. 22, 24, 25). Donatello produced works for the cathedral over a span of more than thirty years. His first known commission was for marble *Prophets* (now lost) for the Porta della Mandorla, in 1406. Surviving works are the marble *David* (Fig. 116), which was intended for one of the buttresses surrounding the dome (see Fig. 118); the *St. John the Evangelist* once on the façade (Fig. 61); relief heads of a *Prophet* and *Sibyl* for the Porta della Mandorla; the organ gallery now known as the *Cantoria* (Fig. 93); and the design for the great stained glass oculus of the *Coronation of the Virgin* (Fig. 57). He also designed and built a large terracotta *Joshua* on one of the buttresses of the north side (now lost, see Fig. 118) and perhaps started a companion figure. In 1415 Donatello and Brunelleschi received payment for a model for a marble figure covered with gilded lead (now lost or never completed). Donatello was involved with Brunelleschi and Nanni di Banco in the building of a model for the great dome in 1418–19; in 1425 he was paid for a bronze vice block needed as part of the machinery of the hoist used in the construction of the dome; and in 1434 he and Luca della Robbia seem to have been in competition to produce a terracotta model for a stone head that was to be placed in the *gula* of the cupola. In 1437 he received the commission for two sets of bronze doors for the sacristies of the Duomo, and although he prepared a model for the doors they were never brought to completion; the commission for one set was later transferred to Michelozzo, Luca della Robbia, and Maso di Bartolommeo. In 1439 he designed a wax model for the *Altar of St. Paul* for the Duomo; this commission was later transferred to Luca della Robbia, who was asked to follow Donatello's model. Unfortunately Luca's altar was never completed and Donatello's model is lost.

4. The Church of San Lorenzo (Fig. 1). Donatello executed a largely sculptural decorative programme for what is now known as the Old Sacristy (Fig. 48) at San Lorenzo (see Figs. 72, 73, 87–89, 99). The reliefs now mounted as two pulpits (Figs. 2–4, 7, 9, 12, 14) were executed for San Lorenzo and were perhaps originally intended to decorate a pulpit, the high altar, and the Tomb

of Cosimo de'Medici. Now lost, but attributed by Vasari to Donatello, are four huge figures of Evangelists, executed in stucco, which were placed in tabernacles at the crossing of the church. The *Martelli Sarcophagus* (Fig. 37) was made for San Lorenzo; originally it was located in the crypt of the church. Others parts of the church's decoration are Donatellian in style, see Fig. 49.

5. The Franciscan Church of Santa Croce. In the right aisle is the *Cavalcanti Annunciation* (Fig. 84). In 1510 Donatello's wooden *Crucifix* (Fig. 74) is recorded as being in Santa Croce, and by that date the statue of *St. Louis of Toulouse* (Fig. 129) had been moved here from Orsanmichele.

6. The Dominican Church of Santa Maria Novella. In 1420 Donatello's *Marzocco* (Fig. 42) was 'placed on the column of the stairs in the courtyard of the papal apartment'. The apartment was located in the area known as the Great Cloister.

7. The Church of Ognissanti. For the friars of Ognissanti Donatello made the *Reliquary Bust of San Rossore* (Fig. 110).

8. The Church of Santa Maria del Carmine. The *Ascension with Christ Giving the Keys to St. Peter* (Fig. 76) may have been part of the iconographic and decorative scheme of the Brancacci Chapel at the Carmine.

9. The Grain Market and Oratory of Orsanmichele (Fig. 26). For the guild niches that surround the exterior Donatello executed the *St. Mark* (Fig. 27), the *St. George* and two reliefs (Fig. 28), and the tabernacle of the Parte Guelfa with the statue of *St. Louis of Toulouse* (Fig. 129). By 1460 the *St. Louis* had already been removed.

10. The Palazzo della Signoria, centre of Florentine Government (Fig. 41). Donatello's marble *David* (Fig. 116) was moved here and installed in an inner room in 1416. In 1495 the bronze *David* (Fig. 134) was placed in the courtyard and the *Judith and Holofernes* (Fig. 136) was installed on the raised speakers' platform in front of the building. The lost *Marzocco* that stood on the *ringhiera* has also been attributed to Donatello (Fig. 41).

11. The Mercato Vecchio. This was the old centre of Florence, and the location of Donatello's lost column statue of *Dovizia* (Figs. 43–45).

12. The Palace of the Medici Family (Fig. 51). Here Donatello's bronze *David* (Fig. 134) stood on a column in the centre of the cortile in 1469; it was removed to the Palazzo della Signoria in 1495, as was the *Judith and Holofernes* (Fig. 136), a bronze fountain group, which was in the garden by 1495, if not earlier. Other works by Donatello listed in a 1492 inventory of the Medici collections have been tentatively identified as the *Ascension, with Christ Giving the Keys to St. Peter* (Fig. 76), the Lille *Feast of Herod* (Fig. 78), and the *Madonna and Child with Angels* now in Boston. Early sixteenth-century sources list a granite vase with marble ornaments by Donatello used as a fountain (the base of the *Judith*?) and Vasari mentions, among other lost or unspecific works at the Palace in 1550 and 1568, an ancient figure of *Marsyas* that had been restored by Donatello.

35

Robbia (1399–1400), and Masaccio (1401). He was near in age to Cosimo de'Medici (1389), his great friend and patron, but more than a decade younger than Giovanni Chellini (1372–3), the physician whom he consulted in 1456, and younger than most of the humanists of the Florentine circle: Niccolò Niccoli (1363), Leonardo Bruni (1370), and Poggio Bracciolini (1380). Equally important, it should be pointed out that Donatello lived in a time of religious zealots, and that he was near in age to both San Bernardino of Siena (1380) and Sant'Antonino of Florence (1389). The intellectual and artistic activity surrounding the young Donatello, therefore, was in the hands of men just enough older than he to present his developing talent with constant challenge.

Little is known about Donatello's family. His father, Niccolò di Betto Bardi (or di Bardo), was by occupation a wool-comber, and perhaps an active figure in the Ciompi Revolt of 1378, which pitted craftsmen and skilled workers against the governing aristocracy. He was purportedly condemned to death for murder in 1380, only later to be declared innocent and freed. He died sometime before 1415. Donatello's mother was named Orsa, and, on the evidence of her son's tax declarations, must have been about forty years of age when he was born. Donatello had at least one sibling, a sister named Tita, who was about five years older than he.[9]

The given name of the Florentine sculptor whom we know familiarly as Donatello was Donato, and it was this name that he used consistently in his tax returns. The earliest documents (1401) identify him as 'Donatus filius Niccolò Bardi de Florentia' and 'Donato filio Niccolò Betti Bardi, de Florentia'; the more common Italian version of this name, Donato di Niccolò di Betto Bardi, appears in a document of 21 June 1408. Despite the fact that this is his complete name, in his *portate* Donatello chose to drop the name Bardi; his full name appears consistently, in fact, only in the earliest documents. Bardi, of course, is a famous name in Florentine fourteenth-century history and patronage, for it belonged to one of the great banking houses of the city; Donatello's lineage, however, has not been traced back further than his father, and his relationship to this important family is uncertain.

His nickname Donatello first appears in 1411 in the commission for the *St. Mark* for Orsanmichele, but it does not reappear until 1426, and then in two Pisan, not Florentine, documents. It subsequently surfaces in a letter of about 1430, another of 1432, and only after 1433 is it found with increasing frequency in the documents; after 1440 it dominates the references. Sometimes the writers felt it necessary to clarify the relationship between the two names, for he is referred to as 'Donato, called Donatello' in the diary of his physician, Giovanni Chellini. Donatello is the name he used almost exclusively when signing his works: it appears in this manner on the Pecci and Crivelli tombs, the *Gattamelata*, the *Judith and Holofernes* (Fig. 20), and the San Lorenzo bronze reliefs[10], as well as on two of the Campanile *Prophets*. There is only a single exception to this rule, for the Venetian *St. John the Baptist* is inscribed as being the work of 'Donato of Florence'.[11] It was not uncommon for Italian artists to be given or to assume nicknames, as Cenni di Pepi (better known as Cimabue or 'ox-head') did in the late thirteenth century; in the fifteenth century this practice seems to have been especially prevalent. Nanni di Bartolo, Donatello's collaborator in 1421, is referred to as Rosso ('Red'), and the real name of Michelozzo, Donatello's partner, is Michele di Bartolommeo. Filippo Brunelleschi was nicknamed Pippo, and Lorenzo Ghiberti was called Nencio by Alberti. Masaccio and Masolino are nicknames for Tommaso, and Nanni, as in Nanni di Banco, is a shortened version of Giovanni. Ghiberti's stepfather, the goldsmith Bartolo di Michele, was called Bartoluccio. Such nicknames were variations on the artists' given names, or references to some personal trait. In this case, Donatello is not a diminutive of Donato, referring to his youth or size, but a seldom used masculine

20. Signature of Donatello: OPVS DONATELLI FLO. Detail from *Judith and Holofernes*. (See Fig. 136.)

form of Donatella (which in turn is derived from the Latin Domitilla and not from Donatus). Actually the sculptor was not the only well known Donatello in fifteenth-century Florence; the other was the Latin grammar text written by the grammarian Donatus in the fourth century, and colloquially called the 'Donatello'. Given the sculptor's classical interests – one might even say his classical vocabulary – and the famous Tuscan wit apparent in other Florentine nicknames, the popular identification of one Donatello with the other is distinctly possible. If so, it is peculiarly apt that even Donato's nickname connects him with the major intellectual and artistic concerns of the Renaissance.

The earliest archival mention of Donatello, in 1401, is not in Florence but in Pistoia, an important town some thirty kilometres to the north-west (Fig. 16).[12] The documents have nothing to do with art, but instead record a fight that took place between 'Donato filio Niccolò Betti Bardi de Florentia' and a German named 'Anichinus Pieri'. On 16 January 1401, the Florentine had hit the German with a large stick, causing a wound, which is recorded as having bled profusely. A document of 24 January established a 'perpetual peace' by warning Donatello that he would be fined the substantial amount of 100 gold florins should he violate the agreement. In addition to its obvious human interest, the document raises the question of what Donatello might have been doing in Pistoia in 1401. Since Brunelleschi is documented as being in Pistoia during 1399 and 1400, working on the silver *Altar of San Jacopo* for the Cathedral (Fig. 21),[13] Donatello's presence less than a year later may be directly related to Brunelleschi's activity there.

Donatello's relationship with Brunelleschi raises the problem of Donatello's early training. Of the various suggestions made, the most reasonable is that Donatello was trained as a goldsmith in the workshop of either Bartoluccio or Brunelleschi. Bartoluccio is such a shadowy figure and Brunelleschi such a compelling one that it is tempting to choose the latter, a course supported by the many documented connections between Donatello and Brunelleschi. In addition, an important relationship can be established between Brunelleschi's early goldsmith work and Donatello's art. The physical vitality and alertness of the small *Prophets* that Brunelleschi made for the Pistoia Altar in 1399–1400 (Fig. 21), for example, and the dramatic interpretation of the Sacrifice of Isaac found in Brunelleschi's compe-

tition relief make these the sole works that predate and foreshadow Donatello's new interpretation of narrative and his representation of human personality. When Brunelleschi abandoned sculpture for architecture, it was Donatello who continued and developed his important innovations.

Summaries of Donatello's life often assert that he accompanied Brunelleschi to Rome in the opening years of the fifteenth century. Brunelleschi's biographer Manetti, writing sometime between 1480 and 1482, tells us that, after losing the competition for the bronze doors to Lorenzo Ghiberti in the winter of 1402/3, Brunelleschi went to Rome and stayed there, returning to Florence on several occasions (he specifically mentions 1409 and 1417). Manetti's account of the Roman experiences of Brunelleschi and Donatello is revealing and anecdotal:

> Neither of them had family problems since they had neither wife nor children, there or elsewhere. Neither of them paid much attention to what they ate and drank or how they were dressed or where they lived, as long as they were able to satisfy themselves by seeing and measuring.

More important, he also tells us how they supported themselves:

> Since both were good masters of the goldsmith's art, they earned their living in that craft. They were given more work to do in the goldsmiths' shops every day than they could handle. And Filippo cut many precious stones given him to dress.[14]

Rather than stating specifically that Donatello accompanied Brunelleschi in 1402/3, Manetti says only that Donatello was in Rome with him, and the most reasonable suggestion is that Donatello joined Brunelleschi there on one or perhaps more occasions. As there is no noticeable influence of ancient art in Donatello's work until the second decade of the Quattrocento, an important trip to Rome should more likely be placed in this later period; a gap in the Florentine documents between April of 1413 and early 1415, for example, provides an appropriate possibility.

Two documents reveal that Donatello was actively at work in Florence during the first decade of the fifteenth century, and connect the youthful artist to the workshop of Bartoluccio and Lorenzo Ghiberti.[15] Here, beginning in 1404, the *North Doors* for the Baptistry were being modelled, cast, and chased (Figs. 10, 13). Such work demanded a number of skilled assistants, and Donatello's presence in Ghiberti's shop further confirms his early training as a goldsmith. The earlier of the two documents mentions Donatello in a list of eleven assistants employed by Ghiberti between 1404 and 1407; unfortunately, it does not clarify when or in what capacity Donatello was in the shop, nor for how long. A second list, recording the assistants employed after the signing of the second contract for the doors in 1407, seems to have been compiled over a period of time, probably terminating only in 1415. Donatello's name is near the top of the list, suggesting that he was employed by Ghiberti soon after the signing. He was one of only four of the twenty-two assistants and *garzoni* who were to receive the top annual salary of seventy-five florins, so his work must have been considered important; since he is documented as having been paid a total of only a little more than eight florins, however, he must have worked for Ghiberti only briefly.

The first documents that connect Donatello with specific works of art reveal that from a relatively young age he was also working as a stone carver. The earlier of these two documents records payment to him in 1406 for marble prophets that he 'has made' to be placed on or above the door on the north flank of the Cathedral later known as the Porta della Mandorla. A document of 1408 refers to a single marble figure one and one-third *braccia* tall (the *braccio*, the Florentine unit of

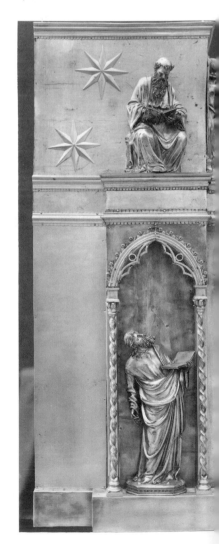

21. Filippo Brunelleschi: *Two Church Fathers*, from the Silver Altar of San Jacopo. 1399–1400. Silver repoussé, partially gilded. Height of standing figure 28.3 cm., seated figure 19.5 cm. Pistoia, Cathedral

measurement, was equal to 58.36 centimetres) and likewise intended for this portal. Whether the figure referred to in the 1408 document is one of the documented prophets from 1406 or an additional figure is not clear. Two figures on the Porta della Mandorla have been connected with these documents, but both are about two *braccia* tall and, for most critics, stylistic factors eliminate the possibility that these mediocre figures could be by Donatello. The figures that are documented as Donatello's earliest works, then, remain either lost or unrecognized.[16]

The two Porta della Mandorla documents of 1406 and 1408 record the beginning of an association between Donatello and the Opera del Duomo, the body responsible for the construction and decoration of the Cathedral (Fig. 22) that lasted for more than three decades and involved Donatello not only as a sculptor (Figs. 61, 93, 116, 118, 122–126), but in other capacities as well (Figs. 25, 57). Shortly before 1420, for example, the Opera engaged Donatello in an architectural project, the construction of a rather large model (it seems to have had an interior diameter of more than three metres) of Brunelleschi's project for the dome of Florence Cathedral; Donatello, Nanni di Banco, and Brunelleschi all received payment for the completed model, while working under them were the project supervisors and the workmen.[17] As the number of statues today in the Museo dell'Opera del Duomo shows, the Opera had provided a training ground for young Florentine sculptors and a livelihood for mature ones since the last quarter of the fourteenth century. During the first half of the fifteenth century the Opera gave commissions for sculpture and other projects to many of the most significant artists working in the

22. The Florentine Duomo Complex: Baptistry, Duomo, and Campanile. 11th-15th centuries

city: Nanni di Banco, Brunelleschi, Luca della Robbia, Bernardo Ciuffagni, Niccolò Lamberti, Paolo Uccello, Andrea del Castagno, Lorenzo Ghiberti, and others; later they employed Michelangelo (Fig. 23). Donatello's next documented commissions were for two additional marble sculptures requested by the Opera for the Duomo complex; fortunately both survive.

In February of 1408, Donatello was commissioned to execute a marble figure of David to be placed on the buttresses of one of the tribunes (the intended location was similar if not identical to the position of his somewhat later *Joshua*; see Fig. 118). The *David*, which was completed and appraised by June 1409 (Fig. 116), was one of a sequence originally intended to include twelve prophets; the first had already been commissioned from Nanni di Banco (Fig. 117), and Donatello's contract states that he has been found competent to execute a David 'under the terms and conditions, and for the same salary' as stipulated in Nanni's contract.[18] Ultimately Donatello received one hundred florins for his figure, while Nanni's was assessed at only eighty-five; probably the discrepancy is explained by the extra labour involved in sculpting the head of Goliath at David's feet.

Donatello's work in another medium is found in documents of 1410–12, which refer to his design and construction of a large terracotta and sandstone figure coated with gesso and white lead to decorate the tribune of the Cathedral (Fig. 118); the patron was again the Opera del Duomo, and the commission may have been given as early as 1409. Donatello's 'huomo grande', specifically identified in the documents as a representation of the Old Testament hero Joshua, is the successor to the slightly over-life-size figures that the Opera had commissioned from Donatello and Nanni di Banco to adorn this same area in 1408; these had obviously proven too small (one, most likely Nanni's, was 'put back on the ground' in July 1409, shortly after it had been put up). The *Joshua* was the Opera's next attempt to solve the problem of medium and scale for the prophet series, and a later document suggests that it must have been about nine *braccia* (5.25 metres) tall. This second attempt also seems to have been unsatisfactory, for reasons that are unknown, since a document of 1415 records a partial payment to Donatello and Brunelleschi for a small model of 'a little figure of stone clad in lead gilt which had been made at the request of the Operai as a demonstration and test for large figures which are to be made for placing on the buttresses of Santa Maria del Fiore'. This project apparently came to nothing (see p. 194), and the final attempt to decorate this area of the Duomo with gigantic figures was made in the 1460s and ultimately led, at the beginning of the sixteenth century, to the creation of Michelangelo's *David* (Fig. 23).

In December 1408, although the *David* commissioned earlier that year was apparently still incomplete, Donatello received the commission to execute one of the four monumental Evangelists to be placed in niches flanking the main door of the Cathedral façade (Figs. 24, 61, 62). The commissions for three of these figures were granted simultaneously to Donatello, to his contemporary Nanni di Banco, and to an older sculptor, Niccolò Lamberti; the documents record the Opera's intent to grant the commission of the fourth Evangelist to whichever of these sculptors produced the best statue. The idea of establishing a competitive relationship between artists in order to encourage them to produce their best work is found with some frequency in Florentine Renaissance art, the most famous example being the competition for the bronze doors of the Baptistry.[19] Later, in 1434, Donatello found himself in competition with Ghiberti to design a stained-glass window for the Duomo (Figs. 25, 57), and with Luca della Robbia to design a head for an area of Brunelleschi's dome known as the '*gula*'. The same spirit of competition was established in the contract for Donatello's *Cantoria* in 1433, which states that he will receive forty florins for each panel in which the workmanship is at least as good as that of the panels of Luca della Robbia's *Cantoria*; if Donatello's should be better

23. Michelangelo: *David*. 1501–4. Marble, height 410 cm. Florence, Accademia

than Luca's, he might receive up to fifty florins per panel (Figs. 93, 94). It is interesting that Donatello seems to have paid little attention to this arrangement, however, since he carved six larger panels and received a total payment at least as great as Luca's. In the case of the commission for the Duomo Evangelists in 1408, however, the competition did not work out as the Opera had intended and in May 1410, when none of the three had finished their work, the fourth Evangelist was commissioned from Bernardo Ciuffagni.

Although payments are recorded to Donatello in 1412 and 1413, his figure of *St. John the Evangelist* (Figs. 61, 62) was not completed and installed until October 1415 (Nanni's Evangelist was completed by February 1414 and Lamberti's by March 1415; the latecomer Ciuffagni's statue was, like Donatello's, only appraised in October 1415). The documents suggest that there were certain difficulties in the execution of these Evangelists, for in July 1410, shortly after Ciuffagni received the commission for the final one, the chapels where they were being carved were closed off from public view, and in January 1415 a payment is documented for a key to lock the chapel in which Donatello was working. These documents are less peculiar in light of Ciuffagni's finished figure, which is indebted not only to Donatello's

24. Bernardino Poccetti: *The Façade of the Duomo.* 1587. Drawing. The seated figures to either side of the main portal are the Evangelists by Nanni di Banco, Bernardo Ciuffagni, Donatello (Figs. 61 and 62), and Niccolò Lamberti. Florence, Museo dell'Opera del Duomo

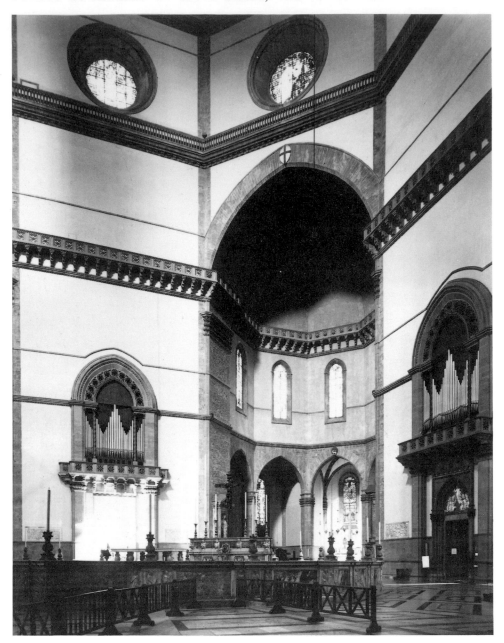

25. Interior of the Duomo, showing Donatello's *Coronation of the Virgin* (Fig. 57) and, above the sacristy portals to the left and right, the original locations of Luca della Robbia's and Donatello's *Cantorie*. (See Figs. 93 and 94.)

conception of the *St. John*, but reveals an awareness of the other two Evangelists as well. The frustration of the patron at the length of time it took to complete the Evangelists is evident in a document of 16 April 1415, in which Donatello is threatened with a fine of twenty-five florins if he does not finish his figure by the end of May; despite his failure to meet the deadline, however, there is no further mention of the fine in the documents.

During the second and third decades of the Quattrocento, Donatello received at least three commissions from Florentine guilds for figures of patron saints for their niches at Orsanmichele (Fig. 26). This Communal structure, which served as a religious shrine in addition to being a grain exchange and warehouse, has in its exterior piers fourteen niches that had been assigned to the most important of the Commune's guilds in 1339. The financial disorders of the 1340s, the Black Death of 1348, and the general upheaval in the Florentine economy in the second half of the Trecento, however, meant that few of the guilds had even begun to decorate their niches by 1406, when a Communal decree was passed that any guild that did not finish its tabernacle within ten years would forfeit ownership. The resumption of

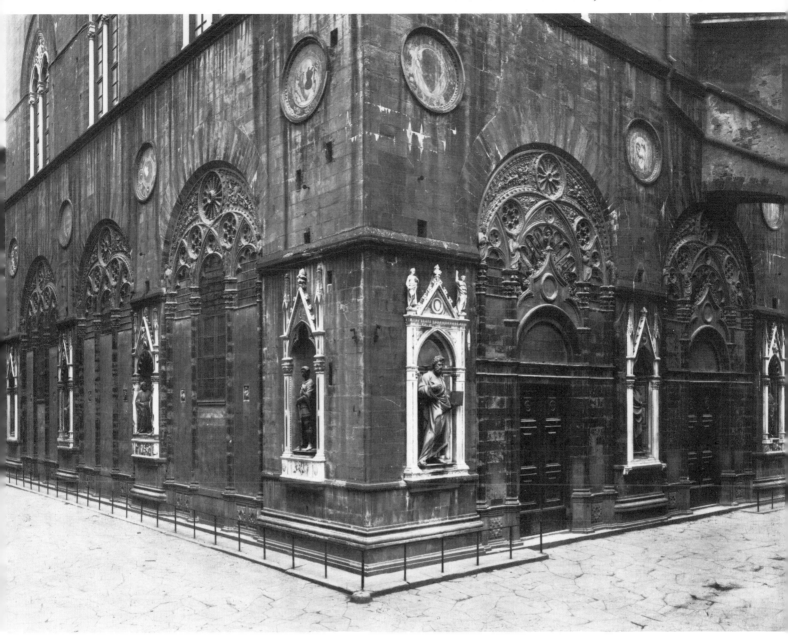

26. Orsanmichele with, in the centre, the St. George tabernacle (Fig. 28) and the tabernacle with Ghiberti's figure of St. Matthew (Fig. 30). To the left of the St. George tabernacle is Nanni di Banco's *Quattro Coronati* (Fig. 31)

this programme of large public sculpture, sponsored by organized groups of Florentine businessmen and artisans, led to the creation of some of the first great sculptures of the Renaissance.

Donatello's earliest commission at Orsanmichele was most likely that for the *St. Mark*, which came from the Arte dei Linaiuoli e Rigattieri (Guild of Linen Weavers and Pedlars) in 1411 (Fig. 27). The commission specified that the figure should be completed within nineteen months, but two years later it was still incomplete; a reassessment of the guild's records by Manfred Wundram, in fact, has suggested that the *St. Mark* is not likely to have been completed before 1415.[20] Three weeks after commissioning their statue the guild signed a contract with two stonecarvers for the marble decoration of the tabernacle that would enclose and frame Donatello's figure. The document is quite specific, for it stipulates that the inside of the tabernacle should be like that of the Trecento tabernacle of the Arte della Lana, and that in its other details it should conform to the drawing (now unfortunately lost) that the carvers had submitted. It also prescribes a delivery date within eighteen months (one week before Donatello's figure was due!) and a total payment

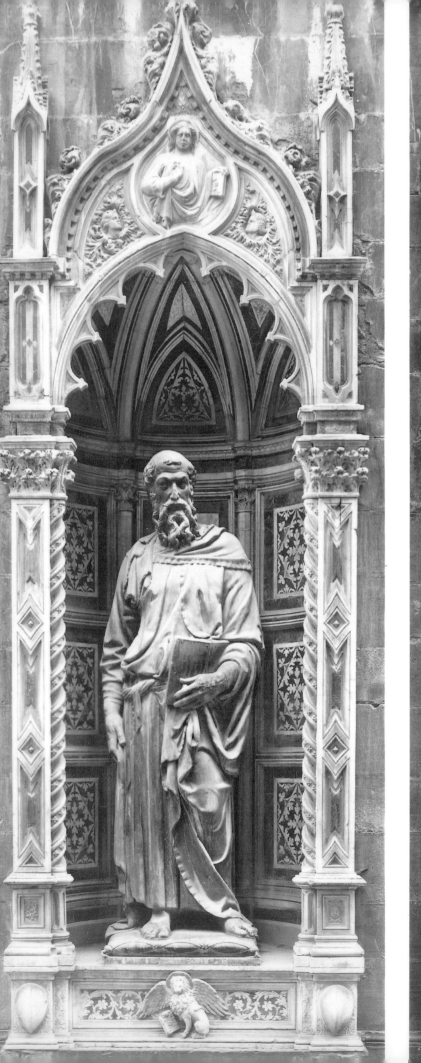
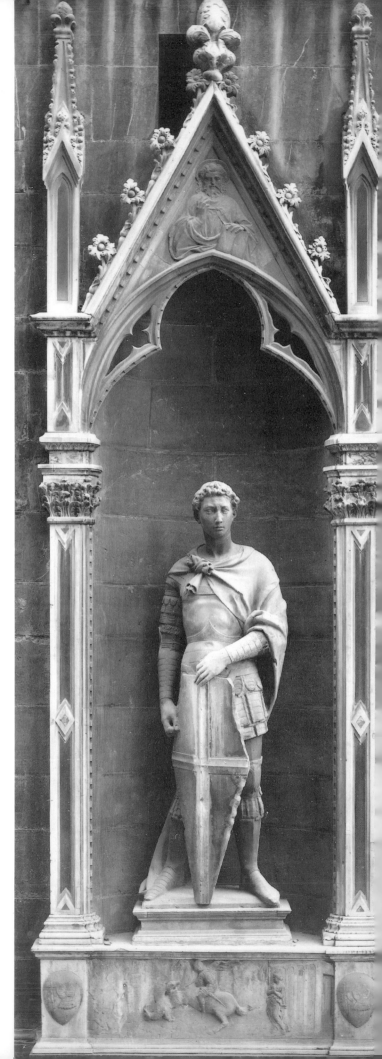

27. *St. Mark* (tabernacle designed and executed by Perfetto di Giovanni and Albizzo di Pietro). *c.*1411–*c.*1415. Marble figure (originally with partial gilding), height of figure 236 cm. Florence, Orsanmichele. (See also Figs. 119 and 120.)

28. *St. George* and two reliefs. *c.*1415–*c.*1417. Marble, height of figure 209 cm. Florence, Orsanmichele. The figure and the narrative at the base of the tabernacle have been removed; the figure is now in the Museo Nazionale, Florence, the relief in restoration (1982). (See also Figs. 26, 79–81, 121.)

29. Lorenzo Ghiberti: *St. John the Baptist* and tabernacle. 1405–17. Bronze figure, originally with partial gilding, and marble tabernacle, originally with mosaic pediment, height of figure with base 255 cm. Florence, Orsanmichele

30. Lorenzo Ghiberti: *St. Matthew* and tabernacle. 1419–22. Bronze figure originally with gilded drapery and marble tabernacle. Height of figure 270 cm. Florence, Orsanmichele. (See Fig. 26.)

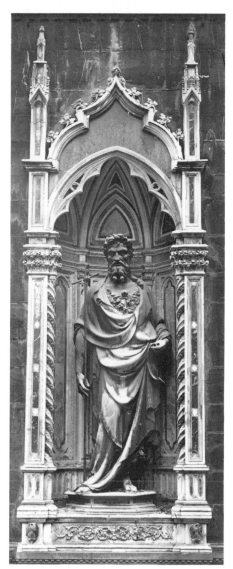

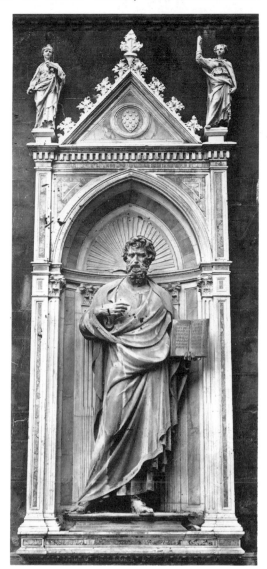

of two hundred florins. Since the normal price for a marble figure by Donatello was between ninety and one hundred florins, the respective values placed on tabernacle and figure are revealing; the guild was clearly willing to pay about twice as much for their tabernacle as for the sculpture of their patron saint. The fact that Donatello's contract explicitly does not state a price for his work – the five guild representatives who commissioned the figure were empowered to assess it upon completion – reveals that whereas decorative work could be evaluated in advance, a more creative, and therefore more unpredictable project such as a figure could only be judged upon completion.[21]

Donatello's *St. Mark* is only one of a sequence of masterpieces produced by Florence's leading sculptors for Orsanmichele between 1406 and the late 1420s, when all the guild tabernacles seem to have been completed. Ghiberti, for example, made three bronze statues, which were the largest bronzes cast in Florence up to that time. These technically innovative works reveal the range of stylistic choices open to a sculptor working in the period. Whereas the *St. John the Baptist* is fully International Gothic (Fig. 29), *St. Matthew* (Fig. 30) and *St. Stephen* respectively reveal Ghiberti's interest in the new, classicizing mode and in new proportional systems.[22] Nanni di Banco, working in marble, produced figures and reliefs for three guilds between *c.*1410 and 1418. His most innovative work is the *Quattro Coronati* for the Arte dei Maestri di Pietra e Legname (Guild of Stone and Wood

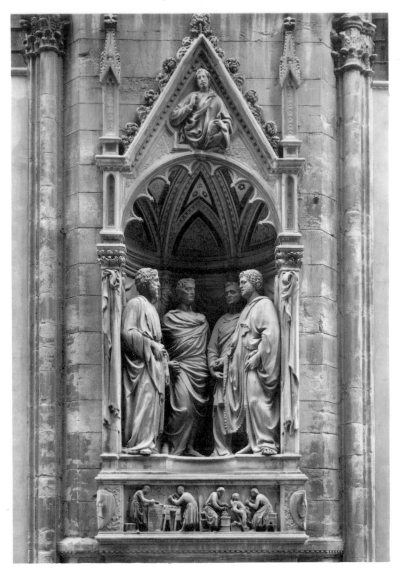

31. Nanni di Banco: *Quattro Coronati* and tabernacle. 1410s. Marble, height of figures 183 cm. Florence, Orsanmichele. (See Fig. 26.)

Workers; Fig. 31); here classically inspired heads, drapery, and setting are united with naturalistic observation to create a compelling moral example. The guilds also commissioned a marble *St. Luke* from Lamberti (now removed), two eclectic works (*St. James*, *Madonna and Child*), which are difficult to attribute, and the controversial *St. Peter* for the Arte dei Beccai (Butchers). This last work, first attributed to Donatello as early as the late fifteenth century, gained an attribution in the sixteenth century as a collaborative effort of Donatello and Brunelleschi; the addition of Brunelleschi's name is undoubtedly tied to the illusionistic perspective devices in the inlaid marble of the tabernacle. Although this joint attribution has recently been revived by James Beck, the statue does not seem to justify it.[23] Donatello's work for the Arte dei Spadai e Corazzai (Guild of Swordsmiths and Armourers) at Orsanmichele includes the *St. George* and two reliefs (Figs. 28, 79–81, 121). There are no surviving documents for any of this work, but Milanesi states that he had seen a document that dated the purchase of marble for a 'base ... under the figure' to February 1416, a date that should perhaps be converted into modern style to become February 1417. On stylistic grounds, Wundram has dated the *St. George* to 1414/15 and the narrative relief to 1417.[24] Donatello's third project for Orsanmichele, the *St. Louis of Toulouse* and the tabernacle for the Parte Guelfa, belongs to the decade of the 1420s, when he began working in a new medium, bronze (Fig. 129). With this work he for the first time had control over an entire project, for he

designed both figure and tabernacle as a coordinated ensemble for the Parte Guelfa. The tabernacle has been doubted as authentic on the theory that Michelozzo, Donatello's partner from the mid-1420s, was responsible for all architectural decoration; this does not seem to have been the case, and the imaginative combination of architectural and sculptural elements in the Parte Guelfa tabernacle is consistent with Donatello's approach.

An entry of 1412 in the membership rolls of the Company of St. Luke, the confraternity to which artists were required to belong, reveals that 'Donato di Nicholo orafo e scharpellatore' was enrolled in that year. The description of Donatello as both 'goldsmith and stone-carver' is an important indication of his skills at this time, even if no certain works of goldsmithery from this period survive. Unfortunately the records of Donatello's matriculation into the two guilds to which he must have belonged, the Arte della Seta, to which goldsmiths belonged, and the Maestri di Pietra e Legname, the guild that included stone- and wood-carvers, are not preserved or have yet to be discovered. The years of his matriculations can only be guessed, but Brunelleschi, who was about a decade older, applied for registration in the Arte della Seta in 1398, matriculating as a Master in 1404, while Donatello's contemporary Nanni di Banco joined the Maestri di Pietra e Legname in 1405.[25]

The earliest known reference to Donatello's having assistants and, by implication, being the head of a workshop is in 1416, when the marble *David* (Fig. 116), originally intended for the Duomo buttresses, was transferred to the Palazzo della Signoria at the request of the city authorities. Donatello is documented as receiving five florins 'for several days that he has spent with one or others of his assistants in adapting and completing the figure of David.' Later documents, especially those for the Padua Altar, mention a number of assistants, sometimes listing their names, rates of pay, and the specific work which they undertook. For instance, in late 1447 several of Donatello's assistants were paid separately for work on the Evangelist panels and the angels; among the music-making angels it is relatively easy to discern several hands. Fig. 32 is much closer to the master's lively style than Fig. 33, where the angel is unanimated, his proportions are poor, and the chasing is crude. Donatello obviously allowed a certain latitude in quality. Baccio Bandinelli may have been exaggerating the number of Donatello's assistants when he wrote to Grand Duke Cosimo I in 1547: 'Some who were with Donatello have told me that he always had eighteen or twenty assistants in his workshop; otherwise he never could have completed an altar of St. Anthony of Padua, together with other works.'[26] Not enough is known about the traditional workshop structure in the Quattrocento and, in any case, it is unlikely that Donatello's workshop would have been traditional. A contemporary reference from 1429, however, describes how such a number of assistants might be employed:

> For the masters, when they have resolved to fashion some rare masterpieces out of raw wood or stone, have been used to entrust the first tasks, of beginning and rough-hewing the work, to some apprentices (not quite unskilled, but still not deeply versed in it), they themselves either just adding the finishing touch or improving such parts as are more conspicuous or more difficult.[27]

Certain works by Donatello show obvious evidence of workshop participation: parts of the *Tomb of Baldassare Cossa* (Figs. 46, 47), for example, were clearly carved by assistants, and the uneven quality in the panels of the *Prato Pulpit* and the *Cantoria* (Figs. 103, 93), both joint commissions with Michelozzo, demonstrates that these must have been carved in part by assistants using Donatello's models.

The sculptor certainly seems to have been in need of a large workshop given the number of projects he undertook simultaneously. During the years he was working

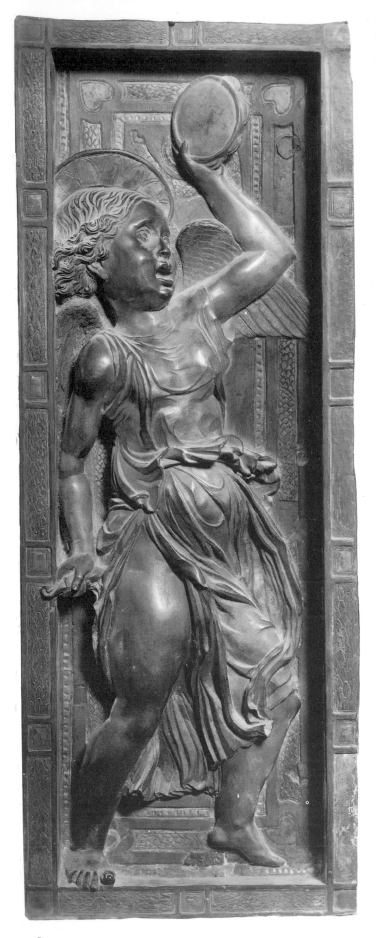
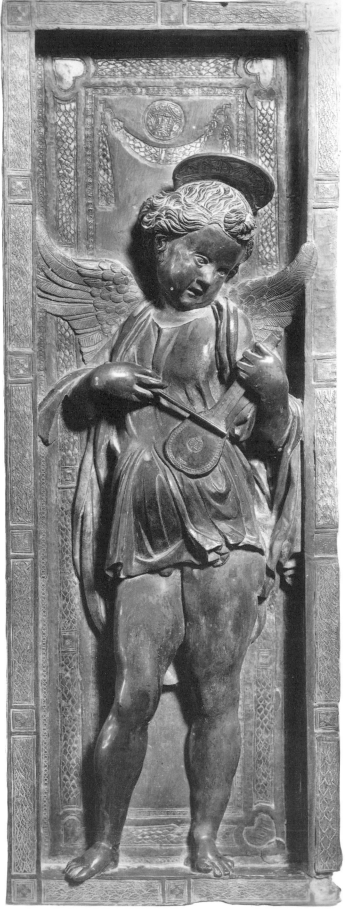

for the guilds at Orsanmichele, he also began several other commissions for the Opera del Duomo, including a commission in 1415 for two marble statues for the niches of the Campanile (Fig. 22). During the Trecento the eight most prominent niches of the bell-tower (on the front, or western, and the southern flanks) had been filled with figures of prophets and sibyls; over the course of the next two decades Donatello was involved in the execution of at least five statues for the completion of this programme. He finished one statue in 1418, and another in 1420 (Fig. 122). That each took approximately two years to complete may explain why the Opera granted a joint commission to Donatello and Nanni di Bartolo in 1421 for a prophet for this series; this figure, documented to be the *Abraham and Isaac* (Fig. 126), was finished and paid for in record-breaking time, within seven months of its commission. In 1423 and 1425 Donatello alone received payments for a fourth figure, which was appraised in 1426 (Fig. 123), while his fifth prophet, Habakkuk, was appraised and paid for in 1436 (Figs. 124, 125); it is probably the last figure in marble that Donatello ever completed.

As a mature and proven sculptor in his early thirties, Donatello undertook a variety of commissions for the Opera. In 1418 he received a partial payment for a sculpture of a lion, which he was carving of local sandstone (*macigno*), to be placed on the column of the staircase of the papal apartments being built at the Florentine church of Santa Maria Novella (Fig. 42). The payments recorded for the lion, which was completed in 1419 or 1420, total twenty-four florins, suggesting that the local availability of the material and the greater ease in carving *macigno* (in contrast to marble) made for a less expensive sculpture. The lion as a civic symbol of Florence, called the Marzocco, dates back to at least 1260, and the *Marzocco della Piazza*, a gilded sculpture of the lion victorious over a wolf (Siena?), was probably first placed in front of the Palazzo della Signoria sometime early in the Quattrocento (Fig. 41). Images of the Marzocco also seem to have been placed on the newel posts of staircases in Florentine palaces and public buildings, and Eve Borsook reports that a copy of the Florentine Marzocco was set up in the public square of towns conquered by Florence.[28]

Donatello's diversity of media and forms in the 1420s seems to have gone hand-in-hand with a greater range of patrons, but unfortunately there is, in the cases of these new private commissions, a scarcity of documentary evidence. When Nanni di Banco died in 1421, he left the large relief of the *Assumption of the Virgin* for the Porta della Mandorla incomplete, and in 1422 Donatello was paid the modest sum of six florins for executing approximately life-size busts in relief of a prophet and a sibyl to help complete the decoration.[29] The highly classicizing profiles of these figures suggest that two compositions of the Madonna and Child by Donatello should be dated to this period. One is the gilded copper plaquette in the Schnütgen-Museum in Cologne (Fig. 34), which is of such high quality that it deserves an attribution to the master himself, despite its small scale and modest material. The other is the marble relief in Berlin, the so-called *Pazzi Madonna* (Fig. 91).[30] When Vasari wrote his *Vite* in 1550 he noted a good many reliefs of the Madonna and Child theme by Donatello, and over the centuries the number of these attributions increased until, in Schubring's book of 1922, no fewer than twenty-seven reliefs – in marble, stucco, clay, gilded terracotta, bronze, stone, and even papier mâché – were given to Donatello himself and twenty-three more were included as 'school work' or 'imitation'. Janson, in an exclusionist mood that emphasized major media, limited the reliefs to two, both of them marble. Pope-Hennessy has attempted to sort out the numerous examples, most recently adding a pigmented terracotta from Boca Raton, Florida.[31] The rediscovery of the *Chellini Madonna* in the 1960s added another definite example; what is even more significant about this work, however, is that Donatello designed its reverse to be a mould to make reproductions (Figs.

32. Donatello and workshop: *Angel with tambourine* from the Padua Altar. 1446–50. Bronze, with partial gilding, 58 × 21 cm. Padua, Sant'Antonio. (See Fig. 127.)

33. Workshop of Donatello: *Angel with viol* from the Padua Altar. 1446–50. Bronze, with partial gilding, 58 × 21 cm. Padua, Sant'Antonio. (See Fig. 127.)

68, 69; see pp. 123–5). Although the physician to whom Donatello gave the *Madonna* stated that the reverse was for producing glass copies – and recent experiments have shown this to be possible – the existence of two early stuccoes reveals that the *Chellini Madonna* was used to make reproductions in this more modest medium as well. Given the Cologne *Madonna*'s medium of repoussé metal, it is possible that some of the stucco versions of this composition were moulded on its reverse side. It was also during this period that Donatello first worked in wood, creating the *Crucifix* now in Santa Croce (Fig. 74).

The documents from 1423 reveal some startling facts: Donatello not only began to receive a number of commissions from outside Florence but, even more surprising, these were for works to be executed in bronze. The Opera of the Cathedral of Orvieto commissioned him to make a gilded bronze statuette of St. John the Baptist, and he was at least prepared to begin the work, since later that same year he received some wax to be used in modelling the figure. He was commissioned to produce a similar statuette for the Baptistry in Ancona. Unfortunately neither work is known today; they either were never completed or have been lost.[32]

From 1423 also dates the first documentary evidence of Donatello's six- or seven-year involvement in an important non-Florentine project, the Sienese Baptismal Font (Fig. 35).[33] This collaborative project was also to include works by the Sienese Jacopo della Quercia, by Donatello's fellow Florentine Lorenzo Ghiberti, and by other artists. In 1427, Donatello delivered the *Feast of Herod*, and in 1428 and 1429 received payments for two figures of *Virtues* (Figs. 95, 138, 140). In 1429 he is also documented as being at work on a tabernacle door for the font and on certain 'fanciulini innudi'; he ultimately made three of these dancing or musical putti (Fig.

34. *Madonna and Child*. 1420s–1430s. Gilded copper repoussé, 11.2 × 10.2 cm. Cologne, Schnütgen-Museum

35. The Sienese Baptismal Font, with sculptural decoration by Donatello, Lorenzo Ghiberti, Jacopo della Quercia, Giovanni di Turino, Turino di Sano, and Goro di Ser Neroccio. 1416–34. Marble, with polychromy, gilded bronze, and enamel, height 402 cm. Siena, Baptistry. (See also Figs. 36, 95, 96, 138–141.)

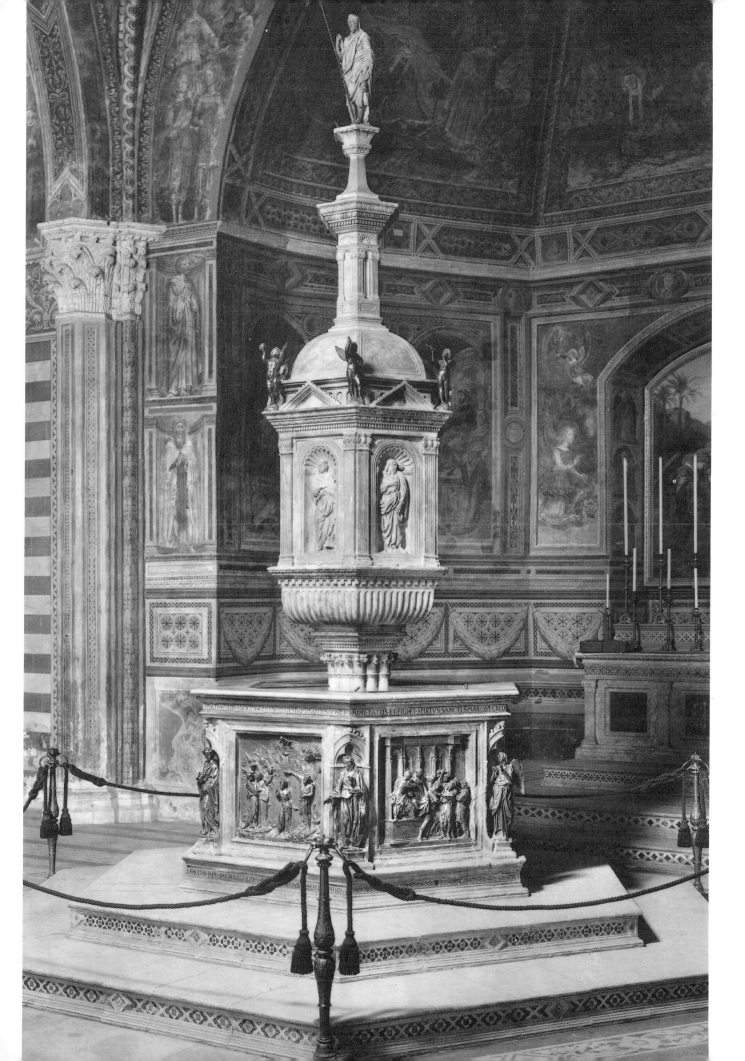

36). When he demanded a final account (and presumably a final payment) in 1434, the document then drawn up reveals that the gilded bronze tabernacle door he had created for the font was rejected by the Sienese officials. The document does not specify the problem but simply states that the door 'did not turn out the way the administrator and counsellors like'.[34] The rejected work was handed over to Donatello's representative, and the Sienese made Donatello a gift of five florins above and beyond the small amount that they calculated they owed him. During this period he also executed another bronze work in Siena, the *Tomb of Giovanni Pecci*, Archbishop of Grosseto, who died on 1 March 1426 (Fig. 82).

There is a possibility, however, that Donatello's earliest bronze commission may have been Florentine, for in May 1423 the officials in charge of the decoration of the niche of the Parte Guelfa at Orsanmichele were given the substantial amount of 300 florins so that *St. Louis of Toulouse* 'may be brought to completion', suggesting that the commission may have dated from 1422 or even earlier (Figs. 129, 130, 58–60). This figure, constructed of many interlocking pieces of gilded bronze and with an elaborate crozier and a mitre adorned with enamels and inlaid glass, is a masterful demonstration of technical proficiency and creativity in bronze (see p. 121). Ronald Lightbown recently proposed that the commission of the *Tomb of Baldassare Cossa* (Figs. 46, 47), with its bronze effigy of the ex-Pope, may date from 1422, being yet another bronze commission in Florence before 1423.

But Donatello did not give up working in marble. There are documented payments for the *Prophets* for the Campanile in 1423 and in subsequent years until the cycle was finally completed in 1436; the *Prato Pulpit* and *Cantoria* occupy him until 1438 and 1439 respectively, and there are a number of smaller works in marble that date from this period as well. An analysis suggests that from 1423 until his departure for Padua in the early 1440s he was spending approximately equal time working in marble and in bronze; in addition, there are works in *macigno*, stucco, and polychromed wood. Only after his arrival in Padua does Donatello begin to work almost exclusively in bronze.

During this period Donatello's engineering skills were on occasion in demand. In 1425, for example, he and Ghiberti were called upon by the Opera to cast bronze vice blocks (*mozetti*), parts of the screw vices used in the construction of Brunelleschi's dome; Donatello produced one rather small block and Ghiberti five larger ones.[35] In 1430 Donatello and Michelozzo were called to the vicinity of Lucca (Fig. 16) to assist Brunelleschi in an imaginative military scheme to divert a river and flood the area around Lucca.[36]

In 1427 the city of Florence levied the *Catasto*; the requirements of this graduated tax on wealth meant that each Florentine citizen had to submit a personal statement of his property, debtors, and creditors. Donatello's is so revealing it is here quoted in its entirety:

11 July 1427, before you, the lords, officials of the tax of the people and the city of Florence, this is the property and obligations of Donato son of Niccolò son of Betto, carver, assessed in the Santo Spirito quarter, in the ward of the Shell, as owing 1 florin, 10 shillings, 2 pence. Without any property except a few household goods for personal and family use. I practise my art together in partnership with Michelozzo di Bartolommeo, with no capital, except 30 florins worth of various tools and equipment for this art.

And from this partnership and shop I gain my property and in the manner that is shown in the declaration of the property of the said Michelozzo, in the San Giovanni quarter, in the ward of the Dragon, under the name of Leonardo di Bartolommeo and brothers. Also, I am owed by the Cathedral administrator of Siena 180 florins on account of a narrative scene in bronze [Fig. 95], which I did

36. *Dancing Putto*, from the Sienese Baptismal Font. 1429. Gilded bronze, height 36 cm. (See Fig. 35.)

for him some time ago. Also, from the convent and monks of Ognissanti I am owed on account of a bronze half figure of St. Rossore [Fig. 110], on which no bargain has been set. I believe I will get more than 30 florins from it.

I have the following in my house:
 Donato, aged 41
 Madonna Orsa, my mother, 80
 Madonna Tita, my sister, a widow without dowry, 45
 Giuliano, son of Madonna Tita, crippled, 18
I rent a house from Guglielmo Adimari, on the Corso degli Adimari, in the parish of San Cristoforo [see Fig. 18]. I pay 15 florins a year.

<div align="center">Creditors</div>

To Master Jacopo di Piero, carver, of Siena [Jacopo della Quercia], on account of that narrative scene for the Siena Administration, as shown, 48 florins.

To Giovanni Turini, goldsmith of Siena, for time he took on that scene, 10 florins.

To the Cathedral Administration of Siena, 25 florins for gilding that scene, at their request.

To Sandro Mantellini, 35 florins, as shown in his book.

To Guglielmo Adimari, 30 florins for two years back rent on the house I live in.

To Giovanni di Jacopo degli Strozzi, 15 florins for a figure of St. Rossore he cast for me several times in his kiln, and other things.

To various people for various reasons, small sums, 15 florins.

To debt to the city of Florence for old assessments from '11 to '24, and for all of a new assessment, 1 florin.

I Michele di Bartolommeo, goldsmith, have done this writing at the request of the said Donato.[37]

Donatello's later tax declarations, filed in 1431, 1433, and 1458, are much less informative. The fact that he did not file the required reports in 1442, 1446, and 1451 suggests that he was away from Florence during those years.

Michelozzo, the Florentine goldsmith, sculptor, and architect, not only reports in his 1427 *Catasto* declaration the partnership he shares with Donatello, but also that they have been partners for 'due anni o circha' ('two years or thereabouts'). Michelozzo may have began this association as he left Ghiberti's shop, where he had worked on the *St. Matthew* (Fig. 30); Ghiberti complains in April 1425, in a letter to Giovanni Turini in Siena, of the ingratitude of those who had been his assistants, referring perhaps to Michelozzo. The declaration identifies a number of unfinished sculptural projects as joint works. For the *Tomb of Baldassare Cossa* (Fig. 46), for example, the partners have received 600 florins out of an expected final estimate of 800; Michelozzo promises that they will try to stay within this contractual price. For the *Tomb of Cardinal Brancaccio* (see Fig. 63) they have received a total of 300 florins of the 850 they expect; in this case, Michelozzo points out, they have agreed to bear all expenses, including the shipping of the finished marbles to Naples. Two additional works may have been on Michelozzo's list as joint commissions because there was a tax advantage in declaring them thus: one is the *Tomb of Bartolommeo Aragazzi*, which Michelozzo seems to have executed completely on his own, and the other is a Campanile figure, listed as being three-quarters done, which is surely the work of Donatello (Fig. 124). From the two *portate al Catasto*, then, an outline of the relationship between the two artists begins to emerge.[38]

Why did Donatello and Michelozzo form a partnership? Ronald Lightbown's recent and thorough examination of their collaboration suggests that the most reasonable explanation lies in the numerous important commissions Donatello

received in the early 1420s: he needed Michelozzo's skills as an artist and as a financial manager. Earlier critics have argued that the partnership was formed because Donatello needed Michelozzo to perform certain specific tasks. It has been suggested, for example, that Michelozzo, who later was important as an architect (Fig. 51), designed and executed the architectural aspects of Donatello's commissions; this is indeed what seems to have happened later in their joint commissions for the Brancaccio tomb and the *Prato Pulpit*. The Parte Guelfa tabernacle and the Cossa tomb, however, reveal that Donatello could handle architecture without Michelozzo's assistance. It has also been proposed that Michelozzo, who as a goldsmith in the early 1420s had assisted Ghiberti on bronze projects, was needed by Donatello to help with the casting, chasing, and gilding of his recent commissions in bronze. Michelozzo's *Catasto* statement, however, explicitly states that his job as Donatello's partner is 'larte dellontaglio' ('the art of stone-carving') even though he signed Donatello's declaration as 'goldsmith'. Lightbown argues that the two men collaborated on whatever work was in process, and that there was no precise differentiation of labour. There is some evidence that Michelozzo was the businessman of the pair, for it was he who wrote Donatello's *portata al Catasto* in 1427, as well as letters to their patrons, and he certainly seems to have been the one who managed the finances. In this capacity, he probably also organized and controlled the workshop of apprentices and assistants, and oversaw the petty details of their travels, since it is Michelozzo's declaration that they jointly owned a mule – 'because of our business we have to go about often'.

In 1426 the two rented a workshop in Pisa (Fig. 16) so that the work on the Brancaccio tomb could be executed near both the marble quarries and the port from which it was to be transported to Naples; this saved the partners the expense of transporting the marble to Florence for carving and then back to Pisa for shipping. In 1426 Donatello bought a boat for transporting the marble blocks from Carrara to the Pisa workshop, conveniently located near the bank of the Arno River. Payments for marble were made to Donatello from April to June, and other documents from July, October, and December 1426 confirm he was still in the port city.[39] The documents of July and December 1426 are especially interesting, for they connect Donatello with the young Florentine painter Masaccio. Since Michelozzo is not mentioned in these documents, Donatello must have been the supervisor of the Pisan workshop.

These are also the earliest records we have of a relationship between Donatello and the Medici family. A branch of the Medici bank in Pisa made the payments to Donatello for the Brancaccio tomb, and the *Catasto* declarations of Cosimo de'Medici and his brother for 1427 reveal that they owe Donatello and Michelozzo 188 florins for work on the project. Cosimo's father Giovanni was one of the executors of Rainaldo Brancaccio's estate, as he had been for the estate of Baldassare Cossa, and his involvement, or more likely that of his son Cosimo, in these two estates may help explain the commissioning of the two monuments from Donatello.

On 14 July 1428, Michelozzo and Donatello received an important 'foreign' commission: they were to design and execute the new exterior 'pulpit' for the Cathedral of Prato, from which the most sacred relic in Tuscany, the belt or girdle of the Virgin Mary, was displayed (Fig. 103).[40] The documents are unusually complete and therefore especially interesting. The first contract, for example, was signed by Michelozzo alone for the two partners; as it is specific about the architectural components and vague about the figural reliefs, it seems clear that it was Michelozzo who was to design the architectural part of the pulpit. A regular schedule of payments and an optimistic completion date of 1 September 1429 are stipulated in the contract. From the very beginning, however, there is evidence that the two sculptors were dilatory, and by November 1428 the Prato authorities felt it

necessary to force them to pledge their own property as security: they would fulfil the contract or else repay the monies advanced to them. Nevertheless, payments continued to the two artists, as well as to their assistants (as many as ten are specifically named) when the masters were absent. The current interpretation of the documents suggests that the architectural framework was largely completed by 1432, and it is known that the bronze capital was modelled (most likely by Donatello) and cast by Michelozzo in 1433. But none of the six figurative reliefs, which were Donatello's specific responsibility, had been delivered by 1434, and a new agreement had to be signed awarding him twenty-five florins for each relief. He then proceeded to finish one relief within twenty-three days; a letter to the Prato officials from Matteo degli Organi comments on the positive Florentine reaction to the relief and states that Donatello would like a special consideration so that he might enjoy the approaching Florentine holiday of San Giovanni Battista (24 June):

> To the worthy Operaii of the Chapel of Our Lady in Prato
> Most dear Sirs
> The cause of this letter is that Donatello has finished that story in marble, and I promise you that I know all the experts in this town are saying with the same breath that never has such a story been seen. And it seems to me that he has a good mind to serve you well, he wants us to know it now he is so well disposed; indeed, one does not come across these masters every day. He begs me to write to you for God's sake not to omit to send him some money to spend during this holiday, and I charge you to do so; moreover, he is the kind of man for whom enough is as good as a feast, and he is content with anything. So that if the Opera must quieten him by usury, he wants the money to keep himself true to the purpose as he has begun, and no wrong will be done to us.
> In Florence, 19 June 1434, Matteo degli Organi

The Prato officials sent Donatello some money on 20 and 29 June, but only in September were three partially completed panels sent to Prato so that they could be mounted on the pulpit to judge their effectiveness *in situ*. Almost two years later Donatello took these back to Florence in order to finish them; he returned them to Prato in June of 1436. But in November of the same year, when the officials asked him to come to Prato, they report that he 'laughed us to scorn'. The whole matter came to a head in 1438, ten years after the original commission, when a request that the Prato officials pay Donatello the amount they supposedly owed him so that he would complete the reliefs was met with the following response: 'Donatello has always led us after him wheresoever it pleased him, and there has never been found a board of *Operai* to put a bar effectively to his inconstancy, but we have always followed his inclination and treated him with pleasantness, and he quite the contrary, but now things shall not be so.' The adjudication at this time required both a payment to Donatello and his completion of the reliefs, a request with which he seems to have hastily complied, and by July of 1438 all six reliefs had been completed. The officials then decided to have the backgrounds filled with gold mosaic, a project again undertaken by Donatello. There seems to have been no final meeting between the Operai at Prato and the two Florentine sculptors to compare accounts and to make a final settlement. The sculptors wrote as late as 1455 about this matter, but the lack of documents suggests there was no reply.

In the years around 1430, several direct and indirect references reveal Donatello's contact with the circle of prominent Florentine humanists and antiquarians. Letters written by Nanni di Miniato in 1428 and 1430, for example, refer to two Roman sarcophagi found between Pisa and Lucca (Fig. 102); the second letter testifies that Donatello had seen them and had praised them as 'chose buone' ('good things').

That Donatello's judgement about antique works was considered important is further revealed by a letter written by Poggio Bracciolini; referring to an unknown ancient work he says: 'I also have something here which I shall bring home with me. Donatellus saw it and praised it highly.' Evidently Donatello personally collected ancient works, for the diaries of the widely travelled antiquarian Ciriaco d'Ancona state in 1433 or 1434 that he had seen in the studios of Donatello and Ghiberti 'a good many antique things, as well as new works made by them in bronze and marble'. Later sources add further information. Vespasiano da Bisticci, writing a series of lives of celebrated Florentines in about 1485, tells us that Donatello was among the intimate friends of the important – and difficult – humanist Niccolò Niccoli. Vasari states that Donatello restored many antiques for Cosimo de' Medici, including a white marble *Marsyas*, which stood at the entrance to the garden of the Palazzo Medici and 'very many antique heads, which were placed over the doors'.[41]

Donatello's contact with these men in the 1430s would have reinforced or clarified for him humanist ideas that had undoubtedly been circulating informally among Renaissance artists for some time. One was the notion of *statua*, derived from Pliny's *Natural History*, which offers many examples of sculpture serving an important purpose in the life of civilized man and being related to historical time. The traditional philosophical and theological questions of the relationship of man and nature were certainly raised again by the concept of linear perspective, which visually re-created natural space and underscored man's unique position as the perceiver of God through nature. Donatello seems to have been well aware of the application, if not the theories, of perspective almost twenty years before Alberti codified them in *On Painting* in 1435/6. He might also have known something of Alberti's ideas on the importance of the dramatic and significant narrative, the interpretation of human life Alberti called the *istoria* and saw as the basis for a work of art. Alberti's *De statua*, for which the date is unknown, is much more a practical than a theoretical discourse on sculpture; whether its set of ideal proportions for the human figure or the corresponding change in proportions in Donatello's statuary came first remains a problem.

It was perhaps during the late 1420s and the 1430s that Donatello's most purely classicizing works were created. Evidence suggests, for example, that the lost *Dovizia* for the Mercato Vecchio, which was very antique in type and was based on an iconographic scheme related to the ideology of the humanist Leonardo Bruni, should be dated *c.*1430 (Figs. 43–45). The so-called *Atys-Amorino* is often dated to the 1430s (Fig. 115), as is the *Cavalcanti Annunciation*, with its terracotta putti perhaps inspired by the writings of Vitruvius or Pliny (Figs. 84–86, 71). There is much debate about the bust presumed to be of Niccolò da Uzzano (Fig. 109), which seems related to the revival of the ancient Roman portrait bust (Fig. 106); if it is a work by Donatello it must date from this period. Pope-Hennessy has recently suggested that Donatello is most likely the artist responsible for the revival of the ancient bronze statuette, arguing that the *Pugilist* at the Bargello is close in style to works by Donatello (Fig. 108).

Obviously contributing to Donatello's classicizing phase was another trip to Rome. The last documents that explicitly confirm his presence in Florence are in January 1431, but he (and Michelozzo, it seems) had been in Rome long enough by the autumn of 1432 for the irritated patrons of the *Prato Pulpit* to apply to Cosimo de'Medici to aid them in obtaining Donatello's return. Giovanni d'Antonio de'Medici was sent to Rome with a message from Cosimo that Donatello would suffer no financial penalty if he returned, and in a letter of 11 October to the Prato authorities Giovanni reported Donatello's intent to return by the end of the month; he added that Donatello 'has many and legitimate excuses, so make no complaint of him, and do nothing against him, not even if any ask you to do so, and especially

that ——— for that would be an ill thing'.[42] When Donatello had not returned by December the Cambio di Ferro commissioned Donatello's assistant, Pagno di Lapo, to go to Rome, armed with letters from Cosimo de'Medici and others. Pagno was paid for his trip on 1 April 1433, and by 31 May Donatello was back in Florence. There are two works in Rome that Donatello seems to have executed there: the largely effaced and relatively uninteresting, but signed, *Tomb of Giovanni Crivelli* (died 29 July 1432; Santa Maria in Aracoeli), and the Tabernacle now in the Sacristy of St. Peter's.[43]

The relief of the *Entombment*, which surmounts the Tabernacle in St. Peter's, is one of the few examples of pure *schiacciato* carving in Donatello's œuvre, and suggests that the other *schiacciato* reliefs, the *Ascension, with Christ Giving the Keys to St. Peter* (Fig. 76), the Lille *Feast of Herod* (Fig. 78), and the *Madonna* now in Boston,[44] should all be dated in the late 1420s and early 1430s. The unusual technique of *schiacciato* carving (see pp. 110–11 and 137–8), which was invented by Donatello and was only popular in his immediate circle, demands a delicate raking light and does not usually function very well in an architectural setting, as the Roman *Entombment* reveals. The only other pure *rilievi schiacciati*, the two noted above, are later found in inventories of the Medici possessions, suggesting that this *tour de force* of marble carving was better suited to the collections of Renaissance connoisseurs.

In 1436 Donatello brought one of the Opera del Duomo's long-standing projects to completion by finishing the last marble prophet for the Campanile niches (Fig. 124). His attention was already turning, however, to the series of decorative projects that the Opera had begun to commission for the crossing area and dome of the Duomo itself. Over the next three decades, works in terracotta, stained-glass, bronze, marble, and intarsia were commissioned from such artists as Luca della Robbia, Lorenzo Ghiberti, Paolo Uccello, Andrea del Castagno, Buggiano, Giuliano da Maiano, Maso Finiguerra, Alesso Baldovinetti, Mino da Fiesole, Michelozzo and, of course, Donatello.

Donatello's work for the Duomo during the 1430s is some of his most varied and challenging. In 1433 he received the commission for a marble organ gallery (popularly – and incorrectly – known as the *Cantoria*; Fig. 93) to be placed over the portal of the south sacristy (the door to the right in Fig. 25) as a counterpart to the one already begun by Luca della Robbia in 1432 (Fig. 94). There are regular payments for Donatello's *Cantoria* from 1433 until 1440, but the final accounting waited until 1446, when it seems to have been undertaken at the insistence of Donatello's friend Cosimo de'Medici.

The following year, 1434, Donatello won the competition to design the first oculus in the drum of the dome, an enormous stained-glass window almost four metres in diameter (Fig. 57). It is surprising that he defeated Ghiberti, who had been designing stained-glass windows for the Opera for almost three decades, especially since the window is in the most prominent position, opposite the Duomo's entrance (the right-hand oculus in Fig. 25). For his design he received eighteen florins – the defeated Ghiberti was awarded fifteen – which he shared with the painter Paolo Uccello and another artist, suggesting that Donatello had some help in this commission. The window, executed by two professional glaziers, was completed in December 1437, and installed by February 1438. Despite the success of Donatello's simple and legible design, which was praised as such by Vasari, this composition had little effect on the style of the remaining seven oculi, whose commissions were awarded during the 1440s: three to Ghiberti, three to Uccello, and one to Castagno.

Also in 1434 a single document records a competition between Donatello and Luca della Robbia to design terracotta models for a head to be placed in that part of the cupola known as the '*gula*'. Although later documents do not refer to this competition, it may have been related to the temporary octagonal oculus, finished

in 1436, which closed off the dome until the construction of the lantern was begun.

In 1437 Donatello received what was probably the most prestigious commission to be awarded for this part of the Cathedral: he was asked to make two pairs of bronze doors for the portals of the paired sacristies in the great piers below the dome (Fig. 25).[45] The decision to employ Donatello was made in February, and the actual contract was awarded in late March. The first door was to be completed by April 1439 and the second by April 1441; curiously the price set for the first door, 1100 florins, was 200 florins more than the value of the second, and both were modest sums compared to the 22,000 florins that Ghiberti says he was paid for the *North Doors* of the Baptistry. A model of Donatello's doors was already available in early 1437, and by March a sum of 250 florins had been paid to the artist. A subsequent purchase of bronze for the doors in 1439, however, is the only other direct documentary reference to their execution, and in 1445 Donatello's contract for one of the doors was cancelled; the commission was awarded to Michelozzo, Luca della Robbia, and Maso di Bartolommeo. The commission for Donatello's other door is mentioned again in 1446, when his *Cantoria* was evaluated, for it was then stipulated that no further payment for the organ gallery would be made to him until he had cast the sacristy doors. In 1459 he is still being referred to as 'intagliatore e chondottore de li porti de la sagrestia'.

The three semicircular arms around the crossing encompassed fifteen chapels that needed altars, and in 1439 two were commissioned from Donatello. The documents are difficult to interpret, but it seems that this same commission was shortly thereafter transferred to Luca della Robbia. Luca, however, was required to follow a wax model that Donatello had prepared for one of these altars; the model included an altar table resting on four columns and incorporating scenes from the life of St. Paul. This altar was never completed. Donatello was also involved in the work on the marble choir, which was being planned for the area under the dome; in 1439, when a provisional wooden display of this choir was mounted, Donatello was hired by the Opera to select the coloured marbles from which it would be constructed.[46]

Although his work for the Duomo was the most public, and perhaps most prestigious, to be undertaken in Florence, Donatello did not neglect other commissions. The single most important recent discovery in Donatello studies has been the date of 1438, which emerged on the wooden *St. John the Baptist* when the figure was cleaned in the early 1970s (Figs. 113, 114). It had previously been dated to a supposed trip to Venice in the early 1450s, after Donatello's work in Padua, and interpreted as an example of a dramatic and expressionistic late style. The new date provides a sobering demonstration that the dating of Donatello's work on the basis of an internal stylistic development or the supposition of an emotional *spätstil* is simply not reliable. The tradition of polychromed wooden sculpture in Tuscany during the fifteenth century has recently been examined by Deborah Strom, who has suggested that Donatello's *Penitent Magdalene* and the attributed *Crucifix* from Bosco ai Frati might be dated during this same period, the late 1430s and the early 1440s (Figs. 131–133, 75). Since Donatello is documented as being active in Florence during 1438, it seems most likely that the *John the Baptist*, made for a chapel in the Venetian church of Santa Maria Gloriosa dei Frari that had been granted to the Florentines in 1436, was produced in Florence and subsequently shipped to Venice.

Also thought to date from the late 1430s or the early 1440s is the sculptural and architectural decoration of stucco, bronze and *pietra serena* that Donatello created for Brunelleschi's Sacristy (now known as the Old Sacristy), the Medici chapel in San Lorenzo (Fig. 48; see pp. 78–81). Donatello's works in the chapel include four stucco roundels of Evangelists (see Fig. 99), four polychromed stucco compo-

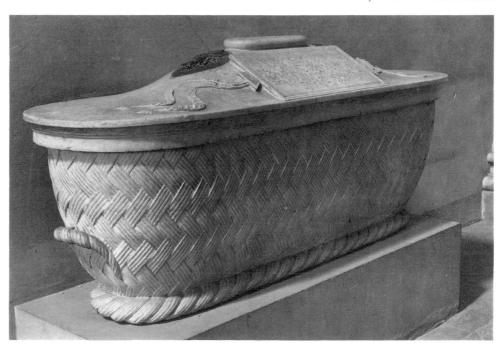

37. Donatello and workshop: *Sarcophagus of Niccolò and Fioretta de' Martelli*. 1440s–50s. Marble, with bronze and porphyry inlay, 89 × 203 cm. Florence, San Lorenzo

sitions of scenes from the life of St. John the Evangelist (Fig. 89), two stucco overdoors with monumental figures of paired saints (Figs. 72, 73), the architectural surrounds of the portals to either side of the altar recess, and two pairs of bronze doors (Figs. 87, 88). Despite reports that Brunelleschi did not appreciate Donatello's additions to the Sacristy, the total effect is handsome and impressive, and there is no family chapel in Florence that can compete with this elegant and unusually rich programme.

The Sacristy of San Lorenzo provides an example of private family patronage that is rare in Donatello's surviving, documented works. Institutional documents are, of course, much more likely to survive than private ones, and the same can be said of the resulting works of art; the loss is surely much greater in the secular, personal realm. Renaissance artists executed a considerable amount of work for private patrons, however, and to judge from Vasari's account, Donatello seems to have been no exception:

> But whoever wanted to tell the full story of Donatello's life and works would have to write far more than I intend in narrating the lives of our artists; for apart from his major works, which I have noted in some detail, Donatello set his hand to the smallest things of his art. For instance, he made coats-of-arms to go on chimney pieces and fronts of town houses, a very fine example of which can be seen on the house of the Sommai opposite the tower of the Vacca. He also made, for the Martelli family, a wicker-work chest, shaped like a cradle, to serve as an urn; this is below the church of San Lorenzo since no tombs of any kind appear above, although one can see there the epitaph on Cosimo de' Medici's tomb, which, like the others, has its opening beneath.

The arms of the Sommai seem to have disappeared long ago, but the *Sarcophagus of Niccolò and Fioretta de' Martelli* still survives (Fig. 37);[47] it has been moved upstairs in San Lorenzo and is now in a chapel opposite a rather sentimental late nineteenth-century memorial to Donatello. As an imaginative and sensitive variation on the traditional sarcophagus form, it certainly deserves to be reintroduced into Donatello's *œuvre*. A coat-of-arms of the Martelli Family also survives; it is not only an example of marble carving of high quality, but the unusual conception of the supporting figure struggling to hold the heavy *stemma*, the *schiacciato* treatment of

38. Donatello and workshop: *Martelli Coat of Arms*. 1440s–50s. Marble with traces of polychromy, 130 × 80 cm. Florence, Casa Martelli

his hand, and the fluttering decorative ribbons favoured by Donatello suggest that it was designed, if not executed, by him (Fig. 38).[48] Occasionally very explicit objects are mentioned that are now unfortunately lost; an especially interesting one for Donatello's goldsmith activity is the silver arm reliquary Giovanni de'Medici donated to the Monastery of Santa Verdiana in 1451 and which Richa claims was by Donatello.[49] Also, a relatively large number of objects survive that are certainly Donatellian in style and evidence of how naturally his lively rhythms and motifs were applied to useful objects. Given that there is some indication that Donatello employed bell-founders to cast his work (see p. 115), the bell called the '*Piagnona*' in the Museum of San Marco (Fig. 39), with its band of dancing putti, is all the more intriguing. It bears an inscription identifying the donor as Cosimo de'Medici.[50]

Although the extent of Donatello's activity for such private patrons is unknown, he certainly had more than enough work for the Opera. It comes as somewhat of a surprise, therefore, to learn that he left Florence in the early 1440s; the exact date and reason are not clear. By 5 February 1440, the *Cantoria* had been installed in the Duomo and, as there are no later Florentine documents in 1440, and no documents at all for Donatello in 1441, 1442, or 1443, it is possible that he was gone from Florence soon after the beginning of the new decade. The single exception to this lack of documentation is a report in a tax declaration of 1458 that Donatello had bought a house in Figline di Prato on 21 March 1443; as a tax document it can be regarded with some suspicion. The next reference to him occurs in a Paduan document of January 1444, when one 'Maestro Zuan', identified as one of Donatello's partners, receives some iron to be used in making 'the crucifix'. This document surely refers to the bronze *Crucifix* visible in Fig. 127, which Donatello made for the church of Sant'Antonio of Padua (commonly known as the Santo). Vasari states that Donatello was called to Padua by the Signoria of Venice to make the *Equestrian Monument to Gattamelata* (Fig. 52), but there is no documentary

39. Workshop of Donatello?: '*La Piagnona*' (the bell of San Marco). Before 1464. Bronze. Florence, Museo di San Marco

reference to work on the monument before May 1447. The evidence, then, does not tell us when Donatello left Florence, whether he went directly to Padua, or, most tantalizing of all, what it was that induced him to leave Florence at this particular time.

Donatello's work in Padua, however, was extensive and challenging enough to keep him there. His earliest documented sculpture is the *Crucifix*, now disfigured by a Baroque loincloth, mentioned above.[51] There are two payments in 1444 for materials, but in 1445 the *Crucifix* was still unfinished, and Donatello owed the Arca del Santo money, no doubt because of his failure to deliver this work on which they had paid advances. Perhaps part of the delay was occasioned by his absence in Florence, where he is documented as being on 5 October 1445. In 1447 a pedestal for the work was made, and in 1449 wood for the cross was purchased and gilded and a '*diadema*' made and gilded for the figure; only then did Donatello receive the final payment.

By 1447 Donatello was working on the Gattamelata (Figs. 52, 66, 105) to be placed outside the Santo. The statue is a complex mixture of classical allusion and contemporary politics (see pp. 90–4 and 176–83). All the known documents for it fall within 1447, with the exception of the final settlement between Donatello and Gattamelata's son and heir in 1453, which set the value of the monument at 1650 ducats (the ducat was a Venetian coin roughly equivalent to a florin at this time), and stated that Donatello must spend September placing the horse and rider on their pedestal; this was accomplished by October, when documents show that he should be paid the amount still due.

The opportunity to cast a bronze equestrian statue was matched by the possibilities offered in accepting the commission for a high altar for the Santo. The Padua Altar, an impressive and unprecedented complex with seven life-sized bronze figures and twenty-one bronze reliefs, several limestone reliefs, smaller decorative

elements, and an architectural setting, was completed with astonishing speed; unfortunately its dismemberment in the next century makes it impossible to reconstruct Donatello's original solution to the challenges presented by this commission (see Figs. 127, 128, 92, 97, 101, 32, 33 and pp. 208–9). The speed with which the work was accomplished is certainly due to the help of many assistants, some of whom are named and their work specified in the lengthy documentation.[52] The altar was probably begun in the second half of 1446, with payments in 1447, 1448 (when a provisional mounting of the Altar was made for St. Anthony's feast day), 1449, and 1450. Documents from June of 1450 suggest that the altar had been finished, but four years later an artist was employed to 'complete' it and in 1456 Donatello, then back in Florence, was still trying to collect some money due him for this major work. Between mid-1450, when his three Paduan projects seem to have been virtually complete, and late 1454, when according to documents he was back in Florence (see Fig. 18, no. 7), he most likely continued to live in Padua. He is documented as being there as late as October 1453, and the agreement on his house there states he had rented it for the entire year.

He is also known to have travelled at this time to at least three important north Italian centres: Mantua, Ferrara, and Modena (Fig. 16). He was at the court of Ludovico Gonzaga in Mantua in 1450, where he received a commission to make a reliquary for the remains of Sant'Anselmo; although he produced a model, the work was never completed. In 1451 he received a payment of ten ducats from the Bishop of Ferrara for unknown work. And at Modena in the same year he received the commission to execute a gilded bronze *Monument to Borso d'Este*, for which he was paid an advance of two hundred florins. In 1452 he purchased metal with which to execute the statue, but this project too was left unfinished; in 1453 an emissary from Modena made two trips to Padua to try to persuade Donatello to return and resume work on the monument. It is also reported that in 1453 Donatello provided the designs for some architectural decorations for the Archbishop's Palace at Zara. It may be possible that during this period Donatello proposed projects for the Venetians, for a letter written by Alfonso of Aragon to Doge Francesco Foscari in 1452 suggests that Donatello was in their employ; Pope-Hennessy, however, reasonably connects this reference to the Signoria's patronage of the *Gattamelata*.[53]

Whatever the reasons for his leaving Florence, or for his wanderlust, Donatello was back by 15 November 1454, when he rented, for a period of two years and eleven months, a house with a *bottega* on the Piazza del Duomo (Fig. 18).[54] Further evidence of his return to Florence is afforded by a recently discovered letter, written by Piero di Cosimo de'Medici on 12 September 1454, which lists items Piero was sending from Faenza to Florence. Included are three objects that belong to Donatello: a bronze head (a portrait?), a bronze relief, and '*una capsa vechia*', perhaps an old case or container. Another letter of the same year documents two Madonnas by Donatello sold to the family and Donatello's work on the '*schrittoio*' of Giovanni de'Medici.[55] Donatello's connections with the Medici seem to have been intact even after such a lengthy stay outside Florence.

Between late 1454 and his departure for Siena in 1457, Donatello's activities in his native city are somewhat uncertain. We do, however, have evidence of an illness, apparently serious, and of his gift of a work of art to Giovanni Chellini, the physician who treated him (Fig. 68). The relevant entry in Chellini's diary is quoted at the beginning of Chapter 4. The diary date of 1456, of course, provides only the latest date for the *Chellini Madonna*, which might have been made as much as a decade or two earlier. The illness Chellini treated, however, is probably related to a reference in a letter of 1458 that Donatello had almost died among the Paduans.[56]

Donatello seems to have achieved extraordinary fame by this point in his career, since he is one of only seven artists included in Bartolommeo Fazio's *De viris*

illustribus, written in Naples about 1456; the others are Lorenzo Ghiberti and his son Vittorio, the Italian painter Gentile da Fabriano, the painter and medalist Pisanello, as well as two Flemish painters, Jan van Eyck and Rogier van der Weyden. The only specific works Fazio mentions are the bronzes in Padua, although he does say that Donatello also worked in marble:

> Donatello, likewise a Florentine, will also distinguish himself by the excellence of his talent and art. He is much noted for work not only in bronze but also in marble: he seems to 'form faces that live', and to be approaching very near to the glory of the ancients. His in Padua are the St. Anthony and other excellent images of saints on the same altar. Also his in the same city is the famous general Gattamelata, bronze and mounted on a horse, of marvellous workmanship.[57]

In the middle of September 1457, a month and a half before the lease ran out on his house and workshop in Florence, Donatello was in Siena. There, the Opera declared he would spend the rest of his life working for 'the honour of the city', and in October instructed one of their agents, the Camarlengo, to provide him with everything he needed for himself and his work.[58] A week later the bronze *St. John the Baptist* arrived in three pieces and missing an arm; it was probably sent from Donatello's Florentine shop (Fig. 65; see pp. 117–20). Again his reasons for leaving Florence are unclear, although he obviously found himself well taken care of in Siena. In November the Opera del Duomo provided him with twenty pounds of wax, a furnace, and an iron tripod and, sometime before 10 December, when he was given fifty pounds of wax, he was instructed to make what is referred to as a '*storia*' for the door of the Duomo. The Opera rented a house for him in January 1458, the same month they acquired iron for him to make two cornices for the organs and metal and wax to cast a relief for the door. In March and April the door is mentioned again among the Duomo expenditures but no documents are known for it thereafter. In 1459 Donatello is referred to as 'making the bronze doors', but in 1461 he is listed as owing the Opera the money he had received. Exactly what he accomplished during these years in Siena is unknown, although among the possibilities is an interesting low relief in marble, the *Madonna del Perdono* over the right transept door of the cathedral (Fig. 90). It seems possible that Donatello may have designed and begun the relief; it was certainly finished by another hand.[59] The gilded terracotta *Madonna and Child* in the Victoria and Albert Museum can probably also be dated to this period (Fig. 70). On 4 July 1458, the magistrates of the Sienese Consistory deliberated about sending Donatello and Urbano da Cortona to Val d'Orcia (Fig. 16) to procure alabaster 'for the palace', and four days later the Opera del Duomo decided to allocate to Donatello a marble statue of San Bernardino for a price not to exceed sixty-eight florins; nothing more is known of these two projects. It is possible that the commission for the San Bernardino was an enticement to Donatello to stay in Siena, since he had offered in June 1458, in a letter to Ludovico Gonzaga from his correspondent, Gianfrancesco Suardi, to return to Mantua to finish the Arca di Sant'Anselmo.'[60] Two documents, which, in the light of his illness in 1456, seem to be connected with Donatello's health, should not be overlooked: on 19 May 1458, the Opera del Duomo paid for 'carrying Master Donatello's bed', and in April 1459 they bought him a bed and a feather bolster.

In spite of his public resolve to spend the rest of his life in Siena, Donatello was back in Florence by 1 June 1459, when the Florentine Opera del Duomo rented a house for him on the corner of Via del Cocomero; the unspecified payment to him at the end of the month was nearly the last documented payment he was to receive. Very little is known about him in the last seven years before his death. Even Ludovico Gonzaga, writing regularly to the Sienese Captain Gianfrancesco Suardi throughout 1458 in an effort to get Donatello to return to Mantua and finish the

DONATO SCVLTORE
FIORENT.

40. Christoph Lederer: *Portrait of Donatello*, from the second edition of Vasari's *Le Vite*. 1568. Wood engraving

Arca di Sant'Anselmo, had no success. Vasari maintains that Piero de'Medici gave Donatello a small pension for the rest of his days, and it is true that after the last payment from Siena in early 1461, Donatello seems to have officially received only two lire, ten soldi – and even that from Piero's overseer for unspecified work in the chapel of the Annunciation in Santissima Annunziata. His only known works are the San Lorenzo pulpit reliefs, which were executed with the help of assistants, and were left unfinished at his death.

It is quite possible that Vasari's assertion, quoted at the beginning of the next chapter, is correct, and that Donatello was incapacitated and 'took to his bed'; he is certainly right about the location of the house in Via del Cocomero. Donatello died in December 1466. Andrea della Robbia was one of his pall bearers, a fact he reported with great pride to Vasari many years later.[61] Donatello survived his friend Cosimo by two years, and long enough for new tastes and forces to have affected his own work: the *St. Louis of Toulouse* had been taken down from the Parte Guelfa tabernacle (see pp. 72–4), and his Campanile figures on the north side had been moved to the more prominent west face. The series of colossal prophets for the Duomo had been ceded to Agostino di Duccio, and even if Donatello had been well enough to work, Piero de'Medici's preference was for Mino da Fiesole, who sculpted his portrait bust, and for the very different art of Benozzo Gozzoli. But Donatello had already earned his place in history: for the Renaissance, as a sculptor equal to the ancients, and for us as a sculptor equal to Masaccio's genius in painting and Brunelleschi's in architecture.

CHAPTER THREE

Sculpture, Society and Politics

When he [Donatello] reached the age of [eighty-three] he became so palsied that he could no longer work at all, and he had to keep to his bed in a poor little house which he had in the Via del Cocomero, near the nunnery of San Niccolò. He grew worse from day to day and gradually wasted away until he died on 13 December 1466. He was buried in the church of San Lorenzo, near Cosimo's own tomb, as he himself had directed, so that just as he had always been near Cosimo in spirit while alive so his body might be near him after death.

Vasari, *Life of Donato*, 1568

In fourteenth-century Florence, a few elaborate tombs testified to the wealth and position of particular private families, and the extensive decoration of the Duomo, Baptistry and Campanile to the general wealth and stature of the Florentine Commune; the social usefulness of sculpture, apart from its religious purpose, was limited. Art reflected, or was meant to reflect, prosperity and power. In the fifteenth century, however, Florentines, self-conscious and self-assured, began to regard art, and particularly sculpture, as more clearly part of that power and not merely as its reflection. This attitude appears in literature and contemporary comment, as well as in sculpture, whose forms, both secular and new, were often imbued with secular themes or meanings beyond their religious iconography. Quattrocento sculpture was subject to Leonardo Bruni's admonition that it be 'significato', and to Alberti's definition of *statua* in terms of contemporary relevance, giving it a cultural significance that not only helped to remove the appellation of 'craftsman' from the sculptor, but made it possible to consider and reconsider the meaning and importance of a statue as if it were literature.

This change in attitude was a gradual process, involving a number of cultural variants; yet humanist thought and writing, which often used the visual arts as metaphor, was certainly a primary impetus. Petrarch can be credited with reintroducing such references to art, particularly in *De remediis utriusque fortunae* (1354–66), and providing a basis for art criticism by distinguishing between a knowledgeable and an uninformed viewer, and defining useful as opposed to merely sensuous delight in the image. The Renaissance stories applied to Donatello's *Zuccone* are really elaborations of classical formulae used by Petrarch, who described sculpture in terms of 'signa spirantia' ('breathing statues') and 'vox sola deest' ('only the voice is lacking'). His revival of Latin literature was championed in Florence by Boccaccio and Coluccio Salutati, but Italian knowledge of classical Greek began only with the arrival of Manuel Chrysoloras, who left Constantinople about 1395 for Italy and taught Greek in Florence. In a letter from Rome, where Pope John XXIII had sent

him as a diplomat in 1411, Chrysoloras outlined, in Aristotelian terms, the importance of sculpture and what to admire in it: detailed lifelikeness, variety, and intense emotional expression.[1] It is with this strong classical background, as a follower of Salutati and a pupil of Manuel Chrysoloras, that Leonardo Bruni wrote a letter in 1425 to advise Niccolò da Uzzano on how to judge the panels for Ghiberti's second set of Baptistry doors.

Bruni's letter was both a reflection of what had already occurred in Quattrocento sculpture and a guideline for future programmes.[2] His statement may now seem very general, but it is an example of critical judgement and concern quite different from the medieval idea of sculpture as simply architectural ornament. Bruni not only offers two criteria for the panels, but defines his terms: they should be *illustri*, meaning nourishing to the eye with a variety of design, and *significati*, having an import worth remembering. It was only several decades later that Alberti and Filarete discussed the place and importance of sculpture in relationship to architecture and the ideal city, but the notion of sculpture as an art form to be considered seriously – and intellectually – was well-established in the early Quattrocento in Florence.

Although these ideas would have been applied to sculpture in general, E. H. Gombrich has pointed out that another notion, that of artistic progress, had affected Florentine art at least since Cennino Cennini; the artist 'had not only to think of his commission but of his mission . . . to add to the glory of the age through the progress of art'.[3] Donatello, perhaps more than any other sculptor, was drawn into this new role; Alamanno Rinuccini wrote in 1473, comparing his age to the ancients' in the preface to a translation of *Philostratus*: 'As to sculptors, though I might mention many who would be outstanding if they had happened to be born a little before our time, the one Donatello surpassed all the rest to such an extent that he is almost the only one to count in the field.'[4] Thus, only seven years after the sculptor's death, a humanist who may be expected to have known the ancient attitude toward sculpture, and to have taken it into account in a comparison between the ancient and modern ages, singled out Donatello.

Either by good fortune or by the particular suitability of his style, he became associated with civic statuary rather early in his career. On 2 July 1416, the Signoria of Florence requested that 'a certain marble figure of David at present owned by the Opera' be sent to the Palazzo della Signoria; the Operai acted immediately and paid Donatello and his assistants five gold florins for 'adapting and completing' this figure of *David* (Fig. 116; see pp. 191–3). In August the statue was transported to the Palazzo, where it was installed on two marble brackets. Fifty pieces of gold-leaf were used on the figure, gold- and silver-leaf and glass inlays on the base and brackets, and the wall behind was painted with the lilies of Florence on a blue ground; the statue was inscribed PRO PATRIA FORTITER DIMICANTIBUS ETIAM ADVERSUS TERRIBILISSIMOS HOSTES DII PRAESTANT AUXILIUM ('To those who fight bravely for the fatherland the gods lend aid even against the most terrible foes').

The idea of the triumph of the brave over the strong, and of justice over tyranny, had long appealed to the Florentine republic; embodied in Hercules or the young David, it had appeared in Florentine literature and art since at least the early Trecento.[5] In 1416 Florence was just emerging from a long period of war and of threatened republican freedom, and the city's identification with the hero must have been particularly strong. The warfare had begun with Giangaleazzo Visconti's campaigns into Tuscany, which would have led to the subjugation of Florence if he had not suddenly died in 1402 while blockading the city. Rather than taking advantage of this unexpected peace, Florence renewed her offensive against Pisa and finally in 1406 secured an outlet to the sea. Then, in 1408, open conflict had

42. The *Marzocco della Chiesa*, for the staircase of the papal apartments at Santa Maria Novella. *c*.1418–20. Sandstone, with red and white marble inlay, height 135.5 cm. Florence, Museo Nazionale

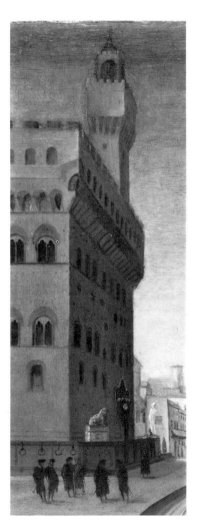

41. Ascribed to Piero di Cosimo: *Portrait of a Man in Armour* (detail). *c*.1504–34. London, National Gallery. The painting shows the *Marzocco della Piazza* (by Donatello?) on the *ringhiera* in front of the Palazzo della Signoria

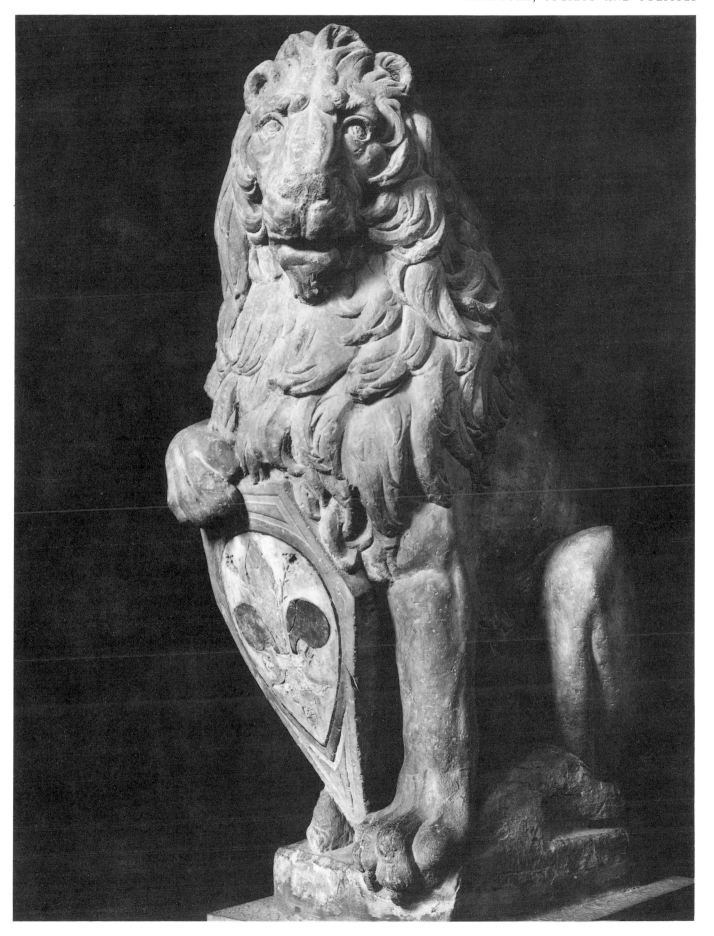

begun with King Ladislas of Naples, continuing until his death in 1414. Florence's alliance with France and Pope John XXIII brought assistance against Ladislas, but obviously affected Florentine relations with Pope Gregory XII and the Curia in Rome. The humanists in Florence, particularly Salutati and Leonardo Bruni, wrote of these conflicts in terms of the republic being threatened by a tyrant and, although no immediate connection has yet been discovered with the transfer of the *David* to the Palazzo della Signoria in July 1416, both its general symbolism as well as its inscription seem directly related to contemporary politics.

David, in this context, is an example of *statua* as Alberti was to define it in *De statua*. Borrowing the term from Pliny's *Natural History* (where it was restricted to large bronze statues), Alberti used it to mean something quite different from *figura* – the usual Florentine word for a statue. Charles Seymour has defined this concept most clearly: '*statua* applies to time actually lived, and serves both as a memorial and a guide for human achievement at grips with history. It implies the notion of dedication to humanly defined ideals; it functions as a constituent part of a noble and impressive environment fit for noble and impressive human beings.'[6]

Not all commissions with political motivations produced *statua* and, in fact, Donatello's next such commission from the Opera del Duomo was for a straightforward image, although the politics were far less simple. In 1418 an addition to Santa Maria Novella was begun in preparation for the visit to Florence of Pope Martin V, whose election at the Council of Constance in 1417 had ended the nearly forty year long Schism; these papal apartments were to serve as a temporary palace from February 1419 to September 1420 while the Pope attempted to regain papal territory and prepared for his return to Rome. In the meantime Florence was courting Martin V and protecting business and banking interests with the Curia, in spite of fears that a united church, created by the Council of Constance, would pose a threat to the liberty of the Florentine Commune. If Martin made peace with Milan, the temporal power of the Papacy would cover much of Italy. Eventually the Pope did establish a policy of neutrality toward the Visconti and Milan in the hope of securing help against the Neapolitan Kingdom; Florentine fears that this would encourage another Milanese push south were realized in 1423 when war broke out again.

No doubt to emphasize the idea of Florentine liberty, the Operai commissioned the *Marzocco* (a traditional heraldic symbol of Florence) to stand on the newel post of a grand staircase in the new papal apartments (Fig. 42).[7] It could well have been the staircase designed at this time by Ghiberti,[8] and this gathering of artistic forces attests to the importance Florence attached to the project. As symbols of the people, stone lions and real ones had been used in the Piazza della Signoria, and Pope Martin could not have failed to connect Donatello's *Marzocco* with the one guarding the Palazzo della Signoria (Fig. 41).[9]

Donatello was at work on the *Marzocco* from 1418 until 1420, the period during which he was busy with the project for the Campanile prophets. It is not surprising, therefore, to find in these works surface modulations that are similarly subtle, or a handling of the eye, eyelid, and facial muscles that recalls the early prophets and looks forward to *Jeremiah* and the *Zuccone* (Figs. 122–125); it is only surprising that this is a lion. His face, narrow and long, is made longer by the tuft of hair under his chin, while the proportions of the head are more human than leonine. His right paw rests on a shield displaying the Florentine lily, carefully and expertly inlaid with coloured marble. Although the stairs were demolished, perhaps in the sixteenth century, the *Marzocco* presumably remained in Santa Maria Novella until 1812 when it was used to replace a lion in front of the Palazzo Vecchio. In 1885 it was moved to the Bargello, but by then the soft sandstone, which had been intended for indoors, was badly worn on the base; the tail seems to have crossed under the body to

Plate II. *St. George*. Detail. *c.* 1415–*c.* 1417. Marble. (See Fig. 28.)

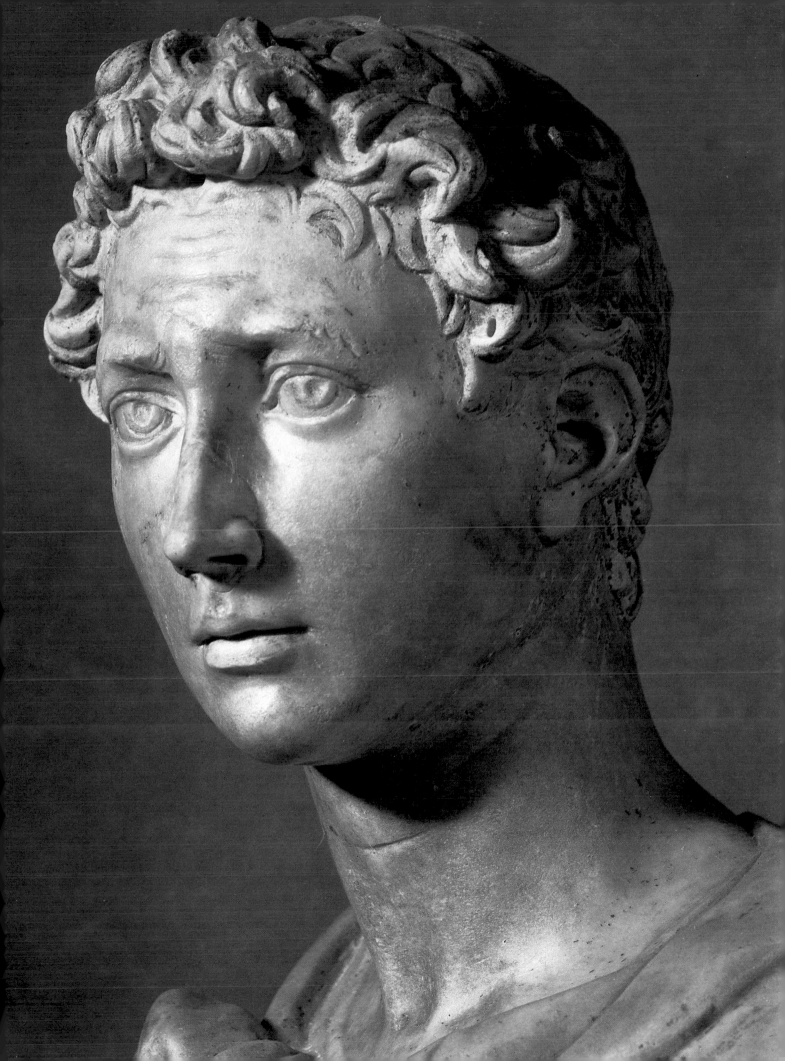

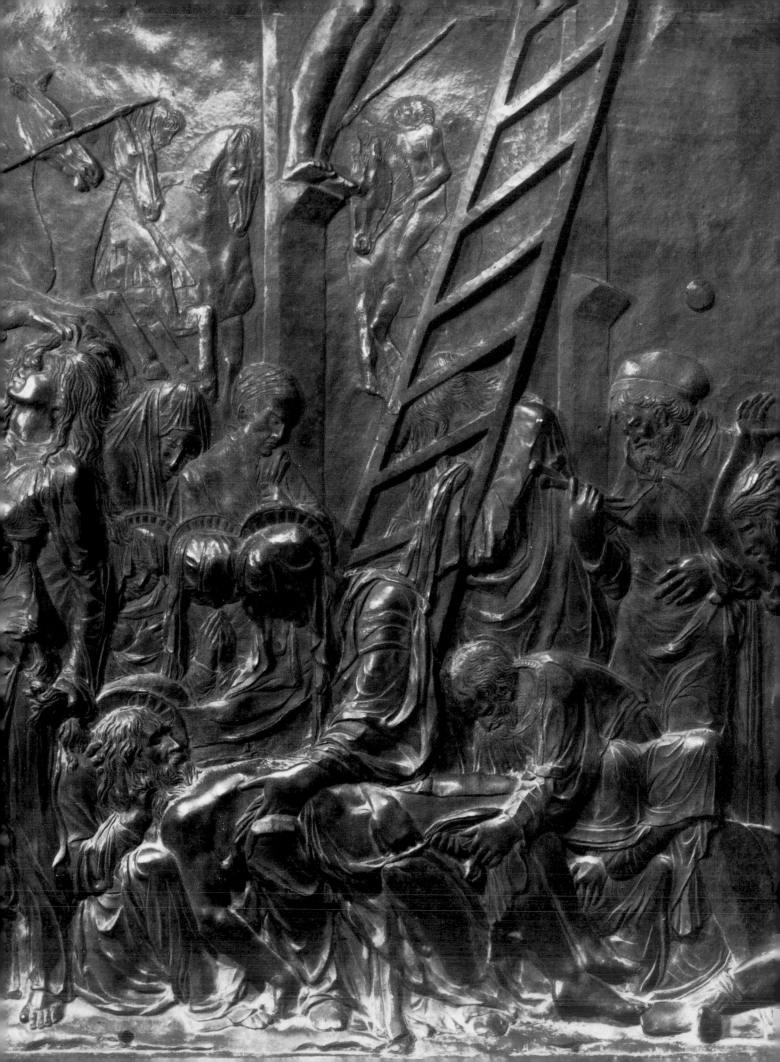

emerge by the shield, but this detail has been lost to erosion. The *Marzocco* mixes such naturalistic touches with a rather abstract and rigid handling of the mane, and a body unnaturalistic in its stiffness, erect pose, and anatomy. It recalls earlier lions, the medieval images found in paintings, and the lions in the Palazzo Davanzati, Palazzo dell'Arte della Lana, and in the cortile of the Bargello; Donatello's lion seems deliberately faithful to the Marzocco as symbol.

In any case, Donatello seems to have impressed the Commune with his ability to convey such symbolism, since it later awarded him the commission for the *Dovizia*, a representation of Communal Abundance and Wealth, which stood on a column in the Old Market (Fig. 43).[10] The statue has been lost, but if the *Marzocco* is an indication of Donatello's attitude toward Communal symbolism, we might expect that the *Dovizia* was a similar treatment of traditional and original form and content. A general reconstruction of the monument can be made from its image in paintings and from several della Robbia variations (Figs. 44, 45). It was an idealized allegory, heroically scaled, and towering above the Mercato Vecchio, the commercial centre of Florence. Although no documents are known for the commission of the *Dovizia*, the base was an ancient column moved to the Mercato sometime between 1428 and 1431 at the instigation of the Communal authorities; thus Communal patronage is likely. Unfortunately, the figure was carved of locally quarried sandstone, and exposure to the weather caused its disintegration; it was replaced in the eighteenth century.

The *Dovizia*'s most obvious connections were classical and, as a public monument, it depended on classical clarity of form and meaning. The figure was represented in a forceful *contrapposto*, conveying a sense of energy enhanced by the wind-swept wet drapery of her classically inspired tunic. The costume parted to reveal her left leg and her right breast, and she held two attributes, a large basket of fruit on her head and a cornucopia on her left arm. In the light of these classical references, the figure is usually interpreted as a representation of Abundance, derived from an ancient *Lar*, or deity of the market-place, but contemporary humanist writings and Florentine history suggest a more specific political meaning.

By the early fifteenth century, the mendicant teaching that amassing wealth (*dovitiae*, the opposite of *paupertas*) was a sin was clearly at odds with the attitudes of the vigorous business and banking community of Florence. Leonardo Bruni, Chancellor of the Republic of Florence when Donatello's sculpture was created, justified *dovitiae* by pointing out that only wealth could make Charity possible, and Charity, the greatest of the Christian virtues, had been claimed as typical of the Florentines as early as the fourteenth century. Bruni's defence, therefore, made wealth a civic virtue as well. The cornucopia filled with fruit was an emblem of civic or public Charity developed in Florence and used exclusively in the Duomo complex; its use on Donatello's *Dovizia* reinforced the connection between Wealth and Charity.

The assertion in the *Dovizia*, a public sculpture, that Wealth and Charity were peculiarly Florentine civic virtues occurred at the same time that the financial structure of the Florentine Commune was undergoing transformation. Expensive wars had overtaxed an already overextended financial structure, and a new tax (the *Catasto*), increased forced loans (*prestanze*), and new investment incentive (the *monte*) were putting unprecedented demands on the Florentine citizenry. Since the *monte* was a form of insurance and investment which guaranteed dowries to a family's daughters, it was seen as a 'good work' offered to the citizens by the state. The new policies were much debated and there was grave concern at the end of the 1420s about the soundness of the Florentine economy. Donatello's *Dovizia*, with her aggressive movement, sensuous beauty, and abundant basket and cornucopia, may have been a calculated statement of propaganda to both the hard-pressed

Detail of Fig. 4

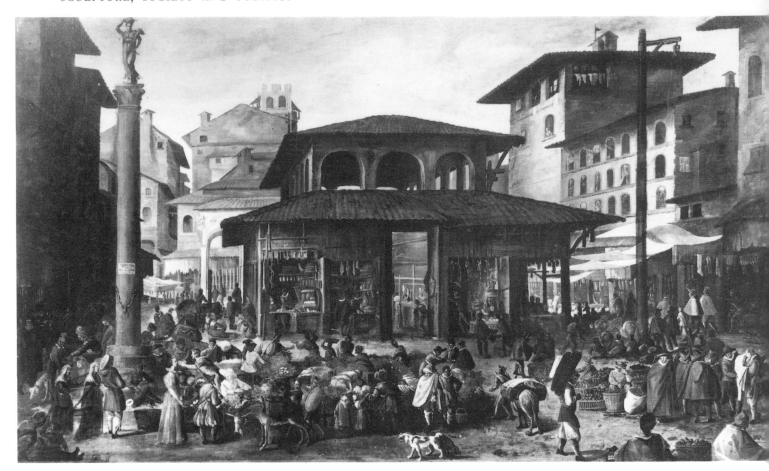

Florentines and the European banking community – about the resources, stability, and beneficence of the Florentine Commune.

Column statues were a recognized antique type, and the distinctly classical quality of the *Dovizia* may have been intended to refer to Florence's ancient origins and republican traditions. As a market figure she must also have referred to the concept of Abundance, and it is not impossible that her attributes were intended to refer as well to the etymology of the ancient name of Florence. 'Florentia' was the name the humanists believed had been given to the new settlement by its Roman founders – an auspicious name, an indication that this place would flourish and flower. Donatello's *Dovizia* visually expressed the fulfilment of their wish.

Perhaps the politically most complicated commission undertaken by Donatello was for the statue of *St. Louis of Toulouse* for the niche of the Parte Guelfa on Orsanmichele (Figs. 129, 130).[11] Although it is clear that the work was meant to convey, or strengthen, the power of the Parte, the members seem to have been unsure whether it did so; for us, the subtleties of the political issues have long since been lost, leaving more clear-cut, yet more puzzling questions. The Parte Guelfa was a political party that had grown, in the thirteenth century, out of the Guelf–Ghibelline rivalry. In the fourteenth and early fifteenth centuries it rightly saw itself as responsible for Florence's long history of independence and, backed by conservative wealth, acted more like an ally than a political party: it sent diplomats to foreign courts, considered its palace a rival of the Palazzo della Signoria, and usurped certain key government posts. Given the members' political sympathies, it is not surprising that they were bankers to the Curia and also to the Angevin kings. This connection, in turn, probably explains why they adopted Louis of Toulouse, the son of Charles of Anjou and a Franciscan, as their patron saint. Beginning in 1325 they controlled the charitable confraternity connected with Orsanmichele, and

43. Circle of Filippo Napoletano?: *The Mercato Vecchio in Florence.* Early seventeenth century? Oil on canvas. Calenzano (near Prato), Berini Collection. The painting shows Donatello's lost column statue of *Dovizia*

44. Anonymous Florentine painter: *Ideal City View* (detail). *c.*1490? Paint on wooden panel. Baltimore, Walters Art Gallery. The painting shows a column statue based on Donatello's *Dovizia*

45. The della Robbia workshop, after Donatello: *Dovizia.* Early sixteenth century? Enamelled terracotta, height 78 cm. Florence, Casa Buonarroti

when it was decided to rebuild the old oratory in 1336, the guild of Por Santa Maria was in charge of construction, and the Parte Guelfa in charge of decoration. A programme of statues for the exterior was proposed in 1339, but little was done before the beginning of the fifteenth century. Both the greater and the lesser guilds were represented; but only the greater guilds (as of 1408) were allowed to have bronze statues; Donatello's statue of *St. Louis* for the Parte, underway in 1423, was not only made of costly bronze, but was gilded as well.

The hold that this group of nobles and wealthy merchants had on Florentine life was not consistently strong, however, and after the War of the Eight Saints (1371–5), and particularly after the Ciompi Revolt, which briefly overthrew the nobility in favour of the *popolani*, the Parte Guelfa lost political power and no doubt prestige. Nevertheless, it still remained fairly prosperous, and in 1418 had the Palazzo di Parte Guelfa remodelled on Brunelleschi's design. In the first years of the century Leonardo Bruni wrote in *Laudatio Florentinae Urbis*, 'But of all the magistracies and there are many in this city, none is more illustrious, nor founded on loftier principles, than that called the heads of the Parte Guelfa'; ten years later, about 1415, in *Historiarum Florentini Populi*, he went so far as to claim that the Parte Guelfa, seen by him as pro-republic, rather than pro-papacy, had begun in ancient Florence.[12] It is not surprising that Bruni, who was with the Curia in Rome, thought well of the Parte Guelfa, but his assessment is very much at odds with that of Buonaccorso Pitti, the merchant who records in his diary that Captains of the Parte Guelfa met to reform the scrutinies in November 1413. He continues: 'They were motivated to do this, because the Parte had lost much of its accustomed honour and reputation. So low indeed had it fallen that the Captains had difficulty in recruiting citizens to accompany them on their processions to make the customary offerings.'[13]

The Parte Guelfa was obviously not at the height of its power when it commissioned Donatello to make the *St. Louis of Toulouse*, but the ideal of the Parte as custodian of liberty was enjoying a revival. The central niche on the east side of Orsanmichele, fronting on Via Calzaiuoli, the broadest of the surrounding streets, was still retained for the Parte. Perhaps indicative of their insecurity, they chose Donatello, who was known for his works for the Operai, and who had earned himself a reputation as a stone-carver. Yet for bronze, especially given the problems involved in gilding (see pp. 120–1), the Parte could have been expected to ask Ghiberti, the only artist who had produced bronzes for Orsanmichele. To assign the project to Donatello, who had yet to do a large bronze figure, was an artistic long-shot.

Did the statue convey or strengthen the power of the Parte Guelfa? By January 1460, the niche was empty – 'as it were, abandoned, in a condition unworthy of the Parte Guelfa' – and for sale, and 'the statue had subsequently been removed since it was adjudged undignified for the Parte Guelfa to be placed on a par with the guilds.' Later that month the Mercanzia (Merchants' Tribunal) bought the tabernacle, and the Parte used the money to finish the ceiling of the Audience Hall of their Palazzo. No contemporary comments on the statue itself have survived; by the time Vasari saw it, the figure was high up on the façade of Santa Croce and in that position may well have deserved his criticism of it as Donatello's 'least successful' work.[14]

The reasons for the removal of the *St. Louis* from its tabernacle after less than forty years are not clear. Possibly this was another subtle attempt by the Medici (who were involved in the selling of the tabernacle) to limit other power; or perhaps what seems like an attempt to preserve the Parte's dignity in the deliberation should be taken at face value, and the removal was indeed an attempt by the Parte to dissociate itself from the guilds and improve its image. In any case, a gilded, over-life-size statue on an important civic building on the main street between the

73

Palazzo della Signoria and the Duomo could not be ignored. It is also possible that Donatello, master of the forceful, expressive statue, succeeded all too well. There is no record of the Parte's reaction to the *St. Louis* and no mention of the figure in any of the several diaries that cover the period 1425–60. Its impression on the modern viewer is strong and unorthodox (see pp. 210–12); even though our understanding of St. Louis, of the political situation of the Parte, and of the perceptions of the fifteenth-century viewer, is limited, the striking character of the forms, the relationship of the figure to the tabernacle, and the timeless message of slumped and rounded shoulders on a young man are all the same now as they were then. It is tempting to view Donatello's *St. Louis of Toulouse* as too strong a political statement, and therefore one that needed to be removed – either to erase or to underscore its message.

Donatello does not seem to have ever shrunk from controversy, and controversy certainly surrounded his next known politically involved commission, that of the *Tomb of Baldassare Cossa*, Pope John XXIII, who had been deposed by the Council of Constance in 1415 (Figs. 46, 47).[15] Any monument to Cossa was, by the nature of the man, bound to be more than a tomb; the very idea of a monument was complicated by issues concerning the papacy, the Florentine Republic, the Medici, the humanists, and allegations about the Pope's conduct in matters of papal finance and morality.

Baldassare Cossa's ecclesiastical career was short and far from illustrious, yet in many ways it nurtured two elements basic to any understanding of the Renaissance, humanism and the power of the Medici. His first important appointment was as Chamberlain to Pope Boniface IX, but soon he was accused of using that office for personal gain through partnership with various banking houses. He became a cardinal in 1402 (later he was accused of having bought his hat with Medici money) and, after regaining Bologna in 1403 for the papacy, was made Cardinal-legate of that city. The Cardinals who supported the Council of Pisa, held on neutral Florentine territory in 1409, elected Cossa Pope in May 1410 in an attempt to end the Schism; instead he simply became one of three papal claimants. It was not until April 1411 that Pope John XXIII moved against his enemy King Ladislas of Naples, a constant threat to Florence, who had kept him from Rome. Although victorious, John XXIII, even with the support of Florence and Louis of Anjou, enjoyed peace for only a short time. In June 1413, Ladislas drove him from Rome, and he took refuge outside Florence. Buonaccorso Pitti wrote that John XXIII, by distributing benefices and promises, had 'won over many influential citizens' in an attempt to form a league with Florence and again confront Ladislas.[16] This failed, and John moved to Bologna to begin negotiations for support from the German Emperor Sigismund. Sigismund insisted that an ecclesiastical council convene in Constance, where his influence would be felt, and John XXIII finally agreed in 1414. The Council of Constance eventually ended the Schism, but only after charging Cossa with a list of crimes and deposing him on 25 May 1415.

Cossa's economic and political ties with Florence were strengthened by his interest in, and patronage of, Florentine humanism. Manuel Chrysoloras, Leonardo Bruni, and Poggio Bracciolini all accompanied him to Constance and, along with numerous other humanists, served as his secretaries and counsellors throughout his papacy. The cosmopolitan environment provided by the papal court, not to mention the contact with the remains of classical Rome, was undoubtedly a strong influence on their work; in turn, they probably contributed to a general attitude of mutual tolerance between Florentine humanism and ecclesiastical authority.

When John XXIII was deposed, an important intellectual link between Florence and Rome was severed. Leonardo Bruni returned to Florence and began work on his history of the city, and Cossa was imprisoned at Heidelberg. His personal tie

46. Donatello, Michelozzo, and workshop: *Tomb of Baldassare Cossa* (the deposed Pope John XXIII). 1421–*c*.1428. Gilded bronze and marble, with gilding and polychromy, width at base 234 cm. Florence, Baptistry

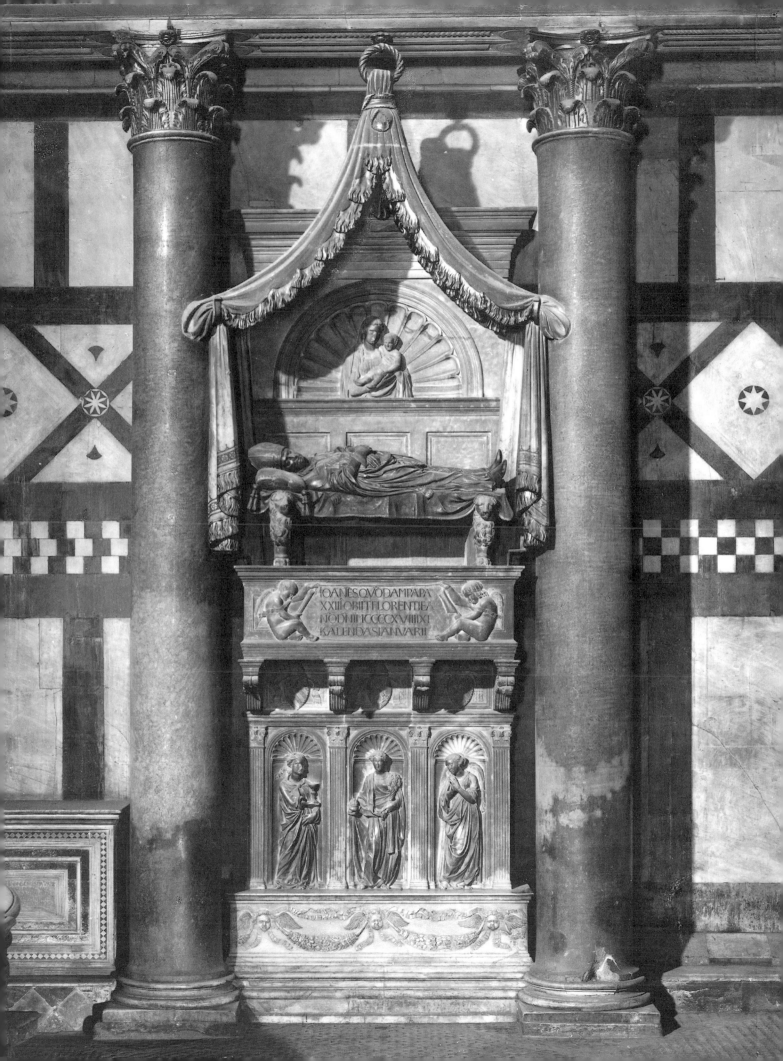

with Florence, however, seems to have held strong, since it was Giovanni di Bicci de'Medici who paid his ransom in 1419, allowing him to return to Florence. Giovanni di Bicci may have considered this a small price to pay for the favours accorded him by Cossa, who had used the Medici bank while he was a cardinal in Bologna and who had established the precedent for the Curia to deal with one banking house at a time, thus paving the way for the Medici to take over papal finances. It seems likely that Giovanni di Bicci's young son, Cosimo de'Medici, had accompanied John XXIII and his retinue to Constance. Baldassare Cossa returned to Florence in June, made peace with the new pope, Martin V, who was in residence at Santa Maria Novella, and died on 22 December 1419. It comes as no surprise that the executors of his will included Giovanni di Bicci de'Medici and Niccolò da Uzzano, one of the leaders of the oligarchy.

The will specified that the estate would pay for the monument and a chapel built for it; the executors needed only to choose a Florentine church. Cossa's intent, however, was obvious since he left to the Florentine Baptistry several relics, including the finger of John the Baptist, and 200 florins to pay for reliquaries. Given the support of the Medici, his one-time military alliance with Florence, and his connections with men like Bruni, even a reputation as black as Baldassare Cossa's could not frustrate his desire to be buried in the most important Florentine church. In 1421 it was decided that the tomb, without a chapel and not protruding enough to obstruct the entrance, could be placed in the Baptistry; the height and magnificence of the resulting monument more than compensated for its restrictions.

Whatever part Donatello may have had in the overall design of the tomb, his most difficult problem must have been the gilded bronze effigy resting on lions that may intentionally recall the *Marzocco* (Fig. 47). As with other Quattrocento portraits, the question arises whether the head is based on a deathmask; practical considerations indicate that Donatello might easily have used such an aid, even though he was likely to have seen Cossa in Florence, and though no trace of a deathmask is evident in the finished portrait. He has tilted the bier upward and turned the head sideways to give a better view of Cossa's face. From the usual viewpoint on the floor of the Baptistry, the face is distinguishable but non-communicative; it is soft, in keeping with the contemporary description of Cossa as a 'stout' man, and the wavy long hairs of the heavy eyebrows are almost indistinguishable from creases in the brow, giving him a look of concern. Close-ups, however, have produced assessments of his face that range from Lightbown's 'robust strength' to Janson's 'heavy-lidded, porcine, yet even in death still twitching with animal energy and animal appetites'. It is tempting to see these interpretations as evidence of Donatello's ability to reproduce in this face the conflicting opinions surrounding Pope John XXIII. In many ways the face is the visual equivalent of the tomb's inscription, IOANNES QUONDAM PAPA XXIII, which so angered Martin V because the ambiguity of 'formerly Pope' could imply that Cossa was Pope when he died.

Baldassare Cossa, opportunist or victim of circumstances, left more to Florence than the relics of St. John the Baptist – although perhaps only later generations have been able to fully appreciate his legacy. His dealings with Giovanni di Bicci established a Medici priority with the Curia and ensured the fortune of that family at a time when Medici fortunes were becoming synonymous with Florentine fortunes. Giovanni's son Cosimo took over the family interests in 1429 on the death of his father; his humanist concerns strengthened the papal connection and vice versa. As George Holmes has said of the close relationship between Florence and the Papacy in the 1430s: 'There were many reasons for their intimacy and Cosimo's position was certainly not the main one, but in a sense he was the most important person in that complex of financial, political and cultural links.'[17] During most of Donatello's

career Cosimo de'Medici was also the most important private patron in Florence, and after his return from exile in 1434, he was probably a rival to, perhaps even the equivalent of, public Communal patronage.

The question of Donatello's relationship to Cosimo is interesting and important, not only for Donatello's career, but for an understanding of the attitude of fifteenth-century Florence toward patronage of the visual arts. According to Vasari, Cosimo held Donatello in such esteem that he kept him constantly employed, and on his deathbed (1464) recommended Donatello to his son Piero, who in turn gave the aged sculptor a farm in Cafaggiolo outside Florence; beset with difficulties and bothered by the trials of rural life, Donatello soon asked Piero to take back the property. Piero laughed and exchanged the farm for a weekly stipend; the sculptor then lived happily as 'servitore ed amico della casa de'Medici' ('servant and friend of the house of the Medici'). Vespasiano da Bisticci, in his life of Cosimo, gives a slightly different cast to the situation by saying that Cosimo, unwilling to see

47. *Effigy of Baldassare Cossa* (detail of Fig. 46). Marble and gilded bronze, length of effigy 213 cm.

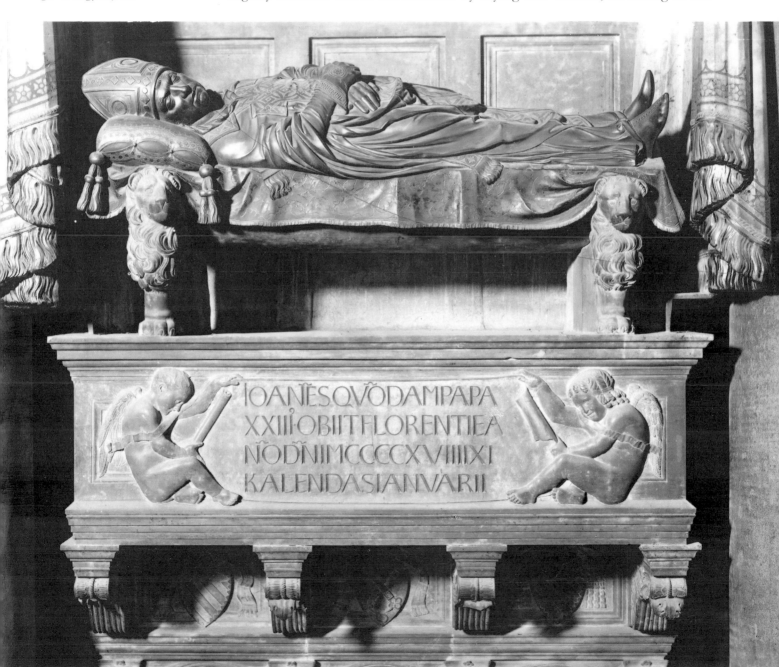

Donatello short of work, set him to work on certain doors and pulpits for San Lorenzo and ordered the bank to pay enough money for the master and four assistants; 'e a questo modo lo mantenne' ('and in this way he supported him').[18] Vespasiano also says that Cosimo himself had an expert's understanding of sculpture, and was a good friend of Donatello's. From these accounts it might be concluded that Cosimo was a true patron of the arts, supporting Donatello in the cause of Art.

As E. H. Gombrich has argued, however, the notion that architecture, sculpture, and painting should be included among areas of learning worthy of support would not have occurred to the early Medici: 'When the Medici first appear in their role as patrons their activity still fits completely into the age-old traditions of communal religious life.'[19] Patronage and good works belonged to the category of things that were not of direct, personal, economic benefit, although they might be of personal spiritual benefit; banking carried the constant accusation of usury, a sin that could, however, be expiated by charitable works. It is in this context that Pope Eugenius IV, according to Vespasiano, told Cosimo to spent 10,000 florins on building, in order to lift 'this weight from his shoulders'.[20]

If Cosimo had not been a humanist, this straightforward and essentially medieval idea would thoroughly explain his actions. By the late 1430s, however, and because of the learned circle in which he moved, Cosimo's actions concerning architecture surely reflected the ideas of Leonardo Bruni and Matteo Palmieri, who considered a city's buildings significant to the quality and dignity of its social life. This attitude is echoed by Luca Landucci, who began his diary with the details of his apprenticeship in 1450, noted the *Catasto* of 1458, and then gave an account of Florence's building activity: 'At this time the lantern of the cupola of Santa Maria del Fiore was begun; and the palace of Cosimo de'Medici, and the churches of San Lorenzo and Santo Spirito, and the Badia on the way to Fiesole.'[21] Only after giving this information, evidence of his civic pride, does Landucci list the famous men alive at the time.

The immense propaganda value of architecture and architectural decoration would not have been lost on the Medici, who wielded patronage in lieu of authority. By the time Cosimo took over the family bank, he had witnessed the sculptural programme taking shape for the Duomo complex (much of it by Donatello) and the niches for Orsanmichele being filled (*St. Mark*, *St. George* and *St. Louis* by Donatello). Cosimo himself had been one of the committee of four involved in the commission of Ghiberti's *St. Matthew* for the bankers' niche. Donatello's reputation was firmly established and, along with numerous smaller commissions in and outside of Florence, he had completed the *Marzocco*, the Cossa Tomb, and was probably at work on the *Dovizia*. It is in this context that the relationship between Donatello and Cosimo should be assessed.

Although Vasari and other older sources often mention the relationship between Donatello and the Medici, no documented Medici commission is known. Payments were made through their branch banks, as for the Brancaccio and Cossa tombs, but not on behalf of the Medici. Only a letter from their agent Giovanni di Luca Rossi to Piero's brother, Giovanni di Cosimo de'Medici, written on 9 October 1455, gives evidence of a monetary link; Rossi gave Donatello three florins as a final payment for 'due Vergine Marie'.[22] The sculptor was unhappy with the payment, but had gone the morning before to Volterra to oversee the marble-work for Giovanni's '*schrittoio*' (either study or desk). Donatello and his companion were paid eight florins for the trip and the Madonnas and marbles were sent to Fiesole, probably for the Medici villa being built near there at this time; the whole matter seems to refer to rather routine work. In spite of the lack of documentation, older sources consistently credit Donatello with work in San Lorenzo; the sculptural decoration in the church is extensive, and seems to have been part of the Medici's

48. Filippo Brunelleschi: The Old Sacristy of San Lorenzo, Florence, 1421–8. View of interior showing sculptural decoration by Donatello (after 1428–*c*.1440). (See also Figs. 72, 73, 87–89, and 99.)

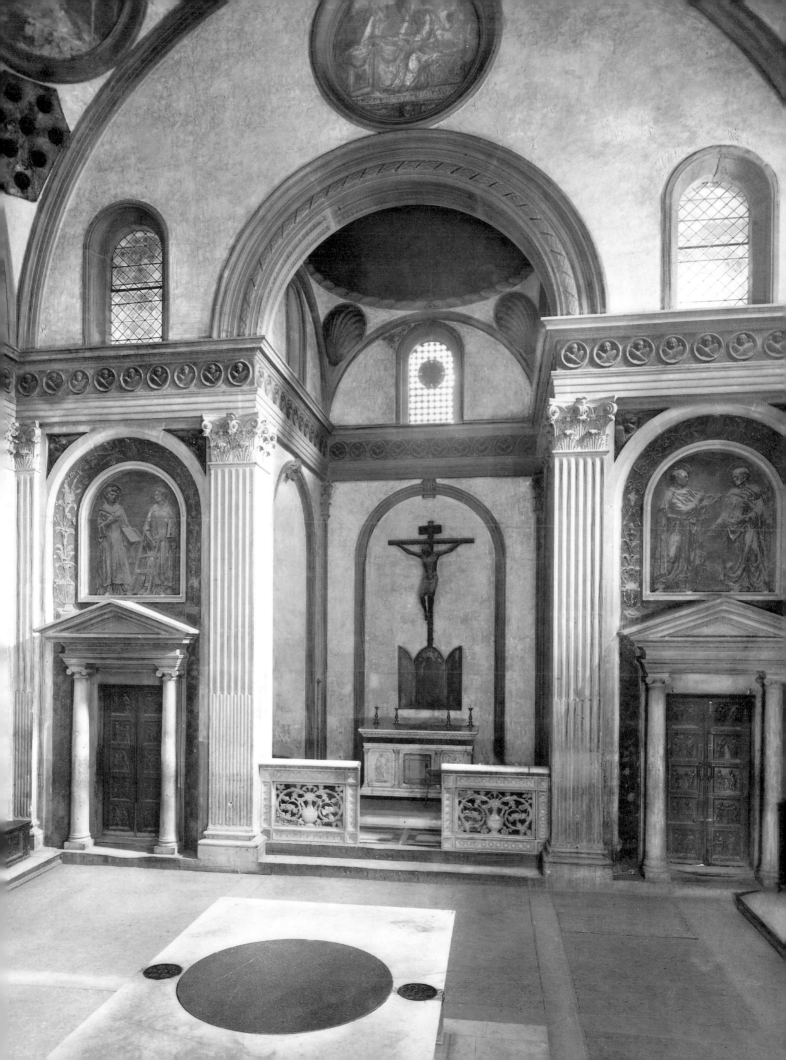

continuing project of refurbishing their local church. Although the end-product may be Medicean, the original idea for rebuilding the church seems to have been the prior's, and the Medici were just one of eight wealthy families pledged to build a chapel. Giovanni di Bicci also undertook to build the sacristy (Fig. 48), which was already vaulted when he died in 1429; the project was then overseen by his son Lorenzo. In 1440 Lorenzo died, and by the following year Cosimo, according to the chapter records of San Lorenzo, began to take a firmer hand than his brother had, while being careful not to seem to have usurped the entire project.[23] Because of economic difficulties the construction went forward fitfully; presumably Cosimo could have overcome the financial problems, but by not doing so he concealed his power. This simultaneously strengthened his control over the frustrated architect Brunelleschi and enabled Cosimo to indulge his own interest in architecture, particularly after Brunelleschi's death in 1446. Given the amount of sculpture by Donatello, or work that is Donatellian in style, and the literary hints at Donatello's stipend or salary from Cosimo, it is possible that the sculptor was part of a similar piece by piece scheme to decorate San Lorenzo, a scheme that played down Cosimo's role but increased his influence.

Although there are no documents concerning Donatello's work for San Lorenzo, modern scholars generally accept as his the pulpit reliefs (Figs. 1–4, 7, 9, 12, 14) and, in the Old Sacristy, the four roundels of the Evangelists on the upper walls, the four scenes of the Life of St. John the Evangelist in the pendentives, the two lunettes over the doors, and the bronze doors themselves (Figs. 72, 73, 87–9, 99).[24] Stylistic considerations and written notices seem to place the construction and decoration of the sacristy in the early 1430s or, at the latest, before Donatello's departure for Padua in the early 1440s. The reliefs of the two bronze pulpits in the nave most likely date after Donatello's Sienese sojourn (although there may have been some planning and execution before then), and the chasing of some of the reliefs was not completed until after his death in 1466.

This list of Donatello's projects is large and diversified, and includes much of the sculptural decoration for San Lorenzo. Beccherucci's recent theory that the relief panels now set up as two pulpits were originally intended for one pulpit, for the high altar, and for Cosimo's tomb, as mentioned by Vasari, would extend Medicean use of Donatello's talents beyond the decoration of the sacristy to a more significant part of the choir and chapels assigned to the family. It is interesting that in Vasari's list of attributions are four large stucco *Saints* (five *braccia*, or about ten feet high), which were in the crossing, and he states that much of the fifteenth-century sculptural decoration is Donatellian in style. The *Cantoria* over the door to the cloister (Fig. 49) is close in design to Donatello's *Cantoria* for the Duomo (Fig. 93). It rests on six consoles and, although it does not have a frieze of putti, it depends for general design on a frame of six pairs of columns set out from the box behind, and a protruding cornice much like that on the Duomo *Cantoria* or, perhaps more relevantly, one of the San Lorenzo pulpits. Its lower quality and generally derivative design preclude an attribution to the master, but this *Cantoria* reflects the work of Donatello's assistants or followers, and certainly an interest in his style.[25]

Similar observations can be made about other decoration in the Old Sacristy, much of which has been at one time or another attributed to Donatello. Most controversial are the porticoes of the bronze doors, and the design and decoration of the wall that unites the doors with the reliefs above; both Manetti and Vasari attribute the porticoes to Donatello, the earlier writer claiming in his biography of Brunelleschi that the architect not only disliked them, but composed sonnets to dissociate himself from them and Donatello. They have been viewed as unsatisfactory disturbances in the Brunelleschian architectural scheme (Fig. 48), and Janson attributes them to Michelozzo on the grounds that they are unlike

49. Workshop of Donatello?: *Cantoria. c.*1460? Marble and mosaic. Florence, San Lorenzo

Donatello's architectural style for the Duomo *Cantoria* and the Santa Croce *Annunciation*, and are certainly unlike Brunelleschi. What has been overlooked, however, is that they do seem calculated to monumentalize the doors and to serve as bases substantial enough to support visually the large reliefs above; in other words, they seem designed with Donatello's work in mind, rather than as partners in Brunelleschi's classicism. Even the egg-and-dart moulding is distinctly different from the same configuration used elsewhere in the sacristy. The stone moulding that runs up the sides of the corner pilasters echoes the arch of the relief at the top and encloses both relief and portico on a wall painted the colour of terracotta and decorated with a raised stucco motif of vase and vine; thus the wall areas on either side of the apse and beneath the frieze are handled as complete entities. The vase and vine motif is repeated in the unusual altar railing, which treats stone as if it were wrought metal, creating a lacy openwork perhaps inspired by Byzantine stone-work; while such irreverence toward a medium is typical of Donatello, work such as an altar railing gives few stylistic clues for an attribution and would almost certainly have been executed by an assistant. The altar, the font, the lavabo and the frieze around the sacristy have been attributed to Donatello, or to his design, and even the marble tomb of Giovanni di Bicci and his wife, Piccarda Bueri, reflects Donatellian motifs and perhaps his design. Regardless of how much of the sculptural decoration is actually by the master, the patrons seem to have made a conscious and conscientious attempt to impose his style on the decoration of San Lorenzo.

Given the implications of this work at San Lorenzo, it is all too easy to be taken in by Vasari's assessment of Donatello's relationship with the Medici: that Cosimo had such great esteem for Donatello's talent that he kept him constantly employed, and that the sculptor would drop everything to come when he was summoned. Vasari himself supplies his evidence. He notes that Donatello restored an antique *Marsyas* placed at the exit from the garden of the Medici palace,[26] and indeed influenced Cosimo's decision to collect antiquities (some restored by Donatello); in the palace he did the courtyard medallions (Fig. 51), placed antique heads in new surrounds over the doors, and made a granite basin fountain; to the Medici collection he added Madonnas in marble and bronze, relief scenes in marble, a bronze head of Cosimo's wife, a bronze crucifix, a bronze Crucifixion and a Passion panel;[27] the bronze *David* came from the palace courtyard. According to Vasari, Cosimo also seems to have recommended Donatello to his friends, and he relates the story of an

ill-fated bronze head for a Genoese merchant, a commission received through Cosimo. He notes the *Cavalcanti Annunciation* and the Brancaccio tomb in Naples, both of which have connections with the Medici; the Cavalcanti were related by marriage, and the account for the Tomb of Rainaldo Brancaccio, the Cardinal who had crowned Pope John XXIII and advised him to go to Florence in 1419, was handled by Cosimo and Lorenzo. Vasari also claims that the *Tomb of Baldassare Cossa* was ordered by Cosimo. As if to point to the long-lasting connection between Donatello and the Medici, Vasari surmises that a marble bust by Donatello in the collection of Guidobaldo, Duke of Urbino, was given to the Duke's ancestors by Giuliano de'Medici.

Vasari's claims, tempting because for the most part they cannot be disproven, are joined by documentary evidence that is just as tantalizing. In their *Catasto* declaration of 1433 Cosimo and Lorenzo note that they have rented an *albergo* (an inn) with two small houses alongside it to Donatello for five florins a year (Fig. 18); as Isabelle Hyman has pointed out, the Medici received fifteen florins a year for the inn alone according to their 1427 and 1430 declarations and thus Donatello's rent was a bargain.[28] It might be possible to discount this as merely a business deal were it not for the discrepancy in rents, and the coincidence that it was not only the early 1430s, when Donatello's work for San Lorenzo probably began, but also that these buildings were on the corner of Via Larga and Via de'Gori where the Medici Palace now stands, and were therefore less than a block from the church. Several of Donatello's patrons used the Medici bank for payments, so that it is difficult at times to ascertain whether they were simply the most reliable bankers, or were more directly involved. One such case, when Cosimo seems to have been more than just a banker, concerned Donatello's dealings with the Prato Cathedral Operai for the *Prato Pulpit*; Cosimo not only sent a letter to Rome in 1433 to persuade Donatello to return to Prato and finish the project, but he also received payment from the Operai for him five years later.[29] It may have been a simple banking matter in 1446 when the Operai of the Florence Cathedral promised Cosimo and his associates that they would pay Donatello what was due him on the *Cantoria* after he cast the sacristy doors, but when Ludovico Gonzaga wrote to Cosimo in 1458 for his help in persuading Donatello to execute the Arca di Sant'Anselmo in Mantua, the connection between Donatello and the Medici seems more personal. Vasari's lists of Donatello's sculpture in the Medici household are reinforced by the family inventory of 1492, which lists a marble relief of the Ascension in a wooden frame, which could easily be that in the Victoria and Albert Museum (Fig. 76), and 'a panel of marble with many figures in low relief and other things in perspective, i.e. . . . of St. John, by Donatello', which seems to describe the *Feast of Herod* at Lille (Fig. 78).[30]

Circumstantial as this link between sculptor and patron is, it has some force because the clues are so pervasive. Two of Donatello's best known works, the *Judith and Holofernes*[31] and the bronze *David*[32] are not only suspiciously without known commissions, but have historical and iconographical connections with the Medici family (Figs. 136, 134). Hans Kauffmann's proposal (revived by Francis Ames-Lewis) that the two statues were part of a programme for the Medici Palace, and were commissioned simultaneously, perhaps strives for too neat a scholarly thesis, but they may, indeed, have conveyed a single theme.

It is known that these two sculptures were together in the Medici Palace at the end of the fifteenth century. The bronze *David* was first mentioned in 1469 in the description of the wedding of Lorenzo il Magnifico; it was then on a column in the centre of the palace courtyard. A marginal note in the *Zibaldone*, added probably in the 1470s, identifies an inscription as 'on the column below the Judith in the Medici Palace'. In 1495, after the Medici were expelled from Florence and their palace sacked, the deliberations of the Signoria note that two bronze statues, a David from

the courtyard, and a Judith from the garden, were to be turned over, along with their pedestals, to the Operai of the Palazzo della Signoria. The fate of the pedestals is unknown, but their general forms can be reconstructed from other early sources. *Judith and Holofernes* was set on a column surmounting a basin, and the whole functioned as a garden fountain; *David* rested on a multi-coloured marble column placed on an openwork bronze and marble base. In the second edition (1568) of the *Vite*, in the *Life of Baccio Bandinelli*, Vasari describes this base as enabling passers-by to 'look from the street entrance right through to the entrance of the second courtyard', in other words, to the garden. This seems to indicate an intention to correlate the statues and make them visible together.

In terms of form, *David* and *Judith and Holofernes* are well-suited for such a pairing. David is slightly smaller in stature, but he is in scale with Judith; both are about life-size. The differences in actual size of the sculptures – *David* is a single figure and lacks the high base – would be minimized in the usual view from the street into the courtyard and then into the garden. Both are also well-designed for such central positions; although *David* is perhaps best comprehended head-on, his laurel-wreath base invites the viewer from any direction; in the *Judith and Holofernes* Donatello's signature is on that edge of the square pillow that corresponds with one side of the triangular base as well as offering a head-on view of Judith, but this coincidence seems to be simply logical rather than to impose a single viewpoint, since other more obvious features of the composition lead the viewer around the statue (see pp. 206–8). When the fountain was playing, water pouring from the regularly spaced spouts into the basin would have tended to equalize all views. Most obviously, but no less important visually, both statues are made of bronze, a material that would stand out in light or shade against the stone of the palace.

In terms of theme, Judith and David are philosophically and historically connected in Florence. Both slew an oppressor of the Chosen People, and here they stand directly on the vanquished enemy, literally trampling evil, a medieval image well-known in earlier Florentine art.[33] In the Renaissance there are several examples of the pairing of David and Judith, including Ghiberti's *Gates of Paradise*, where the border figure next to the narrative panel of *David and Goliath* is Judith holding the head of Holofernes.[34] During the debate over the placing of Michelangelo's *David* in Florence in 1504, Botticelli agreed with Cosimo Rosselli that the statue would best be placed on the steps in front of the Cathedral, but added that a Judith should then be put on the opposite side. Although this pairing was not carried out, it is interesting that Michelangelo's *David* subsequently replaced Donatello's *Judith and Holofernes* on the platform in front of the Palazzo Vecchio.[35]

Given the ideological connection Florentines seem to have made between these two biblical heroes, and given their particular regard for David as a symbol of the victory of justice over tyranny, the political implications of these statues in the Medici Palace could hardly have been incidental to their aesthetic appeal. The inscriptions on the *Judith* while it was in the garden read: 'Kingdoms fall through luxury, cities rise through virtues; behold the neck of pride severed by the hand of humility'; and on the other side, 'Piero Son of Cosimo Medici has dedicated the statue of this woman to that liberty and fortitude bestowed on the republic by the invincible and constant spirit of the citizens'. These images of republican liberty, put forth by the Medici in their avowed role as concerned citizens, would seem to have bridged the gap, or at least clouded the distinction, between the ambitions of the Medici and Florence's ideal of self-rule. The Medici controlled the city, and after the completion of the palace in the 1450s many of the affairs of the Republic were settled at meetings at the Palazzo Medici, rather than at the Palazzo della Signoria. In addition to the *David* and *Judith and Holofernes* there were in the interior of the Palace three huge canvases representing the Labours of Hercules, and a small

bronze of Hercules and Antaeus, all by Antonio Pollaiuolo. Hercules was also recognized as a tyrant slayer and defender of liberty symbolically applicable to the Florentine political situation.[36] Although much was lost when the palace was sacked in 1494, these few pieces seem to indicate a comprehensive and co-ordinated statement by the Medici of the continuation and preservation of political values dear to the Florentines. Since the Medici were in reality controlling the government, it seems likely that the figures were meant to serve as propaganda, publicly asserting those principles of republicanism the Medici were covertly eroding.

It was also at the Palazzo Medici that important foreign visitors, for example Galeazzo Maria Sforza and Sigismondo Malatesta, were lodged and entertained, and it is probably safe to assume that their hosts were eager to impress these ideas upon such foreigners as well as upon Florentines. It is also possible that *David* and *Judith and Holofernes* might have served to threaten or to guard. Certainly Judith, with her sword held high and her gaze directed toward the courtyard, would have seemed to menace anyone entering the garden. In the 1504 discussion of the placing of Michelangelo's *David* she was mentioned as a 'deadly sign'. Both she and the bronze *David* might easily have been perceived as warnings to those who would threaten the Medici.

When Donatello's marble *David* was transferred from the Cathedral workshop to the Palazzo della Signoria in 1416, the act was a premeditated choice of a work of art as a political symbol for which an appropriate setting was prepared. It is not totally clear that this was the case when *Judith and Holofernes* and *David*, along with Pollaiuolo's three large Hercules paintings, were ordered to be consigned to the Palazzo della Signoria on 9 October 1495. Luca Landucci reports that through the spring of 1495 the threat of the return of the French King, Charles VIII, who had occupied the Medici Palace when the family was expelled in 1494, hung over Florence; the French occupation of the year before must have left a great sense of dread, since Landucci several times notes the rumour that the King had promised his troops that they could sack the city. Whether by coincidence or not, just when the tide began to turn against the French army in Italy in 1495 Landucci reports that Piero de'Medici's household effects and clothes were sold by auction in Orsanmichele; he writes on 9 July that this took several days. On 11 August he notes that 'all these days' they were selling Piero's things – velvet counterpanes, paintings and pictures; again on 14 November: 'All this time Piero's effects were being sold by auction.'[37] On 9 December *David* was set up in the courtyard of the Palazzo della Signoria and on 21 December the *Judith and Holofernes* was installed on the platform in front of the Palazzo with a new inscription 'Placed by the Citizens as an Example of Public Health'. The Florentines had rid themselves of the French as well as of the Medici.

One can imagine that it would have been difficult to find a bidder who could afford bronze statues such as these, and even more difficult to find one who could comfortably adopt their symbolic baggage. The Medici sale was underway for three months before they were consigned to the Palazzo della Signoria, and two more months before they were installed. *Judith and Holofernes* was given a new dedication, and, in 1498, *David* acquired four civic coats-of-arms on its pedestal. The Medici connection, however, does not seem to have been easily broken, and although the statues could have been emblems of the republican ideals of Florence, it is not clear that they were readily accepted. Francesco the Herald, first speaker on the question of where to place Michelangelo's *David* in 1504, thought that it should replace one of Donatello's two statues, more appropriately the *Judith*, 'a deadly sign and inappropriate in this place because our symbol is the cross as well as the lily, and it is not fitting that the woman should slay the man, and, worst of all, it was placed in its position under an evil constellation.' His argument, unlike the others, had nothing

50. Detail of *David* (Fig. 134).
*c.*1446–*c.*1460. Bronze

to do with aesthetics or practicality; it was his conviction that Judith was not a proper symbol. After a decade in the Palazzo della Signoria, both of these statues still seem to have recalled their previous owners.

Detail of Fig. 7

It is tempting to speculate why the bronze *David* and *Judith and Holofernes* would not suit Communal symbolism. In both works Donatello has chosen to emphasize not simple power, or the unquestioned victory of the mythic hero, but rather the complexity and contemplative attitude of the individual. These are profoundly personal interpretations, and their arrogant gazes (Figs. 50, 137) would seem to have ironically undermined the ostensibly democratic meaning. Francesco the Herald's objection to *David* could easily have been its lack of forcefulness, and the lack of allusion to the actual act of killing Goliath, which characterized David's identification with Hercules and thus with the *virtù* of the Florentine republic.

Although it is far from clear that either the bronze *David* or the *Judith and Holofernes* was commissioned specifically by the Medici for their palace, certain aspects of the iconography of the *David* support the idea of Medicean patronage. The bay or laurel leaves, which appear in relatively stylized form on the wreath at the base, and in a more naturalistic manner decorating the hat of the figure, are associated with the name Lorenzo, the Italian word for laurel being *lauro*. Frederick Hartt has connected this with the plant of the Medici patron saint, Lawrence, and the laurel is known as an heraldic device both of the family and of Lorenzo il Magnifico in particular; Saul Levine has even suggested that Donatello's bronze *David* might be a personal device of Cosimo, referring to the *pater patriae*'s personal triumph over his enemies when he returned from exile in 1434. Francis Ames-Lewis champions Piero, Cosimo's son, as the patron.[38] Also, the reproduction on Goliath's helmet of the design from a classical cameo later acquired by the Medici family enriches the symbolism of the statue in a manner most appropriate to Marsilio Ficino's intellectual circle, and therefore to the Medici.

Another argument in support of such a commission is that the *David* certainly fits well – iconographically and visually – in the courtyard of the Medici Palace (Fig. 51). A figure on a column in the middle of a private palace courtyard is without

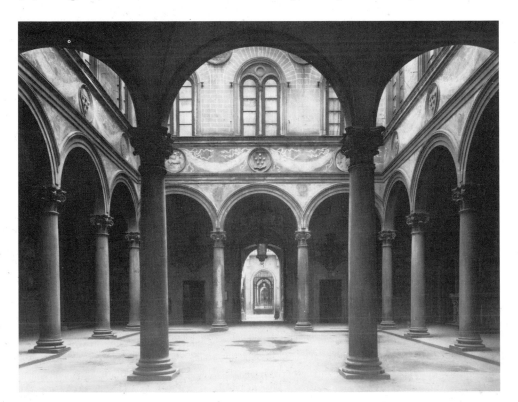

51. Michelozzo: Courtyard of the Medici Palace. 1446–*c*.1452. View towards the entrance

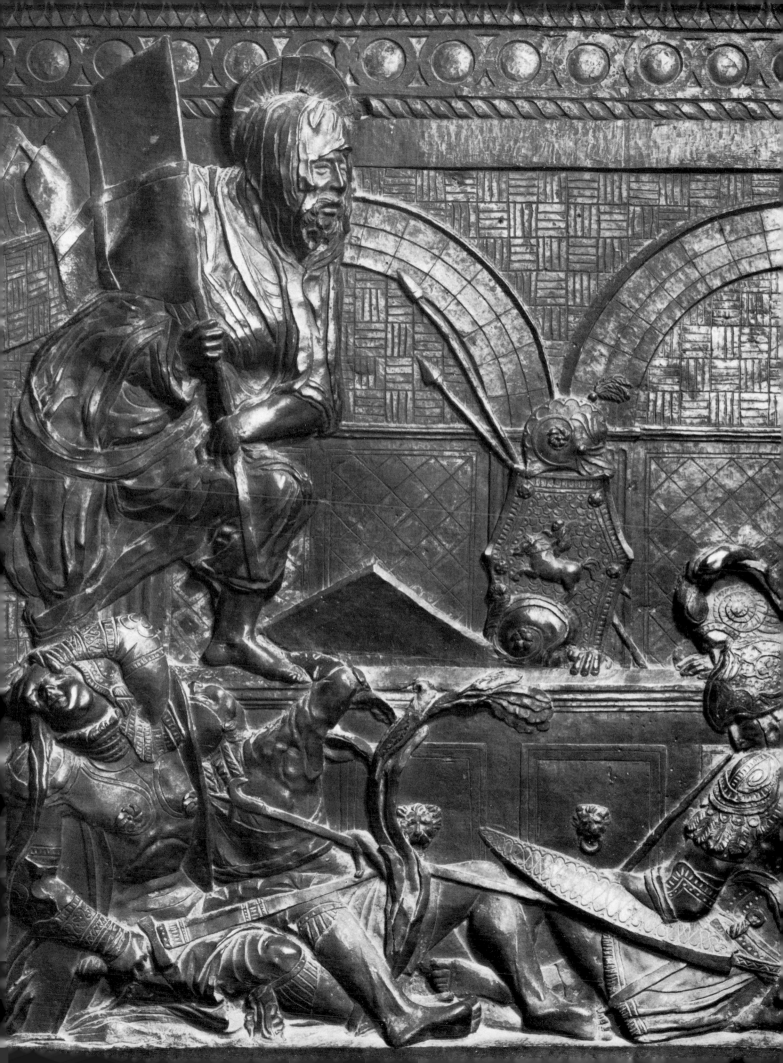

known precedent in Florentine art, but the palace itself, in its conception and planning, is equally without precedent. Isabelle Hyman's research has demonstrated that this centrally planned palace, with its elegantly colonnaded *cortile*, was a new departure in Florentine palace design, inspired, at least in part, by those writings of Vitruvius that stress the importance of the atrium or peristyle court in a Roman house; her rhetorical conclusion concerning the relationship between the statue of David and the *cortile* is particularly apt: 'Is it a coincidence that the first really classical statue of the Renaissance occupied a prominent place in the first really classical architectural enclosure?'[39] The repeated, rounded forms of the *cortile* – columns, arcade, window design, and medallions and garlands of the frieze – all echo the circular wreath of the *David*'s base and the figure's undulating and rounded forms.

The position of the *David* on top of a column in the courtyard would also explain the statue's contradictions in viewpoint. The figure is certainly meant to be seen from below, but this makes it impossible to see the relief on the helmet of Goliath (Fig. 135), which is obviously important for the iconography, and which was inspired by the same ancient cameo as one of the *cortile* medallions. In the Medici *cortile*, however, raised on a column, the putti triumph could easily have been seen from the windows of the *piano nobile* or from the loggia. The peculiar, simplified technique of the relief, with forms lacking a great deal of internal detail and silhouetted against a rough ground, is well-suited, if not calculated, for such a distant viewpoint.

The *Judith and Holofernes* provides fewer formal references to its original location, yet satisfies the conditions necessary for a garden sculpture by being conceived in the round. Documentary evidence for its original commissioning by the Medici is circumstantial and contradictory, but Hartt's theory, supported by Pope-Hennessy, seems most reasonable in assuming that payments in the Cambini account books to Donatello, and by Donatello to Bartolommeo di Paolo Serragli, for bronze, iron, wax, pitch, charcoal and wood in 1456, refer to work on the *Judith*. Only eight years later the statue is noted as being in the garden. This could be one more example of Medici fastidiousness in keeping references to artistic commissions out of business and family accounts, since Serragli, one of the earliest known dealers in art, was an agent for the Medici supplying ancient works from Rome and modern palace and villa decorations in Florence. Another, incidental connection to the Medici has been pointed out by Saul Levine, who sees a close resemblance between Judith's features and those of Lucrezia Tornabuoni, Piero de'Medici's wife. And Hartt has noted that the most likely source for an interpretation of the lost inscription identifying the *Judith and Holofernes* as Humilitas (humility) cutting down Superbia (pride) is the *Summa* of Sant'Antonino, a copy of which was in Cosimo de'Medici's library.[40]

Judith and Holofernes and *David*, then, would seem to have functioned well, aesthetically and symbolically, in the Medici palace. It is likely that they were commissioned by the Medici from Donatello, but knowing whether they were commissioned at one time and as part of a preconceived programme is complicated by their dating. Cosimo's intention to build the palace was first evident in 1443, and construction began in 1446. Janson's dating of about 1460 for the *Judith and Holofernes* is generally accepted on the basis of style and technique; the group could easily, therefore, have been specifically intended for the Medici garden. His analysis suggests a stylistic gulf between this statue and the *David* that would preclude their being commissioned at or about the same time, a contrast exaggerated by the present poor surface condition of the *Judith and Holofernes*. Ames-Lewis, who denies the validity of stylistic development as a dating tool in this case, champions a date of about 1460 for the *David* on the basis of the history of the cameo used for the helmet relief, and Piero de'Medici's special interest in the theme of the Victorious David.

Plate III. Dancing Putti. Detail of the *Cantoria* (Fig. 93). 1433–9. Marble, with gold and coloured marble inlay.

89

Purely stylistic considerations, and comparisons to Donatello's style of the early 1430s, originally led Janson to propose an early date, about 1430–2, for the *David*; this was generally accepted, with the implication that the figure could not have been originally commissioned for the Medici *cortile*.

Recently, however, Janson has argued for an even earlier date of about 1425, suggesting that the work was a Communal commission during the worst years of the Florentine conflict with Filippo Maria Visconti.[41] The proposal is based on the absence of a finial on Goliath's helmet and an iconographic interpretation of the statue as a victorious Florentine David resting his foot on a Ghibelline winged helmet originally surmounted by Filippo Maria's personal emblem of a serpent devouring a child. Such a reading may be correct, but does not in itself necessitate a date in the 1420s; this dating is primarily the result of stylistic comparison to the putti from the Siena font (Fig. 36). Although open conflict between Florence and Milan ended in 1428, the threats did not, and, as one might imagine, the situation also involved the Medici.

Rather than the *David*'s being simply a Communal statement against Milan, there seems to be sufficient evidence for its carrying a similar message from Cosimo de'Medici. When the election of pro-Medicean officials in 1434 drove Rinaldo degli Albizzi from Florence, he sought support from Filippo Maria and his *condottieri* in the hope of overthrowing Cosimo. It was not until 1440 that Rinaldo received such support; but the Milanese defeat at the subsequent Battle of Anghiari was not only a loss for Filippo Maria and his *condottiere* Piccinino, but also marked the end of the Albizzi threat to the Medici. Ridding himself of the powerful family that had long controlled the Florentine government might easily have been an occasion Cosimo would have wished to commemorate; he would find a perfect parallel in Florence's routing of the Milanese forces, and a perfect commemoration in the acceptable image of David, already well-known as a symbol of Florentine liberty. The victory at Anghiari did not free Florence from the threat of Milan, however, and the situation became worse as it was realized that since Filippo Maria had only an illegitimate daughter as successor, Venice might easily absorb the Milanese duchy and become an even more formidable force in the northern part of the peninsula. The other contender for Milanese power was the *condottiere* Francesco Sforza who, for his continued support of Filippo Maria, had demanded and won marriage to the Duke's daughter in 1441. Knowing it was the lesser of two evils, Cosimo made the unpopular move of subsidizing Sforza with Florentine funds until he emerged as Duke of Milan from the three-year struggle following Filippo Maria Visconti's death in 1447. More obliquely, but as aptly, the *David* could have signified this Medici/Florentine triumph, and have been a suitable and relevant commission for Cosimo in the 1440s or 1450s and therefore for the Medici palace *cortile*.

As Donatello's career is reconstructed, either by Vasari, or from literary and documentary accounts discovered by modern art historians, the Medici name appears with greater frequency as the sculptor advances in age. Categories of patronage become more difficult to discern as the private interests of the Medici family merge with civic, political, and social interests. Perhaps nowhere is the pervasiveness of Cosimo seen so clearly as in the commissioning of the *Equestrian Monument to Gattamelata*, the memorial to the *condottiere* Erasmo da Narni, in Padua (Fig. 52).[42] Just as the specific sources of Medici control in Florentine government were difficult to pin-point, the connection between Cosimo and Donatello's foreign sojourn is vague; still, tantalizing hints occur. Two major issues surrounding the statue raise the Medici name in a search for answers; one concerns the reason for Donatello's sudden departure for Padua, the other how and why the monument acquired its revolutionary combination of iconography and form.

Documents concerning Donatello's work and whereabouts all but disappear by

52. *Equestrian monument of Gattamelata (Erasmo da Narni)*. *c.*1445–53. Bronze, marble, and limestone, height of horse and rider about 340 cm. Padua, Piazza di Sant'Antonio. (See also Figs. 66 and 105.)

1440. In 1439 the Opera del Duomo of Florence bought 367 pounds of bronze and brass for the sacristy doors that were to be executed by him, and 300 (pounds?) of bronze for a second head for the *Cantoria*. In 1440 he received a hundred florins on his account for the *Cantoria*; the next notice of him is in Padua when he received a payment in January 1444, in connection with the bronze *Crucifix* for the Santo. In leaving Florence Donatello was abandoning what would seem a choice commission for the sacristy doors in the Duomo, as well as interrupting his work in San Lorenzo, which he resumed nearly twenty years later with the pulpit reliefs. Vasari claims that the Signoria of Venice, hearing of Donatello's fame, sent for him to make the monument to Gattamelata, who had died on 16 January 1443. Janson, on the basis of the relatively small commission for the *Crucifix*, which could in any case have been sent from Florence, argues that it probably was the equestrian statue that lured Donatello north, and that Gattamelata's heirs probably chose the sculptor either on the recommendation of the Florentine exile, Palla Strozzi, in Padua, or on the relatively new reputation of Florentine artists for equestrian figures, established by the commission in 1441 of the Ferrarese monument to Niccolò d'Este. Although the tradition is strong that the Gattamelata monument was commissioned by the Venetian Senate, as the epitaph on the *condottiere*'s tomb inside the Santo states, and another epitaph by Ciriaco of Ancona reiterates, payments to Donatello were made by Gattamelata's heirs through Onofrio di Palla Strozzi; the financial evidence, therefore, is not linked to the Venetian state, but rather to Florence.

Erasmo da Narni, himself, was no stranger to Florence, nor to Cosimo de'Medici. Alessandro Parronchi has brought to light five letters dating from 1435 to 1439 from Gattamelata, and a sixth from his heirs, asking Cosimo for help in various situations. Cosimo is addressed as 'tanquam frater honorande' then 'tanquam pater honorande' ('as if an honoured brother', 'as if an honoured father'), seeming to indicate that the two had a more personal relationship than that occasioned by military service, or by Gattamelata's visits to Florence with his superior, Braccio da Montone, who was also under military contract to Florence.

Although the circumstances that led to this personal relationship are unknown, the actions of Cosimo and Gattamelata during the year of 1433 to 1434 are intriguingly interrelated. During the same period as Cosimo was in exile in Venice, Gattamelata was hired by the Venetian Republic as head of their troops and faced Piccinino and the Milanese forces at Castel Bolognese in August 1434: Gattamelata was defeated, and wounded. This Venetian defeat had both foreign and domestic import for Florence since an increase in Milanese authority or territory was seen as a great threat to Florentine liberty. Florentine reaction to the Milanese victory was decisive and swift. The situation could not be trusted to the incompetent Rinaldo degli Albizzi, who was then in power but whose military reputation was still suffering from the Florentine rout at Lucca. The election of October 1434, therefore, brought about the restoration of Medici sympathizers to the government and the return of Cosimo de'Medici from Venice. Gattamelata, intentionally or unintentionally, was serving Cosimo's interests while in the employ of Venice.

The great honour paid to Erasmo da Narni by the commissioning of the equestrian monument seems to have been the result of his rare attributes of loyalty and trustworthiness, which are mentioned in letters and epitaphs, since he was not often victorious on the field. Janson cites a satire from about 1455, *Urbis Romae ad Venetias Epistolion*, which mocks the Venetians for honouring Gattamelata in the way that not even the ancient Romans were: that is, with a statue of himself and the horse on which he fled. Again one wonders whether the debt of gratitude to Gattamelata was not Florence's (or Cosimo's), more than Venice's.

In this context of Florence's relations with Venice and Milan, it is interesting that the Medici inventory of 1492 includes 'uno colmo di braccia 2½ chon dua teste al

naturale, cio Francesco Sforza et Ghathamelata, di mano d'uno da Vinegia' ('a *colmo* 2½ *braccia* tall with two portrait heads of Francesco Sforza and Gattamelata from the hand of a Venetian').[43] The term *colmo* was applied to a semicircular relief of wood or marble placed over a doorway; since this rather large panel is not valued at very much in comparison with other works, it was probably made of wood. In any case, the work commemorated Sforza, who defeated Filippo Maria Visconti and Piccinino in their alliance with Rinaldo degli Albizzi, and Gattamelata, whose earlier defeat at the hands of Piccinino had helped lead to Cosimo's return to power.

Another connection between Gattamelata and the Medici, noted by Alessandro Parronchi, involves the inventory of votive offerings in the chapel at Santissima Annunziata, Florence, which lists in 1441 and 1468 a silver image of 'gatta malata' on horseback; the 1468 entry immediately follows votives for Piero de'Medici's wife Lucrezia and his son Lorenzo. Giulia Brunetti has discovered the precise date of the offering for Gattamelata, 5 February 1441, probably indicating that it was occasioned by the *condottiere*'s second stroke in 1440. One wonders who paid for it, and whether this equestrian statuette might in some way have prefigured the monumental bronze. Speculation increases with the document recording a small payment to Donatello for work for the chapel in 1461, and the fact that the votive changed in weight from fourteen pounds in 1441 to nine pounds, eight ounces, in 1468. Given the connections between Cosimo and Gattamelata, and the relationship between Donatello and the Medici, it is quite possible that Donatello might have travelled to Padua at Cosimo's request.

Even the image itself recalls Florence, though it is a unique and new mixture of antique and modern elements (see pp. 176–83 for detailed discussion of the sources and iconography). Equestrian monuments in the north seem to have been confined to rulers, while in Tuscany there was a long tradition of publicly commemorating *condottieri*. Although the painted images of Sir John Hawkwood by Paolo Uccello, and the later Niccolò da Tolentino (1456) by Andrea del Castagno are the first to come to mind in Florence, there were earlier examples of sculpted equestrian memorials. A wooden statue was erected for Piero Farnese in the Duomo in the fourteenth century, and the original plans in 1393 for Sir John Hawkwood were for a marble monument, 'ornari lapidibus et figuris marmoriis'.[44] The latter was ultimately painted, but Uccello was instructed to fresco the image *de terra viridi*, presumably to resemble the patina of bronze.

The most obvious political association for an equestrian statue in Padua would be with the bronze Horses of San Marco (Fig. 53), which were as evocative for the Venetian republic as the lily was for Florence. As has been pointed out, the ancient horses, themselves trophies of war brought back from Constantinople in 1204, had become identified with Venetian power and civic pride. When Venetian ambassadors had sought to make peace with Padua in 1379, for example, the Paduan representative explicitly referred to the Horses as a symbol of the political aspirations and attitudes of the Venetians: 'You will never have peace from the lord of Padua . . . until we first put bridles on those unreined horses of yours which stand on the royal house of your Evangelist, Saint Mark.'[45] Padua came under Venetian control in 1405 and, no matter who commissioned the *Monument to Gattamelata*, it could not have been erected without the approval of the Venetian Senate. In general form Gattamelata's horse recalled the Venetian symbols on San Marco, signifying that Venetian power was not only still unbridled, but had come to Padua.

Such a political connection was undoubtedly intended, but it is interesting that whatever model Donatello might have used for Gattamelata's horse, its head is closer to two antique horse heads connected with the Medici, than it is to the heads of the Venetian Horses. Rather than sharing the latters' free and prancing nobility, Gattamelata's horse shows the tension of reined-in power; teeth are bared, veins

bulge in the muzzle, the skin on the neck wrinkles tightly and the eyelids arch in strain and wariness. These same characteristics are seen in the bronze head now in the Museo Archeologico, Florence; it was among the things confiscated in 1495 from the Medici Palace, where it had served as a fountain and where Donatello could easily have seen it (Fig. 54). The other head, offering the same formal comparison and with an equally intriguing history, is now in the Museo Nazionale, Naples, but came originally from the collection of Count Matalone in Naples. Vasari reports that in the Count's house was 'a horse's head by Donatello which many believed to be antique'; Milanesi notes that among the Medici private papers is a letter from the Count, written from Naples in 1471, thanking Lorenzo il Magnifico for the gift of a bronze horse's head.[46] Although it is generally agreed that the head is indeed antique, and not by Donatello, the coincidence of Donatello, the Medici, and the Gattamelata recurs.

Whatever the circumstances of the commissioning of the *Equestrian Monument to Gattamelata*, the sculpture was intended to convey a political message, above and beyond being a memorial to Erasmo da Narni. Its content might range from an assertion of Venetian military power to Cosimo de'Medici's respectful intervention; at a time when the cry of '*Palle!*' – a pro-Medicean reference to the balls on the Medici coat-of-arms (see Figs. 48, 51) – raised political passions, it can hardly have gone unnoticed that Gattamelata's horse is poised with one hoof on a ball. Even though it may be difficult to reconstruct the specific iconography, and impossible to recall the visual associations, there can be little doubt that the monument is an example of *statua* as Leonardo Bruni and Alberti defined it; it alludes to history and important ideals, and beautifies and dignifies the city.

Donatello's known *œuvre* seems to have an inordinately high percentage of

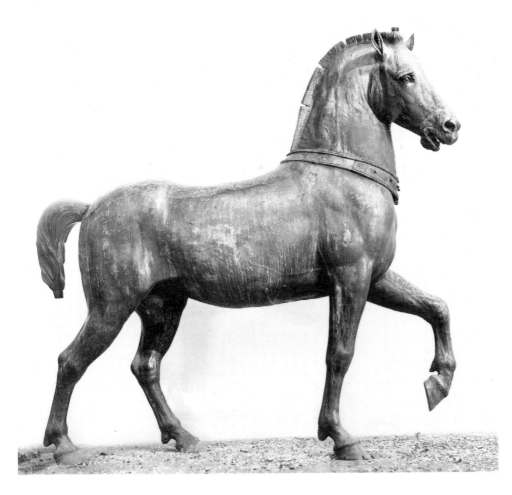

53. *Horse*, from a Quadriga. Roman, third century AD? Bronze, with gilding, height 233 cm. Venice, San Marco

sculpture with implications for the contemporary political situation. Some works, such as the decoration for San Lorenzo, are simply examples of a talented artist working for the politically most powerful family in Florence; others, such as the *Marzocco* or the marble *David*, are straightforward civic symbols. But some of the iconographically most complex images of the Quattrocento have come from Donatello's hand as well. Yet, unlike many of Botticelli's paintings, for example, which were dismissed as decorative until their recondite intellectual keys were discovered, Donatello's sculptures have consistently been seen as powerful. The difficulty of their interpretation has been perceived as a function of their relevance to ideas and events obscured by intervening time; Donatello has not allowed us the possibility of labelling the bronze *David* frivolous.

It is tempting to see this intense relationship between Donatello's art and contemporary history as the result of the sculptor's own intellectual force and personal vision. In some ways, this is true; in others, Donatello was simply taking full advantage of the intellectual atmosphere and the possibilities offered for sculpture by the very concept of *statua*, the political needs of the Florentine republic, and the more subtle insinuations of the Medici. His statues both reflected and projected power. It is not surprising, then, that an anonymous early sixteenth-century biographer of Savonarola made Donatello's name synonymous with 'important sculptor' as he described the famous burning of vanities at *carnevale*; on one hand 'antique sculpted figures of beautiful women, Roman and Florentine, by great masters of portrait sculpture, such as Donatello' were being burned, while on the other, a solemn procession continued around the city led by youths carrying a statue of the Christ Child on a golden base: 'It was of a stupendous beauty, made by that great sculptor Donatello.'[47]

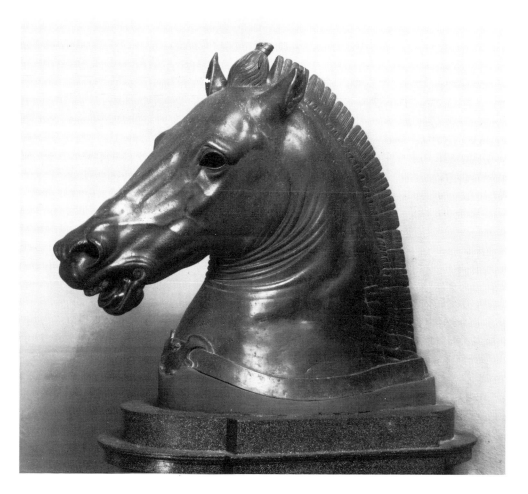

54. *Horse's Head*. Greek, Late Hellenistic. Bronze, life size. Florence, Museo Archeologico

CHAPTER FOUR

Technical Expertise and Innovation

On 27 August 1456, Donato, called Donatello, the singular and outstanding master of bronze, wood, and terracotta figures who made the large male statue above a chapel over the portal of Santa Reparata toward the Servi and had begun a companion figure nine braccia tall, generously presented me, in consideration of the medical care I had been giving him, with a bronze roundel the size of a trencher on which was sculpted the Virgin Mary with the Child at her neck, flanked by two angels; the other side is hollowed so that molten glass can be cast in it to make the same figures as those on the other side.

> Giovanni Chellini, *Libro debitori creditori e ricordanze*.[1]

Donatello's genius for iconographic and formal invention, combined with his foresight and intelligence in adapting to a relatively new taste and interest in antiquity as well as to problems of perspective, readily testify to his stature as a Renaissance artist. Less easily recognized, but perhaps equally important for an understanding of his career, is the originality and adventurousness with which he chose and worked his materials. No doubt some of these choices were made by the patron but, particularly in the case of unusual media or techniques, Donatello's exploitation of the materials seems concerned with their aesthetic expressiveness; the traditional concerns of the patron for practicality or ostentation become less important. A prime example is the bronze *David* (Fig. 134); long before the peculiarities of David's dress are noted, and certainly before the patronage is debated, the viewer is struck by the bronze itself. Usually such attention has to do with a sculptor's virtuosity, or with a particularly tactile evocation of the thing presented, but the refined finish on the limbs of the bronze *David* evokes more than human flesh. Donatello has emphasized the strength of the medium itself, and the viewer, in turn, imparts this to David, who would otherwise stand a frail and ineffectual figure. What a different conception both aesthetically and icononographically *David* would have been in the less mercurial and more straightforward medium of stone.

It could be argued that a good sculptor will choose and use his medium with care and with his specific subject in mind, and that it is a twentieth-century interest in the abstract quality of materials that draws attention to Donatello's technique. No doubt this is partly true, but, beginning with his contemporaries, writers on art or on Donatello have cited his technique, or used him as an example of technical proficiency or of negligence. No other fifteenth-century sculptor has been both so applauded and attacked. In a case that seems obviously apocryphal, since Donatello would have been in his early teens, Vasari claims, in his *Life of Brunelleschi*, that

Donatello took part in the 1401 competition for the bronze doors of the Baptistry in Florence; he does not leave it at that, but adds what was apparently the expected thing to say about the sculptor: Donatello's panel did not win because, although the idea was good, the execution was poor. When such historical criticism is levelled at extant works, it is possible to understand, if not agree with, what was new and annoying to fifteenth- and sixteenth-century sensibilities.

Donatello's long and full career also offers a wealth of information about fifteenth-century working methods, some traditional and others peculiar to Donatello and the Renaissance. He worked with other masters as partners, with assistants, apprentices, and other craftsmen from whom he commissioned work. He was sometimes salaried, and at other times not paid until the work was completed and appraised. Unusually complete records, such as those for the altar in Padua and the pulpit in Prato, give a glimpse of comparative costs and working times, not to mention how much wine and food the appraisers in Prato consumed.[2]

Some basic information remains unknown simply because it was basic and not worth recording or preserving; this is certainly true of Donatello's use of drawings, either as preliminary sketches for the conception of a project, or as a form to communicate an idea to his shop or his patron. Vasari claims to have owned drawings by Donatello, and Pomponius Gauricus, in *De sculptura*, recounts an anecdote about Donatello's great speed and deftness as a draughtsman, but only one drawing has been reasonably connected with him, the *Massacre of the Innocents* with a

55. Attributed to Donatello: *The Massacre of the Innocents* (drawn over a lightly-sketched tabernacle). 1430s–1450s. Metalpoint and pen-and-ink, 28.6 × 20.2 cm. Rennes, Musée des Beaux-Arts

David on the reverse, which is now in Rennes (Fig. 55).[3] The rapid strokes and treatment do recall Donatello's style as it is known in sculpture, but because there are no finished sculptures related to the drawings the attribution must remain tentative. Drawings might provide a means for evaluating workshop production, and perhaps even for understanding whether his hurried or cursory treatment of the finish in many of his bronzes (and some marbles) was part of the original conception or – in what would seem a totally twentieth-century notion – whether the resulting sculpture was subject to the accidents of casting and the possibility of being 'finished' whenever Donatello so chose.[4]

There is documentary evidence, however, that he often produced models, and, since most surviving documents are concerned with money, these seem to have been primarily exhibition or sample pieces for the patron. In 1450 he made a model for a reliquary bust of Sant'Anselmo commissioned by Ludovico Gonzaga of Mantua (the work was never executed), and one of the early documents for the *Prato Pulpit*, 14 July 1428, stipulates that Donatello and Michelozzo must follow the model they had made and deposited in the sacristy. In 1450 Donatello sued a Paduan rag dealer named Petruccio da Firenze, for whom he had made a wood and wax model for a *capella* to be erected by a confraternity in Venice; Petruccio had never paid him for what Janson is probably correct in calling a speculation in the art market rather than a personal commission.

The Operai of Florence Cathedral seem to have been particularly concerned with ensuring that that they would receive the best possible results, and did so by arranging competitions or paying for trial pieces. Donatello was often involved with producing such models under a variety of circumstances. In 1415 he and Brunelleschi made a marble figure (now lost) covered with gilded lead to be used as an example for those to be put on the *sproni* of the Cathedral (see p. 194); in this case the figure does not seem to have been a model for a specific commission, and this strange medium must have been a trial solution to a technical problem. In the 1434 competition with Luca della Robbia for the head for the '*gula*' of the Duomo, both sculptors made clay models for the one to be made in stone; Luca seems to have always made full-size models in clay (as he did for his *Cantoria*), but such evidence is unknown for Donatello.[5] When the Operai decided to employ Donatello in February 1437 to make two sets of bronze doors for the sacristies, he was under obligation to follow a model that existed in early 1437; he received the large payment of 250 florins in March, the same month the contract was drawn up. The next year he made a wax model for the altar of St. Paul in the Duomo; whether the commission for the altar itself was originally his is uncertain, but a surviving contract states that Luca della Robbia was required to use Donatello's model for his execution of the same altar. Unfortunately, the altar was never completed. Unlike drawings, these models had little chance of survival, primarily because they seem to have been made from relatively impermanent materials such as wood or wax. It is also possible that they were sketches, which would presumably have lowered their aesthetic value to a patron. The marble core of the figure by Donatello and Brunelleschi would certainly have lasted, but it probably was simply a core and had only the general shape of the statue. There is, however, one possible extant model.

From late 1457 to at least 1459 Donatello was at work in Siena on a set of bronze doors for the Sienese Cathedral. An inventory of the Cathedral workshop in 1467 lists 'two panels with wax figures by Donatello for the doors', and an inventory of 1639 notes 'a bronze demonstration panel three-quarters of a *braccio* in size'. These dimensions are matched by a strange bronze relief of the *Lamentation* by Donatello in the Victoria and Albert Museum, London; the background has been totally cut away above and behind the figures, leaving the group isolated in its grief (Fig. 56).[6]

Kauffmann was the first to suggest that this might be a trial piece for the doors;

he was followed by Middeldorf, who demonstrated that the ground was cut away after casting, and Janson, who elaborated on this argument. The relief could easily be a model or trial piece, since the drapery shows many of the characteristics of the original tool gouges in the wax, and the arms and legs in particular show the fluid quality of wax smoothed with a finger. It has generally been argued that the ground was cut away to compensate for, or to play down, a poor casting that left the ground and some of the drapery riddled with holes – hardly a good advertisement for Donatello's finished product. Janson has suggested that, unlike the *Feast of Herod* and the *John the Baptist*, the *Lamentation* was cast by local and untried bronze founders. Given the evidence of Donatello's other bronzes, which were often patched and sometimes left with holes, as well as the fact that the relief works exceedingly well without a background, so well that to imagine one is to detract from the impact of the low relief,[7] it seems reasonable to wonder whether the sculptor might not have intended this result. Even the idea that it was made 'per

56. *The Lamentation.* 1457–9? Bronze, 33.5 × 41.5 cm. London, Victoria and Albert Museum

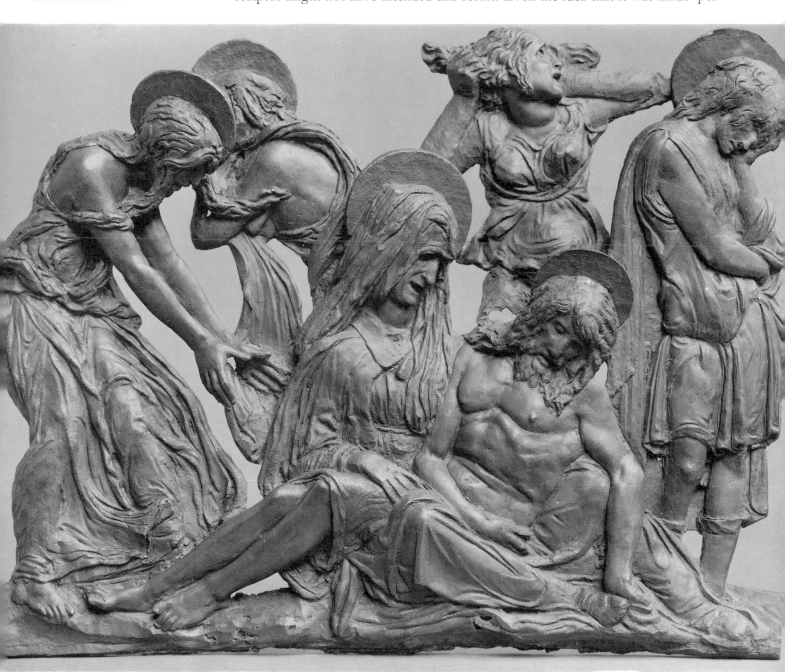

mostra', rather than as a design or a model, seems to indicate some unusual circumstance. A series of bronze reliefs against a ground of some other material would certainly have been effective but, as far as we know, unorthodox.

Donatello had petitioned in October 1457 to remain in Siena where he wanted 'to live and die'; yet, after two years or more of work on the doors, he left for reasons unknown, and without completing the commission. Both Vasari and the Anonimo Magliabechiano relate stories about how Donatello's loyalty to Florence caused him to abandon a project that would have brought glory to Siena. Although this seems unlikely there certainly is a need for an explanation. Janson has pointed out that the installation of Ghiberti's *Gates of Paradise* in 1452 must have fired the Florence/Siena and Donatello/Ghiberti rivalries; Donatello, it seems, would not have voluntarily abandoned such a plum, and Janson postulates that perhaps the Sienese ran out of money for the project. Cutting away the bronze backgrounds would have saved a considerable amount of money but would have been a controversial solution. In the end, the Sienese were to wait until 1958 for their bronze doors.

An inventory of the media of Donatello's known works reveals that he readily changed and combined techniques and materials, and an innovation such as the *Lamentation* relief would certainly be possible in his career. The major drawback to accepting the panel as the demonstration piece is that, as Pope-Hennessy has argued, its style is much closer to that of the bronze doors of San Lorenzo than to either the Paduan reliefs or the San Lorenzo pulpits, which would mark the limits of Donatello's style of the 1450s. Even his use of the ball-peen hammer to differentiate textures and enliven the surface is similar to that of the San Lorenzo doors (Fig. 88). More telling, however, is Janson's observation that such low modelling, with the entire composition brought to the foreground, occurs only in the San Lorenzo doors and the base of the *Judith and Holofernes*: 'Apparently the master reserved it for the few occasions when he had to apply bronze reliefs to the surface of what he regarded as "solid objects", such as doors or bases, whose material reality should not be challenged by vistas of illusionistic depth. If the *Lamentation* was not made as a door panel, we should be at a loss to explain why Donatello treated it as if it were.'[8] The reliability of style as a basis for dating Donatello's works has been brought into question by the bronze *David* and by the stylistic reshuffling of his wooden figures caused by the recent discovery of an unexpectedly early date for the *John the Baptist*. Whether the *Lamentation* in the Victoria and Albert Museum is Donatello's demonstration panel remains conjectural, but little stands in the way of this possibility.

Some indication of Donatello's talent as an artist in two dimensions appears in the unlikely medium of stained glass. In 1413 the eight oculi in the drum of the Cathedral dome were completed; by 1433 three were blocked with canvas, and it had been decided to begin the project with the *Coronation of the Virgin* in the only oculus directly visible when entering the church (Figs. 25, 57).[9] In December Ghiberti submitted a design, and in April 1434 the Operai decided that, of the two designs requested and submitted, they preferred Donatello's to Ghiberti's. Less than a week later, the commission for the execution was awarded to the glass painters Domenico di Piero da Pisa and Angiolo di Lippo, and the window was installed in 1438. Little attention has been paid to it because much of the painted modelling, which would make a stylistic analysis possible, has been lost, and the window itself has generally been judged to be an inferior example of the art of stained glass; but a poor stained glass window can be made from a good design, and a poor design can result in a good window.

The design is certainly consistent with Donatello's style, and the simplicity of the large figures pushed to the foreground of a space defined by a frame, in this case of

57. Designed by Donatello and executed by Domenico di Piero of Pisa and Angelo Lippi: *The Coronation of the Virgin*. 1434–7. Stained glass, diameter 380 cm. Florence, Duomo. (See also Fig. 25.)

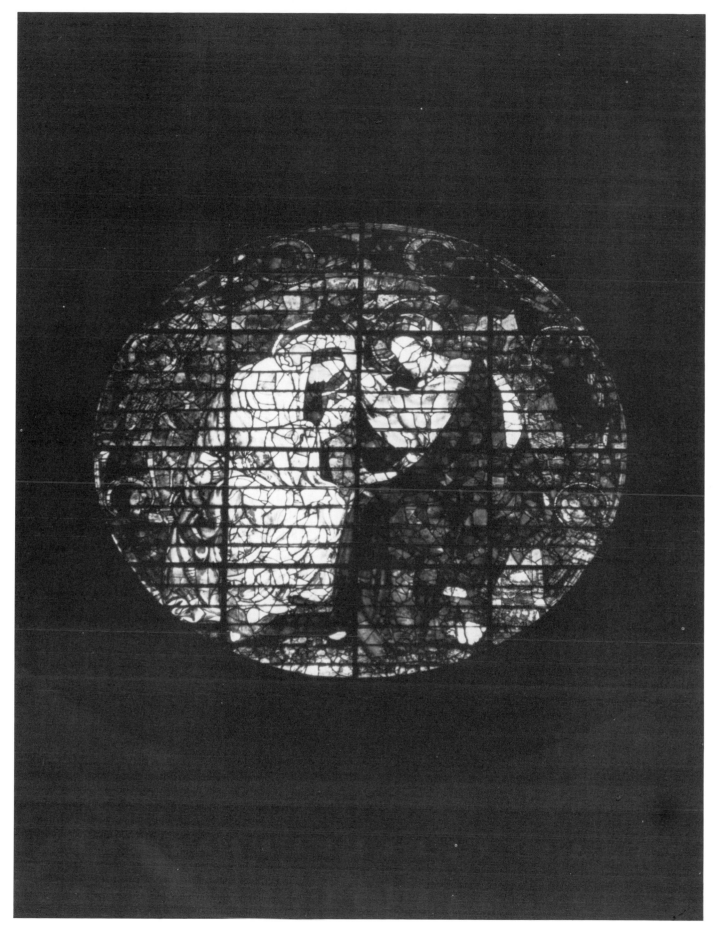

cherubim, recalls any number of his compositions, the *Cavalcanti Annunciation*, several Madonnas including the *Chellini Madonna* and the *Madonna del Perdono* (Figs. 68, 90), or the Evangelists in the Old Sacristy. It is perhaps foolish to regret the loss of the paint, since it seems unlikely that Donatello could have had much to do with the actual execution of the window. The only known payment to him is eighteen florins at the same time as Ghiberti was paid fifteen; the Operai were paying for designs requested, and presumably Donatello received slightly more because his work was judged to be better. When the decision was made in favour of Donatello, it was explicitly stated that his design should not be disposed of; this would have been important only if Donatello, busy with the *Prato Pulpit*, were no longer directly involved in the project.

The traditional practice of making stained-glass, as known through Theophilus, Cennino Cennini, and Giovanni da Pisa, indicates that in Italy, unlike in Northern Europe, there was a distinction between the artist responsible for the composition, and the one concerned with the execution.[10] From Cennino it seems likely that Donatello's design was a cartoon as large as the finished window, but it is unclear whether he would have been routinely called on to paint the glass when it was assembled. Giuseppe Marchini criticizes the *Coronation* window for large masses of colour with little modelling except for 'too much heavy enamel, resulting in poor transparency'.[11] One wonders whether this was an attempt to over-ride and break up the prominent grid pattern of the reinforcing support, which becomes all too obvious because of the lack of strong modelling.

Modern criticism concerning the artistic merit of the window reflects, in part, the foreignness of the medium and the inaccessibility of the object. It has mostly been directed at how far the *Coronation* window diverges from the accepted notion of a stained-glass window, substituting a sculptural monumentality for the requisite ornamentality. Of all the oculi, Donatello's is the most readable; perhaps this is obvious, since the subject calls for only two figures. Yet Ghiberti's *Ascension* really requires only one, and its composition is difficult to comprehend visually; instead, the window is alive with abstract patterns of colour and light. By this notion of stained glass, respected in the other oculi, the *Coronation* window is indeed inferior, and might be judged as merely a mistake on the part of the Operai looking for a well-known artist. It was not the Operai, however, who chose the design, but, as the document states, a group of men, masters of theology and painting, and masters of windows and glass oculi. Surely the stained-glass makers themselves would have been aware of the results of Donatello's design. Trusting their judgement, and taking the window on its own terms, it becomes obvious that it has several advantages. In a church dedicated to the Virgin of the Assumption, the Coronation was the most important scene in a cycle devoted to the life of Christ; Donatello's composition made it visible from the west doors. Light shines through the white of the Virgin's mantle, over the main altar, with an intensity lacking in all the other decorated windows. The clear red of Christ's mantle, the singular blue-green of his tunic, and the blue of the background are not used in the other windows. Even when the sun is overhead at noon, or in the west during a late afternoon Mass, the eastern window maintains its prominence.

In spite of these triumphs, Donatello was not asked to do any of the other windows. But the next competition was not until 1443, when Ghiberti's design for the *Ascension* was preferred over Paolo Uccello's, and Donatello, who in the meantime had received the commission for the Duomo sacristy doors and had probably been at work in San Lorenzo for a good part of the time, was most likely already in Padua.

The wide range of projects that Donatello undertook also raises questions concerning his training and his profession in a society organized by the apprentice-

ship and guild system. What little is known about his early life seems to indicate that he was trained in a goldsmith's shop, the acknowledged education for practitioners of the 'Arte del disegno', and not just for goldsmiths.[12] Although it does not seem to have been unusual for fifteenth-century artists to have a number of talents, Donatello's name is at times accompanied by a list, as it is in Giovanni Chellini's records quoted at the beginning of this chapter. When the Fabbrica of Orvieto Cathedral commissioned a gilded bronze statue of John the Baptist on 10 February 1423, they referred to Donatello as 'intagliatorem figurarum, magistrum lapidum, atque intagliatorem figurarum in ligno et eximium magistrum omnium trajectorum' ('a carver of figures, a master in stone, and also master carver of figures in wood, and great master of all carving'). He referred to himself as 'magister intagli et lapidum' ('master carver and stone worker'), and for the Duomo window he is called 'Donato maestro d'intaglio', probably with the alternative meaning of 'inlayer'. In Siena he was a 'sculptore' or 'intagliatore' from Florence, but in the Duomo document for the clay head, dated 3 August 1434, he is titled 'aurifex intagli', recalling his early contact with gold-working. The only extant record of any professional affiliation is the notice of his entry into the Company of St. Luke, where he is listed as an 'orafo' ('goldsmith') and 'scarpellatore' ('stonecarver'). This confraternity is usually thought of as a company of painters only, but, according to Staley, its members were makers of pictures, frescoes and designs, decorators of stone, wood, metal, glass, stucco, and leather. Presumably this membership would have covered a number of his interests, and he may have been enrolled in the greater guild of the Arte della Seta, which since 1322 had included the subordinate guild of goldsmiths; the latter group admitted painters, potters, sculptors, and other artisans.[13]

The diversity of Donatello's professional life does not seem to have been extraordinary for an active and well-known artist. References to Ghiberti, who should be an apt comparison, are usually to 'Lorenzo di Bartolo Orefice', giving his full name and title as a goldsmith, but he is not consistently called master, or even given a profession. In his two matriculations into the guild he is called 'aurifex', and for the 1427 *Catasto* 'Lorenzo di Bartolo orafo'; but for the 1446 tax and again in 1453 he is listed as 'maestro d'intaglio'. His title is not always consistent with his duties, so that in connection with his relief for the Siena font he is called 'intagliatore' and 'orafo e sculptore'.[14]

That Donatello is rarely called a goldsmith does not mean he did not learn the craft; on the contrary, there are many indications that he was well-versed in goldsmith techniques, or sympathetic enough to the aesthetics of the art to include it in his works, even if he might have subcontracted the actual execution or left it to his helpers. Benvenuto Cellini claimed in his treatise that Donatello 'stuck to the goldsmith's art right along into manhood'.[15] In discussing precious stones, Filarete singled out Donatello – 'many of those polished by Donatello were most beautiful' – but the reference seems so out of place it is hard to know what to make of it.[16] Donatello was, however, one of Ghiberti's assistants for the *North Doors* of the Baptistry, and such training undoubtedly contributed to his own conception of *St. Louis of Toulouse* (Figs. 129, 130). The saint's mitre and crozier (Figs. 58, 59) might almost be the objects themselves, rather than parts of the bronze statue, since they are treated as a goldsmith would have treated the actual objects. The mitre is set with two large glass stones held by multiple and varied bevels, which rise from the surface to accent the size of the jewels; the setting would become even precious stones. The flat designs, and the bands of fleur-de-lis were originally inlaid with coloured enamel, but much of this is lost and only the *intagliatura* remains. St. Louis's crozier, an historical object that conjures up an image of medieval excesses, is less ornamental than the mitre, but no less faithful to the aesthetics of its genre.

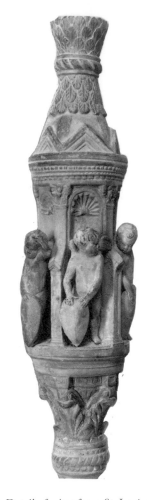

58. Detail of mitre from *St. Louis of Toulouse* (Fig. 129). *c.*1422–*c.*1425. Gilded bronze with enamel and glass

59. Detail of crozier from *St. Louis of Toulouse* (Fig. 129). *c.*1422–*c.*1425. Gilded bronze

Decorative bandings and mouldings break the staff at several places, and a tiny Renaissance tempietto provides the base of a curved finial, which is now missing. The multiple mouldings and forms of this structure are basically architectural, but vary widely in scale. Along with the spontaneity and the casualness of the putti, they create a sense of lavishness and ornament, rather than being merely a miniature reproduction of full-scale architecture. There is an attention to detail rarely seen in Donatello's work, but which is in keeping with the finely finished and carefully chased image of *St. Louis*.

Donatello did not always maintain this attitude toward the goldsmith's craft. The design on Goliath's helmet in the bronze *David* (Fig. 135), taken from an antique cameo, is a direct and known involvement with a jewel-like object; although the quotation might easily have been the patron's idea, it is reasonable to assume that Donatello would have had some interest in the cameo, especially since the exacting demands of low relief at such a scale would present a parallel to his own work. It is in this direct confrontation of an antique object with its Renaissance derivation, however, that his technical style appears most divergent. The essence of the jeweller's craft is a perfection of the surface, yet this aspect of the cameo is ignored in the bronze copy. In order to differentiate figures from ground, Donatello carefully hammered the background, but the winged putti are left in a relatively rough state, their forms indicated by gouges and their facial features non-existent. He did not reproduce the precision of the original jewel.

This lack of sympathy with the goldsmith's exactness does not seem to have pervaded Donatello's style, although it may have been part of his technique in bronze finishing (see p. 117). With infinite precision, elements in the miracle scenes on the Padua Altar (Fig. 97) were picked out in gold and silver but, although the

conception was undoubtedly Donatello's, the execution may have been by the goldsmith Francesco da Firenze, who is noted in court proceedings of 1450 as having been with Donatello for six years.[17]

It is obviously impossible to separate a sensibility learned as a goldsmith from a general sense of ornament, but goldwork often appears on Donatello's sculpture used in ways that accent the forms and make them, particularly in relief, more readable. This is true of the Padua reliefs, as well as of the four stucco Saints and Four Evangelists in San Lorenzo, where ornaments, haloes, and garment borders are picked out in gold. Traces of gilding remain on the San Lorenzo pulpit reliefs as well as on the reliefs on the base of the *Judith and Holofernes*, Judith's sword and costume, and Holofernes' belt; similar decorative passages in the *Atys-Amorino* are also highlighted in gold.

In some instances, however, such decorative work seems very much at odds with illusion. In the *Tomb of Giovanni Pecci* (Fig. 82), elaborate inlaid enamel, now gone except for bits of reddish-brown, once enlivened the frame of the bier and the coats-of-arms flanking the inscription, as well as the ends of the stole, the cope, and the mitre. The brilliance of colour against the dark of the bronze must have been even more extraordinary than on the gilded *St. Louis*. But unlike the *St. Louis*, this is decoration on a relief–sculpture that promises three dimensions, but offers scarcely more than two. The enamelling on St. Louis's mitre provides a reference point for perceiving the three-dimensional shape of the mitre, and it changes with our viewpoint; on the Pecci tomb, it is an immutable ornament, straining against the illusion of three-dimensionality that Donatello sought elsewhere on the tomb.

Small, personally-owned objects, such as those made by a goldsmith, are always the first to disappear with time, depriving us of knowledge of the popular market and of an artist's more mundane, but not necessarily lower quality, production. Thus a small gilded copper repoussé plaquette in Cologne is particularly intriguing for its closeness to Donatello's style, its quality, and its unusual technique (Fig. 34).[18] It belongs to the large group of intimate Madonna and Child images seemingly made popular by Donatello and mentioned by Vasari, and may have been reproduced many times in less costly materials. The process of gently pushing at a plate of relatively soft metal from the rear to create an image on the opposite side is an ancient technique (see Fig. 6), and whether or not Donatello associated it with antique art, he would have appreciated the subtlety such a relief achieved with a minimum of depth. In this way repoussé is related to *relievo schiacciato*, but, unlike it, is not achieved by carving but by a kind of modelling. In the Cologne *Madonna and Child* this has imparted a great freedom to the forms, and a liveliness, especially in the Child's turning, which would have been far harder to attain by carving.

Given the number of specific goldsmith techniques Donatello employed in his sculpture, it seems certain that he had considerable early training in the craft. Just as certainly, he must have had training in stone carving, since his earliest documented work was the marble prophets for the Porta della Mandorla; the Duomo Operai refer to him on 23 November 1406 as 'Donato Niccolai scarpellatori', the professional title that, along with 'orafo', he then gave himself when he entered the Company of St. Luke in 1412. Hartt has pointed out that Donatello shows a notable ability in marble from his earliest works, and he is referred to as 'intagliatore' and even 'picchiapietra' ('stone-hitter').[19] The problems involved, however, in envisioning the finished product – 'imprisoned in the stone', as Michelangelo would later say – are quite different from those encountered in making a clay or wax casting model. It is tempting to see Donatello as coming to terms with these problems in the large and obvious patch on the marble *David*'s left arm (Fig. 116). The elbow is set in as a separate piece of stone, but whether this was occasioned by a naive miscalculation of the limits of the block or an unexpected faulty vein in the

60. Detail of the base of the tabernacle of *St. Louis of Toulouse* (Fig. 129). *c*.1422–*c*.1425. Marble

marble, or is simply a repair, cannot be ascertained. By the time he carved the *Cavalcanti Annunciation* in Santa Croce, however, it is clear that the limitations of the stone no longer bound his conceptions (Figs. 84–86). The relief itself is made of two large blocks of *macigno*, or sandstone, and their joining, which could have posed a problem, is masked by the architectural background and even suggests a closed door. This soft, native Florentine stone carves easily but weathers badly, so it was a perfect choice both for an indoor monument and for a design dependent on a free sense of line to convey movement of the figures and to achieve the illusion that they are separate from their background. With what seems almost a gesture of perverse denial of the nature of marble, Donatello designed the *Martelli Sarcophagus* to resemble a woven basket (Fig. 37), and in the Parte Guelfa tabernacle inserted a carved, thick straw pallet between the floor of the tabernacle and the base (Fig. 60), probably in imitation of those used to move and protect marble blocks.

It is also as a stone-carver that Donatello first confronted the problems of placement for sculpture, and his solutions are already obvious in the *St. John the Evangelist*, designed for a rather high and shallow niche on the Duomo façade (Fig. 24).[20] As Charles Seymour has pointed out, the odd proportions of the figure seen head-on (Fig. 61) become normal when viewed appropriately from below (Fig. 62); the over-long torso, languid right arm, and oddly down-curved thighs become elements that reinforce the statue's three-dimensionality and monumentality. Hartt is probably right in stressing that these optical corrections, which in any case are not new in Donatello, are the result of the practice of carving figures from a semi-reclined block, as shown in Andrea Pisano's Trecento relief of *Sculpture* for the Campanile, and Nanni di Banco's predella for the *Quattro Coronati* (Fig. 31); the angle of the statue would thus simulate the effect of the low viewpoint. Donatello's block was the same size as those for the other three Evangelists, since they were all cut to a height of four *braccia* when they arrived in Florence; he was the only sculptor of the original three, however, to take full advantage of the relatively thin block by reducing the depth of the finished figure from fifty-four centimetres at the base to less than twenty at the belly and treating the piece almost as if it were relief. Interestingly, the fourth Evangelist figure, the *St. Matthew* by Ciuffagni, follows the

proportions set by the *John the Evangelist* and not by the other two; the throne is lower, the torso longer, and only in a less aggressive thrust of the neck and a less daring depth to the upper body does the statue differ from Donatello's placing and spatial solution for *St. John*.

This is the same attention to the spatial relationship between viewer and figure that Vasari seems to have been alluding to in the anecdote about the guild not wanting to accept Donatello's *St. Mark* (Figs. 27, 119) for Orsanmichele when they first saw it on ground level. The sculptor offered to retouch the figure but, instead, simply put it in the niche, hidden from view, and uncovered it after two weeks to receive the great praise of the guild consuls. Although the distortions for its viewpoint are not as distinct as in the *St. John*, *St. Mark*'s torso and arms are slightly exaggerated; the statue does lose some of its ungainliness when seen from street level, rather than in a head-on photograph.

Giovanni Cinelli, writing in 1677, makes another point about Donatello's optical corrections in the *St. Mark*, saying that the sculptor took care not to give his works an overly fine finish and 'enhanced their effectiveness from a distance, even though they became somewhat less striking when viewed at close range. And in order to avoid this comparison, he insisted on showing his works only after they had been installed in their proper places, as happened in the case of the marble St. Mark for Or San Michele.'[21] Cinelli obviously knew Vasari's anecdote but interpreted it, as Janson does, in reference to actual stone-carving technique rather than to proportional refinements. Unfortunately, it is impossible to tell from the now badly weathered statue whether Cinelli was at least partially correct.

Nevertheless, there is other evidence that Donatello's finishing technique caused comment quite early; before 1530, and therefore before Vasari, Antonio Billi noted a striking difference between the two *Cantorie*, one by Donatello, the other by Luca della Robbia (Figs. 93, 94). Of Luca's figures he said they were 'finished with great diligence' while Donatello's were 'sketchy and not finished' ('abozzate et non finite'), but nevertheless looked fine from the ground.[22] In the *Life of Luca della Robbia*, Vasari made the same comparison, saying that Donatello's *Cantoria* was more successful since 'the smooth, high finish of Luca's work causes the eye to lose it at a distance and not see it clearly.' The sketchy quality of Donatello's work does not mean indistinct lines or ill-defined forms, but refers to the actual finish itself. Vasari describes the process of marble carving as beginning with a series of chisels, then files to erase all traces of the chisel marks, then rasps, pumice stone, Tripoli earth, and finally straw, until 'finished and shining [the statue] appears before us in its beauty'.[23] Such a high finish causes reflections that not only glint in the light, but bring light to areas that should be in shadow for the sculpture to be read correctly, especially from a distance. Donatello's surfaces are finished beyond rough chiselling, but are left unpolished to take full advantage of the marble's inner luminosity, which is diminished when greater emphasis is placed on a reflective surface.

Bernardo Davanzati, in a comment on Tacitus at the end of the sixteenth century, used Donatello's sculptural technique as a descriptive analogy for colourful and forceful writing, saying that the eyes of the *Zuccone* (Fig. 125) look as if they were dug out with a spade, but if Donatello had not used this technique of 'spezzatura magnanima' ('working quickly and expressively') then the prophet would look blind, since 'la lontananza si mangia la diligenzia' ('distance devours all refinements').[24] He continues by saying that there is a time for using 'not proper words but appropriate ones'. Weathering has made it impossible to judge the original surface finish of the *Zuccone*, but the broad, expressive masses of drapery, and the exaggerated arm muscles and straining tendons in the necks of both the *Zuccone* and *Jeremiah* (Figs. 124, 123) seem to be adjustments for distant viewing. The careful and complete drill-work in the hair of the *John the Evangelist* contrasts with the

61. *St. John the Evangelist*, from the Duomo façade. 1408–15. Marble, height 210 cm. Florence, Museo dell'Opera del Duomo. (See Fig. 24.)

62. *St John the Evangelist* (Fig. 61) viewed from below

Jeremiah, where a line of preliminary drill holes is even left in the drapery folds. *St. George*'s fine-boned, smooth face (Plate II) and the *Evangelist*'s neat beard are very different from the straggly scratches on the prophets' faces. The *Zuccone* and the *Jeremiah* are the last known large marble statues by Donatello. Commission restrictions and popular taste probably played a part in his switch to bronze, but it also seems that the 'spezzatura magnanima' he sought in these last marbles would be hindered by carving, and the modelling techniques of bronze would be more suitable for this broader, more expressive style.

It is difficult to assess whether Donatello had a similar attitude later in his career about the relative merits of bronze and marble for relief sculpture. No securely datable works in stone are known after the *Cantoria*, with the exception of the reliefs from the Padua Altar; the extant *Entombment* is executed in limestone, a stone relatively easy to carve in comparison with marble (Fig. 92). In any case, he showed no aversion to marble as a medium for relief sculpture early in his career; on the contrary, his proficiency in it produced the new sculptural type, *rilievo schiacciato*.

Although the literal meaning of the term, 'flattened' or 'squashed' relief, seems clear, there is no generally accepted definition of the kind of relief to which it refers and whether the entire work must be done, more or less uniformly, in extremely low relief.[25] Much of the confusion arises from the lack of a contemporary or near contemporary reference to the technique with a consistent example; Vasari's references are so contradictory that they imply the term was never very precise. Yet the one idea consistent among early writers on art is that the technique originated with Donatello, who was also its greatest practitioner.

Whether Donatello had a source or an inspiration for his new relief style is unknown; several antique art forms might be seen as precedents, but none is actually comparable. Given his strong connections with the art of goldsmithing, it is possible he was influenced by the art of cameo carving. Vasari claims that his flattened reliefs were related to ancient Arretine ware, a kind of pottery decorated with low reliefs produced by a stamp or mould. It is also quite possible that Donatello would have known the low relief often seen on antique sarcophagi, though not used to produce the effect of indefinite space as *rilievo schiacciato* was.

One of the best examples of Donatello's *rilievo schiacciato* is the *Assumption of the Virgin* from the *Tomb of Cardinal Rainaldo Brancaccio*, in Naples, mentioned by Vasari as a relief that received 'infinite praise' (Fig. 63).[26] It is easy to see why: the technique itself seems to lead to our understanding of the subject. Only the body of the Virgin is carved with any significant depth, and only her praying hands approach three-dimensionality, while the angels, whose bodies appear and disappear through the clouds, are for the most part 'flattened'. They are perceived by the barest indications of declivities in the marble, and sometimes only by the scratch of an outline. This juxtaposition and contrast underscores the miraculous assumption of the actual body of the Virgin, seated on a chair, and shrinking in timidity.

The technique of *rilievo schiacciato* is sometimes described as a kind of engraving on the stone, emphasizing the pictorial nature of the result and the delicateness of the process. What the analogy ignores is that the forms are rounded as well as outlined. Yet, although they are raised, they do not obey the laws of traditional relief sculpture (Fig. 15) by being in higher or lower relief depending on their positioning in the illusionistic space of the narrative. Angels that overlap, giving distinct clues to their positions, are not necessarily differentiated by varying depths of carving except where they overlap. Even in an angel whose position means that his arms, torso, and legs cannot be in the same plane, the swell of the forms nevertheless varies little in physical height; instead, he is 'flattened', or 'squashed'. It is easy to imagine the difficulties inherent in such a technique: the composition must avoid any jarring confrontations of forms; figures will be most readable when

their poses are in planes parallel to the surface plane, but they must avoid repetition or a seeming lack of movement; and distortions necessary to compensate for the limitations in carving depth (such as those in the heads of the angels in the lower right of the *Assumption*) must be minimized. It is no wonder that only Desiderio da Settignano, and to a lesser degree Agostino di Duccio, understood the technique well enough to reproduce it in their own work with some degree of success; most other Quattrocento sculptors steered clear of its difficulty. When *rilievo schiacciato* appears again, it is in the very early *Madonna of the Stairs* by Michelangelo, where the tentativeness of the carving, the awkward hands and feet of the Virgin, and the not entirely successful stairway betray Michelangelo's youth; one can imagine he might have undertaken the task of carving in *rilievo schiacciato* as a kind of artistic initiation rite.

Given the illusion Donatello sought in the Brancaccio *Assumption*, it is not surprising that the clouds are rather ill-defined; the entire surface of the relief is left unpolished, and one suspects that polishing would have rubbed out more than one of the background putti. Donatello's technique of surface finish in marble relief seems to have been close to his technique in marble statuary, leaving the surface rough and allowing the stone's crystalline structure to absorb and reflect light quite differently than does a smooth surface.

Whatever his reason for abandoning marble statuary, Donatello's turning to bronze also meant abandoning *rilievo schiacciato*. Perhaps, as Hartt has suggested, he simply realized that the subtleties of *schiacciato* would not work in bronze, and even with his first bronze relief, *The Feast of Herod* (Fig. 95), the relief style is closer to Ghiberti's pictorial relief style (Figs. 15, 98), than to his own in the relief of *St. George* (Fig. 80). Although some of the background is extremely low (Fig. 96), most of the figures are considerably higher and parts of others are even totally free of the ground. True *schiacciato* in bronze would probably seem like a rather uneven engraving or *niello* work, with the subtleties of surface modulation lost in the shine of the medium, leaving only outlines. Hartt suggests that Donatello slightly modified the traditional method of building up a model for a bronze relief in order to accomplish his feat of complex architecture in the *Feast of Herod*; he proposes that the artist did a single background layer of clay or wax rolled on a board, then laid successive layers he could cut through on an angle to form his architectural planes in perspective, and then finally, added the figures.[27] The process is a total reversal of the technique he would have been using in marble.

The additive process of modelling in order to cast bronze statuary was opposed to Donatello's earliest experience as a stone-carver. Although he could make a model, even full-size, for a finished stone statue, once the carving was begun in stone, few changes were possible, a mistake was difficult to rectify, and an unforeseen flaw could be a disaster. Since the idea must be so well-defined and complete beforehand, the statue finally carved in stone is in some ways a copy, and the sculptor, if not the sculpture, surely suffers from the drudgery of this reproduction. In bronze, as in stone, the wax or clay model is easily changed or modified, but, because of the casting process, the model for bronze can in some ways be thought of as the finished work, rather than as a preliminary step.

The major sources of our knowledge of Italian casting procedures are both sixteenth-century: the treatises on goldsmithing and on sculpture written by Benvenuto Cellini, and the technical remarks that preface Vasari's *Vite*.[28] From modern casting and what is known about ancient casting, the process has changed very little over the centuries, so that Cellini's detailed account is probably quite close to the Quattrocento process for casting large pieces. First, a core was made approximating the finished work but slightly smaller. Its composition varied – clay mixed with bits of cloth, horse dung, hair, urine – but what was sought was a

63. *The Assumption of the Virgin*, from the tomb of Cardinal Rainaldo Brancaccio. *c*.1425–*c*.1428. Marble, 53.5 × 78 cm. Naples, Sant'Angelo a Nilo

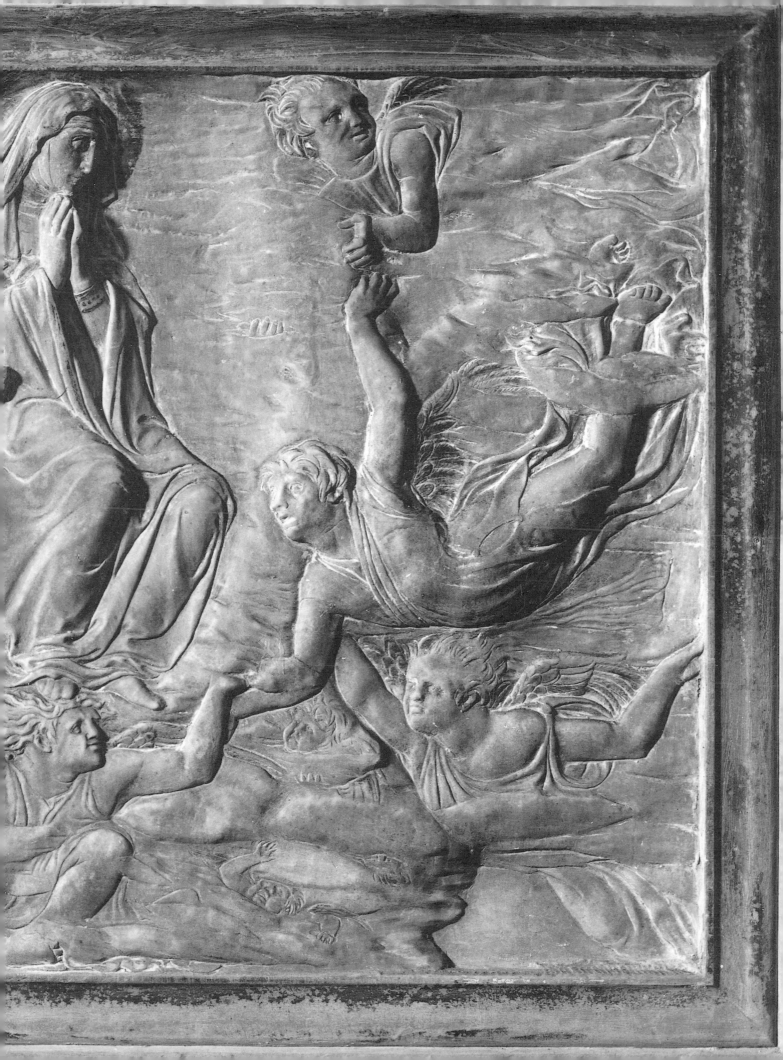

product that would not crack while it dried, could be easily modelled, and which would be porous enough after firing to accommodate gases from the molten metal. Over this a layer of wax, the thickness of the finished cast, was modelled in detail; the bronze, if the casting went well, would exactly duplicate this layer and no other hand needed to intervene, even for chasing, between the sculptor's modelling in wax and the final bronze work of art. Next, a layer of very fine, very liquid clay was brushed on the wax, with successive layers becoming increasingly thicker and coarser. The inner core and outer mould were then tied together by inserted rods to prevent their slipping against one another, and vents positioned for hot air and gases. Slow heating of the mould (a fierce heat would boil the wax and injure the detail) drove off the wax and fired the whole. The molten bronze, a mixture mostly of copper, with tin, lead, and a trace of zinc, was then poured into the hot mould. (The metal acquired by the founder Andrea dalle Caldiere for the Padua Altar in 1447 was 852 pounds of copper and thirty-eight pounds of tin.)[29] If the piece were large, and it was therefore necessary to counterbalance the force of the bronze during the pouring, the mould was sunk into a hole in the ground; work proceeded quickly, so that the clay would not absorb moisture from the earth. This is what Donatello seems to have done with the hind part of the horse for the *Gattamelata* (Fig. 52), since he was reimbursed in May 1447 for the cost of digging and filling the pit where it was cast.

Cellini's method, recounted by him with all its attendant crises to emphasize his triumph in casting the *Perseus*, is the most direct bronze casting process. After the bronze is poured, outer mould and inner core are removed, and the resulting work retains every mark of the artist's hand; it requires only polishing. The problem is that the founder has only one chance; the original model is lost when the wax is melted away. It is not certain that Donatello used this method, although he might well have for small reliefs. He seems, however, to have used a method close to the one described by Vasari which allows the model to be re-used, since in his *Catasto* declaration of 1427 he noted that he owed fifteen florins to Giovanni di Jacopo degli Strozzi for the repeated casting of the bust of *San Rossore* (Fig. 110).[30]

This indirect casting technique begins with a full-size clay model, or any model not finished in wax as it would be in Cellini's process. Plaster is built up around it in sections, which take a negative impression of the model and can be removed; relatively large sections are used for uncomplicated areas, and small, thin ones for the delicate work. The model is then taken out, the sections reassembled, and the inside of the empty piece-mould is lined with wax. For a small object the mould is cooled, filled with wax, which hardens on contact, and the excess poured off, leaving a skin; for larger objects, the wax is brushed on the inside surfaces. The inside is filled with a core, the piece-mould removed, and the wax (which is then a positive of the model) is touched up. The founder is now at the point at which Cellini's method begins. The difference is that this wax model is a reproduction, and thus a step removed from the original model, though probably the Renaissance sculptor himself would perfect the wax image for piece-mould casting.

Bronze casting obviously required a great deal of equipment, an oven, a furnace, assistants, and considerable expertise, and the question therefore arises whether a sculptor would be likely to undertake the process himself. Most likely Donatello did not, but instead, as Pomponius Gauricus stated in his 1504 *De sculptura*, employed 'bell-founders'.[31] The documents for *San Rossore* and the work in Padua show that at least in those two cases he did not do his own casting. The same may be true of the *Feast of Herod* since Donatello's *Catasto* record of 1427 states that he owed ten florins to the goldsmith Giovanni Turini for helping with the relief. This is a rather large sum simply for the gilding, and does not seem to include the price of the gold, since Donatello also owed twenty-five florins to the Sienese Opera

specifically for gilding; it might indicate that Giovanni had some larger role in the casting. Based on the idea that Donatello did not cast his own work, the suggestion has been made that he joined with Michelozzo for the latter's knowledge of bronze casting; however, apart from Michelozzo's documented work on the bronze capital for the *Prato Pulpit*, there is little evidence to support the possibility.

Bruno Bearzi's analysis of the bronze doors in San Lorenzo (Figs. 87, 88) has revealed that Donatello may indeed have used bell-founders for this casting, since the doors contain twenty-five percent tin rather than the usual mixture;[32] tin was extremely expensive but when mixed in this higher proportion produced a very hard alloy suitable for bells. The advantage to Donatello would have been that bell-metal reproduced the model with great fidelity, although it did not give a fine finish. Presumably the reason this mixture was not always used for bronze sculpture was that it is also very brittle, making extensive chasing difficult and hazardous. Without such reworking, the rough heads of the San Lorenzo saints have retained the spontaneity of the modelled wax; hair and beards are sketched impressions, rather than carefully controlled detail, and the imprecision of the outline where figure meets ground produces a sense of movement and atmosphere. The flat background is easily cleaned and brought to a uniform finish, and the only area needing more complete chasing is the drapery. Rather than risking cracks or breaks in the brittle bronze, Donatello finished the drapery with an overall hammering, as he did on that of the Padua Altar saints; a small ball-peen was used on the nearer surfaces, and a larger one in the folds. The result is not only a technical triumph, but an ingenious aesthetic solution to differentiating figure from ground without extensive chasing. Regardless of how involved he was in the physical labour of casting, Donatello was obviously sufficiently aware of the process to use it to his artistic advantage.

Although it may at first seem strange that he entrusted parts of the casting to others, it was in fact a common practice, and is probably evidence of his good sense, given all that could go wrong. Ghiberti noted in his diary on 1 December 1414:

> In the following I shall record all the expenses I shall have for casting the figure of St. John the Baptist. I undertook to cast it at my own expense; in case of failure I was to forfeit my expenses; in case of success ... the consuls and operai ... were to use toward me the same discretion that they would use toward another master whom they sent for to do the casting. On the above day I shall start taking note of all the expenses that will occur in the casting.[33]

These 'expenses' were not trifles, since the total cost of this statue (Fig. 29) for Orsanmichele was 1100 florins (Brunelleschi's annual salary as *capomaestro* of the Duomo works was only thirty-six florins, and later a hundred). The initial investment was therefore quite high, but of the 1100, Ghiberti received 530 florins for his work; his slightly later *St. Matthew* (Fig. 30) also cost 1100 florins, but this time he received 650. Founding was a profitable business – Krautheimer has noted that bronze founders seem to have been in the same economic class as some bankers[34] – but involved a considerable risk of time and money.

Many difficulties could occur during the casting, ranging from breaking the mould, to air bubbles causing 'spongy' areas in the bronze. Residual wax or moisture could cause a dangerous explosion. A miscalculation in temperature might prevent the bronze from flowing properly; the core could slip or air pockets could form, causing thin areas or holes in the bronze. Both Ghiberti's *St. John the Baptist* and *St. Matthew* were partly recast, and thin places where the bronze broke were mended; Krautheimer has also listed a large number of casting problems in both the first and second sets of Ghiberti's bronze doors.[35]

It is not surprising, then, that a similar list can be made for Donatello's works. Cellini, in his autobiography, criticized Donatello for the great difficulty he seemed

64. Detail of *Christ before Caiaphas*, from the San Lorenzo pulpits. 1460s. Bronze. Florence, San Lorenzo. (See Fig. 1.)

to have had in casting, and it is all too easy to find evidence for the statement. The bronze *David* (Figs. 134, 135, 50) has a large patch on the thigh and a hole under the chin, and the joinings of the base and Goliath's head are far from precise; yet Gelli in 1550 wrote, 'according to the bronze sculptors, there is nothing more perfect and without fault than this'. Donatello's repairs range from the neat rectangular patch on David's thigh and the one under the Madonna's chin in Padua to the two amorphous blotches on the left side of Gattemelata's face, which seem more like putty than bronze (Fig. 105). Unlike Ghiberti, whose repairs on the Baptistry doors are discreet inserts or entire figures recast and added, Donatello seems to have paid far less attention to perfection. Flaws are not repaired on the figures for the Padua Altar, and the left foot of Holofernes, which seems to have lost its sole in the casting, was only partially repaired, leaving a gaping hole for the heel section of the sole; more remarkable is the *David*'s lack of a right index finger below the second knuckle. But, although a list of flaws in Donatello's casts would be lengthy, very few defects detract from the works of art themselves.

Criticism was also levelled at Donatello for his chasing of bronze. Condivi, in his biography of Michelangelo, said that the latter admired Donatello except for the fact that he lacked the patience to give his work a clean finish; Baccio Bandinelli wrote in 1547: 'When he did the pulpits and doors of bronze in San Lorenzo for Cosimo il Vecchio, Donatello was so old that his eyesight no longer permitted him to judge them properly and to give them a beautiful finish; although their conception is good, Donatello never did coarser work.'[36] His finish on the bronze doors is hardly a misjudgement, but must have seemed highly erratic to eyes accustomed to a traditional polish. The same is true of the bronze reliefs on the San Lorenzo pulpits. The emotion of the narrative events is heightened by Donatello's knife gashes in the wax models, preserved in bronze because they have not been chased and polished to perfection (Fig. 64). The scholarly argument concerning what Donatello himself did on the panels often centres on their finish; passages of regular hammering and unimaginative chasing, for example on the *Lamentation*, probably indicate a follower's hand (Fig. 4 and p. 70). Hartt has pointed out that in the *Agony in the Garden* most likely only the figures are by the master, while the rest was left in shapeless wax and subsequently hacked into crude rocks and trees (Fig. 12). The use of the ball-peen hammer in the background sky is certainly an assistant's poor attempt to imitate the effect on the bronze doors. The date of 15 June 1465, under the *Martyrdom of St. Lawrence*, is probably a casting date and indicates that the panel was ready to be chased a year and a half before Donatello's death; yet the bronze maintains the roughly modelled character of the figures on the San Lorenzo doors, particularly in the body of the tortured saint, and raises the question of exactly how 'finished' Donatello intended these panels to be. To modern eyes, the finish and content seem complementary, and the panels emerge as the bronze equivalent of what Vasari praised in Donatello's marble *Cantoria*. It should be remembered, however, that the officials of the Santo in Padua repeatedly admonished Donatello to clean (chase) their bronzes well.

Cellini's description of casting is for one continuous pour, and Ghiberti's commission for the *St. Matthew* (Fig. 30) specified a cast of one or two pieces including the base but, judging from modern practice, these must have been exceptions to a norm of piece-casting. There is ample evidence that Donatello cast his larger bronzes in sections. The Pecci tomb, which would seem simple enough to cast as a whole, was done in three pieces (Fig. 82). In the bronze *Crucifix* for the Santo in Padua, the arms were cast separately, but carefully joined to the body. The arms of the *Atys-Amorino* have also been attached, but in a much clumsier fashion, and Janson may be right that they were separate because of a casting flaw (Fig. 115).

Donatello's *St. John the Baptist* in Siena was definitely cast in separate pieces, since they were listed when it was consigned to the Opera del Duomo in 1457 as a bronze *St. John* lacking an arm and consisting of three separate pieces, a head, a piece from the middle to the knees, and a piece with the base (Fig. 65).[37] It was probably sent in sections not only to minimize damage, but also to keep the duty as low as possible. Presumably it was then assembled by Donatello in Siena. The resulting joints are all but invisible, including that for the right arm that was listed as missing. In 1465 the statue was described as unfinished, and in 1474 'the bronze arm of the figure of St. John made by Donatello' was consigned to the Sienese Operaio. Billi, Gelli, and Vasari all claim that the lack of the arm had to do with Donatello's withholding it for higher pay, and it seems clear that he never did attach it. Opinion is divided on whether the right arm is in fact by Donatello; he obviously would have planned one and probably cast it, but there are too many possibilities and Donatello himself is too unpredictable, for a sure attribution based on style. In any case, the present arm does not detract from Donatello's image of the Baptist, who is again shown preaching, as he was in the wooden statue for the Frari in Venice twenty years

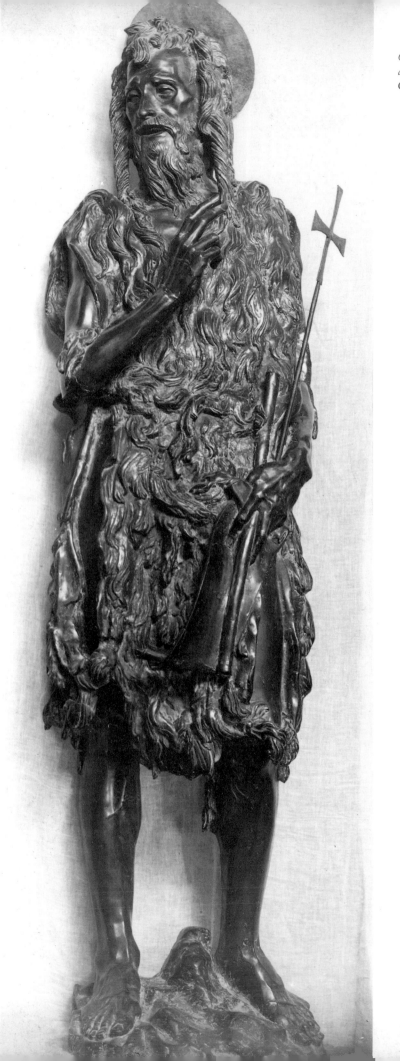

65. *St. John the Baptist* and detail.
c.1457. Bronze, height 185 cm. Siena,
Cathedral

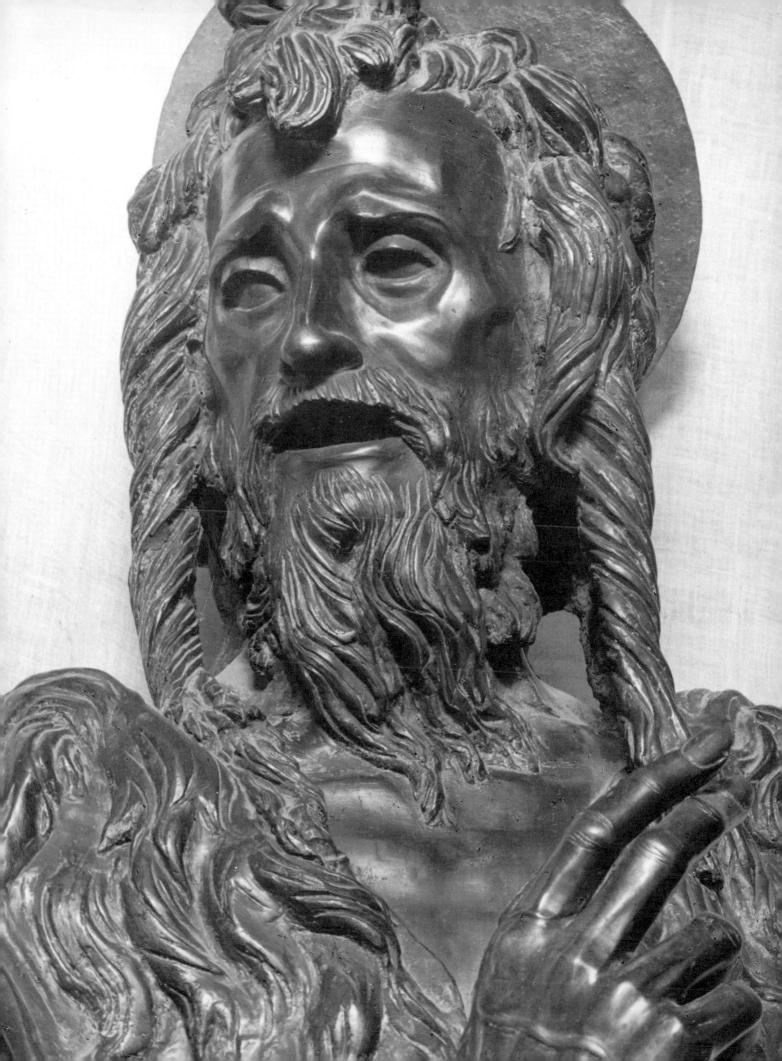

before (Fig. 113). He is no longer, however, the gangly saint he was in wood, when his over-large hands, and feet and even nose made his thinness seem more adolescent extremism than saintly fervour. In Siena the *Baptist* is an older man, his proportions somewhat stockier; the physical toll his life has taken is no longer sinew standing out against bone, but vein against flesh and eyes so sunken that the light on the bronze registers bone ridges before eyelids. Donatello has finished the bronze so that the Baptist's skin is as smooth as David's (Figs. 50, 134, 135), and the foil of the rough areas of his hairshift fracturing the light reflection is all the more effective. As in the Padua Altar figures (Fig. 101), the selective chasing brings the surface alive with changing light.

In some cases, the number of pieces Donatello used seems inordinately large, either for the size of the work or the complexity of the model; this is particularly true of the *Judith and Holofernes*, which is made up of eleven separate pieces carefully joined (Fig. 136).[38] Some of the divisions seem simply casting conveniences, such as the uneven breaks at the corners of the base, but others, since they are so aesthetically effective, raise questions about the original model. It seems quite possible, for instance, that the large pillow was cast from life, meaning that a negative mould in plaster was made around an actual pillow; it is not attached to the base, but rests freely upon it, enhancing the figures' ultimate instability and imparting a sense of the momentary action associated with narrative. The parts of the pillow are completely interrelated – a depression causing the down to fluff elsewhere, or the cover to gape open between its fasteners. Bruno Bearzi has long championed the idea that the legs of Holofernes were cast from life, since their veins and sinews seem to belong to a middle-aged labourer; Janson disagrees, arguing that such realism is a style in itself. In any case, the thighs continue ten centimetres under Judith's drapery and, as with the pillow, their realism profits from being a separate piece.

The question of casting from life arises in other contexts as well. Francis Ames-Lewis has raised the possibility that the wings on Goliath's helmet in the *David* were moulded in this way, because they so carefully reproduce feathers (Fig. 135);[39] this may simply be testimony to Donatello's powers of observation, since the wings of the *Atys-Amorino* (Fig. 115) and those that adorn the wreath under the *Cavalcanti Annunciation* (Fig. 84) seem similarly organic. Bruno Bearzi pointed out the proof that Donatello, at least once, cast from the actual object; Judith's veil (Fig. 137) is broken on the edge where the weave of the actual cloth, which Donatello dipped in wax and which the furnace failed to consume, is preserved in bronze. Hartt has noted the same phenomenon in Christ's banner in the San Lorenzo *Descent into Limbo*. One wonders whether a similar procedure might have been used for the tack on Gattamelata's horse (Fig. 66); bands of metal totally free from the horse flamboyantly mock the line between artifice and reality with an inset of actual chain and a bridle strap that flops from its buckle. Gattamelata's bronze spurs are handled the same way, and the straps around his waist rest an inch away from his armour.

This kind of experimentation in bronze is hardly surprising. Donatello's first large-scale effort in the medium was the *St. Louis of Toulouse*, and, as a view from the back shows, the figure was not composed in a traditional fashion; it is a construction of pieces and sheets of bronze, not permanently joined as in other works, but bolted one to another (Figs. 129, 67). As in the *Gattamelata*, parts of the statue maintain their identities as separate objects; the mitre is removable (Fig. 58) and the remarkable right hand is simply a perfect glove. Bruno Bearzi, who thoroughly examined the figure during the cleaning after World War II, is convinced that Donatello made a mannikin in clay and then draped it in sheets of wax;[40] he points out that casting in pieces cuts the overall cost, but the *St. Louis* is composed in such a way that cost and difficulty were both increased. This process might well have

appealed to Donatello, since the resulting emphasis on the ecclesiastical vestments is so important to this interpretation of Louis as would-be king turned friar (see pp. 210–12). It is also possible that he had little idea of the difficulties he might encounter and, in his first large bronze, went forward with the audacity of youth.

The usual reason given for the *St. Louis* being cast in several pieces is that it was fire-gilded, a process in which the work must be evenly heated for a long period over a charcoal fire; the protrusions and indentations of a large figure would make this impossible. Fire-gilding is extremely weather-resistant and had been known for a long time; it was completely described by Theophilus in the twelfth century.[41] One part gold is dissolved in seven parts mercury and the amalgam is heated to over 450°C; as it is stirred, in a process called 'milling' the gold, the mercury evaporates and the gold condenses to a red powder. This powder is brushed evenly over the bronze, and the piece is then heated to 450°C over charcoal with sulphuric acid to eliminate oxidation. The mercury is driven off but has split the gold molecules so that they adhere to the bronze. This heating is bound to cause some distortion in the pieces of bronze, which seems to have happened in the puzzle Donatello cut for himself; there is an insert in *St. Louis*'s left shoulder, probably compensating for a deformation of the metal. The statue of *St. Louis of Toulouse* is one more example of Donatello's versatility, if not a unique variation on casting from life.

66. The saddle, armour, and trappings of the *Equestrian Monument of Gattamelata* (Fig. 52)

67. Back view of *St. Louis of Toulouse* (Fig. 129). *c.*1422–*c.*1425. Gilded bronze

His ability to work in so many media, and to combine them in new and unusual ways, is so striking that even when Giovanni Chellini's statement (the epigraph to this chapter) was discovered, it was never quite believed that Donatello had made a bronze roundel meant to be a re-usable mould for glass, until the bronze relief in the Victoria and Albert Museum was brought to public attention in 1975 (Fig. 68).[42] Playful putti attend an intimate image of the Madonna and Child in low relief in a heavy flanged frame, and on the reverse the composition is repeated as a negative mould. Both front and back are casts from the same original model, although, significantly, the back is a better cast and the front was slightly reworked. Physical evidence indicates that the original version of the roundel was a turned wooden plate with the central image built up in wax, and the complexity of the succession of

68. *The Chellini Madonna and Child with Angels*. 1440s–1456. Bronze, with traces of gilding, diameter 28.5 cm. London, Victoria and Albert Museum

negative and positive impressions necessary to produce this two-sided result makes it unlikely that there was not a specific purpose for the back.

With Chellini's claim for his roundel in mind, the Glass Department of the Royal College of Art, London, and the Venini glass firm of Murano made glass impressions from bronze moulds taken from the original (Fig. 69). The extraordinary beauty of the glass image exceeds even that of the bronze roundel. The drapery design, especially, seems conceived for the demands of a coloured transparent medium, since areas that are raised in bronze become natural highlights, while raised areas in coloured glass are thicker, and therefore less transparent, and become shadow; yet, it is only in comparison that this curious negative effect of the bronze is apparent. No earlier glass impressions of the roundel are known, and it seems

69. Glass cast from a replica of the reverse of the *Chellini Madonna*. Made by Messrs Venini of Murano, Venice, in 1977. Diameter 28.5 cm. London, Victoria and Albert Museum

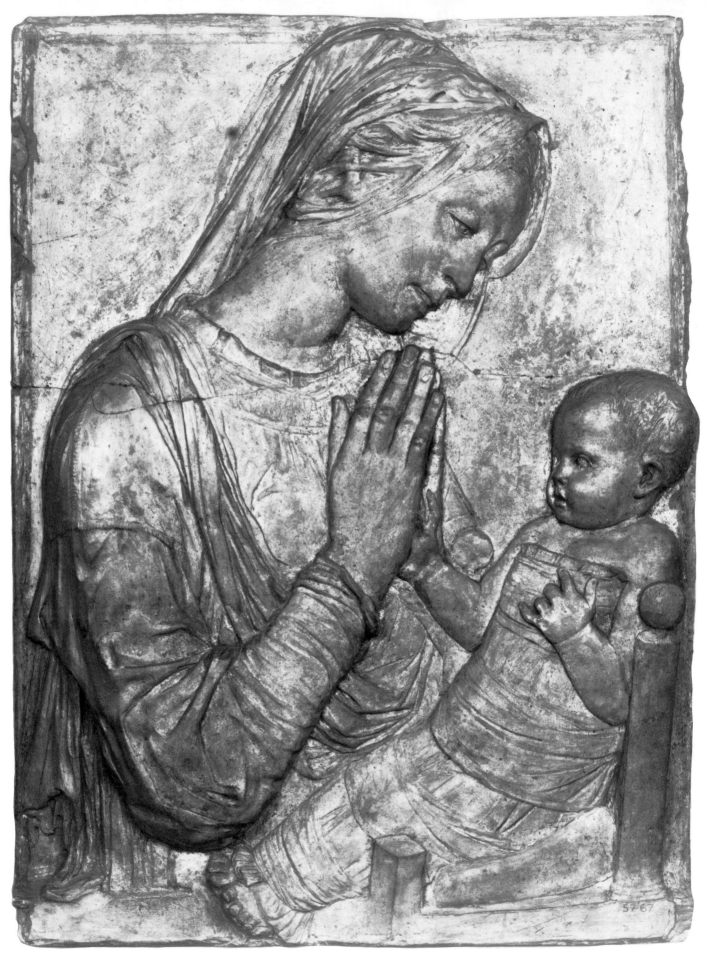

unlikely that any were made after it was given to Chellini, since the gilding now seen as traces of gold leaf applied to underlying gesso (on the moulding of the flange, the cufic lettering, the background, the haloes, the Virgin's crown, cuff and shoulder, the putti wings, bowl and railing) would have burned off if the mould were used for molten glass.

Although no contemporary examples are known, there is considerable evidence that glass was used in such a way in the fifteenth century. Filarete, sometime before 1460, notes in his *Treatise on Architecture* that glass reliefs were set into architecture, and that his friend Angelo da Murano made glass panels. This reference is to the Paduan glassmaker Angelo Barovier (1405–60), famous for his technical innovations in crystalline glass. Given Donatello's previous concern with the properties of glass in connection with the Duomo oculus, and his presence in Padua during the 1440s and early 1450s, it is quite possible that he would have known, or known of, Barovier; the bronze roundel might even have been made in Padua, since the gilding resembles Donatello's Paduan work, and Chellini's reference of 1456 is not to a commission, but a payment or gift. Donatello's interest in the aesthetic possibilities offered by the transparency of glass certainly is in keeping with his expansive and catholic taste in media. He might also have considered glass an intriguing alternative to stucco and terracotta, which he used both as architectural additions, much as Filarete suggested for glass, and as a medium for reproduction.

The Chellini *Madonna and Child*, if its owner was correct, may indeed have been intended as a mould for glass, but evidence of its casting function appears in the more common medium of stucco. Two possibly contemporary stucco casts remain, a badly damaged one in the Museo del Castelvecchio in Verona, and another in the church of San Lorenzo at Vicchio di Rimaggio near Florence. A copy in bronze, deformed probably because of a bad wax model, exists in the National Gallery, Washington, D.C. There is evidence that Luca della Robbia made bronzes to be used for reproductions in stucco, and the commercial possibilities of this process are obvious.[43] Relatively small and intimate images of the Madonna and Child seem to have become increasingly popular during the fifteenth century; Ghiberti was the first to attempt to meet, and therefore to help to create, the demand in the 1420s, and about 1430 Donatello probably entered the market, judging from the number of Donatellian images (with or without an extant original by the master) appearing at that time. As Pope-Hennessy has pointed out, it is difficult to attribute specific Madonna reliefs to Donatello, but relatively easy to find evidence of his style or compositions in those reliefs that belong to this reproduction tradition.[44]

Terracotta and stucco, materials associated with reproductions and comparatively inexpensive pieces of sculpture, rarely hold a prominent position in the reconstructed *œuvre* of a great Renaissance sculptor – the only notable exceptions being that of Luca della Robbia – partly because such pieces were more likely to break and less likely to be valued, and partly because the materials themselves are associated with useful, and perhaps therefore less worthy, objects.[45] In this context, it is interesting that Chellini defines Donatello's greatness as a mastery in bronze, wood, and terracotta (or clay), whereas a twentieth-century writer would be likely to say marble and bronze. As owner of a mould made by Donatello, however, it is not too surprising that Chellini mentions clay, especially since he then describes the colossal figure for the Cathedral; his notice might easily indicate that Donatello's production in the medium was greater than is known.

One particularly striking example of Chellini's claim is the large, gilded terracotta *Madonna and Child* in the Victoria and Albert Museum, London (Fig. 70);[46] it is now badly rubbed but, in its original gilded state, must have been as extraordinarily impressive in its medium as it still is in its composition. The tilt of the Madonna's head, toward the Child but away from the surface plane, not only increases the

70. *Madonna and Child*. 1450s. Gilded terracotta, 74.3 × 55.9 cm. London, Victoria and Albert Museum

spatial illusion, but also allows her thin veil to gather at the nape of her neck, falling behind her back, and exposing the rounded forms of both neck and shoulder. As Pope-Hennessy has noted, the terracotta is modelled, and Donatello has taken full advantage of the medium's plasticity; the replicas in stucco in the Museo Bardini, Florence, and the Bode Museum, East Berlin, are of much lower quality in their over-simplified forms and cloying treatment of the relationship between Mother and Child. In the Victoria and Albert terracotta, as in the painted terracotta *Virgin and Child* also in the Bode Museum (formerly in the Kaiser Friedrich Museum and all but destroyed by fire in 1945), Donatello has again taken a traditional image and given it complex nuances of feeling; in both cases, the Virgin is in an attitude of pious prayer as the Child naturally and warmly reaches out to her. Although the extent of Donatello's use of terracotta cannot be estimated, it is known that terracotta images of the Virgin were listed along with the most mundane commodities of his trade: a letter dated 10 June 1450, from Ludovico Gonzaga to his wife, informs her that 'three images of Our Lady, one of tufa and two of terracotta' will arrive with Donatello's freight sent by him from Padua.

In any case, terracotta was enjoying a renaissance of its own in the work of minor masters as well as of Ghiberti and Donatello, and its use was either suggested or reinforced by Pliny the Elder's discussion of it in his *Natural History*, and by Vitruvius' connection of terracotta with the Etruscans, the original settlers of Tuscany.[47] In its very use, terracotta seems to have been considered a revival of ancient art. Pliny noted that it was used for acroteria, roof-line figures decorating Etruscan temples; Donatello's terracotta *Joshua* can easily be seen as a fifteenth-century Christian equivalent. The same could be said for the terracotta putti that perch on the fanciful pediment of the *Cavalcanti Annunciation* tabernacle (Figs. 84, 71). Not only is this combination of stone and terracotta highly unusual, but the position of the two reclining centre putti suggests the shape of a triangular temple pediment, and all six figures are left in their natural terracotta colour with some gilding. The lost ornaments on the steps of the Padua Altar and the bust of *Niccolò da Uzzano(?)* (Fig. 109) were also made of terracotta; Janson notes that a contemporary copy of the bust exists in terracotta, which raises the question, again, of the medium's use for sculptural reproductions.

Part of the appeal of terracotta and stucco for Donatello must also have been their immediacy and ease of modelling. Vasari describes how stucco architectural decoration is made: mouldings are stamped with wood dies, and more complicated bas-relief compositions are worked as if the medium were clay or wax.[48] Stucco, composed of crushed marble mixed with lime from travertine, forms a top layer for larger works over a base of numerous iron nails or spikes with small pieces of brick or tufa stuffed among them. It is worked in a semi-hardened state, and Vasari claims that it becomes like marble and lasts forever. The problem, of course, is that the kind of stucco decoration Vasari attributes to Donatello in his *Life of Dello Delli* in most cases disappeared long ago. According to Vasari, Donatello in his youth assisted Dello and made with his own hand much of the stucco and gesso decoration for a roomful of furniture for Giovanni de'Medici. Whether or not this story is apocryphal, it probably indicates that Donatello was well-known for his work in the medium.

In any case, his surviving reliefs in stucco were for the Medici – the four Evangelist roundels, the four roundels of the Life of John the Evangelist, and the two panels of standing saints over the doors in the Old Sacristy of San Lorenzo (Figs. 48, 72, 73, 89, 99). Although his choice of the medium was unusual, stucco met the needs of the location perhaps better than any other material. It is relatively light and would not put excessive strain on the ceiling; sections in high relief could be built up in light tufa. Stucco could be modelled when semi-hardened or carved when dry

71. *Putti* from the *Cavalcanti Annunciation* (Fig. 84). Terracotta, with traces of gilding. Height of standing putto without base 76 cm.

72. *Sts. Cosmas and Damian.* After
1428–*c*.1440. Stucco, with
polychromy, approx. 215 × 180 cm.,
without frame and moulding.
Florence, San Lorenzo, Old Sacristy.
(See Fig. 48.)

for precision of line and detail. Additions could also be made after the stucco was
dry, and, given the size of the reliefs and the uniqueness of the task, Donatello no
doubt welcomed the medium's versatility, since he seems to have taken full ad-
vantage of these properties. The pendentive reliefs, for example the *Ascension of St.
John* (Fig. 89), pose a problem in readability, since they are at an angle to, and some
distance from, the ground and therefore receive only strongly raking light. Avoid-
ing the problem of cast shadows, Donatello used a modified *relievo schiacciato* for the
background figures and architecture, and probably achieved the exactness of line by
carving the stucco. In the roundels of the seated Evangelists, however, which are in
higher relief, Donatello modelled the seraphim at the bottom, and particularly the
hair of the saints, as if he were working on a clay model; although the roundels were
whitewashed and are in poor condition, this imprecision of outline, unexpected in
relief and accentuated by the bright and changing sunlight from the cupola, serves
to emphasize the monumentality and energy of the figures. In the four saints over
the doors (Figs. 72, 73) the stucco is finely finished, and the drapery planes shift with
great subtlety; such fluidity was probably achieved by using a wet brush over the

73. Detail of Fig. 72

nearly dry stucco. The heads are in high relief, and at certain angles in certain light even appear to be in the round; the feet extend over the ledge of the frame. In the Old Sacristy Donatello has maintained a consistency of architectural decoration by using one medium, but nonetheless has been able to vary his technique with subject matter and positioning.

His expertise in these modelled media is evident as well in his innovative handling of the gesso covering on his two wooden statues, the *St. John the Baptist* for the church of the Frari in Venice,[49] and the *Penitent Magdalene* (Figs. 113, 131).[50] The recently discovered date of 1438 on the *St. John* has led to a re-evaluation of his wooden sculpture and therefore a possible dating of the *Penitent Magdalene* as well to the late 1430s or early 1440s. In terms of Donatello's technique this is hardly surprising, since the gesso work would then fall into the same period as his similar efforts in the Old Sacristy of San Lorenzo. Earlier wood sculptors had used the gesso merely as a seal and a stable ground preparation for polychromy; although it no doubt softened some of the carving, there does not seem to have been any attempt to use the gesso as an addition to the sculptural form. Donatello, on the

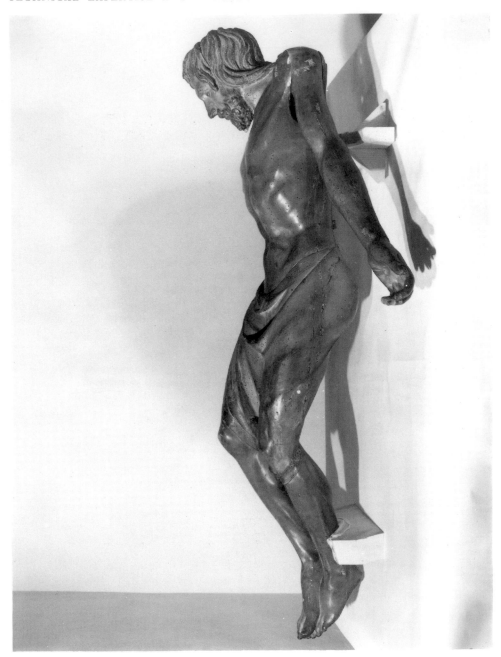

74. *Crucifix* (with arms in lowered position). *c.*1410–*c.*1425. Wood, with polychromy, height approx. 168 cm. Florence, Santa Croce

other hand, used the gesso, sometimes with bits of cloth, to build up certain areas, thereby increasing the flexibility of handling the carved medium of wood. Especially in the *Penitent Magdalene* it is obvious that he did not allow the gesso to demonstrate its own properties as a medium, but used it as if it were carved wood. The stray tendrils of hair over the Magdalene's arm are gesso additions that would be indistinguishable from carved sections were they not broken; without them, it was no doubt easier to carve the forearm, and by their addition, Donatello overcame the restrictions of the subtractive process of carving.

Wood does not seem to have been a very prestigious sculptural medium in the Quattrocento, no doubt because it lacked intrinsic value; there are no known contracts for work in it. Its most widespread use seems to have been for crucifixes such as the one in Santa Croce,[51] and the one in the convent at Bosco ai Frati,[52] both of which have been attributed to Donatello (Figs. 74, 75). Wood not only limited each figure to the diameter of the log, but its thickness needed to be carefully controlled in order to minimize cracking. In a crucifix these problems could be

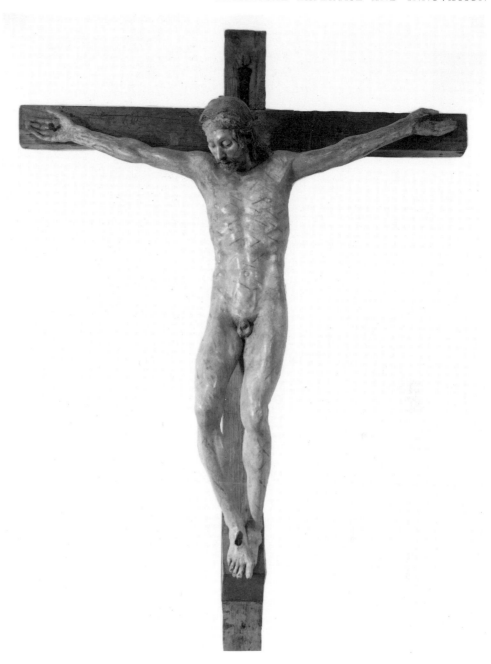

75. Donatello?: *Crucifix*. Late
1430s–early 1440s. Wood, with
polychromy, height 170 cm. Bosco ai
Frati, Convent

solved by sectioning the sculpture; the Santa Croce figure is composed of five separate pieces, with the arms jointed to allow the figure to be taken down and carried in Good Friday processions. A standing figure was traditionally hollowed out from the back to allow for the expansion and contraction of the wood; both the pose and the positioning of the figure were therefore severely constrained.

In the *St. John the Baptist* and *Penitent Magdalene*, however, Donatello has made the pose as expressive and animated as possible, stabilizing the figure not on a massive drapery base, but on a firm, spread-legged stance. Instead of hollowing the wood from the back, he cut up between the legs and, particularly in the *St. John*, thinned the figure from front to back. Although neither statue could be considered as a figure in-the-round, or one that could be seen from any viewpoint, both come closer to the Renaissance ideal of the free-standing statue than any of their wooden predecessors. Indeed, their thinness becomes an attribute of the hermit saint; the same might be said of the medium itself in Donatello's hands, since the adjectives that describe the saints – craggy, weathered – could be applied to untouched and

natural wood, and the verticality that suggests emaciation and self-denial also constitutes faithfulness to the grain and texture of the sculptural material.

Although his handling of the log was innovative, Donatello did not depart from the medieval norm in his use of polychromy. Having chosen to use gesso, he lost the option of leaving the natural wood surface one would imagine to be his preference, and which was the kind of wooden sculpture Vasari admired a century later. The colour is naturalistic but subdued, and confined to flesh tones and browns. Unlike Trecento examples, it is not colour that differentiates planes and forms, but rather natural light encouraged by gold on the highlights in the Baptist's hair-shirt and the Magdalene's hair; St. John's mantle and the edge of his scroll are also gilded, so that the sculptural form is apparent even in the dimmest light, where a flatter colour might mask the planes.

On the other hand, Donatello did use colour to distinguish form in the reliefs in the Old Sacristy. In the Evangelist roundels it is confined to bits of decorative gilding, and what seems to have been a flat blue ground presumably akin to the blue of fresco painting and seen as non-defined space. Colour serves to detach these rather high-relief figures from their background; the same seems to have been true for the martyred saints over the doorways (Figs. 72, 73). Some colour remains on the faces of these saints and, although the extent of the polychromy is unknown, the intent was undoubtedly to increase the illusion of free-standing statues. In the low relief of the scenes of the life of John the Evangelist (Fig. 89), Donatello applied colour in a truly painterly fashion: it is only because of the blue sky, the shades of brown on the architecture and landscape, and touches of black and gold on the figures that the reliefs are comprehensible in the dim light of the pendentives. On all of the San Lorenzo reliefs, however, as well as on the wooden sculpture, polychromy is subdued and restrained.

Donatello's conservative and sophisticated approach to colour on these materials, which for one reason or another required surface finishing, is not an indication that he disapproved of surface decoration or decorative colour. At one end of his spectrum are the bits of eye-catching colour in *St. Louis*'s mitre and in the Pecci tomb, and at the other, the sumptuous scheme of the Cossa tomb (Fig. 46) with the marble bier painted terracotta red and draped with a blue cloth, the pillow blue with a gold-tasselled cover, and the canopy gold-fringed, bordered with flowers, lined with a painted fabric woven with red and blue flowers, and pulled back to reveal the totally gilded bronze effigy. Between these extremes is a liberal use of gold and a mixing of media throughout his career that suggests that even if the extravagances originated with the patron, they met little opposition from Donatello's own aesthetic viewpoint.

The mystique of gold, especially in fifteenth-century Florence, whose economy depended on the stable, and internationally known, gold florin, seems to blur the distinction between taste, or style, and a show of political or social power. The gilding (perhaps overly restored) on the *Cavalcanti Annunciation* (Fig. 84) is visually important as a means of bringing attention to the relief, but perhaps also functioned to upgrade the local sandstone from which the work was carved. Although no trace of gilding remains on the marble *St. Mark*, such ornamentation is mentioned by the guild in 1411 and presumably would have been applied much as it was to the *Annunciation*, and for similar reasons. The Signoria may have been similarly motivated in gilding the marble *David* when it was moved to the Palazzo in 1416. In the Padua Altar Donatello created not only a sumptuous overview by using gold (as well as silver), but made the narrative scenes more readable by gilding the architectural backgrounds, and heightened the illusion of three-dimensionality in the other panels by gilding the ornamental patterns. The effectiveness of gilding in a dim interior is extraordinary; the gold differentiates one plane from another, while

the play of reflected light keeps the surface in constant motion. This kind of selective gilding for emphasis and clarity was a traditional treatment of bronze, and for Donatello the most important models would probably have been Andrea Pisano's doors for the Baptistry and Ghiberti's first set (Figs. 10, 13), both of which have gilded figures against a plain ground.

The taste for totally gilded sculpture in Florence is usually associated with the conspicuous and politically important *Gates of Paradise* by Ghiberti, commissioned in 1424 but not begun until several years later (Fig. 15). For Donatello, however, the most important example must have been the Sienese Baptismal Font, for which a model, probably conceived by Ghiberti, existed in 1417; by 1423 no other work seems to have been done on the font, and Donatello was assigned the *Feast of Herod*. In 1427 this relief, along with one of Ghiberti's panels, was the first work to be delivered for the project. The continuous space of the *Feast of Herod* (Fig. 95) is very different from the bits of architecture and figures in the reliefs on the first two sets of Baptistry doors, and such a simple division of gilded sculpture and bronze ground would not have been possible here. Total gilding of such a low relief obviously does not serve to differentiate forms, as partial gilding does on the doors, but then the *Feast of Herod* is not meant to be seen from a distance and greatly benefits from the increased amount of reflected light.

Although it is unknown whether the idea for total gilding originated with Ghiberti or Donatello, it is noteworthy that all of Donatello's completely gilded sculpture dates from one period, around 1425; it is also remarkable that the examples do not seem to share the same reason for their gilding, but rather exemplify different possibilities. Gilding on the *Feast of Herod* may have been an aesthetic solution to a problem of its position, but on the *St. Louis of Toulouse* at Orsanmichele it is more clearly a bid for power by the Parte Guelfa (Fig. 129). On the *San Rossore* (Fig. 110) it is a visual reference to the traditional relic-case form, and on Cossa's effigy (Fig. 47), a sumptuous and perhaps defiant reference to papal splendour. It is also possible that gilding was seen as a revival of classical art, since Pliny notes that bronze, originally used for figures of gods and only later for images of men, was commonly gilded. A copy of Pliny's *Natural History* is listed in Piero de'Medici's inventory of 1464, and traces of gilding remain on the antique bronze horse's head that had been a fountain at the Medici palace; also the important equestrian statue of Marcus Aurelius in Rome was gilded.[53] In any case, the volatility and changeability of the gold surface, in either bright or dim light, would certainly have appealed to Donatello.

The question of aesthetic versus monetary value arises too in connection with Donatello's inventive mixtures of media, but it is more often settled in favour of visual creativity. The gold mosaic work set into the marble behind the putti in the *Cantoria* and the *Prato Pulpit* (Figs. 93, 103) is much more important for the illusion of depth than for the illusion of wealth; the combination of marble and mosaic had long been known in the form of decorative Cosmati work, and Donatello simply expanded its function. Bronze and marble provided still another contrast in colour and texture: two bronze heads were added between the consoles under the *Cantoria*, and the supporting capital under the *Prato Pulpit* is bronze. In its originally gilded state the Prato capital would surely have been impressive, but it is probably safe to assume that Donatello's choice of bronze was also related to Pliny's notice that it had been chosen for the capitals of the columns in the Pantheon, and that this fashion was adopted by wealthy Romans for their private houses.[54] A few statues probably had parts in less permanent materials, which long ago disappeared: the marble *David* must have had a sling, probably of leather; *St. John the Evangelist* originally held a pen, most likely of bronze; the *Atys-Amorino* held something in his hands, probably something in another material since there is no evidence of an

attachment, and *St. George* probably had a helmet and a weapon made in metal. In the case of the Cossa tomb, the use of different kinds of media was probably influenced by its location; the marble relates it to the Baptistry columns, while the bronze sets the tomb apart, emphasizing the effigy (Fig. 46). Donatello was seemingly bound neither by medieval ideas of appropriate or inappropriate combinations of media, nor by the later notion of pure material.

Nowhere does this seem to have been truer than on the Padua Altar. At the centre of this large complex was a group of life-size standing saints (Figs. 127, 128) around an Enthroned *Madonna and Child* (Fig. 101); although these figures may strike the twentieth-century viewer as remote and severe – a reaction due as much to the darkness of the bronze as to their relatively sombre expressions – documents reveal that they were originally decorated with gilded highlights. The sacred space surrounding them was rich, colourful, and varied; it was defined by an architectural canopy supported and enframed by eight marble columns with bases, of which four were round with fluting, and four were square; if the latter are the ones identified by Sartori, they were decorated with figural motifs. The records also mention marble mouldings and cornices both painted and gilded; the whole was surmounted by a cupola, above which was a stone figure of God the Father. Two surviving volute fragments suggest a pedimental scheme similar to that of the *Cavalcanti Annunciation* (Fig. 84). This was all raised on a base lavishly decorated at eye-level with twenty-one bronze reliefs of various sizes, most of which are documented as being 'adorned' with both gold and silver highlights: four scenes, each more than a metre wide, representing miracles of St. Anthony of Padua (Fig. 97), and, at the corners, large square reliefs of the symbols of the Evangelists. The original scheme included ten vertical panels of musical angels (Figs. 32, 33), which would have been arranged in relation to the narratives and/or the Evangelist panels, but two panels of paired singing angels and a Dead Christ with Angels were added when a tabernacle for the Eucharist became an important part of the altar. Behind and below the retable was a large relief of the *Entombment* (Fig. 92) with brightly coloured inlaid marble patterning on the sarcophagus, frame, and background; the two ruined marble relief fragments in the Fondazione Salvatore Romano in Florence may have been part of the Padua Altar and have similar inlaid marble patterns. Documents also mention 'certain flowers' made by a potter, who also provided terracotta tiles and border-strips. Some parts of the altar were made of alabaster, for which Donatello personally supervised the quarrying. One set of altar steps was made of red and white Veronese marble, a second of *pietra di Nanto*. The altar frontal and the 'pavimento' (the floor of the shrine that enclosed the Madonna and saints?) were painted by the Paduan artist, Francesco Squarcione, teacher of Mantegna. Presumably the coat-of-arms of the altar's first donor was placed somewhere on the complex as specified in his will. The complexity and variation of the Padua Altar are directly related to its size and architectural nature, as well as to the size and extravagance of the Santo itself; yet they also reflect the complexity and variation of Donatello's attitude toward his media.

An artist who distinguishes himself by his technique runs the risk of being praised for his 'craftsmanship' – a nearly damning art-historical comment – or of being criticized for his facileness. Yet Donatello never relied completely on his technical skill or on the qualities of his medium to carry the burden of evoking the aesthetic response. Even in works that might at first captivate the viewer because of the surprise of the medium, the gilded *St. Louis of Toulouse*, for instance, or the wooden *Penitent Magdalene*, his technique remains the means to an end, never an end in itself.

CHAPTER FIVE

Illusion and Drama in Relief Sculpture

The world is so full of Donatello's works that it can truly be affirmed that no artist ever produced more than he. Taking pleasure in everything, he put his hand to all things, without considering if they were lowly or esteemed. There was nothing which is necessary to sculpture lacking in Donato's work in all kinds of sculpture – in the round, half-relief, low relief and the lowest relief.... Besides making the difficulty of art seem easy with the abundance of his works, he brought together inventiveness, design, skill, judgement, and every other quality that a divine genius possesses.

He is therefore rightly recognized as the first to make good use of the invention of scenes done in low relief, which he executed with thoughtfulness, facility and skill, demonstrating his intimate knowledge and mastery of the technique and producing sculptures of unusual beauty.

Vasari, *Life of Donato*, 1568

As a sculptor of reliefs, Donatello is renowned for two radical innovations: the technique known as *rilievo schiacciato* and the first use in sculpture of the linear perspective system developed by his contemporary Brunelleschi. Both innovations enabled him to create a much greater illusion of space than had previously been possible; linear perspective also allowed him to intensify this illusion by establishing a precise relationship between the spectator and the scene depicted, thereby enhancing the dramatic effect the narrative had on the viewer. Vasari's praise of Donatello's expertise in relief sculpture was not a rhetorical formula but, as the reliefs themselves prove, an appreciation of his unique intelligence and skill.

When Donatello received his training, the style of relief sculpture being practised in Florence was the same as that employed by Andrea Pisano almost a century earlier. As Ghiberti's *Agony in the Garden* demonstrates (Fig. 13), this technique is perfectly adequate for a scene in which all the figures are represented in the immediate foreground. Its limitation is that there is little potential for recession. Each form is treated as if it were a three-dimensional miniature, and, as Pope-Hennessy observes, the figures 'register as statuettes'.[1] The difficulties become clear when one realizes that a representation of a human figure in a small relief like Ghiberti's will be approximately twenty centimetres high and three centimetres thick; if the depth of the relief is a generous six centimetres, then no more than two figures can be overlapped, restricting one of the most important clues by which the eye perceives the relative position of forms in space. Ghiberti, in fact, has avoided overlapping his figures here, except for the torso and legs of one of the Apostles, which disappear behind the body of St. Peter on the right. An additional difficulty is that the attempt

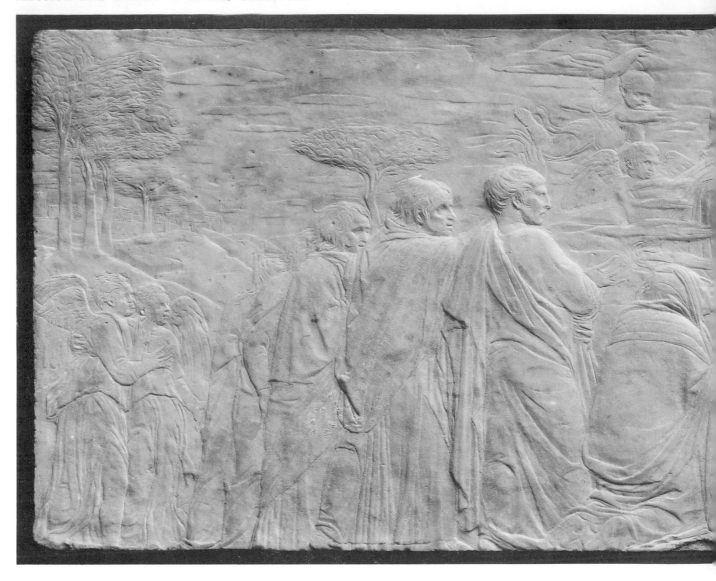

to read deep space in the relief is immediately prevented by its flat background; the angel alone penetrates this background plane, but he is represented as if coming out toward the spectator, reversing the eye's natural urge to move back into illusionistic depth. It is a sign of Ghiberti's genius that he has with seeming ease developed a complicated and convincing composition within the spatial limitations of this style of relief sculpture.

76. *The Ascension, with Christ Giving the Keys to St. Peter*. 1420s–early 1430s. Marble, 41 × 114.5 cm. London, Victoria and Albert Museum

Ghiberti's *Pentecost*, however, reveals how the restrictions of the traditional style can become insurmountable (Fig. 10). The requirements of this narrative, thirteen figures gathered in an upper room while a large group eavesdrops outside, are almost impossible to render while maintaining the figure scale established by the other scenes of the Baptistry Doors. To compensate, Ghiberti has been forced to create a building out of scale with the figures, and even then the Virgin and the Apostles must be squeezed in at the top of the relief.

Donatello's unorthodox solution to the problems posed by the traditional relief can best be demonstrated by examining a fully developed work, the marble relief of *The Ascension, with Christ Giving the Keys to St. Peter* (Fig. 76).[2] The actual depth of this relief is only about one-fifth of that of Ghiberti's *North Doors*, yet a sense of spatial continuity extends from a row of overlapped figures in the foreground to a distant landscape with trees, clouds, and even to the city of Jerusalem on a hilltop in the left background. Not only has Donatello dissolved the flat background, which

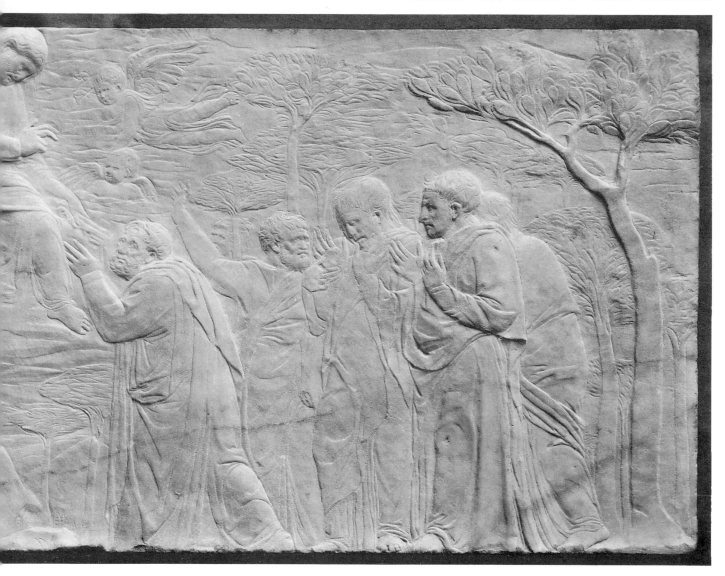

so limited the illusion in Ghiberti's *Agony in the Garden*, but he has succeeded in creating a suggestion of atmosphere; the clouds even seem to thicken as they gather around Christ, while angels disappear and reappear in the mist.

In this new, extremely low relief no form has the three-dimensional bulk required of every object in the traditional mode: the projection exceeds the thickness of a sheet of paper only in the most important figures. The *Ascension* is one of the most subtle examples of Donatello's *rilievo schiacciato*, and although the term literally means 'flattened' or 'squashed', as in *schiacciata*, a popular Tuscan bread that is flattened before being baked, Donatello has not created this relief by physically crushing his medium. He has, rather, chiselled the marble surface to create indentations and protrusions that will catch the light; the illusion of forms in a surrounding space results from the effect of light hitting his delicately modulated surface, creating highlights and shadows. *Rilievo schiacciato* is rather like drawing with light and shadow, and this new relief style was developed during the same period that cast shadows were being rediscovered by the painters of Florence (Figs. 17, 77).[3] Unfortunately, photographs of works in the technique must be taken with a strong raking light, which distorts the subtle effects it makes possible; shadows become exaggerated and harsh, while the depth of relief seems more palpable than it actually is. The luminosity of the marble, so evident in an original, cannot be captured in a black-and-white illustration.

Rilievo schiacciato makes possible not only overlapping, but also diminution, a further visual clue to the relative position of forms in space. Diminution is virtually impossible in the relief type practised by Ghiberti, though he clearly made an attempt to reduce the size of the upper figures in the *Pentecost* (Fig. 10). In Donatello's *Ascension*, however, overlapping and diminution are combined to establish convincing relationships between the Apostles, trees, buildings, and clouds in a spatial continuum. *Rilievo schiacciato* obviously encouraged the development of complex scale and spatial relationships not attainable in the traditional relief technique.

The illusion is heightened by the fact that Donatello has established a precise viewpoint for the observer. By eliminating the ground plane he implies that we must be positioned slightly below the surface on which the figures are standing. This plane, which in the usual Renaissance composition plays an important role in indicating space, appears in Donatello's relief only as the line on which the foreground Apostles seem to stand; we see only its edge, and the effect is rather like sitting in the front row at the theatre. The feet of the other Apostles cannot be seen, and the level of their heads is below, rather than above, that of the closer figures. We are forced to assume a low position relative to the scene, and as we look rather sharply upward at the focus of the composition, the ascending Christ, we realize how Donatello has integrated viewpoint and narrative; the drama of the Ascension, an event not expected by the Apostles who witnessed it, is emphasized by the position defined for the spectator, and the long, horizontal relief achieves an emphatically vertical momentum appropriate to its subject. Whether the precise viewpoint implied was first suggested by the original position of the work or was initially conceived as an aid to make the illusion more convincing, and to heighten the narrative, is not clear.

The original function and location of the relief are uncertain. Its recorded history begins only in 1492, when a relief of this subject appears in inventories of the possessions of Lorenzo de'Medici. Internal evidence, however, suggests a connection with the Carmelite church of Santa Maria del Carmine in Florence, and in particular with the Brancacci Chapel, frescoed in the 1420s by Masaccio and Masolino (Figs. 17, 77).[4] There are strong similarities between the scenes presented

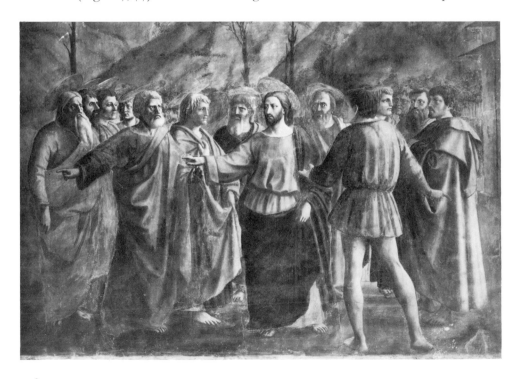

77. Masaccio: *The Tribute Money*. *c.*1425–*c.*1427. Fresco, 255 × 598 cm. Florence, Santa Maria del Carmine, Brancacci Chapel

in Donatello's relief and a mystery play staged annually at the Carmine as part of the Feast of the Ascension; portions of the following synopsis of the performance, based on a description written by Abraham, Bishop of Souzdal, after seeing a production in 1439, could almost describe Donatello's marble relief:

> On his arrival in the church [Abraham of Souzdal] found a stage disguised as a hill, the Mount of Olives. Below to the left, on the far side of a partition, was a castellated structure, the city of Jerusalem, and above, fifty or more feet from the ground, was a platform concealed by a blue curtain painted with sun, moon and stars. When all of the spectators were assembled, there appeared on the main stage four youths dressed as angels leading an actor representing Christ towards Jerusalem. After a brief interval these figures re-entered from the city, bringing with them the Virgin Mary and St. Mary Magdalene. Returning once again to the castellated structure, the actor representing Christ fetched from it the apostles, headed by St. Peter, whom he led up the stairs to the main stage. Arrived at the Mount of Olives, the Virgin Mary moved to Christ's right, St. Peter to his left, and the apostles, 'barefoot, some beardless, some with beards, just as they were in life', ranged themselves on either side of the main group. After a brief dialogue, in which Christ conferred on each of the apostles his peculiar gifts, he climbed to the summit of the hill, speaking the words: 'Since all that was prophesied concerning me is now accomplished I go to my Father, who is also your Father, and to my God, who is also your God.' The Apostles turned to one another in consternation, exclaiming, 'O Lord, do not abandon us, for without Thee we are as orphans', to which Christ replied: 'Cease weeping, for I do not leave you orphans. I go to my Father, and I will beseech him to send the spirit of consolation and truth upon you, which will teach you all things. If I do not depart, the Paraclete will not descend upon you.' At this point a clap of thunder resounded through the church, and a cradle, masked by painted clouds, descended on pulleys from an aperture above the stage. During its descent, the actor representing Christ took up two golden keys, and blessing St. Peter handed them to him with the words: 'Thou art Peter, and upon this rock I will build my church.' Thereupon Christ took his place on the cradle, and with the aid of seven ropes was slowly hoisted out of sight, leaving the apostles bathed in tears below. 'A marvellous performance,' notes Abraham of Souzdal, 'and without equal anywhere.'[5]

In the Gospel accounts the Donation of the Keys and the Ascension of Christ are two distinct events, and their combination in both play and relief seems unlikely to have been coincidental.

Despite the fact that the Donation of the Keys is the most significant episode in the legend of St. Peter – it establishes his claim to primacy – it does not appear in the cycle of frescoes dedicated to the Legend of St. Peter in the Brancacci Chapel, even though the episode was especially important to the Carmelite order in charge of the Carmine.[6] Besides filling a serious void in the Brancacci Chapel narrative, Donatello's relief has yet another connection with the chapel: the semicircular arrangement of the figures around Christ is closely related to the composition of Masaccio's fresco of the *Tribute Money* (Fig. 77) and, as Millard Meiss has pointed out, Donatello's use of this composition is unique in his *œuvre*.[7] Adding further support to these connections between Donatello's relief and the Brancacci Chapel is the fact that the types of Donatello's Apostles are similar to those painted by Masaccio; as in the fresco, the figures in the relief range from the coarse and realistic St. Peter to classicized Apostles, such as the one standing to the left behind the kneeling Virgin Mary. The conclusion that Donatello's *Ascension, with Christ Giving the Keys to St. Peter* was originally part of the decorative scheme of the Brancacci

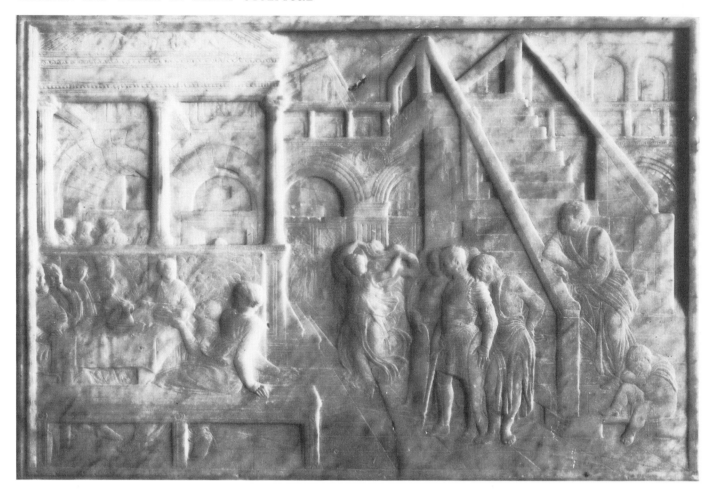

78. *The Feast of Herod*. 1420s–1430s. Marble, 50 × 71.5 cm., relief 43.5 × 65 cm. Lille, Musée des Beaux-Arts

Chapel is iconographically and visually compelling; a high position, as part of the altar or altar tabernacle, would take full advantage of the spectator's carefully defined viewpoint.

An equally accomplished *tour de force* of *schiacciato* carving in marble is the *Feast of Herod*, now in Lille (Fig. 78).[8] Like the *Ascension*, it too is apparently first documented in the Medici inventory of 1492, and it is possible that these works were among the reliefs by Donatello described by Vasari in 1550 as being in the Palazzo Medici: 'other stories, executed in marble with very beautiful figures, and of *schiacciato rilievo maravigliose*'. Similar in shape and size and seemingly not distant from each other in date, the two reliefs demonstrate Donatello's involvement with *rilievo schiacciato* in the years around 1430. In both, the delicacy of the carving creates almost magical effects of atmosphere and movement, demonstrating technical proficiency of the highest order.

In the *Feast of Herod* the ground plane is not only visible, it is demarcated in a manner that reveals Donatello's use of the linear perspective developed by Brunelleschi. The complex architectural scheme is also controlled by this system, but even it does not explain the most distant structure, which is set at an oblique angle to the rest of Herod's palace. More than in any other work by Donatello, the architecture here becomes an end in itself; it is like a scenographic fantasy intended to draw the audience's attention away from the dramatic narrative taking place on the foreground stage.

This perspective construction, with its vanishing point near the column base directly to the left of the dancing Salome, is undoubtedly based on Brunelleschi's system for representing architectural masses and spaces on a flat surface. Alberti, who seems to have been the first to write about it, called the system 'costruzione

legittima' and referred to the vanishing point as the 'centric point', but Brunelleschi's biographer Manetti called it simply 'perspective', as did Vasari. Today known as linear or scientific perspective, its origin and development are among the most discussed problems in Renaissance art history.[9]

Linear perspective provides a means of representing on a plane surface the illusion that parallel lines converge at a point on the horizon. As Richard Krautheimer has pointed out, Brunelleschi, the pragmatic engineer and architect, seems to have evolved this system because of its particular usefulness to his concerns: 'as a means of representing building projects in perspective and to scale, and of surveying existing architecture, whether Roman ruins or architectural sites in Florence'.[10] The dates of Brunelleschi's evolution of the system, which must have been gradual, and of his presentation of it in two lost panel paintings, are unknown. Donatello may even have been involved in its development, since Manetti reports that during a trip to Rome Brunelleschi and Donatello measured many buildings and 'drew the elevations on strips of parchment graphs with numbers and symbols which Filippo alone understood'.[11] Samuel Edgerton's recently proposed date of 1425 for Brunelleschi's perspective panels is arbitrary and seems too late, especially since Donatello's bronze relief of the *Feast of Herod* (Fig. 95), one of the most complex demonstrations of the fully developed scheme, was probably completed by August of that year, and Donatello had already used the system, albeit somewhat tentatively, in an earlier work (Fig. 80). A date of *c.*1410–20 seems more reasonable for the two Brunelleschi demonstration panels.[12]

The Brunelleschian system of linear perspective was enthusiastically adopted by Renaissance painters because it provided a simple means of constructing an illusion of deep space and of controlling the scale of figures and objects within that space. Once a few easily understood rules were mastered, a painter could create a convincing representation of a spacious piazza populated both near and far with figures and objects in correct scale, and the new Renaissance concept of the 'painting as a window' owes much of its success to this scheme. Although Trecento painters had already begun to design compositions in relation to the spectator, the realization that the vanishing point should be placed directly opposite and on the same level as the spectator's eye enabled Quattrocento painters to calculate more carefully the relationship of the viewer to the work of art. Donatello's *Ascension, with Christ Giving the Keys* (Fig. 76) is devoid of the architecture demanded by the linear perspective scheme, but his sensitivity to the spectator's low viewpoint demonstrates familiarity with Brunelleschi's ideas. The new Renaissance concepts of the work of art as a controlled illusion and of the importance of the fixed viewpoint were major preoccupations of European painting, if not of relief sculpture, until the late nineteenth century; only the reassertion of the importance of the flat surface of the picture and the incorporation of the constantly changing viewpoint of the artist in the work of Cézanne brought this long tradition to an end.

The use of Brunelleschian perspective in Early Renaissance art is not always aesthetically satisfactory, for so simple and effective a device encouraged artists to make works that first and foremost demonstrated their mastery of the system. In these paintings and reliefs the spectator is seduced into a dramatically recessed architectural perspective toward a vanishing point, only to discover that the spatial effect is the most interesting aspect of the work. Donatello's *Feast of Herod* at Lille does not have this particular problem, since the vanishing point, slightly off-centre, is well-hidden; nevertheless, it is the display of complex architecture in perspective that dominates the work (Fig. 78).[13] The theme of the dance of Salome and the presentation of St. John's severed head to Herod, one of the most gruesome tales in Western art, takes second place to loggias, arcades, and a prominent staircase.

Fortunately some of Donatello's reliefs survive *in situ*, or their original sites are

79. *God the Father*, relief from the *St. George Tabernacle* (Fig. 28). *c.*1415–*c.*1417. Marble, height 68 cm. Florence, Orsanmichele

known, so that their effectiveness in relation to setting can be analyzed. Among his earliest low reliefs are the two in marble that adorn the gable and predella of the St. George tabernacle at Orsanmichele (Figs. 79–81). The photograph of the *God the Father* relief at the apex of the tabernacle was taken from a height level with the relief; seen from the street, however, God does not appear to be distorted but simply looking sharply downwards, toward St. George in the niche below.[14] The overlapping of the frame by God's halo thrusts the figure forward, relating him to the saint. Although the relief of God the Father uses the flattening of forms characteristic of *rilievo schiacciato*, its physical depth is significantly greater than that of the *Ascension* and *Feast of Herod* reliefs (Figs. 76, 78). The more assertive relief technique here surely results from Donatello's having taken the outside setting and viewing distance into account.

On the other hand, the style of the predella, which represents the scene of St.

80. *St. George and the Dragon*, predella of the *St. George Tabernacle* (Fig. 28). *c*.1417. Marble, 39 × 120 cm.

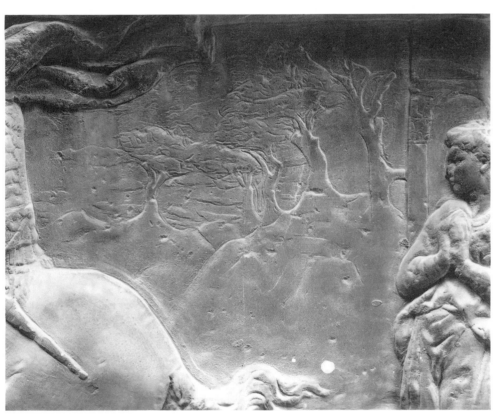

81. Detail of Fig. 80

George and the Dragon (Figs. 80, 81), seems at first inconsistent. Some areas are treated in relatively high relief (the dragon, George, the princess, and most of the horse) while the cave, loggia, trees and clouds in the background are in very low relief. The restriction of the *schiacciato* technique to the background areas in this case may be explained as a concession to the exterior location of the relief, where strong light and distance would make pure *rilievo schiacciato* difficult to read. In other words, by this point in his career Donatello had developed the technique, and had realized how it might be used in conjunction with the traditional high relief mode. In the *St. George* predella, narrative composition and depth of relief are coordinated; the areas of more palpable relief draw attention to the actors in the drama, while the *schiacciato* cave and loggia are treated in illusionistic recession to create an effect of space within which the action of the battle is represented. The rough stones of the dragon's cave and its entrance arch are foreshortened, and the loggia on the right,

82. *Tomb of Giovanni Pecci, Bishop of Grosseto. c.*1426. Bronze, with traces of enamelled inlay, 247 × 88 cm. Siena, Cathedral

complete with a view into its interior, is probably the earliest example of Donatello's use of linear perspective.[15] He has already realized the narrative potential of the Brunelleschian scheme and has directed the receding orthogonal lines to the central figure of St. George.

Donatello's interest in coordinating illusionism with the viewpoint of the observer led to a unique solution to the problem of the medieval floor tomb in the *Tomb of Giovanni Pecci* (Fig. 82).[16] Jacopo della Quercia's contemporary *Tomb of Lorenzo Trenta* demonstrates how the recumbent figure of the deceased was traditionally represented, as if seen from directly above (Fig. 83). This view is quite satisfactory in a photograph (with the exception of the awkward flattening of the feet), and as the tomb itself is an abstraction there seems little reason to demand a particular viewpoint. Donatello, however, reveals his dissatisfaction with the *status quo* by establishing a single viewpoint at the foot of the Pecci monument. The most immediate clue to the intended viewpoint is the inscription, which in most previous examples encircled the figure (Fig. 83). On the Pecci tomb it is written on a scroll held by two small putti below the feet of the figure, and when the viewer is in position to read the inscription the soles of the Bishop's feet are visible, confirming this viewpoint.

The figure lies in a concave, semicylindrical bier of which we glimpse the bottom edge (below the Bishop's feet) and also the sharply foreshortened supporting legs. Below this we are allowed to see parts of a pair of panelled frames, apparently intended to suggest the floor of the church. The placement of Donatello's signature on one of these panels is a witty touch, for it suggests the illusion that bier and scroll cover a tomb by Donatello in the floor beneath. With the exception of the feet, the figure seems purely conventional in its treatment; like Lorenzo Trenta the Bishop is represented as if seen from above. But the bier includes references to foreshortening in the cylindrical elements at its edges, in the shell niche, and in the curves of the panelled inner surfaces near the right shoulder, thigh and feet. Enhancing the realism of this recession is the cut-out shape of the monument, which minimizes any suggestion that the Pecci tomb is merely another decorative paving slab intended to cover a rectangular area of Cathedral flooring.

In traditional tombs, such as that of Lorenzo Trenta, the deceased was often shown as if lying in eternal rest, but despite the sense of peace and serenity conveyed by the face and delicate hands of Bishop Pecci, Donatello's tomb monument insistently avoids such eternity – the Bishop is shown on his bier, not in his tomb. Adding a distinct note of immediacy, two putti wrestle with the stiff scroll carrying the inscription and coats-of-arms, which seems to threaten to roll shut. Although their bodies are largely hidden by the scroll, their efforts are readily apparent; the putto on our left has his hair vigorously swept back from his forehead, and he even seems to be using his nose to restrain the scroll. The Pecci tomb provides more than an illusion; it makes a pointed contrast between life and death.

Donatello's innovations in *rilievo schiacciato*, in linear perspective, and in the coordination of viewpoint and illusion, reveal not only the Renaissance concern with creating a work of art that is realistic, true to what the eye sees, but also the emergence of an important new attitude: the artist's consciousness of those who will see the work of art. This new awareness of the spectator can be understood as part of what Jakob Burckhardt, in *The Civilization of the Renaissance in Italy*, termed 'The Discovery of Man'. The sensitivity of the artist to the response his work will elicit becomes part of the creative process, and Renaissance art must be analyzed in the light of this new subtlety of interaction between artist, spectator, and the work itself.

Donatello's relief style, however, is not limited to illusionistic *rilievo schiacciato*. Never satisfied with a single solution, he explored other ways of making relief

83. Jacopo della Quercia: *Tomb of Lorenzo Trenta*. 1416. Marble, 247 × 122 cm. Lucca, San Frediano

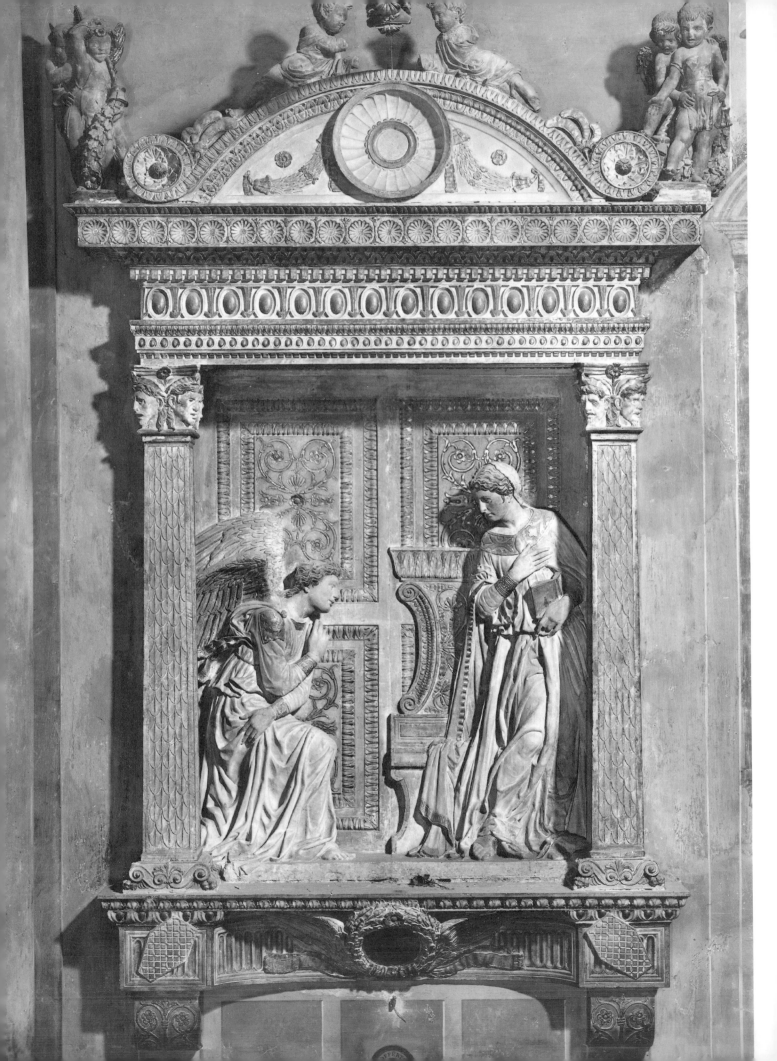

sculpture expressive; he also restricted the illusion, and incorporated actual space into the relief. In the *Cavalcanti Annunciation* at Santa Croce, for example, a richly patterned and partially gilded background immediately behind the figures prevents the illusion of further depth (Figs. 84–86 and Frontispiece).[17] The life-sized figures seem three-dimensional, and the deep tabernacle (it both protrudes from the wall and is recessed into it, making possible an internal depth of about sixty centimetres) defines a space that adequately contains the two carved figures. Were it not that figures and background are carved from the same blocks of stone, there would even be some question whether this is a relief sculpture. The *Annunciation*, in fact, is less like Donatello's illusionistic *schiacciato* reliefs than like a much enlarged version of the traditional relief style of Ghiberti's *Agony in the Garden* (Fig 13).

The restricted spatial effect is an appropriate accompaniment to this Annunciation, for even the dove of the Holy Spirit, listed in iconographic handbooks as an 'essential' element in representations of this subject, is absent. The circumscribed scene includes only the angel Gabriel, the Virgin, her book and lyre-back chair. The flat background completely avoids the suggestion of the complex architectural illusionism so favoured in contemporary paintings of the Annunciation: there is no loggia, no view into the Virgin's bedchamber, and no symbolic garden (*hortus conclusus*).[18] In addition, the angel does not carry a lily, and the Virgin is not even allowed the luxury of the reading-stand so often included in Trecento treatments of this scene.

It seems at first as if Donatello has chosen to represent the moment when Gabriel has just alighted. His large wings are still unfurled, the drapery and ribbon at his right shoulder are swept back by his rushing motion, and rather than kneeling he has assumed a momentary genuflection on his left knee. His mouth is open, as if he were captured in the very act of addressing the Virgin: 'Hail, thou that art highly favoured' (Luke 1:28). She holds the open book she was reading when Gabriel entered; according to St. Bernard, she had just read the prophecy in Isaiah 7:14: 'A virgin shall conceive, and bear a son.' Like Gabriel, the Virgin is caught in motion: she is in the process of rising, her mantle still draped on the seat of the chair behind her. Although the lower part of her body is turned away from the angel, her right foot, raised in retreat, is still poised in mid-air. A shift away from the strong left-to-right movement established by the angel is initiated by the placement of the Virgin's torso parallel to the background, and by the positioning of her hand over her heart; it is continued as her head turns back toward the angel, so that her face is in almost full profile. Her movement initiates a reciprocal exchange of glance from Mary to the angel and back again. The position of her hand on her heart must signify her acceptance of Gabriel's announcement: 'Behold the handmaid of the Lord.' (Luke 1:38). She seems to radiate nobility and intelligence; the serenity of her expression makes it clear she has already overcome the momentary fear expressed in her pose.

Donatello, then, has incorporated the sequential development of the narrative into his representation: the angel's arrival and proclamation, the Virgin's initial response of fear ('She was troubled at his saying.' Luke 1:29), and her ultimate acceptance after Gabriel's reassurances, are all seen at once. We experience the entire episode. Donatello's interpretation is very different from the traditional Florentine Annunciation, which stressed that the conception of Christ was imminent by including a representation of the dove, or golden rays from heaven, or the figure of God the Father; even Ghiberti's small *Annunciation* relief on the *North Doors* includes all three of these elements. By their absence in the *Cavalcanti Annunciation,* Donatello implies that the conception of the Messiah has already taken place; the moment he represents encompasses both Annunciation and Incarnation.

The richness of the surrounding tabernacle enshrines and glorifies the conception, while at the same time one of the decorative elements also serves to comment

84. *The Cavalcanti Annunciation.* 1430s. Sandstone tabernacle with gilding (restored), terracotta putti with gilding, height of tabernacle 420 cm. Florence, Santa Croce. (See also Frontispiece.)

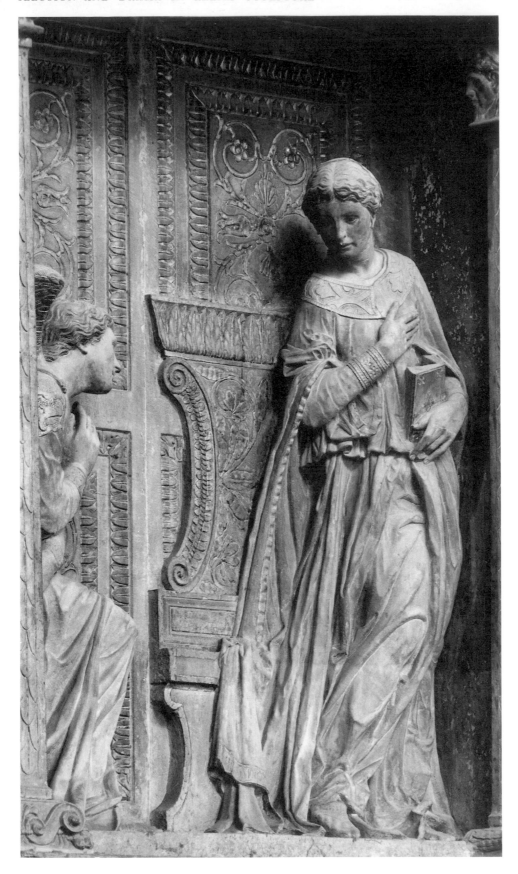

85. Detail of Fig. 84

86. Detail of Fig. 84

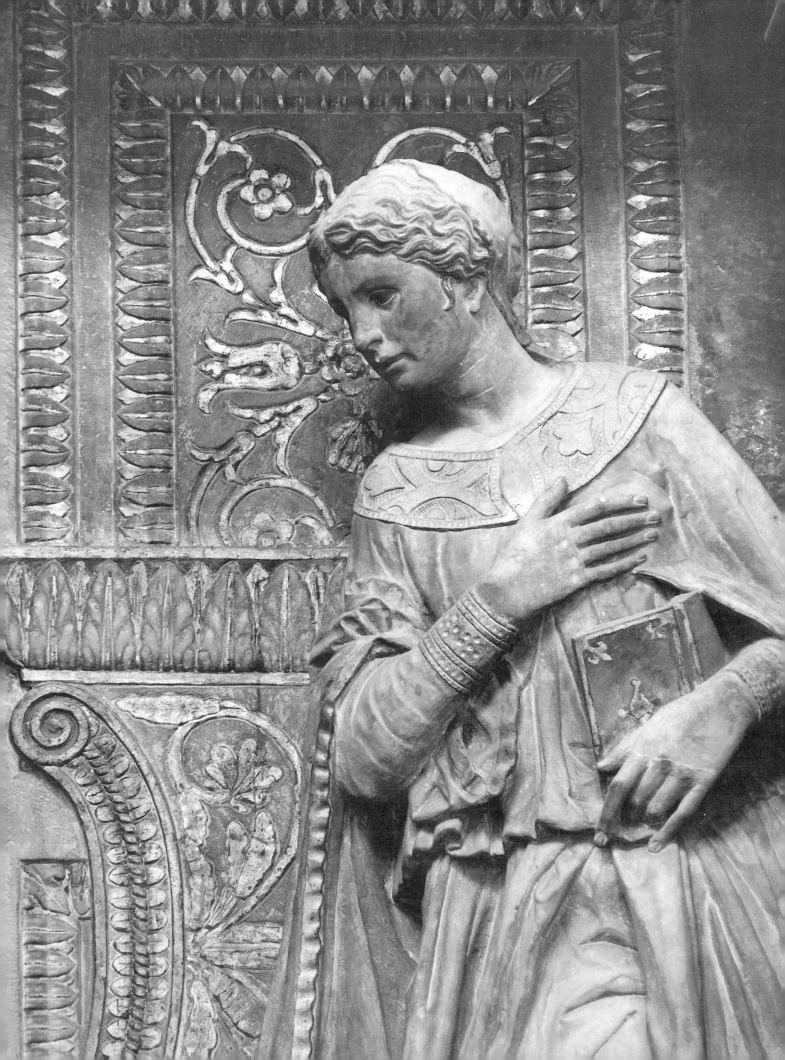

on the narrative. As early as 1550 Vasari noted that the garland-bearing putti above the entablature 'seem afraid of the height and cling to each other for reassurance' (Fig. 71); their acrophobia is in distinct contrast to the serenity seen on the face of the Virgin. She has already overcome the fear, emphasized in her pose, that she felt on first learning she would be the mother of the Son of God.

The physical presence of Mary and Gabriel as life-size, almost three-dimensional figures is enhanced by their position in the carefully defined real space of the tabernacle. The decorated flat background emphasizes the suggestion of captured movement, while its flatness and regularity heighten the balletic relationship of the two figures. The architectural regularity of the tabernacle helps define the reciprocal curves of their poses, while the rounded forms of pediment above and wreath below harmonize with the figural composition. Similarly, the long and elegant curve of Mary's pose is repeated in the bowed shape of the back of her chair. Suppression of space and denial of illusionism here serve to enhance narrative content.

The avoidance of illusionistic recession evident in the *Cavalcanti Annunciation* may also be seen in the two sets of bronze doors made by Donatello for the Sacristy of the Church of San Lorenzo (Figs. 48, 87, 88). The doors are basically simple in design; they resemble panelled wooden doors, but in each of the twenty, almost square panels two figures are represented against a plain background. This motif of paired standing saints is also found in the arched stucco reliefs surmounting these doorways (Fig. 72). Though the latter saints are identifiable as Stephen, Lawrence, Cosmos, and Damian, the iconography of the forty saints on the doors has been a matter of debate. Donatello did not provide each figure with a distinguishing attribute, which suggests that he did not intend a specific identity for each figure. A few, however, may be identified. On the left pair of doors (Fig. 87), Stephen, Lawrence, Cosmas, and Damian reappear as the upper four saints. Lawrence, an early Christian martyr, is the patron saint of the church of San Lorenzo, while Cosmas and Damian, also martyrs, are among the patrons of the Medici family, donors of both the sacristy and its Donatellian decoration. Stephen was the first Christian martyr, and the fact that most of the other figures of the left door hold martyrs' palms has led to its identification as the *Martyrs' Door*. The right door has been called the *Apostles' Door*, but in addition to some clearly recognizable Apostles it includes representations of the four Evangelists and the four Latin Church Fathers, Saints Ambrose, Jerome, Gregory, and Augustine. The iconography of this door seems to centre on St. John the Evangelist, name saint of Giovanni di Bicci de'Medici and patron saint of the sacristy. The inclusion of both Apostles and Evangelists may be explained by the fact that John the Evangelist was both; the Church Fathers are later authors who continued the tradition of Christian exegesis founded by John.

The twenty panels with their representations of paired saints provide perhaps the best demonstration of Cristoforo Landino's description in 1481 of Donatello's style as being characterized by 'varietà'.[19] Donatello has used the repetitiveness of the simple format of the doors to his advantage, for it provides a unity and structure within which he was able to stress differences among the pairs of saints. He interpreted the subject of the doors as being human discourse or intellectual dialogue. He uses every device available – pose, relationship to frame, facial expression, gesture, drapery, and attributes – to aid him in characterizing the infinite variety of interactions possible when human beings enter into scholarly debate. In the *Martyrs' Door* (Fig. 87), the pairs range from the rather vigorous cross-examination of Cosmas and Damian in the top right-hand panel to the two saints in the lowest panel on the right, who firmly turn their backs on each other. The saints in the middle panel of the right-hand doors hold up their books, as if

87. *Martyrs' Door*. After 1428–*c*.1440. Bronze, 235 × 109 cm. Florence, San Lorenzo, Old Sacristy. (See Fig. 48.)

appealing to the spectator for arbitration, while others simply lean on the frame. Some use their palms to accentuate their gestures, so that Donatello's contemporary Filarete commented critically: 'If you have to do apostles, do not make them appear to be fencers as Donatello did in San Lorenzo in Florence, that is, in the two bronze doors in the sacristy.'[20]

In the single panel illustrated here from the right-hand set of doors, we see St. Peter turned and pointing toward St. Paul; Paul's response indicates that Peter's remarks anger him, for he pulls back defiantly (Fig. 88). This panel suggests a possible biblical source for Donatello's disputing logicians, for the Epistle to the Galatians mentions an argument between Peter and Paul, an early example of doctrinal controversy known as the 'Dispute at Antioch' (2:11–14).[21] By the fifteenth century, however, controversy over both doctrine and ritual had become so commonplace that a biblical text is not essential to elucidate Donatello's imaginative and often humorous representation of scholarly and theological debate.

Whereas in the *Cavalcanti Annunciation* the complex pattern of the background set off the figures and emphasized their expressive poses, in the San Lorenzo doors the background acts as a foil because of its lack of pattern. This difference in the treatment of the backgrounds, whose purpose is essentially identical, results at least in part from the difference in scale between the large tabernacle and the small panels of the doors. In the latter, the plain background does not restrict the scene as does the foliated ground of the *Cavalcanti Annunciation*, but the consistent scale of the

88. *Sts. Peter and Paul (The Dispute at Antioch?)* from the *Evangelists' and Apostles' Door*. After 1428–*c*.1440. Bronze, panel 36.5 × 34.5 cm. Florence, San Lorenzo, Old Sacristy. (See Fig. 48.)

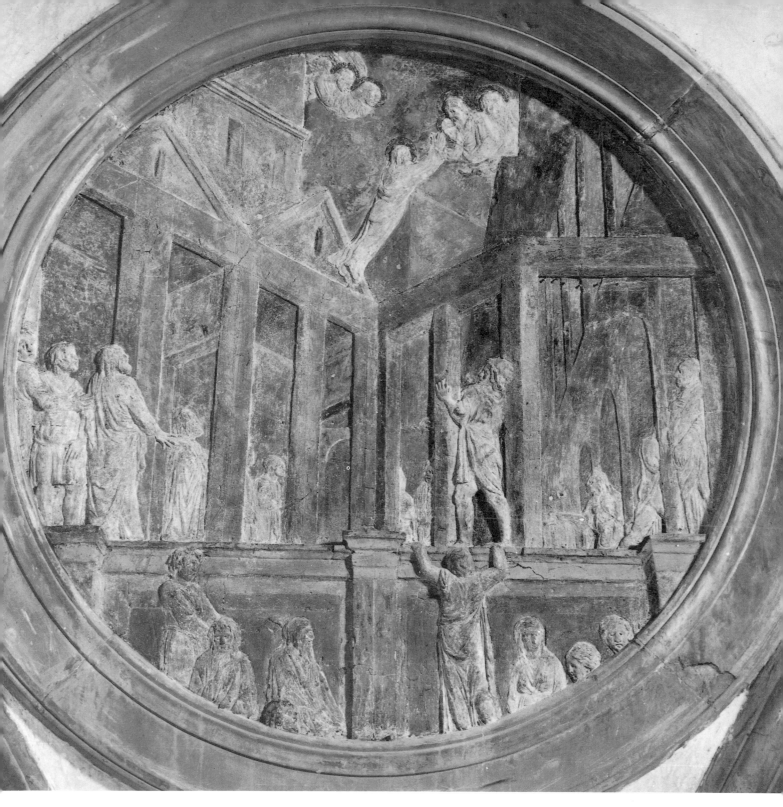

89. *Ascension of St. John the Evangelist.*
After 1428–*c*.1440. Painted stucco,
diameter without moulding approx.
215 cm. Florence, San Lorenzo, Old
Sacristy. (See Fig. 48.)

figures indicates that all the saints remain in the foreground. This position is
constantly reinforced by the relationships between figures and frame: some seem
about to pass behind it and disappear, others overlap it, and some, in what seems
fatigue or disgust, lean upon or grab hold of it. In virtually every case a foot of one
or both saints overlaps the border to establish their foreground position. Donatello
does not allow his figures to become remote.

His concern with illusionism is continued in the stucco roundels with scenes
from the life of St. John the Evangelist in the Old Sacristy (Figs. 48, 89). They are
placed in the pendentives, where the natural curve of the architecture tilts them

153

90. Designed (and begun?) by
Donatello, completed by a later
craftsman: *The Madonna del Perdono*.
1457–8. Marble with coloured
marble inlay. Siena, Cathedral

forward toward the observer; from this angle the scenes are actually viewed straight
on. The settings of the four narratives are illusionistic, and in three of them
Donatello reasonably allows us to see the expanse of ground plane on which the
figures stand. The fourth, however, has a radically different viewpoint: in the
Ascension of St. John the Evangelist the artist gives us a worm's-eye view of the scene,
and no ground plane is visible (Fig. 89). The legend of St. John the Evangelist
concludes with this unusual miracle, in which the body of the saint is raised to
heaven and welcomed by Christ. Donatello, however, has squeezed this all import-
ant part of the story into a tiny area at the top of the roundel, filling approximately
four-fifths of the composition with the group of witnesses and the complex
architecture.

The convention that the visual emphasis is on the religious event rather than on
the setting in which it takes place, on the protagonists rather than on the watching
crowd, has been rejected here, as it often is in Donatello's reliefs. But why is this
scene so different in its viewpoint from the other three? The answer lies in the
subject itself: the spectator's view is manipulated to heighten the drama. The
worm's-eye view and the resulting dramatic recession of the architecture emphasize
the miraculous ascension. In part, this emphasis is accomplished by the contrast
between the rising figure of John and the falling away of some of the architectural
forms as they recede – especially the strong downward diagonal of the arches of the
loggia on the far right. Supporting the effect of the rising figure is the confluence of
the flanking structures; as John White comments, 'One is reminded of fantastic

91. *The Pazzi Madonna*. Marble,
1420s–30s. 74.5 × 69.5 cm. Berlin-
Dahlem, Staatliche Museen

(overleaf)
92. *The Entombment of Christ*, from
the Padua Altar (Fig. 128). 1446–50.
Limestone, with coloured marble
inlay, 138 × 188 cm. Padua,
Sant'Antonio

photographs of skyscrapers.'[22] While the figures on the raised platform direct their
attention toward the disappearing saint, those below are mostly unaware of the
excitement. Joining the two areas, however, is a dramatic figure seen from the rear,
who pulls himself up by his arms to witness the miracle.[23] In this unique roundel
Donatello did not make the illusion conform to our actual point of view, and by
lowering the vanishing point he has forced us to assume a low, and therefore
dramatic, position relative to the ascending saint.

Further experimenting with the viewpoint to heighten an effect is found in
several Madonna and Child reliefs by, or based on designs by, Donatello: the
Chellini Madonna; the *Madonna del Perdono*, designed by Donatello and completed by
another hand; and the large marble relief in Berlin known as the *Pazzi Madonna*
(Figs. 68, 90, 91). In all three examples the figures of Madonna and Child virtually
fill the available space, showing little of the background. The resulting effect of
monumentality is intensified by the illusionism of the frame surrounding each
composition, for all three are sharply recessed, implying a low viewpoint relative to
the figures. Such treatment is consistent with the mood of the reliefs, for in all three
cases the sobriety of the Virgin's expression is underscored by the powerful classi-
cism of her face and the intimacy and directness of her contact with her son. The
downward pull of the recession of the frame seems to force the figures forward and
to isolate them; the compression of the space even seems to force them closer
together.

A similar effect of compression, but with different results, can be seen in the

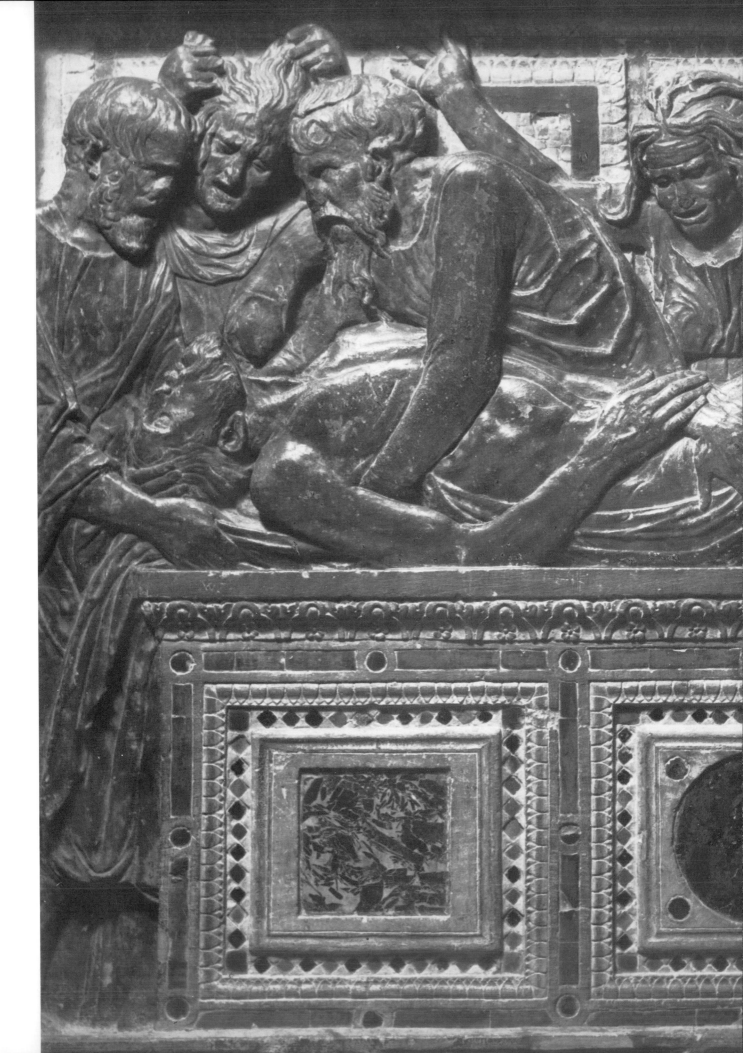

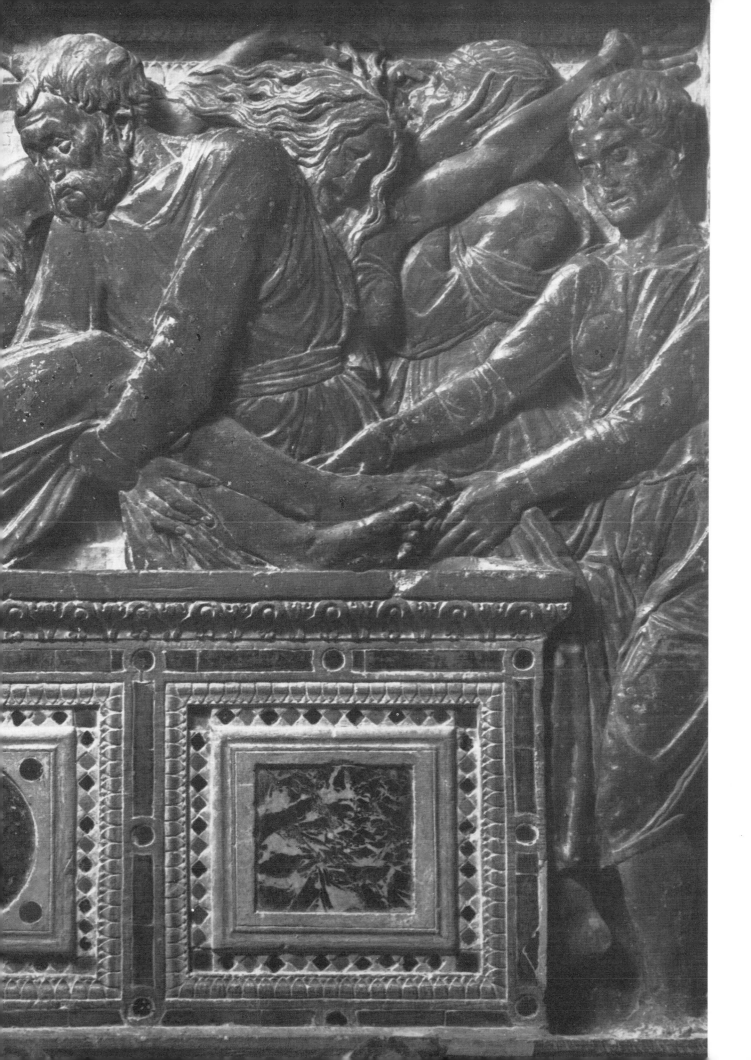

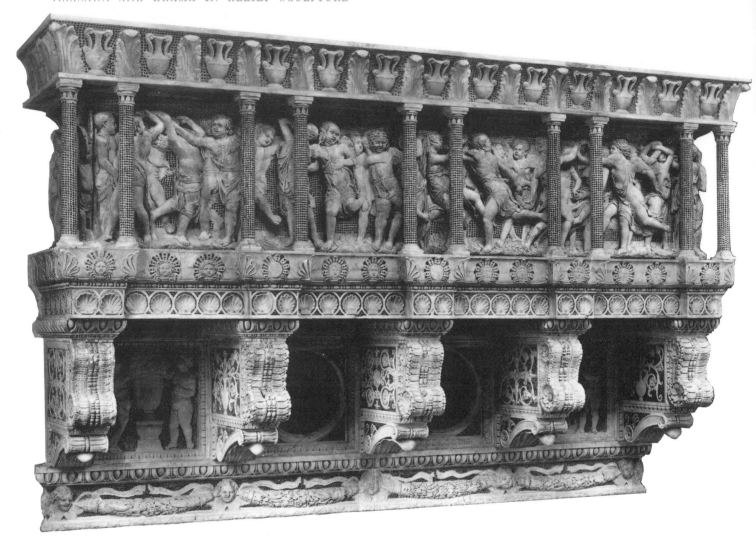

limestone and inlaid marble *Entombment*, which is, as it was originally, part of the back of the Padua Altar (Figs. 92, 127).[24] The patterns of squares, circles, and rectangles, which also appear in other reliefs from the Altar, not only frame the composition, but fill its background and decorate the front plane of the sarcophagus. The emphasis on the sarcophagus that this creates may be in part iconographic, for the fact that it suggests an altar may be related to the relief's original position on the Padua Altar in relation to the door for the reservation of the sacrament, the body of Christ.[25] Donatello has also used the patterned marbles to establish a clear and simple distinction between the natural forms of the human figures and the geometric shapes used throughout other areas of the relief. Because of the severely limited space allotted to the figures, however, the result is conflict. There would not be enough space for the figures who hold the body of Christ to stand erect, and the two male figures that stand at either side of the composition are cut off by the frame. While both frame and sarcophagus define the frontal plane, the background is recessed no more than eight to ten centimetres, and the figures seem pinned between these carefully defined planes. The dramatic physical and emotional energy of the figures, especially of the women, who throw out their arms, pull their hair, and moan or shriek, increases the tension. The compression of space seems to impede gestures, exaggerate expressions, and heighten frenzy.

Donatello's use of the frame to intensify the event and to transform the spatial effect in relief sculpture was entirely different in the *Cantoria*, where there is no

93. *Cantoria*, from the Duomo. 1433–9. Marble, with gold and coloured marble inlay and bronze heads between the consoles, approx. 570 cm. long. Florence, Museo dell'Opera del Duomo. (See Fig. 25 and Plate III.)

illusionism in the fully three-dimensional framing (Fig. 93 and Plate III).[26] Massive consoles support an entablature, which serves as a base for pairs of free-standing columns bearing a concave, projecting cornice. The viewer is allowed to glimpse the 'narrative', a recessed frieze of dancing putti, only through the screen of columns. This type of frame for a relief is unprecedented in Italian art, and there are no compelling antique or medieval precedents.[27] The effect is so striking that one is tempted to imagine Donatello having been inspired by the measured movement sensed when you glimpse a person walking behind a row of columns, for there is a repeated rhythmic effect of appearance, disappearance, and reappearance. Or perhaps this innovation was prompted in part by his desire to make an organ gallery that would contrast with its counterpart, which was being designed and executed at the same time by Luca della Robbia (Fig. 94). In Luca's work each unit of the composition is complete in itself; although the narrative panels are more deeply carved and jut out in front of the enframing pilasters, the union of framing and panels creates the effect of a stable and unified, if somewhat additive, totality. Donatello's wildly dancing putti, on the other hand, are not fixed in position by their frame; the real space separating figures from frame means that our view of the putti changes as we change position. Donatello's work thus suggests the continuity of life, space, time, and movement.

The incorporation of actual space created by framing the relief with virtually free-standing elements is similar to the spatial effect of his *Holy Women at the Tomb* (Fig. 14). Whereas the involvement of real space in the *Cantoria* dramatizes the lively movement of the putti, in the relief from San Lorenzo the space functions as part of the narrative; the emptiness might even be considered the protagonist of the drama, for the point of the story is the discovery that the tomb is empty: Christ is gone, transformed, risen, and the real space incorporated within the composition conveys the miracle of the Resurrection more eloquently than could the presence of Christ.

The use of paired, rather than regularly spaced, columns in Donatello's organ gallery is most likely related to the decision to use paired pilasters as framing elements in Luca della Robbia's *Cantoria*,[28] but despite the matching that results, the *Cantorie* are ultimately very different. While Luca's offers a straightforward pilasters-narrative-pilasters alternation, the glimpses of the putti frieze between

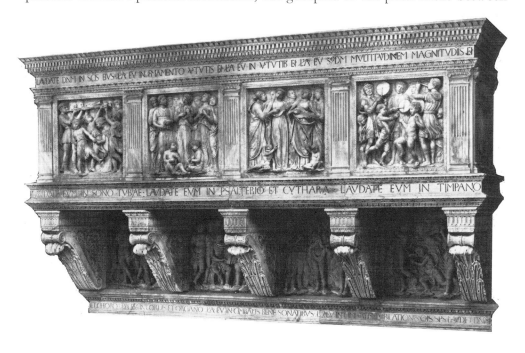

94. Luca della Robbia: *Cantoria*, from the Duomo. 1431–8. Marble, 328 × 560 cm. Florence, Museo dell'Opera del Duomo. (See Fig. 25.)

pairs of columns in Donatello's *Cantoria* create a complex rhythmic pattern. If the columns might be termed 'c', and the putti relief as 'p' or 'P', depending on whether we are allowed a narrow or broad view, the syncopated rhythm created by Donatello across the front of his *Cantoria* could be represented as:

c p c P c p c P c p c P c p c P c p c

This regular rhythm gives structure to the lively irregularity of the movement of the putti in the continuous frieze.

Photographs taken of Donatello's putti reliefs removed from their proper position behind the columns reveal the strongly varied poses and strained movements of individual figures. They rush forward, kicking up their heels and raising their arms, but despite a certain similarity in the poses of the putti, their dancing is more spontaneous than choreographed. A second row of figures in contrasting positions behind the foreground putti heightens the effect of vivacious confusion. Interesting as the reliefs themselves may be, however, Donatello never intended all the putti to be seen at once. The rupturing of the continuous frieze by free-standing columns set in their own staccato rhythm exaggerates the irregularity of the dancing putti; the lively inlaid marble and gold glass mosaic of columns and background further heighten the effect (Plate III).

What is the narrative content of these vivacious putti? Although the mood they convey has been described as bacchic, they must of necessity be related to the Christian setting they were intended to decorate. The base and entablature of Luca della Robbia's *Cantoria* contain the complete text of Psalm 150, and Luca's reliefs seem to illustrate the specific references of this psalm to music and dancing in praise of God. The texts proposed by scholars to explain Donatello's putti include Psalms 148 ('Praise ye the Lord.') and 149 ('Let the children of Zion be joyful in their King.'); Pope-Hennessy recently suggested that Donatello's organ gallery might illustrate the first two verses of Psalm 150: 'Praise ye the Lord. Praise God in his sanctuary: praise him in the firmament of his power. Praise him for his mighty acts: praise him according to his excellent greatness', allowing Luca's gallery to bring this psalm to its conclusion. It has also been argued that Donatello's *Cantoria* might not have had a literary source, dancing being such an obvious companion to music that it is a natural decorative motif for an organ gallery. Yet, given the use of a specific text for Luca's *Cantoria*, it seems likely that Donatello too would have been instructed to illustrate a particular literary source, most likely a psalm; this is supported by the commissioning documents, which mention the 'subject' of his *Cantoria*.[29] The jubilance of Donatello's dancers is, however, too generalized to reveal which of the Psalms, 148, 149, or 150, is the most likely source.

A further possibility deserves reconsideration; Hans Kauffmann suggested that the decoration of both *Cantorie* with joyful musical and dancing putti might be part of a larger iconographic scheme that culminates in the huge window of the *Coronation of the Virgin* by Donatello, placed high above the position of the two organ galleries in the drum of Brunelleschi's dome (Figs. 25, 57). All three works were commissioned in the early 1430s when, as Pope-Hennessy has noted, the imminent completion of the cupola meant that the Operai were turning their attention to the decoration of the dome and the areas below it. The representation of the Assumption and Coronation of the Virgin traditionally included music-making and/or dancing angels or putti, figures that are missing in Donatello's window. The dedication of the main oculus, the one that is on axis with the entrance of the Duomo and directly over the main altar, to the theme of the Coronation is, of course, related to the dedication of the Florentine Cathedral to Santa Maria del Fiore, 'Our Lady of the Flowers'. This reference is employed in both *Cantorie*: in Donatello's the ground is strewn with flowers and some of the putti hold wreaths

decorated with flowers, while in one of the panels of Luca's gallery a dancer holds up a rose, and a drummer has a blossom in his hair. The consoles of both are decorated with elaborate patterns based on the motif of the rose; similar roses adorn Brunelleschi's lantern of the dome. In this context it is interesting to note that the *Prato Pulpit*, designed to display the relic of the *cintola* dropped by the Virgin to St. Thomas at the time of her Assumption, also features dancing and music-making putti (Fig. 103), as does its reliquary, designed by Maso di Bartolommeo in 1447. Without further proof it cannot be established that the music-making and dancing figures of Donatello's and Luca della Robbia's *Cantorie* originally were meant to refer to the theme of the Virgin's Assumption and Coronation celebrated above them, but the possibility should not be ruled out.[30]

The present positions of the *Cantorie* across from one another in a well lit, rather small room at the Museo dell'Opera del Duomo dramatize the differences that must have been apparent when they were first mounted in the Cathedral. Unfortunately, this location also deprives them of the proper height and lighting, factors to which Donatello was especially sensitive. Vasari's impression of the effectiveness of the two works when seen in their original context was that Donatello 'used much more judgement and skill than Luca . . ., for he left almost all of the work in the rough, . . . so that from a distance it looks much better than does Luca's.' (*Life of Luca della Robbia*). Whichever we may prefer today, and for whatever reasons, it seems clear that Donatello's *Cantoria* was designed to attract attention in the vast and relatively dark interior of the Duomo (Fig. 25). In addition to the boldness of execution praised by Vasari, the gold glass and polished marble incrustation would reflect and twinkle in the changing interior light. Its less architectonic nature, in contrast to Luca's refined, box-like structure, would cause it to stand out in the severe architectural surroundings in which the two were originally placed.

The commission for the *Cantoria* enabled Donatello to interrelate relief sculpture, space, and architectural framework, but in the bronze relief he created for the Sienese Baptismal Font he was restricted to designing a square narrative panel in a complex that included work by several other artists; he seems not to have assisted in planning the whole font. His panel, the *Feast of Herod* (Fig. 95 and Plate I), is his most complex relief. In depth of relief it ranges from the fully developed three-dimensional forms of Salome's head and the head of the soldier bearing the salver in the immediate foreground, to the very beautiful *schiacciato* heads and architecture in the background (Fig. 96). It has been argued that Ghiberti invented this type of 'pictorial' relief, which unites the traditional high relief with Donatello's *rilievo schiacciato*; the subtle relationships between height of relief and depth of illusion which it makes possible are well demonstrated in Ghiberti's reliefs for the *Shrine of St. Zenobius* and *Gates of Paradise* (Figs. 98, 15). Donatello's early experiments with this mode in the relief of *St. George and the Dragon* (Figs. 80, 81), however, point to him as the innovator.[31] The *Feast of Herod* demonstrates such complexity of spatial experimentation, narrative, and technique that it stands out as an ostentatious demonstration of the artist's abilities and suggests that here Donatello intended to challenge Ghiberti, the acknowledged master of the art of the bronze relief.

The biblical texts for this subject, Matthew 14:6–11 and Mark 6:21–8, tell how Herod, Tetrarch of Galilee, told his stepdaughter Salome she might have anything she wished if she would entertain him and his birthday guests with her dancing. Herod and Herodias, Herod's new wife and Salome's mother, had been accused by John the Baptist of immoral behaviour, and Herod was at the time holding the prophet in prison. Herodias persuaded her daughter to ask for the head of John on a platter. The Bible reports that Herod was 'sorry' but, 'for the oath's sake' and because of his fear of being embarrassed in front of his guests, he ordered the beheading; the head was presented to Salome, who subsequently offered it to her

96. Detail of Fig. 95

95. *Feast of Herod*, from the Sienese Baptismal Font (Fig. 35). 1423–7. Gilded bronze, 60 × 60 cm. Siena, Baptistry

mother. Donatello's representation, however, follows artistic tradition rather than the biblical text for, like earlier works, it shows a soldier, rather than Salome, presenting the head at the banqueting table.

Salome is represented to the right, in a classically inspired pose (see Fig. 6) that suggests the rhythmic movements of her dance, while Herod is clearly the horrified figure to whom the head is being presented. It is difficult to identify the other figures, but it seems likely that the figure next to Herod is Herodias. Although she is not mentioned in the texts as being present at the birthday celebrations, and the scene of Salome offering the head to her is usually separated from that of the banquet, Herodias is represented as attending the party in an important precedent, the Italo-Byzantine mosaic of this scene in the Florentine Baptistry.[32]

Efforts to identify every figure in the composition are pointless, for Donatello often includes more figures than the narrative demands. Only when a theme is inherently exclusive, such as the *Holy Women at the Tomb* or the *Annunciation*, does he restrict the composition to the figures mentioned in the sources (Figs. 14, 84). In other cases, such as the Siena *Feast of Herod*, the presence of the crowd allows him to represent individual responses in addition to those of the protagonists. The bearded Herod is a classic example of shocked surprise as he recoils, throwing out his hands; his expression is one of dismay. Herodias echoes Herod's diagonal position by

turning sharply toward him, but her gesture is one of accusation: her hand points toward the head of the Baptist. The third figure at the table, who half hides his face with his hand, sets up a contrasting diagonal by recoiling in the opposite direction. Some figures show fright: the children near the lower left corner are about to flee from the scene, as are two figures on the right. In contrast, Salome and her two male companions (surely derived from the pair of curious onlookers in Giotto's representation of this scene in the Peruzzi Chapel at Santa Croce) lean forward to stare at the head in fascination. The popular thirteenth-century text, the *Golden Legend*, describes how Herod and Herodias together evolved the plot that led to John's beheading, and Herodias's clear gesture of blame may be in order to deflect attention from herself, while Herod's theatrical reaction could be a studied effort to appear surprised; Donatello's intent may have been to reveal the complicity of two evil agents in this dramatic story (Plate I).

The narrative is extended by the three figures seen through the first set of arches (Fig. 96). One is the violist, the second a handsome example of a classical profile (most likely derived from an ancient coin), and the third is yet another horrified witness, recoiling from a terrible sight. The second figure, then, must be the soldier bearing the head forward from the place of execution to the banquet hall in the foreground. Some of the shock and fear of the foreground and middle ground figures is also to be found in the most distant chamber, where the figure farthest to the right draws back with a startled expression as she sees the head on the salver.[33]

The architectural setting of the *Feast of Herod* is as confusing and unclear as the narrative. Although the Brunelleschian perspective scheme is clearly stated in the orthogonal and transversal lines of the floor pattern, Donatello obscured this linear system in his decoration of the squares of the pavement. The physical depth of the relief makes it difficult to graph the system of recession, suggesting how complex it must have been for Donatello to create; nevertheless, it is clear that the vanishing point is in the exact centre, at a point on the stone wall near the left shoulder of Herodias. Most of the rest of the illusionistic space and architectural invention seems designed to divert attention from the perspective scheme. The architectural structure is of such complexity, in fact, that it seems like a real place rather than a stage set designed to support a carefully calculated Renaissance composition. For example, the three main arches, which appear to be centralized in the frame are, in fact, not, and a careful examination reveals that they are only the first arches of a continuous arcade that begins near, but significantly not on, the left margin and continues out of the composition to our right. Other architectural complexities, a column, a hint of a corbel table, fill the remaining area near the left margin. Behind the banquet table are other chambers, which seem irregular in size and of questionable spatial relationship to the foreground space. The parallel position of the table and the two walls of arches block the orthogonal recession of Brunelleschi's system, suggesting that overlapping and diminution may be more important to Donatello's creation of an illusion. Many details suggest his playful attitude: for example, the blocks of wood between the arches (scaffolding supports?), which protrude toward the viewer, run counter to the basic recession of linear perspective. Between Herod and Herodias there is an area in the stonework where Donatello suggests a block has been removed from the wall; the resulting recession conforms closely, if not exactly, to the orthogonal system. But a similar element placed near the vanishing point itself cannot be explained in this way and it seems, frankly, perverse; its pattern of recession is arbitrary and deliberately violates the scheme established in the pavement. At the same time the recession of the towel or napkin thrown on the table does conform to the regular recession demanded by the Brunelleschian system. Donatello has employed the mathematical system, but he obviously could not resist denying it as well.

In the photograph reproduced here (Fig. 95), the figural composition also seems irregular, with the main actors, Herod and Salome, thrust outward to opposite edges of the space; this effect is modified, however, when the spectator stands at the font and looks down at the relief. The composition of the figures in a semicircular grouping (similar to that of Masaccio's *Tribute Money* or his own *Ascension, with Christ giving the Keys to St. Peter*; Figs. 77, 76) then becomes apparent, but the energetic outward movement of the recoiling figures and the strong suggestion of figures moving beyond the frame to either side rupture the semicircle. In what is recognized as one of the masterpieces of Renaissance sculpture, then, Donatello has consistently and intentionally denied those formal qualities considered characteristic of the Renaissance: regularity, simplicity, illusionism, centralization.

What the viewer gains from the confusion and disorientation Donatello has created in the *Feast of Herod* is a sense of being witness to an actual event that happened to real people in a real place. The idealization of figures, the controlled emotion, and the geometrically ordered space and composition of other Renaissance works (cf. Figs. 5, 11, 98) are not present here. The starkly realistic treatment may result from the fact that the story is truly terrible: at a birthday celebration a young woman's erotic dance leads not only to the beheading of a good and holy man, but to the bringing of the bloody head into the banqueting hall itself. It is perverse and grotesque, an episode that violates all standards of human decency, and Donatello's exploding composition tries to capture this quality.

The dramatic possibilities of Donatello's relief style are equally evident in *St. Anthony of Padua Healing the Wrathful Son*, one of four narrative bronze reliefs on the Padua Altar (Fig. 97). The horizontal format seems to have encouraged Donatello to expand the complex architectural backgrounds and figures of onlookers of the bronze *Feast of Herod*. The story of the wrathful son is a simple one, requiring two or at most three protagonists. A young Paduan who in anger had kicked his mother came to St. Anthony to confess; Anthony's statement that 'the foot of him who kicks his mother deserves to be cut off' led the youth to cut off his foot, which Anthony then miraculously restored. It is a morality tale that begins with the sin of wrath and moves through confession, penitence, and obedience to, in Anthony's miracle, forgiveness. In Donatello's relief, St. Anthony and the boy are in the centre of the composition and in the immediate foreground; the youth's leg even overlaps the frame. His mother must be the woman directly behind him who holds his leg and head. In addition to the three main actors, there is a crowd of at least eighty people. Some observe the miracle with astonishment and wonder, conveying the excitement that can course through a crowd, but the expansive horizontal format also allows Donatello to bring into the event other figures too far away to witness the miracle, and even some who do not seem to care. Once again the effect is realistic.

The excitement communicated by this relief results in part from the extraordinary spatial setting. While St. Anthony and the youth are forced into the immediate foreground by the thronging crowd, extending behind them is a dramatically recessed courtyard, a vast open space which serves as a foil for the crowd of figures around the miracle. The structure beyond the 'stadium', set at an angle, provides yet another contrasting element to heighten the drama. Although the recession of the stadium is controlled by Brunelleschian linear perspective, with a vanishing point somewhat below the centre point of the relief, the receding lines of the building in the right foreground, its steps, and the paving of the piazza nearby, do not conform; they converge on a second vanishing point to the right of the central one. If these foreground elements set so far to one side conformed to the Brunelleschian scheme, they would not seem visually correct; Brunelleschi's invention works best for architecture that is somewhat removed from the viewer, and Donatello's

'corrections' in this case were necessary to accomplish the optically convincing realism so important to him.

As if recalling his earliest *schiacciato* experiment in marble, the *St. George and the Dragon* (Figs. 80, 81), Donatello included in his bronze, the only Paduan narrative with an exterior setting, a panoramic sky with gilded clouds and a raised gilded representation of the sun. How unusual these are is suggested by a search of Ghiberti's Baptistry doors for similar atmospheric or natural elements; in Ghiberti's works, clouds appear only as an accompaniment to God or to angelic messengers, while in Donatello's relief they are part of the realistic scene before us. In addition the sun may be included as a time-honoured emblem of God's presence and illumination, a divine witness to Anthony's miracle.[34]

A comparison between Donatello's *St. Anthony of Padua Healing the Wrathful Son* and Ghiberti's *Resurrection of the Strozzi Boy* from the *Shrine of St. Zenobius* (Fig. 98) demonstrates once again the distinction between the works of these two great Florentine Renaissance sculptors. Zenobius's miracle, the resurrection of a boy killed in an accident, is no less amazing than Anthony's, but in Ghiberti's relief the crowd, organized and respectful, stands back so that the miracle at the centre can be isolated against the neutral ground. The semicircular arrangement of the crowd at either side enhances the regularity of the composition. The architecture functions solely as a backdrop: its distant setting, its lack of figures, and its low relief execution all serve to separate it from the figural composition.

Donatello's representation, in contrast, seems chaotic. As in the Siena *Feast of Herod* (Fig. 95), he has substituted the excitement and confusion that accompany a real event for the formal patterns and abstract harmony of Ghiberti's relief. The complex and varied patterning of Donatello's architecture and its decoration, of the perspective recession, of the movement and grouping of the figures, of hair and of drapery, of the clouds and sun, all serve to activate and enliven the relief. At the same time, Anthony's miracle gains plausibility because of the successful integration of figures with the architectural setting and skyscape background.

Ghiberti's *Resurrection of the Strozzi Boy* is a typical Renaissance work of art for several reasons: its subject is immediately comprehensible, one is aware of the

97. *St. Anthony of Padua Healing the Wrathful Son*, from the Padua Altar. 1446–50. Bronze, with traces of gold and silver detailing, 57 × 123 cm. Padua, Sant'Antonio. (See Figs. 127 and 128.)

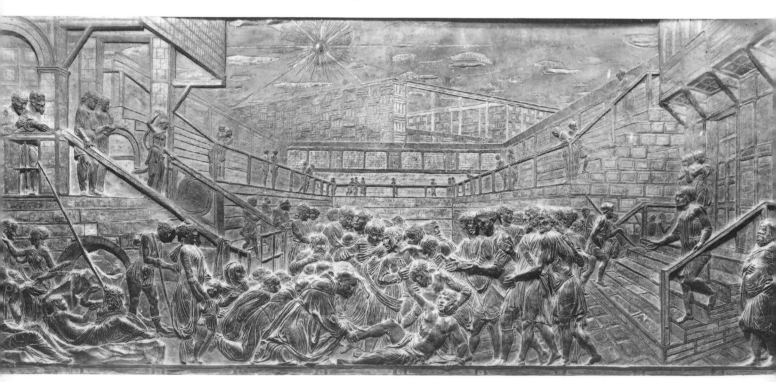

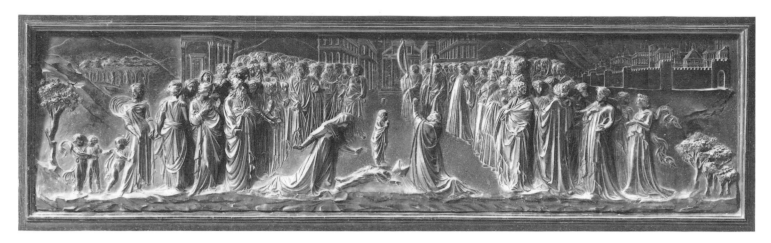

98. Lorenzo Ghiberti: *The Resurrection of the Strozzi Boy*, front relief of the *St. Zenobius Shrine*. 1428–42. Bronze, 41 × 160 cm. Florence, Duomo

rational mind of the artist, and the relief demonstrates impressive technical accomplishment. Ghiberti's lucid and beautiful work is easy to appreciate and enjoy. Donatello's relief, on the other hand, demands a different kind of response; it takes determination and effort to read the narrative, and in the process the viewer experiences the anxiety and excitement expressed by many of the figures. We respond to the confusion and disorientation of people witnessing a miracle that is, after all, a disruption of the natural order of things. The convincing architectural and natural setting confirms the reality of the miracle; it is happening in a specific place, at a specific time of day.

These two works document the profound differences in the personalities and creative processes of Ghiberti and Donatello. Although it is impossible to reconstruct from a finished work of art all the problems confronted by an artist during its evolution, it seems clear Ghiberti's approach was to simplify and clarify; his search was for symmetries and harmonies. Donatello moved in the opposite direction, toward complication, contrast, and variety. Ghiberti chose to understand Zenobius's act as a dignified, solemn, and timeless occasion. For Donatello, Anthony's miracle was a dramatic, emotional event taking place in an atmosphere of charged excitement.

CHAPTER SIX

Ancient and Medieval Sources

His work showed such excellent qualities of grace and design that it was considered nearer what was done by the ancient Greeks and Romans than that of any other artist.

He was striving to recover the beauty of the ancients, which had been lost for so many years.

Vasari, *Life of Donato*, 1568

The search for a fifteenth-century artist's visual sources is particularly intriguing because of the humanist interest in the antique, an interest that seems to have been quickly popularized; ancient images, as well as the very idea of referring to the antique, appear to have carried a cultural significance, which, unfortunately, we cannot fully recapture. As might be expected, Donatello's works make many references to the antique in form, motif, and idea. Yet their break with traditional art was so complete that his references to the medieval work that immediately preceded his are often overlooked. He borrows directly from his sources, either assimilating or imitating – as Gombrich has said of the Renaissance use of the 'style *all'antica*' in general.[1] Donatello's sculptures would never be mistaken for antique or medieval works by the twentieth-century viewer, but it is possible they could have been by his contemporaries; by 1677 the *Atys-Amorino* (Fig. 115) was considered antique, and in 1554 Sabba da Castiglione, after complaining that there were no good antiques on the market, said that works by Donatello were the next best thing.[2] Although Donatello might be expected always to change traditional types, in some instances he follows his model closely. In the case of the *Marzocco* (Fig. 42), for example, the fact that the lion is closely related to earlier images may have a political rather than a stylistic basis, a conscious archaism meant to preserve the associations of the traditional type. But Donatello chose to retain the abstraction, the compact form, and the unusual proportions of medieval examples, rather than capitalizing on naturalism, at which he merely hinted. Whatever his source was for a particular work of art, it was rarely simple, never unmodified, and always fully integrated into his own style.

The problem of 'Donatello and the Antique' has been discussed in a number of articles, the most important being that published by Janson in 1968. In this sensitive study, he defined the basic problems and outlined suggestions on how a full investigation of the question should be conducted. Motif-hunting in antiquity for Renaissance sources is a dangerous and often misguided effort, but there are a few specific ancient works that with good reason have been singled out as being objects known to Donatello and specifically reflected in his work. The triumph relief on the

99. Putti decoration on the desk of *St. Mark the Evangelist*, stucco roundel in the Old Sacristy of San Lorenzo. (See Fig. 48.)

helmet of Goliath in the bronze *David* (Fig. 135) is a transformation of an Imperial Roman cameo known during the Renaissance; Donatello retained the general composition, but changed all the figures to putti. The two putti reliefs between the consoles of the *Cantoria* (Fig. 93) are derived, according to Corwegh, from known ancient reliefs, but are enframed like Early Christian ivories. De Nicola is probably right in citing a sarcophagus in the Camposanto, Pisa, as the source for one of the reliefs on the triangular base of the *Judith and Holofernes*. The putti that decorate the desk of *St. Mark* (Fig. 99), one of the Old Sacristy roundels in San Lorenzo, can be traced to an ancient *intaglio* of boxing putti. These motifs seem to be the visual equivalent of literary influences from the ancient world, such as the *recherché* reference to the 'unending fame of the brave' in the amaranth crown of the marble *David* (Fig. 116); presumably only a well-trained humanist would have recognized such allusions. This list might be expanded, but the excitement is in the chase rather than in the capture, since the point is already clear: Donatello, a perceptive observer and critic of those objects available to him, chose on occasion to quote the antique – undoubtedly, in most cases, for the sophisticated enjoyment of his patrons.[3]

What these examples of Donatello's references have in common is a certain

divergence from their sources. The expectation that he would always make such changes has caused recent scholars to reject the eight narrative roundels that decorate the courtyard of the Medici Palace (Fig. 51).[4] Although Vasari attributed them to Donatello, and the sculptor's connections with the family were strong, the reliefs are suspect partly because they are so closely derived from known antique works. Seven are from gems that eventually entered the Medici collections, and the eighth is from a Roman sarcophagus that was at the Medici Palace in the fifteenth century. The rejection of Vasari's attribution is in part based on the argument that Donatello would not have been interested in making such close copies after ancient works, a thesis inconsistent not only with what is known about Donatello, but with the Renaissance in general. The patron's demand that the artist copy ancient works would hardly have been sufficient reason for him to decline a commission as important as this one. More significant, in this case, is the mediocre quality of the roundels themselves. Although they are *schiacciato* reliefs and circumstantially related to Donatello, the handling is a hard-edged version of *rilievo schiacciato*, and its effect is brittle and harsh. The handsome *sgraffito* (scratched plaster) decoration of garlands and ribbons in the frieze area around the medallions is documented to 1452;[5] since Donatello did not return from Padua until 1453 or 1454, an attribution of the reliefs to him is difficult. Given his earlier partnership with Michelozzo, the architect of the palace, it is understandable that the reliefs recall Donatello's style. Ultimately, however, the roundels are probably the work of Michelozzo's shop, a less illustrious attribution that does not rest merely on the notion that Donatello would not simply copy the antique. His interest is obvious, we know some of the objects he saw (as perhaps Fig. 102), and he himself may have collected antiquities.

Interest in the antique was an important manifestation of a general cultural trend that had begun years earlier. *Rinascità*, the root of the term Renaissance, was first used by Italian writers during the fourteenth century to refer both to the explicit imitation of classical patterns in literature and to the more general revival of classical standards of value. Thirteenth-century Tuscan artists had already been inspired by surviving works of Roman art, whose importance increased during the next three centuries. The idea that Italian Renaissance art is first and foremost a revival of antique art is a *leitmotif* of Renaissance art history beginning in the mid-sixteenth century with Vasari's *Vite*, the same text that places Donatello among the earliest and most enthusiastic Renaissance artists to draw inspiration from ancient works. But unlike other Renaissance artists, whose attitude toward ancient art seems straightforward in its admiration and derivation, Donatello is unpredictable. He incorporated into his work a high degree of creative criticism of the source, and assimilated the classical sense of form to such an extent that the style, rather than a precise object, must be understood as his source.

This inspiration could take the form of either a motif or a type. Donatello's use of togas on two of the Campanile prophets (Figs. 123, 124) is a clear indication of Roman influence, as is the unusual detail of the crimped drapery edge – an effect resulting from cutting material on the bias – which appears on the *St. Mark*, the marble *David*, and the Virgin of the *Cavalcanti Annunciation* (Figs. 119, 116, 85). The typical Roman toga, caught and draped over one arm, does not appear, however, and Donatello's more varied drapery is not only a visual reference to the antique, but an exploitation of the toga's possibilities for suggesting form and motion.[6]

His representations of the human head are often types well-known in ancient art. The profiles of the Madonna in Boston and the Cavalcanti Virgin (Fig. 86), with a straight line from forehead into nose, large eye and ear, full jaw-line, sober expression, and wavy hair pulled back over the ear, are among numerous examples of this classical type (Fig. 100) in Donatello's art. His male heads demonstrate the folly of searching for specific sources, since in profile they sometimes bear an uncanny

100. Head, detail of *Female Figure*. Roman, first–second century AD. Marble. Florence, Uffizi

101. *Madonna and Child*, from the
Padua Altar. 1446–50. Bronze,
height 159 cm. Padua,
Sant'Antonio. (See Figs. 127 and
128.)

resemblance to Roman emperor portraits known through innumerable coins and gems. In the same way, the precise realism of the heads of the Campanile prophets (Figs. 123–125) suggest a knowledge of Roman portrait busts (Fig. 106).

In pose as well, Donatello's figures show the inspiration of earlier art. The *contrapposto*, first used by him in the *St. Mark* (Fig. 27), is a Greek innovation seen in any number of Roman examples. His running female figures with wildly fluttering drapery derive from ancient representations of Maenads (Fig. 6) or from figures on Meleager sarcophagi. One example that illustrates the complexity of Donatello's approach is the *Madonna and Child* from the Padua Altar (Fig. 101). The theory that this hieratic image is related to the earlier Romanesque type of rigid seated Madonna and Child has been countered by the contention that the Madonna is rising from her throne, holding the Child naturally in front of her, but the simple, formal similarity to the medieval type remains hauntingly compelling.[7] Donatello was likely to have been aware of such a visual connection; still, it is impossible to say whether he sought this effect or merely regarded it as a fortuitous reference inherent in the natural pose.

An interesting example of conscious, fashionable imitation is Donatello's use of Roman style capital letters, or '*lettere antiche*' as Ghiberti called them, for inscriptions and signatures on works of art.[8] As Dario Covi has pointed out, Donatello was not an innovator in this case, since the revival of Roman lettering had begun when he was still in his teens; examples are found on painting and sculpture from as early as about 1400. From the surviving evidence, it seems that Ghiberti used *lettere antiche* before Donatello did (witness the inscription on the scroll of *St. John the Baptist* of 1414; Fig. 29), and Donatello's first use of Roman lettering only came a decade later, during the 1420s, in the Cossa and Pecci tombs (Figs. 47, 82); the clear, geometric letters contrast sharply with the florid, Gothic lettering that had been popular earlier, for example in Jacopo della Quercia's Trenta tomb (Fig. 83). Donatello's epigraphy became archaeologically more correct during his stay in Padua, most likely because of his acquaintance with Andrea Mantegna, the Paduan painter and antiquities enthusiast, who first used what Covi calls 'perfected Roman capitals' in his painting. A particularly handsome example of Donatello's later epigraphy is the signature – OPVS DONATELLI FLO. – on the *Judith and Holofernes* (Fig. 20).

The most difficult task confronting those who investigate the ancient sources employed by Donatello is to determine where he encountered particular motifs or ideas. What works did he actually see? It is, of course, unlikely that he knew ancient motifs from large-scale works such as those so well-known today, as most of these were not discovered until after his time.[9] More likely his visual knowledge of antiquity came through small works, such as coins, carved gems, Arretine ware, and similar objects. In addition, Roman sarcophagi, a source of both decorative and figural motifs, were plentiful in Italy (Fig. 102). It is also possible that Ciriaco d'Ancona's visit to Donatello's shop, which Janson dates to 1434, provided the artist with non-visual sources in the descriptions Ciriaco gave of his journeys in Greece; for example, the *Cavalcanti Annunciation* (Fig. 84), in general form rather than in particulars, is surprisingly reminiscent of a Greek stele. Donatello must also have been influenced by the ancient types and motifs preserved and disseminated in medieval works of art, especially ones of the Early Christian and Byzantine periods. As Janson has pointed out, some of these works so resemble classical works it is likely they were considered antique during the Renaissance, leading to some disagreement in contemporary scholarship; for example, the exuberant putti of the *Cantoria* and the *Prato Pulpit* (Figs. 93, 103) have been traced by Gombrich to carved Byzantine ivory boxes such as the *Veroli Casket*, while Janson has argued for a derivation from the boxing putti known on Roman sarcophagi and gems. Several

works are thought to have had their origins in medieval objects; Janson proposes Early Christian or Carolingian ivories as the source for the paired saints on the San Lorenzo doors (Fig. 88), and a Coelus figure from Early Christian sarcophagi as the basis for the angel holding the mandorla from below in the Brancaccio *Assumption* (Fig. 63). Specific sources cannot always be identified, but research reveals a great deal about Donatello's working methods; his imagination seems to have been invigorated by the number and variety of images available, and not constrained by contemporary taste for either a more traditional style or the fashionable antique revival.

For architectural representations Donatello exuberantly, yet rather idiosyncratically, borrowed from the classical. Again, as might be expected, motifs – not monuments – reappear in both new and old settings. The use of antique architecture as a narrative setting appears, for instance, in the Lille and Siena representations of the *Feast of Herod* (Figs. 78, 95). Given the Renaissance attitude toward realism, Donatello's motivation here was probably as much a desire to create an historically authentic scene, as admiration of the antique for its own sake. In the marble example, the pedimented façade supported on columns is clearly an antique device, even if the slender proportions of the columns and the wide intercolumniation are not; this quasi-antique setting is peopled with figures that can be related to antique types and so reinforce the classical allusions. The cut-stone arcade resting on massive piers, which occurs in both reliefs, is reminiscent of Roman aqueducts, and possibly inspired by the fragment of the ancient aqueduct that survived near Florence until the eighteenth century.[10] Neither architectural setting, however, is completely antique: near the left margin of the Siena relief is a glimpse of a late medieval corbel table of a type still visible in older parts of Florence or in the frescoes of Masaccio and Masolino, and in the spandrel of the arcade directly above the Lille Salome is a purely contemporary detail, a scalloped roundel of the type used by Brunelleschi.

Manetti states that Brunelleschi and Donatello made measured drawings of Roman ruins during their trip to Rome; such drawings could have served as architectural inspiration for many years. The impressive barrel-vaulted interiors of the *Miracle of the Ass* from the Padua Altar and *Christ Before Pilate and Caiaphas* from the San Lorenzo pulpit certainly seem connected with the impressive ruin of the Basilica of Maxentius and Constantine in Rome. Today, as in the Renaissance, the monument consists of the three great vaults of one side of the basilica and, rising

102. Sarcophagus with the *Triumph of Bacchus*. Roman. Marble. Lucca, Cathedral. Perhaps the sarcophagus seen by Donatello, as mentioned in letters of 1428 and 1430

above these, remains of huge buttresses that once supported the elevated clerestory of the central nave. One of these buttresses may have been the source for the peculiar architectural fragment that rises from the roof of the tomb in the *Holy Women at the Tomb* in San Lorenzo (Fig. 14).

In addition to narrative settings, Donatello also used classical architectural motifs as a vocabulary for his own constructions and framings, drawing on ancient architecture, architectural sculpture, and decorative details from Roman sarcophagi. He was among the first artists to use these elements extensively, and works such as the *Cavalcanti Annunciation*, the *Cantoria*, the *Prato Pulpit*, and the Parte Guelfa tabernacle provide not only a textbook of the ancient motifs available to him, but an introduction to the unusual way he interpreted and combined his sources (Figs. 84, 93, 103, 129).

The idea of enframing a composition with classical architectural membering – a base, a horizontal entablature, and columns, or more often pilasters, at the sides – was used again and again in works such as those just mentioned, as well as in the *San Lorenzo Pulpit* (Figs. 2, 4, 12). Variations occur, as in the *St. Peter's Tabernacle*, where the capitals of the pilasters support consoles rather than the normal entablature, and in the Crivelli tomb, where the entablature is forced to curve behind the figure. On the Cossa tomb, pilasters enframe the three Virtues within the monument, while true, ancient columns, re-used in building the Baptistry, and their medieval entablature become incorporated as framing members for the whole (Fig. 46). Seldom do Donatello's framing pilasters follow architectural practice and support a triangular pediment above the cornice, but exceptions may be noted in the Parte Guelfa tabernacle and the crozier of *St. Louis* (Figs. 129, 59). The elements in each of these examples are distinctly classical; it is easy to see the resulting frames as ancient revivals as well. Actually, Donatello created in the Parte Guelfa tabernacle the Renaissance equivalent of the Gothic pointed niche and, in the *San Lorenzo* and *Prato Pulpits* and the *Cantoria* (Figs. 2, 103, 93), the Renaissance equivalent of medieval church furniture with its dependence on architectural form. The framing elements of the *Cantoria*, in their projection from the relief plane and therefore their emphasis on architectural verticals and horizontals, are closer to Italian Romanesque pulpits, and to the pulpits of Nicola and Giovanni Pisano, than to Roman sarcophagi, although, of course, ancient examples might also be cited as the source for the medieval. Janson has suggested that the overall design of the *Cantoria* echoes the entablature of a Roman temple, such as the Temple of Concord in Rome; on the other hand, the mosaic on the columns and background recalls medieval Roman Cosmati work. In any case, Donatello's choice and manner of using architectural members can be seen as a revival of the classical style.

Along with these larger constructions, Donatello freely employed small classical motifs. For example, a number of the monuments discussed above make use of supporting consoles with an S-shaped decoration clearly derived from ancient models. The shell as a decorative motif for the back of a niche comes from ancient sarcophagi. It appears in the Pecci and Crivelli tombs, and behind both the Virtues and the Madonna and Child in the Cossa tomb (Figs. 82, 46); one of the most beautiful examples in Donatello's œuvre is the deeply carved shell in the Parte Guelfa tabernacle, a motif repeated in miniature in the crozier of *St. Louis* (Figs. 129, 59). Shells are used more unorthodoxly and playfully as bases for the putti of the Sienese Baptismal Font (Fig. 36). Many of the ancient moulding patterns that were developed as architectural motifs, but which later played an important role as decorations in other media, are to be found in Donatello's art: dentils, bead-and-reel, egg-and-dart, and a basic leaf pattern are among the most common. The rinceau, a motif consisting of an undulating vine with curly leaves and occasional blossoms, appears in the background and on the consoles of the *Cavalcanti Annunciation*, on the bronze

capital of the *Prato Pulpit*, and elsewhere (Figs. 84–86, 103); its use in the stucco decoration around the arches that surmount the doors in the Sacristy of San Lorenzo (Figs. 48, 72) has been traced by Janson to some ancient Roman stucco remains now incorporated into the church of Santa Maria in Cosmedin in Rome. The related Roman motif of a tall, stylized foliate decoration that springs from an elaborate vase only becomes popular quite late in the Quattrocento; Donatello's use of this motif in the *St. Peter's Tabernacle* may be the earliest certain example. Putti are so common in Donatello's art that it is rare to find a work without them; their use varies from major imagery in the *Cantoria* and *Prato Pulpit* to decorative motif in the Pecci tomb and Gattamelata's saddle (Figs. 93, 103, 82, 66). They might even have been a kind of signature for the Donatellian style, since they appear on objects like the San Marco bell (Fig. 39). A particular ancient pattern that he took up without modification unites putti heads, garlands, and fluttering ribbons; for example, see the frieze of the Parte Guelfa tabernacle, and the bases of the Cossa tomb and of the *Cantoria* (Figs. 129, 46, 93).

Perhaps the most versatile motif in Donatello's repertoire was the laurel wreath, used at the base of the bronze *David*, the putti on the Sienese Baptismal Font, and the *Prato Pulpit* (Figs. 134, 36, 103); this use may have been suggested to him by the gigantic laurel wreath that forms the torus at the base of the *Column of Trajan* in Rome. This repetitive pattern could also be flattened, as in the frame of the San Lorenzo Sacristy Doors (Figs. 87, 88). The laurel wreath, either winged and beribboned or held by flying putti, appears twice on the Parte Guelfa tabernacle (Fig. 129) and also at the top of the Crivelli tomb. The motif seems to have been common in antiquity, and may have enjoyed a similar popularity in the early fifteenth century; it is prominent not only on Donatello's works, even appearing on Judith's bodice in *Judith and Holofernes*, but might have been a motif particularly connected with Donatello, since it often appears in Quattrocento decorative work probably meant to seem Donatellian, such as the lid of the *Tomb of Giovanni di Bicci de' Medici and Piccarda Bueri* in the Old Sacristy of San Lorenzo.[11]

Despite Donatello's persistent use of antique motifs for the decorative ensembles discussed above, a trained twentieth-century observer would scarcely mistake these monuments for Greek or Roman works. Whether Donatello's contemporaries would have done so is not known, but when Vasari speaks of Donatello's efforts to 'recover the beauty of the ancients' in the figures of the *Annunciation*, he makes no such claims for the tabernacle as a whole. The complexly contrasting patterns and rich ornamentation of the Parte Guelfa tabernacle, the *Prato Pulpit*, the *Cantoria*, and the *Cavalcanti Annunciation* (Figs. 129, 103, 93, 84) violate the restraint that usually characterizes ancient art. Of course, there are a few exceptional ancient monuments similar to Donatello's decorative works, but a diligent scholar can find a source in antiquity for almost anything. In general, Donatello's manner of using decorative motifs is much more varied and lively than is the ancient use of these same motifs.

An examination of the *Cavalcanti Annunciation* (Fig. 84) from the point of view of its antique inspired details is revealing, for it suggests that Donatello's creative process involved not only a taste for unusual motifs – ones not often used by his contemporaries – but their use in a distinctly unorthodox fashion. In some cases he greatly enlarged motifs found in small-scale ancient works; as Janson has pointed out, the unusual pediment, segmented with terminal scrolls and rosettes, and the framed, leaf-decorated pilasters come not from Greek or Roman architecture, but from Roman funerary urns and tombstones. In other cases Donatello altered the function of the motif; the scrolls that form the base of the pilasters are found in antique sources as part of capitals, not as bases, and Donatello joins them to claw feet that seem to come from the legs of Roman marble furniture, not architecture.

Similarly, the multiple human heads, which here serve as the capitals, never performed this function in antiquity. Donatello has recombined elements and made them perform completely new functions in the decorative scheme; in an attitude unusual in the Renaissance, he displays little respect for his ancient models, using them as a stimulus to his fertile imagination. Other indications of his approach are evident in the grotesquely large egg-and-dart of the frieze, and in the visual conflict between the scalloped rosette cornice and the gigantic rosette that fills the middle of the pediment. Ancient decorative principles certainly did not allow motifs to be changed in scale and function so arbitrarily.

A close examination of the virtually contemporary *Prato Pulpit* and *Cantoria* (Figs. 103, 93) reveals the same taste for violent contrasts of patterning that can be observed in the *Cavalcanti Annunciation*. No surface is left undecorated, and abutting motifs show calculated contrasts in both scale of ornament and repetition of motif. The goal seems to have been to create a lively surface full of variety, one that keeps the viewer's eye busy. These energetic and unprecedented monuments should also provide a warning for those who attempt to reconstruct the Padua Altar: Donatello's solutions to specific problems are characterized by a creative impetus virtually impossible for a twentieth-century scholar to recapture.

The Parte Guelfa tabernacle at Orsanmichele is no exception to Donatello's attitude toward design and decoration (Fig. 129). Although scholars have attributed the design of the tabernacle to Michelozzo or even to Brunelleschi, the internal evidence seems to confirm that it is by Donatello himself. Antique references are pervasive, but once again it is the combinations and contrasts that relate it to Donatello's other ensembles. Although this monument can be considered as two distinct parts, a large figure and its architectural framing, a relationship between the two is established by the repetition of figural elements throughout the tabernacle: heads at the corners of the base and between them flying putti with a wreath,[12] putti with scrolls in the spandrels above, putti heads between garlands in the frieze, and a triple-faced Trinity in the pediment. The purely architectural details are as varied as in the other monuments. The idea of combining small columns with large pilasters is probably derived from Brunelleschi, but here a visual argument arises between the spiral decoration of the columns and the vertical flutes of the pilasters. Further conflict results from the juxtaposition of the large and curving forms of the shell crowning the opening of the tabernacle with the strict and minute geometry of the Romanesque billet motif that decorates the framing arch. The use of spiral columns was undoubtedly inspired by an important example of Florentine architecture, the Baptistry, which during the Renaissance was thought to be an ancient Roman temple of Mars rededicated to Christian service (Fig. 104).[13] These spiral columns frame the central window of the detail shown here, and Donatello's ideas for pilasters and pediment would seem to have originated in the window frames to either side. The heads of lions jutting out below the central window might have inspired his use of human heads as the corners of the base of the Orsanmichele tabernacle. The references to the Baptistry may well have been significant at Orsanmichele, since the Baptistry was a well-established symbol of Florence and the Parte Guelfa was the city's officially recognized political party.

Donatello's use of the antique was not confined, however, to making use of architectural and decorative vocabularies. In several instances he chose a specific and recognizable antique type, which he respected in general form, but brought up-to-date stylistically, or completely changed iconographically. One of the most complicated and fascinating of these works is the *Equestrian Monument to Gattamelata* (Fig. 52). Initially it seems to be a straightforward demonstration of the influence of ancient art on the artist, since it revives the large-scale bronze equestrian statue. Already in the middle of the sixteenth century, Paolo Giovio had written that this

103. Donatello, Michelozzo, and workshop: *Prato Pulpit*, for the display of the relic of the Holy Cintola. 1428–38. Marble, with gold mosaic background and bronze capital, wooden canopy, height of panels 73.5 cm. Prato, Cathedral. (The original marbles are now in the Museo dell'Opera, Prato.)

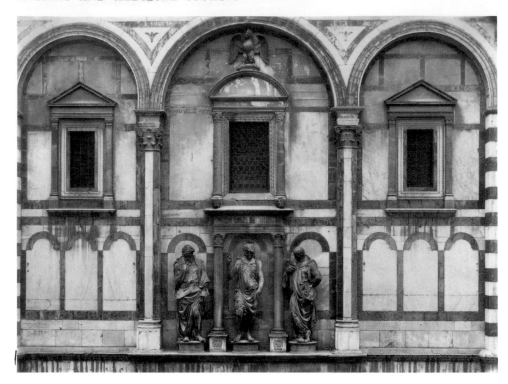

104. Unknown architect: Windows from the Florentine Baptistry. *c*.1060–*c*.1150. (See Fig. 22.)

monumental bronze 'fittingly imitated the ancients', and Vasari, in discussing the *Gattamelata*, had used antiquity as the standard against which to assess Donatello's work: 'He challenges comparison with any of the ancient craftsmen in expressing movement, in design, skill, diligence, and proportion.' The most antique element of the *Gattamelata* is the idea of commemorating an important individual with a monument that is not funereal; Gattamelata's tomb (Fig. 107) is inside the Santo. A document of binding arbitration drawn up in 1453 between Donatello and the family states that the monument was made 'because of the great fame of Gattamelata', while Filarete says it was made 'in memory of' the *condottiere*, and Vasari calls it a 'memorial'. The *Gattamelata*, therefore, would seem to be as antique in inspiration as the eulogies 'in the Roman fashion' recited by two state orators at Erasmo da Narni's funeral. As a public equestrian monument to a military figure, however, Donatello's *Gattamelata* is without precedent in the ancient world. This kind of monument was unknown in ancient Greece, and in republican Rome equestrian monuments were limited to aristocrats; the Empire restricted them to emperors. Throughout the Middle Ages equestrian monuments followed the Imperial tradition of using this type exclusively to honour sovereign rulers; the Scaligeri monuments to the fourteenth-century lords of Verona exemplify the continuation of this Roman attitude. The late medieval equestrian monuments to *condottieri* that precede the *Gattamelata* are located in interior settings, and are funereal in intent; the sculptural examples are neither free-standing nor executed in bronze.[14] Erasmo da Narni, then, is the first non-sovereign to be honoured by a bronze equestrian monument conceived and executed in the round for placement in a public, exterior setting; as Janson has noted, 'Donatello is to be credited not only with the carrying out of this new concept of the equestrian monument but with the creation of the concept itself.'[15] In its specific content, therefore, *Gattamelata* is not a revival of antiquity.

Yet the stylistic influence of ancient models on the work can easily be demonstrated. The powerful expressiveness of the head of the Renaissance horse – bared teeth, flared nostrils, and the lively pattern of veins under the skin – is derived either from the head of the steed of the *Marcus Aurelius* in Rome or, more likely, from the

horse's head that during the fifteenth century was in the Medici Palace (Fig. 54); Donatello probably knew both examples, and perhaps also the *Regisole*, an antique bronze equestrian monument in Pavia destroyed in 1796.[16] The stance of Donatello's horse, however, is drawn from the Horses at San Marco (Fig. 53): the posed effect of the single lifted hoof and the positioning of the other three come from the Venetian model. The unnaturally geometric curve of the rump of the Venetian horses and its repetition in the arched and tied tail are also found in the horse of the *Gattamelata*. Still, Gattamelata's mount is different from its Venetian models: heavy and stocky, he is a genuine Renaissance war horse. Donatello followed the general outline of the Venetian horses, but added a new element of observation to achieve greater realism.

The conception of an equestrian monument representing a figure wearing elaborate armour was unknown in antiquity. Both the *Marcus Aurelius* and *Regisole*, for example, were figures wearing a tunic and cape. The decorated cuirass worn by Gattamelata is derived not from equestrian figures but, as Janson has pointed out, from standing Roman military and imperial figures. Like the horse, it is a combination of antique and contemporary; Hartt has characterized it as 'mongrel armour':

> Gattamelata does indeed display a superb cuirass imitated in part from the richly sculptured ceremonial armour on imperial statues, complete with short kilt and epaulettes made of fringed leather thongs. But his arms and legs are safely sheathed in the latest fifteenth-century armour, an efficient matching of delicately jointed steel plates, combining maximum protection with considerable mobility, and totally unknown to the ancient world. At his side is strapped a gigantic contemporary sword (Roman soldiers used short swords), and even his cuirass is provided with jointed plates over the shoulders, in contemporary style.... It is as if one were to slip a Greek chiton over a business suit.[17]

How can this phenomenon be explained? Could Erasmo da Narni have had an elaborate suit of armour, based on ancient models as represented in sculpture, which he wore for state occasions? Whatever the reason for this costume, which we recognize as not authentically Roman, it was considered antique by Donatello's contemporaries, as is revealed by Filarete's advice to sculptors (*c.*1465): 'Do not as the aforementioned [Donatello] who made a horse in bronze to the memory of Gattamelata. It is so deformed that it has been rarely praised. When you make a figure of a man who has lived in our own times, he should not be dressed in the antique fashion but as he was.'[18] In this context it is also worth noting that Erasmo da Narni does not ride bareback, in the ancient fashion exemplified by *Marcus Aurelius* and depicted previously by Donatello in the relief of *St. George and the Dragon* (Fig. 80). The *condottiere* is firmly mounted in a Renaissance crib saddle with stirrups, suggesting that once again Donatello was more concerned with a realistic representation than with an archaeologically correct re-creation of antiquity.

Janson has traced Gattamelata's commanding gesture and his use of the baton to certain standing Roman figures, but the tradition of an equestrian figure with a baton would have been known to Donatello through the frescoed *Monument to Sir John Hawkwood* by Paolo Uccello, which had been painted in the Florentine Duomo in 1436. A thoroughly realistic, pragmatic explanation for Gattamelata's baton is that a silver-gilt baton, emblem of supreme military command, had been awarded to him by the Venetian government in 1438.[19] Rather than being a repetition of an ancient motif, then, it is possible that he holds the baton to identify him as supreme commander.

The mixture of real and ideal, contemporary and antique elements in the monument as a whole naturally leads to speculation about the image of Gattamelata

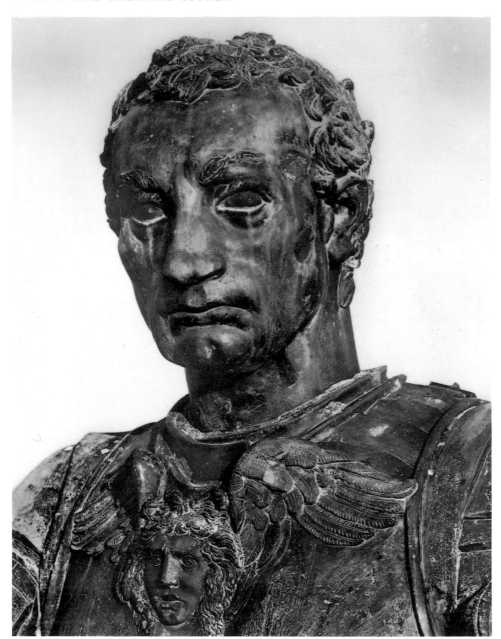

himself. Is the vigorous realism of his head (Fig. 105) an example of realistic or idealized portraiture, and does it reveal the influence of Roman portraiture on the Renaissance artist? The features are certainly distinctive, and one is left with the impression of a specific and recognizable physiognomy, a quality that has more in common with ancient Roman portraiture than with contemporary Italian sculpture. At the same time, the Gattamelata demonstrates an element of abstraction – the repetition of a distinctive curve in throat, eyebrow, nosebridge and eye-socket, and the multiplication of form in the flesh around his mouth and the tensed muscles of his jaw – which explains how his features and expression convey determination and severity across the relatively great viewing distance.

The short-cropped hair, in the fashion of many Roman portrait busts (Fig. 106), has been cited as evidence of Roman influence in the monument, despite the fact that the major Roman source, Marcus Aurelius, has long hair. The earliest surviving dated portrait sculptures of the Florentine Quattrocento – Mino da Fiesole's *Piero de' Medici* of 1453, his *Niccolò Strozzi* of 1454, and a host of others – demonstrate, however, that short hair *all'antica* was popular in fifteenth-century Italy.

106. Portrait Bust. Graeco-Roman, first half of first century AD. Marble, height 34.5 cm. Boston, Museum of Fine Arts.

There is no reason to assume Donatello ignored contemporary fact for the sake of antique revival.

Even though the general died in 1443, almost certainly before Donatello arrived in Padua, this realistic portrait may well be a likeness of him; in any case, it is not that of a man at least seventy years old who had recently suffered several strokes. Janson has argued that the head could not be a re-creation, a revitalization based on a death mask, but this would not have been beyond Donatello's capabilities. Both Janson and Hartt have asserted that the portrait is an idealized conception of a great general, and that there is no evidence that it bears any resemblance to Gattamelata; yet Donatello could have seen him during the earlier years of the Quattrocento. Gattamelata served in the mercenary forces hired by the Florentine Commune from 1409 to 1427; although these troops were not often in the city, he might have spent some time there, perhaps in 1414, when Ladislas of Naples was besieging the city, or in 1420 when Braccio da Montone, Gattamelata's superior, entered the city accompanied by four hundred soldiers. From 1427 to 1434 Gattamelata was in the service of two popes, Martin V and Eugenius IV, and these years include the time Donatello was in Rome in the early 1430s. That Gattamelata maintained his Florentine connections is revealed by the five surviving letters he wrote to Cosimo de'Medici between 1435 and 1439, and a letter of 1443 from his son and his brother-in-law to Cosimo states that the Florentine magnate is like a father to them.[20] Donatello, then, is very likely to have had opportunities to see, perhaps even to meet, Gattamelata during the latter's prime, when he was about the age of the figure represented astride the great horse in the Piazza del Santo in Padua. The theory that the head of the equestrian monument may be a true portrait is supported by the resemblance to the head in Gregorio d'Allegretto's *Tomb of Erasmo da Narni*, erected inside the church of Sant'Antonio in 1456–8 (Fig. 107). Although the

107. Gregorio d'Allegretto: *Tomb of Erasmo di Narni (Gattamelata)*. 1456–8. Marble, lifesize. Padua, Sant'Antonio

renowned Florentine sculptor Donatello might have been permitted to create an abstracted, idealized head for the equestrian monument in the piazza, it seems unlikely that Gattamelata's widow would have been happy with a reproduction of that portrait, if it were false, for the tomb she paid for within the church.[21]

Donatello's *Equestrian Monument to Gattamelata* is profoundly dependent on antique models, and forcefully demonstrates the formative influence exerted by ancient works of art during the Renaissance. But, like the other works discussed in this chapter, it is simultaneously modern, a response to the attitudes and needs of the culture that created it. Thus the *Gattamelata*, like many of Donatello's other works, is the result of a continuous tempering of his ancient sources with contemporary allusion.

Donatello's adoption of the bronze equestrian statue as an antique type to be adapted and modernized leads to speculation concerning his other revivals of classical forms. Pope-Hennessy has persuasively argued for the attribution to Donatello of a small, bronze statuette, the *Pugilist*, in the Museo Nazionale (Fig. 108).[22] Given Donatello's affinity for classical types, and his originality, it seems

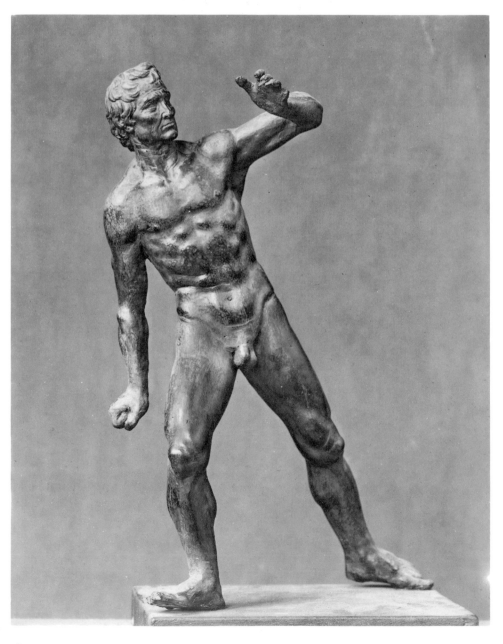

108. Donatello?: *Pugilist*.
1420s–1450s. Bronze, height
34.5 cm. Florence, Museo Nazionale

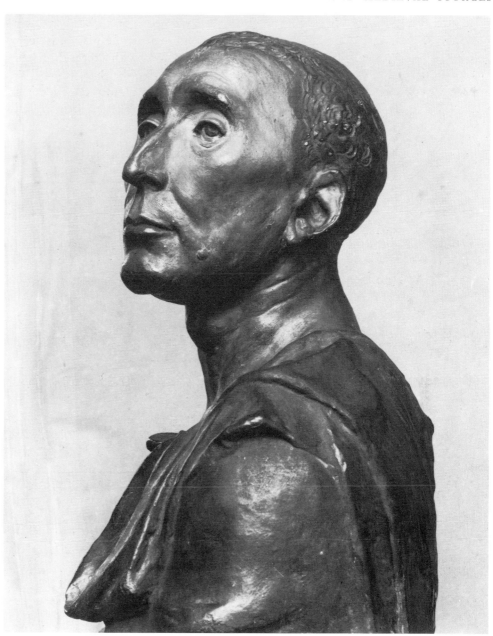

109. Donatello?: *Portrait Bust of
Niccolò da Uzzano?* 1430s?
Polychromed terracotta, height
46 cm. Florence, Museo Nazionale

quite possible that he could have been responsible for the revival of the bronze
statuette, particularly since such small figures appear in the crozier of the *St. Louis*
and as decoration on the Sienese font (Figs. 59, 35, 36). The distance in conception
from these architecturally connected figures to free-standing statuettes would have
been great, but it was Donatello who revived the large, bronze, free-standing
classical nude (Fig. 134). As Pope-Hennessy has pointed out, the handling of the
body, pose, musculature, and facial features in the *Pugilist* is close to other works by
Donatello, and, although such a stylistic analysis may not prove the attribution, it at
least enriches our understanding of his influence and progressiveness.

Another similarly speculative attribution persists because of the portrait quality
of the head of the *Gattamelata*. The bust called *Niccolò da Uzzano* (Fig. 109) is often
denigrated for its slavish realism, but it continues to appear in discussions of
Donatello's œuvre, since it seems so likely that he would have revived the classical
portrait bust, and that therefore an example must exist.[23] The earliest dated
Renaissance portrait bust is that of Piero de'Medici by Mino da Fiesole in 1453.
Mino's rather stylized approach to the portrait was superseded by the work of

Antonio Rossellino; Rossellino was strongly influenced by the humanism of the men for whom he worked, Giovanni Chellini (bust dated 1456), Neri Capponi (before 1457), and Matteo Palmieri (1468), and revived not only the practice of the life-mask, but also Pliny's ideas about the face mirroring the sitter's character. Palmieri's portrait was placed above his doorway in classical Roman fashion and remained *in situ* until 1832; Chellini's was given an indoor position; and the three known Medici portraits by Mino were placed on architraves over doorways in the Medici Palace.[24] Donatello, Giovanni Chellini's patient, would certainly have been involved in the problem and revival of the portrait bust; not only is there evidence of his concern with individuality in his figures for the Campanile and Orsanmichele (see Chapter 7), but he seems to have been known as a portraitist, since Vasari mentions several 'heads' by him in marble and bronze.

Still, the bust in question poses many problems. The identification of the sitter as Niccolò da Uzzano is based on comparison with painted portraits, and on a reference to it under that name as a work by Donatello in Carlo Carlieri's *Ristretto delle cose più notabili della città di Firenze*, 1745; it is not mentioned by Vasari. Niccolò was a wealthy banker and statesman, a humanist and patron of the arts, to whom Ciriaco d'Ancona was introduced when he visited Florence, and to whom the responsibility for overseeing the decoration of the Baptistry was entrusted by the merchants' guild. As one of the executors of Baldassare Cossa's will, he would have been involved in negotiations with Donatello for the tomb, and, as one of the wealthiest and most important men in Florence, he would have merited commemoration in a bust. Niccolò died 23 February 1433, and the portrait, in all probability, would date before or shortly after that date. It is generally considered to be based on a death mask, and the sculptor Joseph Pohl convincingly argued that the process is evident in the material (terracotta), the size (slightly smaller than life due to shrinkage in the kiln), and various anatomical proportions.[25] The bust is usually most vigorously criticized for those areas that would need reworking to make the transition from death mask to portrait – skull, neck, lids, eyesockets. The numerous coats of paint over the terracotta have obscured any finer modelling, and the wedge inserted between the bust and its wooden base to tip it forward weakens the angle of the head, although it was probably meant to strengthen the view from below (Fig. 109 is corrected for this addition). The attribution to Donatello has been rejected because of its faithfulness to reality; it is a likeness (literally warts-and-all), and lacks the intimations of personality and of potential change that characterize the true portrait. In many ways the bust is closer to Pliny's category of *imagines*, objects that simply recorded the ancestors' features for Roman families, than to a true portrait bust (see Fig. 106). If it does represent Niccolò da Uzzano, and dates from the 1430s, it might be such a familial record, in which case it should not be judged by the standards of a portrait and should therefore be reconsidered as a possible work by Donatello.

The supposition that Donatello would have been interested in the classical portrait bust is not, however, without other evidence. Just as he modernized the Roman equestrian monument, he endowed the medieval reliquary with new vitality in the *Reliquary Bust of San Rossore* executed for the friars of the Ognissanti, Florence, in the mid-1420s (Fig. 110).[26] The medieval reliquary, for instance the *St. Zenobius* (Fig. 111), was fashioned to serve as a container for great treasure, and its function was reinforced by a formal abstraction enhanced by inset jewels and enamelling. Such reliquaries were most often made of silver, and the hammered, light-weight, thin-skinned, and fragile object that resulted contributed to the idea of the reliquary as precious wrapping. In contrast, Donatello's reliquary bust has more in common with a Roman portrait bust (Fig. 106).

The *San Rossore* is made of gilded bronze, and the very technique of casting

contributes to a sense of physical presence. Furthermore, Donatello emphasized the same individuality that marks his Campanile prophets. The saint has high cheek-bones and a prominent forehead, a rather specific bone structure that raises the question of whether it might be based on the skull contained inside; his face has distinctive features and an elegant beard and moustache, but unexpected stubble on the cheeks. Compared to St. Zenobius's hieratic pose and the stare of his large, incised pupils, Rossore seems caught in contemplation. Breaking with medieval tradition, Donatello represented the saint looking downward with intense concentration and even anxiety, suggested by his furrowed brow and the veins standing out at his temples. The privacy of his thoughts is emphasized by his eyes; left ungilded, they lack definition, and therefore elude the viewer. Anita Moskowitz recently suggested that there might be a textual reason for what seems a merely meditative pose; the legend of San Rossore says he was converted while reading Psalm 86, and it is quite possible that Donatello represented him at this moment.

Although this sense of portrait, of the possibility of change, pervades the *San Rossore* in a way foreign to the *Niccolò da Uzzano*, the idea of a reliquary bust is not forgotten, but is alluded to in many ways. Rossore is dressed in historically correct Roman armour, over which a mantle is casually draped; the asymmetrical arrange-

110. *Reliquary Bust of San Rossore.*
1422–7. Gilded bronze, height
56 cm. Pisa, Museo di San Matteo

111. Andrea Arditi: *Reliquary Bust of St. Zenobius*. 1331. Silver, in part gilded, with enamels. Florence, Duomo

ment of this costume is certainly a break with the medieval type, but the piece of mantle lying on the base in front of the chest emphasizes that it is an object that is draped, and not a man. On the one hand, the elusive and contemplative glance is naturalistic; on the other, the entire sculpture is gilded, flesh as well as drapery. The bust does not terminate in either a classical Roman pedestal base, or the medieval architectural base, which was an extension of the shoulders; instead, the distinction between sculpture and real space, object and individual, is blurred. Donatello has made it possible for the *San Rossore* to be seen as a reliquary, and yet simultaneously to assume the illusion of portraiture.

The *Reliquary Bust of San Rossore* shows Donatello no more bound by traditional forms than he was awed by classical ones. His reasons for choosing one or the other remain obscure most of the time, but in some commissions there seems to have been a specific influence exerted by the patron or by circumstances. It is probably reasonable to assume, for instance, that in an effort to minimize objections, the *Tomb of Baldassare Cossa* (Fig. 46) is closer to medieval wall tombs than to a typically humanist tomb (such as the slightly later *Tomb of Leonardo Bruni* by Bernardo Rossellino), because of its location in the Baptistry. The virtually contemporary tabernacle for the *St. Louis of Toulouse* (Fig. 129) certainly shows Donatello capable of, and interested in, classical constructs; yet for the tomb he ingeniously used the columns of the building itself as framing elements (physically binding Cossa's monument to the most important architectural monument in Florence), keeping the medieval parted curtains as a draped baldacchino and the medieval caryatids as niche figures. Except for several classical motifs, the tomb type is medieval.

Although the point should not be over-emphasized, lest it obscure his genuine originality, Donatello's wooden sculpture also derives from a medieval type, exemplified by the *Deposition* at Volterra (Fig. 112). In fact, wooden sculpture was rarely produced in Tuscany after Donatello. Individuality and humanity, as well as emotional intensity, so strongly mark his *Penitent Magdalene* and *St. John the Baptist* (Figs. 131, 113, 114) that they seem to belong wholly to fifteenth-century humanism; yet such passion was definitely part of the medieval aesthetic. Does this quality belong to a type of sculpture, or to the particular medium? A definitive answer is impossible, but the question is important in connection with Donatello's Santa Croce *Crucifix*, the *Crucifix* attributed to him at Bosco ai Frati, and the bronze

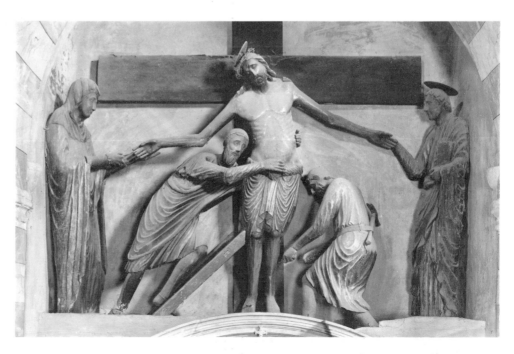

112. Unknown Artist: *The Deposition*. Thirteenth century. Wood, with polychromy and gold leaf. Volterra, Cathedral

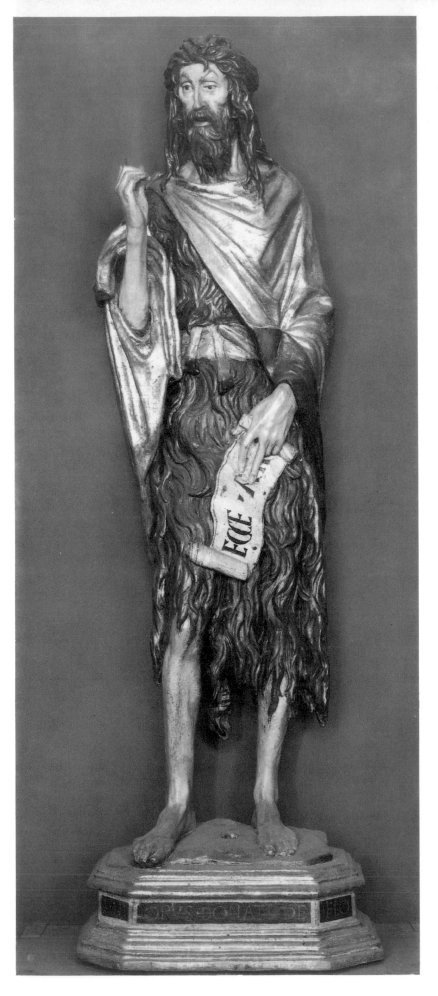

113. *St. John the Baptist.* 1438. Wood, with polychromy and gilding, height 141 cm. Venice, Santa Maria Gloriosa dei Frari

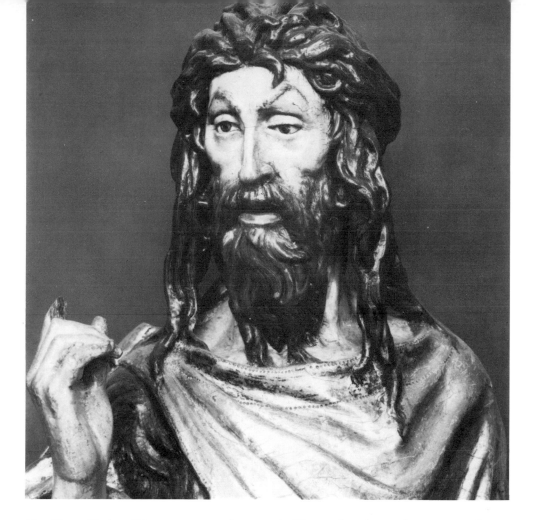

Crucifix at Padua (Figs. 74, 75, and see 127). The undated wooden cross at Santa Croce is usually seen as stylistically close to Ghiberti's *Crucifixion* (*c*.1407–15) on the *North Doors* of the Baptistry and therefore an early work; the austerity of its outline and the relative simplicity of the drapery have, however, more to do with the medieval type and medium than with the contemporary stylistic phase seen on the *North Doors* and called International Gothic. Yet what emerges first from Donatello's wooden sculpture is an impression that it is totally new.

This impression of the totally new could, paradoxically, correspond with an impression of being totally old; Donatello seems to have sought that in the small figure of a boy called, for convenience, *Atys-Amorino* (Fig. 115).[27] The statue is, in each of its parts and aspects, seemingly classical, and it is not surprising that it was mistaken in the seventeenth century for an ancient work, even though Vasari had identified it as by Donatello. The boy's infectious joy explains why the figure has become one of Donatello's most popular works, despite the fact that the apparently secular iconographic content has resisted explication. The uplifted face and the raised arms, the broad and slightly raucous grin, the lively eyes and loose hair, all suggest a pagan mood, which is enhanced by the manner in which the boy rocks back on his heels in a remarkably relaxed *contrapposto*. A search for precedents suggests that his *joie de vivre* is as rare in ancient art as in the Renaissance. Yet although this figure would be unique in either context, Donatello's profound understanding of classical form made this anomaly possible.

None of the proposed identifications satisfactorily explains the figure's many and explicit attributes: his age, the exposure of his genitals by unusual leggings, the wings on his shoulders and on his heels, the little tail and friendly snake, the poppy heads on the belt, the cord tied around his head and decorated with a flower, and his happy and carefree air. The suggestions have included Priapus, Mercury, Perseus,

Amor (Cupid), Harpocrates, Atys, a little Faun, Amor-Hercules, Mithra, Eros-Pantheos, Ebrietas (Intoxication), and the guardian figure Genius; each identification is unfortunately selective in its choice of attributes. Perhaps the decisive clue was the object the boy once held aloft, which has been missing since at least 1677. Erwin Panofsky has suggested that the figure might represent *Time as a Playful Child Throwing Dice*; again this identification fails to include all the figure's attributes.

An expensive bronze figure such as this one would not have been made on speculation, and Donatello's unknown patron certainly must have played a role in the development of the content, and indirectly in Donatello's choice of a general classical form or type. The patron was surely someone with strong humanist concerns, profound learning, and a desire not only to re-create antiquity, for which a copy of an ancient work would have sufficed, but an interest in combining many antique symbols to create a work of new and complex meaning. The intention seems to have been to obfuscate, rather than to clarify the subject, and in this sense, as well as in its eroticism, this bronze prefigures some of the developments of the mannerist style of the next century. Here, as elsewhere, Donatello's actual and precise sources remain obscure and almost completely unknown, although inspiration seems to have come from practically everywhere. Throughout his career he seems to have felt free to use the antique in the same way he used the more familiar medieval, neither adhering to a contemporary taste for the traditional, nor feeling the need to be progressive, but interweaving new and old, form, content, and motif in his art.

115. *'Atys-Amorino'*. 1430s–1450s. Bronze, with traces of gilding, height 104 cm. Florence, Museo Nazionale

CHAPTER SEVEN

Large Figural Sculpture:
Command of Space and Audience

> Although Donatello was a contemporary of these [Renaissance] artists, I was
> uncertain whether I should not place him among the artists of the third period
> [High Renaissance], seeing that his works are the equal of those of the fine
> artists of the ancient world. Anyhow, in this [Renaissance] context he may be
> said to have set the standard for the rest, since in himself he possessed all the
> qualities shared among others. He imparted movement to his figures, giving
> them such vivacity and animation that they are worthy to rank both, as I said,
> with the work of the ancient world and also with that of the modern.
>
> Vasari, Preface to Part Two of the *Lives of the Artists*, 1568

Sculpture exists as both reality and illusion; it occupies the viewer's physical space,
but demands, at the same time, to be understood on its own formal terms. This
tension between natural and imaginative conditions is most acute in large figural
sculpture, where the human forms are life-size or larger, and the viewer therefore
reasonably expects psychological involvement. The power and effectiveness of
Donatello's figures result from his manipulation of this tension, a combination of a
formal command of physical space and the ability to evoke an immediate and strong
response from the viewer. Conceived with vigour and imagination, the sculptures
avoid sentimental illusion, and their individuality adds new dimensions to tra-
ditional iconography.

Although Donatello's sensitivity to this confrontation of illusion with reality is
evident from the beginning of his career, and no statue can be seen as a trial piece
whose solution appears in another work of art, his visual conceptions become more
daring as his style matures. His earliest recorded commission for a large-scale figure,
in 1408, is generally identified with the marble *David* now in the Museo Nazionale
(Fig. 116);[1] it was for one of the twelve figures proposed for the buttresses of the
Duomo, which included a statue of *Isaiah* commissioned a month earlier from
Nanni di Banco for the north transept (Fig. 117). There is no certain evidence that
David was ever put into place, and only three weeks after the final payment was
made to Donatello, either Nanni's *Isaiah* or Donatello's *David* was removed from its
buttress. Although a number of questions about this commission remain un-
answered, the problems Donatello confronted can be understood from the
circumstances.

Evidently a series of statues for the buttresses had been anticipated long before
the 1408 contracts were made, since Andrea da Firenze's mid-Trecento painted
model of the Duomo in the Spanish Chapel, Santa Maria Novella, shows figures on
both the nave and side aisle roof-lines. The commissioning of the *Isaiah* set the

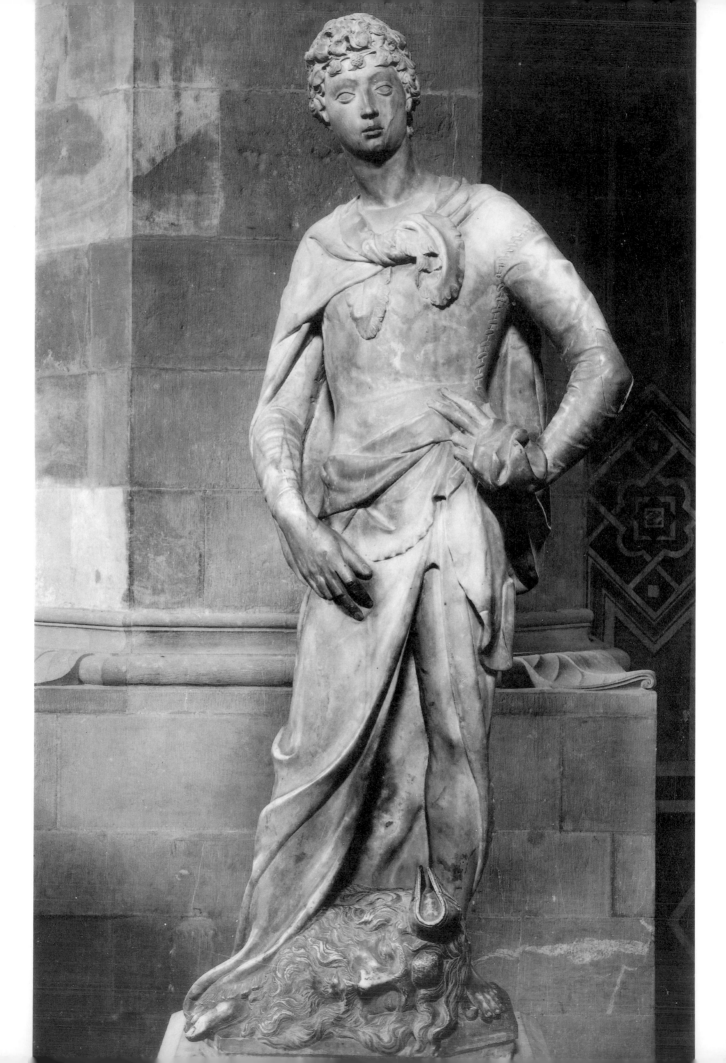

116. *David*. 1408–9, 'finished', 'adapted', and partially gilded in 1416. Marble, originally with a metal or leather sling strap, height with base 191 cm. Florence, Museo Nazionale

117. Nanni di Banco: *Isaiah*. 1408. Marble, height 189.8 cm. Florence, Duomo

height of the statue at three and a quarter *braccia* (just over life size) and, since Nanni and Donatello were working more or less simultaneously, some uniformity in the conception of the prophets could be expected. Although the swaying pose and thin, carefully arranged drapery of the *Isaiah* can be seen simply as evidence of the popular Gothicizing style of the first years of the Quattrocento, these characteristics can also be understood as a response to the demands of the location. Both the *Isaiah* and the *David* depart sharply from the vertical and have poses that were meant to differentiate them from their architectural surroundings, as well as to present lively and clearly articulated outlines. Broad drapery planes define the forms of the body, and sharp folds and animated hemlines not only make the figure more interesting, but also accentuate the distinction between cloth and human form.

Well-adapted as these statues might be for distant viewing, and exciting as the concept of free-standing, slightly over life-size figures on the roof-line must have been, the removal of one of the figures shortly after its installation suggests that the Operai realized, or were persuaded, that these marble figures lost their significance in competition with the Florentine skyline. The project, however, was not abandoned, and in the summer of 1410 payments were made for a terracotta statue referred to in later documents as a colossal figure of Joshua by Donatello.[2] In December 1410 it is already noted as being on the buttress, but only in July 1412 does Donatello receive part of the payment for his work; finally in August it is decided that he should receive 128 florins 'for his labour and craftsmanship and expenses contracted by him'.

The sculpture of Joshua is known only from these documents and later illustrations of the Duomo (Fig. 118); toward the end of the seventeenth century it was still in place, but was taken down shortly afterwards. It was indeed a colossus, scaled to both the immense size of the church and the distance from which it would be viewed. Although colossal statues were commonplace in the ancient world, and were mentioned by Pliny, the concept was as new to the Florentine Renaissance as was *Joshua*'s medium of terracotta covered with whitewash. Nothing is known of the commission for the *Joshua*, and therefore of the origin of these ideas, but several peculiarities in the surviving documents make it tempting to see Donatello as the

118. View of the Florentine Duomo in 1684, from Ferdinando del Migliore, *Firenze città nobilissima*, Florence, 1684. Donatello's lost colossal terracotta *Joshua* (*c*.1409–12) is visible on one of the north buttresses below the dome

193

instigator, and *Joshua* as an experiment both in medium and final visual effect. Payments continue for an unusually long period after the *Joshua* is first noted as being on the Cathedral, suggesting that it was constructed in place on the buttress, and that Vasari was correct in saying that the colossus was made of 'bricks (*mattone*) and stucco'; it would be no wonder then that Donatello's 'craftsmanship' was mentioned in the 1412 payment. On the other hand, Vasari's statement has usually been discounted because his entire notice is that Donatello 'made two giant figures in bricks and stucco'. In support of Vasari is Giovanni Chellini's notation in his *Libro debitori creditori e ricordanze* in 1456 that Donatello had made 'a large male statue . . . and had begun a companion figure nine braccia tall'. Janson is probably correct in saying that the second figure Vasari saw was actually the colossus commissioned from Donatello's pupil, Agostino di Duccio, in 1463, and that Agostino began it on the stump of the figure that Chellini records. Agostino's commission was not only for a figure of the same height and size as the *Joshua*, but also 'in quella forma e manera' ('in that shape and style'); the conditions were well enough fulfilled for Vasari to note that Donatello himself did two terracotta figures for the Duomo buttresses.

The *Joshua* posed the most challenging problem for Donatello in terms of relating a sculpture to its setting and audience, and the solution, both in medium and scale, conformed to the ideas of the Florentine Renaissance in ways that the marble *David* did not. Donatello seems to have continued to be involved with such figures for the Duomo roof-line, since in 1415 he and Filippo Brunelleschi were paid for a small marble figure covered with gilded lead requested by the Operai as a demonstration and test for large statues for the *sproni* of the Duomo. This is usually assumed to have been a model for Agostino's figure as well as a trial of new materials to eliminate the need of continually whitewashing the terracotta. Since Brunelleschi was involved in the commission, however, and since terracotta was again used in 1463, it is also possible that this model was for a different series of statues around the dome.[3] In any case, Donatello seems to have been the accepted authority on the problem of such large statues, and his reputation was no doubt enhanced by his statue of *St. John the Evangelist* for the Duomo façade finished in 1415 (Figs. 61, 62) and the important commission of *St. Mark* for Orsanmichele (Figs. 27, 119, 120).[4]

The first known consideration by the Arte dei Linaiuoli e Rigattieri (Guild of Linen Weavers and Pedlars) for a statue for their niche on Orsanmichele is early in 1409, when the sculptor Niccolò di Pietro Lamberti was sent to Carrara to procure a piece of marble large enough for a figure three and three-quarter *braccia* tall. Lamberti seems to have been chosen for his knowledge of marble, and not necessarily as the figure's sculptor, since two years later the guild charged five of its members with accepting delivery of the stone, choosing a sculptor, and supervising the installation of the figure. On 3 April 1411, Donatello received the commission for a statue four *braccia* tall, standing on a marble base, which was to be completely finished, including gilding and installation, by 1 November 1412. The guild lost little time in preparing the niche, and three weeks after the commission it accepted the design for the tabernacle submitted by two stone-carvers; they were to finish it within eighteen months, making the inside like the Trecento tabernacle of St. Stephen, with black marble inlaid with white roses and rosettes. In April 1413, the representatives were asked to see to the finishing of the tabernacle and statue, but Wundram's analysis of the guild documents suggests that Donatello's figure was not completed before 1415.

While the *St. John* had provided yet another solution to the formal problems of location, the commission for the Linaiuoli offered new possibilities for Donatello, and the significance of the resulting *St. Mark* was quickly realized. Whether or not Vasari's report can be trusted, the value of the comment he ascribes to Mich-

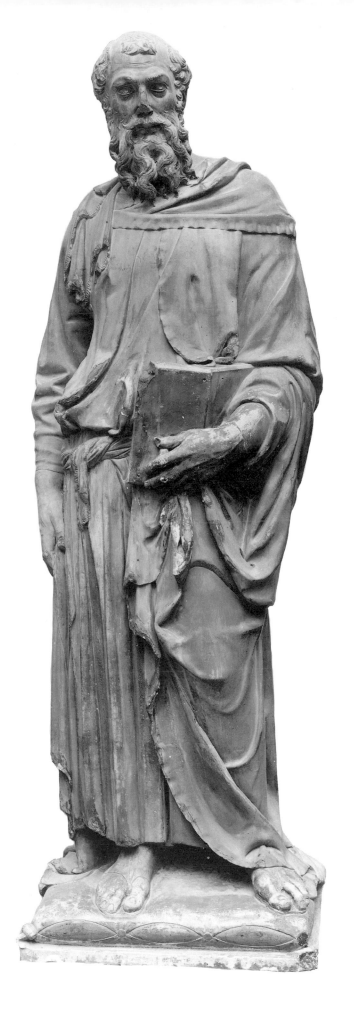

119. *St. Mark. c.*1411–*c.*1415.
Marble, originally with partial
gilding, height 236 cm. Florence,
Orsanmichele. (See Fig. 27.)

elangelo lies in how easy it is to agree with it: 'that he had never seen a figure which had more the air of a good man than this one, and that if St. Mark were such a man, one could believe what he had written.' The figure demands a response on a human level; even though the cues are carefully calculated aesthetically, their sum is psychological.

The most obvious ways of establishing contact between the viewer and a sculpted figure involve gestures and facial expressions that extend toward the audience; Donatello chose not to indulge in such devices for the *St. Mark*, but instead interrelated figure and niche to create an alternative environment. The subtlety of this solution is quite different from his work for the Duomo but, in terms of the relationship between sculpture and architecture, no less startling than the idea of a colossus. The design for the tabernacle was complete within days of Donatello's commission, but the interaction of niche and figure proportions suggests that the sculptor had some say in adjusting the height of the framing pilasters. The monumentality of the *St. Mark* is not related to his towering above the architecture; he rests easily within the niche, in great part because the view from the street places his head near the level of the springing of the arch. Vasari's anecdote about the guild not being pleased with the *St. Mark*, and Donatello's pretending to fix it but simply putting it in the tabernacle, is undoubtedly apocryphal, but demonstrates how obvious the rapport is between the figure of St. Mark and its surroundings.

The figure itself is no less remarkable; Janson refers to it as a 'mutation', in recognition of its lack of stylistic prototypes, even though there are superficial similarities to a wide range of earlier and contemporary art. Donatello's originality lies in his totally coherent use of classical *contrapposto* based on his appreciation of the pose as related to motion, rather than as simply referring to antique art. The clearest example of the second alternative occurs in Nanni di Banco's *Quattro Coronati*, also for Orsanmichele (Fig. 31), and probably almost contemporary with the *St. Mark*; although the spatial situation is quite different, the two rear figures approximate Donatello's statue in their frontal view and general pose.[5] Nanni, with a wide knowledge of the antique, has emphasized the volume of these half-hidden saints by pulling the drapery around the torsos; in the process he reduced their *contrapposto* stance to merely a means of indicating solid bodily form and thus played down any suggestion of possible motion. Donatello, on the other hand, used drapery to emphasize the simultaneous action and repose inherent in *contrapposto*, and therefore the possibility of movement essential to the illusion of a psychologically active being. The strong, columnar folds on *St. Mark's* right leg reinforce its function as weight-bearing as they fall from a jutting hip-bone, itself further defined by the heavy, looped drapery belt; the non-supporting left leg, usually passive in a *contrapposto* pose, acquires the illusion of fleeting movement through transitory ripples spread across the thigh and knee. By bringing the left hand forward and baring the wrist and lower forearm, Donatello has emphasized the figure's quiet power and increased its pivotal movement within the niche; the right arm and shoulder are thrown back, drapery swings across the torso to the right hip, and the mantle edge strains from shoulder to shoulder. Perhaps most telling is the length of the garment itself; it reaches only to the ankle bone, exposing the feet, and giving a clear sense of the man standing on his own. This is a significant break from the traditional drapery, which enveloped the feet and rested on the ground as a strong physical base.

The sum of these aesthetic cues is an overwhelming naturalism, a 'mutation', for which sources are automatically sought. Classical sculpture is a tempting possibility, especially since the crimped drapery edge seems to occur only in antique examples, and Donatello's knowledge could easily have come from the journey he

120. Detail of Fig. 119

made to Rome; but the drapery style is very different from Nanni di Banco's careful re-creation of the classical style as it was known in the early Quattrocento, and the relatively squat proportions of Donatello's figure, with large head and hands, are far from any classical canon. Frederick Hartt has turned to Vasari's description of a model made of real cloth dipped in slip to explain this naturalism as being particularly suited to a linen guild; yet an analysis of individual passages of drapery shows them to be carefully controlled and, in some cases, defying the laws of gravity. The drapery might well be the result of this technique, but it is not the sole source of the statue's naturalism.

The same can be said of other parts of the statue. Again breaking with tradition, Donatello substituted a covered pillow for the usual plinth base; this has been seen as a naturalistic reference to the guild, but the pillow is far from realistic, since it barely registers St. Mark's weight. Instead, the base is one more aesthetic cue for the viewer's perception of this figure to be momentary and transitory. By depriving the *St. Mark* of the kind of base associated with statuary, Donatello introduced the notion of a chance or temporary resting place for the figure; here the pillow approximates the size and shape of the usual architectonic base, but in later works Donatello was much freer. He used the pillow again in *Judith and Holofernes*, where it not only registers the weight upon it, but flops with its own weight over the triangular base (Fig. 136). The *Penitent Magdalene* and both the wooden and bronze figures of *St. John the Baptist* (Figs. 131, 113, 65) are set on uneven and indefinite patches of ground, taking advantage of the shifts in body weight that result, and minimizing the impression of motionless and static statuary; in many ways the same is true of the bronze *David* (Fig. 134). Donatello left several figures, including the *St. Louis of Toulouse* (Fig. 129), also for Orsanmichele, without bases altogether. The power of this new approach to the relationship between sculpted figure and ground, even in the tentative form it takes in the *St. Mark*, can easily be seen in a comparison with the virtually contemporary *St. John the Baptist* by Ghiberti for Orsanmichele (Fig. 29): the base for St. John sets him on a pedestal both literally and figuratively, removing him from the realm of our physical experience and, with an emphasis on severity and surface patterns, setting him apart from the viewer.[6]

The *St. Mark's* command of space involves a subtle interplay of proportion between figure and niche, and a torsion of the figure, which seems to define the 'personal space' that twentieth-century psychology associates with a human personality. The power in repose that characterizes Donatello's treatment, leads to a figure and a corresponding environment that are self-contained and self-sufficient. The head, the most evocative element of figural sculpture for human response, is thrust forward on a rather long neck, but this pose, rather than forming a direct link to the viewer, increases the sense of possible movement. In close-up (Fig. 120), the eyes are unfocused and the jaw slightly under-slung, but from the viewer's normal position shadows play under the heavy brow-ridge and thick moustache, increasing again the momentary, living sense of the statue as well as the saint's self-absorption. The figure's command of the audience is thus our curiosity and concern with the inner man; the comment Vasari attributed to Michelangelo did not focus on the figure's actions, but rather on its personality and character.

The importance of the statue's relationship to its surroundings is hardly surprising; what is remarkable about Donatello's large figural sculpture, and what attests to his extraordinary genius, is that this relationship is exploited in order to evoke not only an aesthetic reaction, but a psychological response akin to the response to a living being. The complex connections between man, nature, and art implied by Donatello's *œuvre* were taken up by writers such as Ghiberti, Alberti, and Poggio Bracciolini, but the first evidence of such a Renaissance concern is visual rather than literary. Donatello's connections with humanist theoreticians are

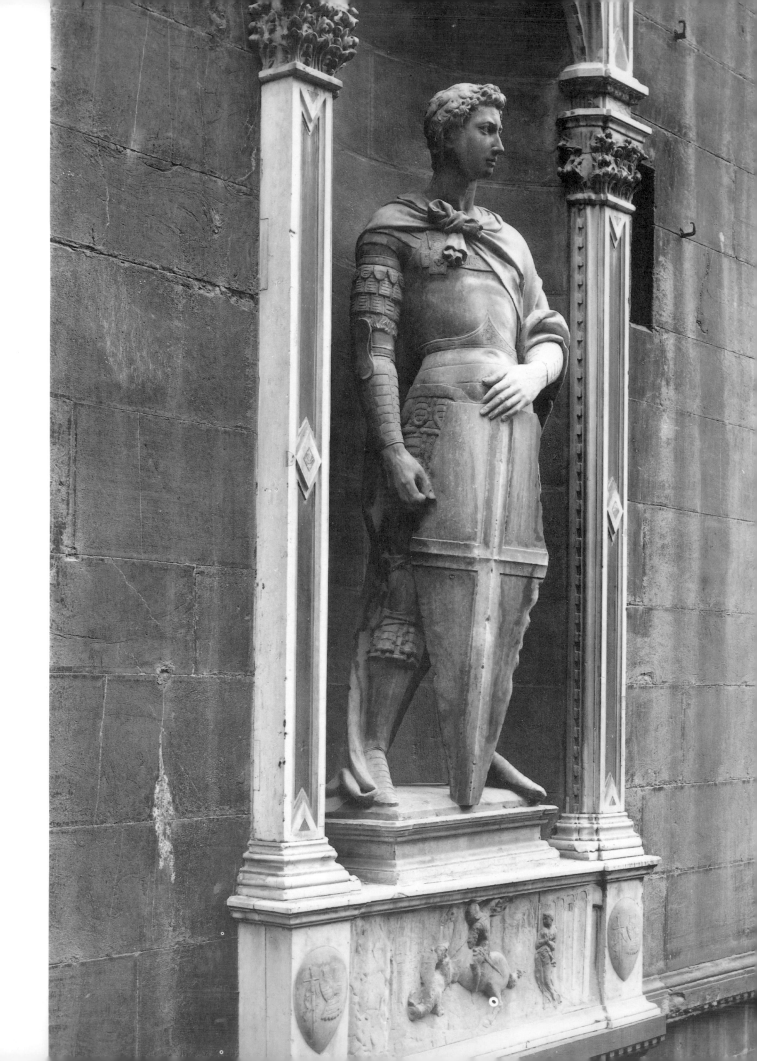

largely unknown, although his work closely parallels their ideas. Alberti, in his 1435/6 dedication of *Della pittura*, refers to him as 'our close friend Donato the sculptor'. The illusion of a living man that Donatello creates is never the ideal human form, but one through which the viewer easily perceives a recognizable psychological state; emotion itself is a human ideal.

Donatello's wide-ranging talent was not confined to the type and form of the *St. Mark*; it shifted drastically in another commission for Orsanmichele, the statue of *St. George* for the Arte dei Spadai e Corazzai (Guild of the Swordsmiths and Armourers; Figs. 28, 121 and Plate II),[7] generally assumed to date from about 1415 to 1417. At first glance, this commission might seem to pose the same problems as the *St. Mark*, but two important differences distinguish the finished statue of *St. George*: first, the personality or reputation of the patron saint of the guild, and second, the peculiarities of the corner pier to which he was assigned.

In physical presence and set of mind, St. George, the warrior saint, is far from the contemplative St. Mark, and Donatello has emphasized this distance. Vasari did not praise the saint's moral character when he looked at the *St. George*, but rather the vivacity and spirit of the figure, its 'terrifying lifelikeness', and 'un maraviglioso gesto di muoversi dentro quel sasso' ('a marvellous sense of movement within the stone'); Vasari's observations could well be ours. Donatello's *St. George* is the essence of youth – his face is open and unlined, his body is slim and taut. There is a sense of hearkening, of readiness, which is neither action nor repose, and whose source is not readily apparent.

Careful examination reveals that Donatello has again used the *contrapposto* pose in an unexpected way. By a subtle arch of the back, throwing the chest and pelvis forward, St. George's weight is slightly shifted to his left leg. Experience has taught us that this forward leg should not be the weight-bearing one, especially since the forward arm should surely be the active arm, as it is in the *St. Mark* (Fig. 121). But St. George's left arm rests on his shield, its repose emphasized by the mantle draped on his shoulder. It is the right arm that tenses with wielding – or the weight of – the metal weapon it once held. Its strength is reinforced by the bindings on the forearm and the bulge of the armour over the biceps. In keeping with this classical, if much subdued, *contrapposto*, the right shoulder is slightly lowered, and, to offset the curve of the spine, is thrown back in a gesture at once arrogant and defensively effective. St. George stands with his legs widely spaced in a position we usually interpret as 'at ease', but the opposing messages of the *contrapposto* pose convey the 'sense of movement' that so impressed Vasari. Whereas *St. Mark* seems self-absorbed, or contemplative, and his naturalism has to do with our perception of the workings of the evangelical mind, here the naturalism is our perception of the taut, anxious body of the young warrior.

Location, the second variant in this commission, might well have seemed a liability when Donatello first confronted it: the northwest corner pier contains a staircase which severely limits the depth of the niche. The easy rapport between figure and architectural space, the sense of personal space enveloping the *St. Mark*, is not possible for the *St. George*. Nevertheless, statue and niche have an interdependence, which fuels the argument concerning the authorship and date of the tabernacle (Fig. 28). Except for the reliefs of *God the Father* and *St. George and the Dragon* (Figs. 79, 80), there is nothing particularly remarkable about the tabernacle itself. It generally conforms to the Gothic type of those already completed for Orsanmichele and varies only in a slightly larger base, simpler side pilasters with lower bases, and lower bases for the two side pinnacles; the overall effect is somewhat less ornamental and slightly more vertical. Such a design might have originated with the stone-cutters hired by the Guild of Swordsmiths and Armourers, or, if Wundram's theory is correct, by the Laudesi in 1402, or it could

121. Side view of *St. George* (Fig. 28). *c.*1415–*c.*1417. Marble, height 209 cm. Florence, Orsanmichele

be the work of Donatello conforming to guild regulations or expectations. It is hard to believe, however, that the treatment of the shallow niche itself did not originate with the sculptor. Unlike the usual elaborately inlaid niches on Orsanmichele (Figs. 26–31), here there is no definition of the wall behind the figure, and therefore no definition of the niche space. The tabernacle becomes both frame and doorway to a place as ambiguous as that offered by the gold ground of a painting or the flat background of relief sculpture. The gentle cupping of the wall maintains the masonry courses of the building, but smooths them slightly so that a casual visual calculation of the curve is difficult. *St. George* seems to be entering our space as much as commanding his own.

This encroachment is not just an illusion, and the view of *St. George* as one passes him on the street shows how tenuous his connection is to the architecture (Fig. 121). Donatello did not flatten the figure in any way to compensate for the shallower niche; *St. George* cannot be fully understood except as a statue in the three-quarter-round. The form changes dramatically as one moves from the presented shield and profile head, to the full frontal, to the deep shadow behind the shield and the strong line of the forward leg. The upward angle of the lost weapon would have been one more intrusion into the viewer's space. But although the forms change, the sense of physical readiness does not; one sees none of the surprises, none of the unexpected views, which characterize sculpture in the round. *St. George* tenses at the edge of our space, pushed there by the architecture, but dependent on the tabernacle for his lifelikeness. Photographs of the figure out of its tabernacle show the tension to be stiffness, the alert pose to be mere rigidity, when seen without the architectural foil. In the *St. George* Donatello has successfully conveyed a physical state through an actual, subtle, spatial interaction with the viewer.

Remarkably, Donatello had not exhausted his repertoire of possibilities for architectural sculpture, and was far from settling into a formula even when confron-

122. East side of the Campanile (see Fig. 22). The following marble figures are *in situ* (left to right): *Beardless Prophet* by Donatello (1415–20); *Prophet*, possibly by Nanni di Banco or Nanni di Bartolo (c.1405–c.1420); *Abraham and Isaac* by Donatello and Nanni di Bartolo (1421); and *Bearded Prophet* by Donatello (1415–20). These figures, now in the Museo dell'Opera del Duomo, Florence, are all approximately 180–90 cm. high

ted with a number of commissions for the Florentine Campanile.[8] The Opera decided, about 1415, to resume the programme of prophets and sibyls in niches on the third storey of the Campanile (Fig. 122; see also Fig. 22); the niches on the more prominent south and west faces were already filled with Trecento figures in fairly heavy drapery, carrying the traditional unfurled scrolls. Donatello, as might be expected, largely ignored such concrete iconography, relying on the individuality and intensity of prophecy to distinguish his figures; even, or perhaps especially, from such a great distance, they are psychologically commanding.

The documentary information as to which statues are by Donatello is incomplete and inconclusive, and only in the case of the *Abraham and Isaac* are the references specific enough to match statue and document. Nonetheless, his name is connected with at least five statues, usually identified as *The Beardless Prophet* (Fig. 122, left-hand niche), *Abraham and Isaac* (Fig. 122, third niche, and Fig. 126), *The Bearded Prophet* (Fig. 122, fourth niche), *Jeremiah* (Fig. 123), and the *Zuccone* (Figs. 124, 125). He was commissioned to do two marble figures on 5 December 1415; one was completed in 1418, the other in 1420, and both were installed on the Campanile in 1422. Stylistically, these have been identified as the *Bearded Prophet* and the *Beardless Prophet*. In March 1421, Donatello and Nanni di Bartolo (Rosso) received the commission for *Abraham and Isaac* and completed it in only eight months, so that it, too, was ready for installation in 1422. The two other figures, the *Zuccone* and *Jeremiah*, were carved between 9 March 1423 and 11 January 1436. Although their contracts have not been found, one statue was completed in 1425, the other in 1436; each is inscribed OPVS DONATELLI on the base. The chronology of these two has been vigorously debated, but as Pope-Hennessy points out, since the payments indicate that the second statue was three-quarters finished within a year of the completion of the earlier, stylistic arguments concerning chronology are irrelevant. The designation given here is the traditional one, based on the name Jeremiah inscribed on the scroll (probably added in 1464 when the statues were moved from the north side, facing the church, to the west); the *Zuccone*, meaning the 'bald-headed one', or literally 'pumpkin head', is thus the *Habakkuk* mentioned in documents in 1434, 1435, and 1436.

The carefully controlled relationship between statue and niche that Donatello established at Orsanmichele could not be as effective on the Campanile, where the programme had already been begun by the Trecento figures, and the niches were a repetitive architectural motif. Instead, he exploited this regularity as a foil for figures whose poses and drapery patterns are far from predictable. Such an approach to architectural sculpture had been used in the thirteenth century by Giovanni Pisano for the façade of the Sienese Duomo, where prophets and sibyls lean out and twist free of the horizontals and verticals of the architecture; this may or may not have been Donatello's source – certainly the Campanile figures are less expressionistic – but the intention is similar.

The two earlier figures, the *Beardless Prophet* and the *Bearded Prophet* (Fig. 122, first and fourth niches), follow stylistically from *St. Mark* (Fig. 27) and *St. John the Evangelist* (Figs. 61, 62) in general type and in the use of drapery to create volume and strategically reveal form. Their poses seem to be chance positions – one's toes curl over the plinth, the other's mantle falls forward as he loosens it to hold open his curling scroll – but the poses are careful reinforcements for the effect of heads bent in thought. Although the downward glances first catch the viewer's attention, once that attention is there, it becomes clear that these prophets are not interested in the street below. The heavily lined faces, the heads and hands accentuated by strong distinctions of light and shadow, the sense of weight, both physical and psychological, on the shoulders, and the lack of easy identification give these men a command of their audience far greater than that induced by a simple, directed glance.

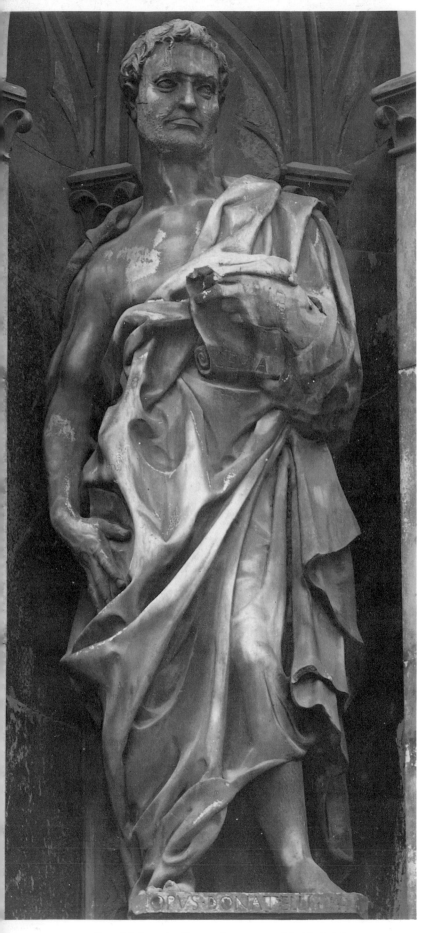

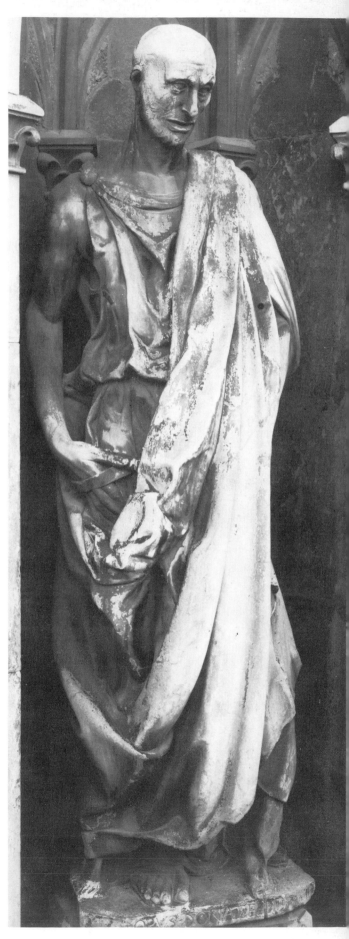

123. *Jeremiah*, from the Campanile. *c.*1423–5. Marble, height 191 cm. Florence, Museo dell'Opera del Duomo

124. *Zuccone (Habakkuk)*, from the Campanile. *c.*1427–36. Marble, height 195 cm. Florence, Museo dell'Opera del Duomo

125. Detail of Fig. 124

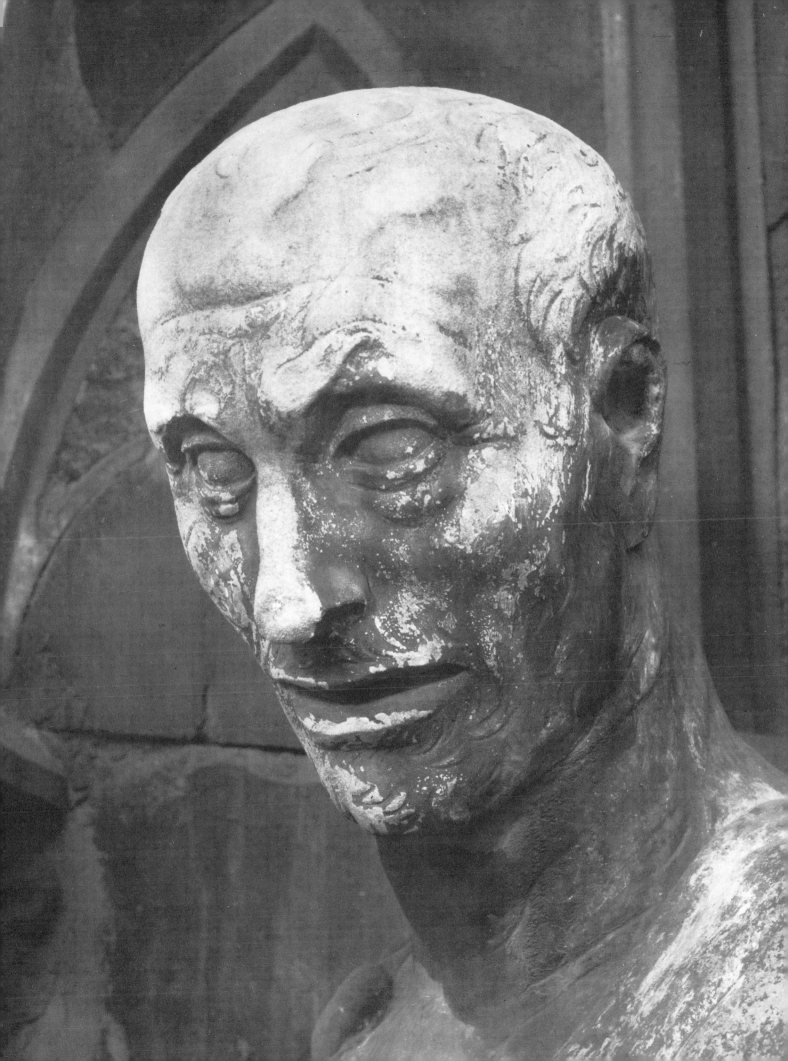

Donatello's part in the collaboration on the *Abraham and Isaac* (Fig. 122, third niche from left, and Fig. 126) is not clear from the documents and cannot be inferred from what is known about his relationship with Rosso. The statue is unique among the Campanile figures, not only because its identity is readily apparent, but because it represents a narrative moment; Abraham's wrist is powerless as he hearkens to the voice behind him, and the knife slides down Isaac's shoulder. Unlike the other prophets, most of whom are known as authors of books of the Old Testament, Abraham's importance lies in his action, not his word; his relationship with God is best understood at the moment his hand is stayed. Judging from Donatello's *œuvre*, it is quite possible that he was responsible for the interpretation and composition; from a sculptor's point of view, a double-figured statue in a programme of single figures in niches must have presented complicated design problems.

The brilliance of the finished composition certainly points to Donatello. The statue has long been underestimated because photographs were taken, not only level with it, but head-on as well. This viewpoint emphasizes the monolithic character of the figures, the dullness of their outline, and the oddly bowed position of Abraham's arms. In place on the east side of the Campanile, Abraham turns toward the Duomo, and a view from this direction is the most effective; it reveals the impotence of his right hand, allows us to read the twist of his head and shoulders as representing dumb-struck awe and not arrogance, to see Isaac's pose as submission, and to appreciate the subtlety and variation achieved in the outline of the group. Rosso's part in the commission is usually assumed to have been confined to the carving; yet even here, especially in the figure of Abraham, Donatello's expertise is evident. The viewer is once again confronted with a man who is confronting God; the struggle in Abraham is expressed as much by the angles of his pose, which could easily be read from the street, as by the rolling of his eyes, which could not.

Donatello used the suggestive power of such abstract elements to even greater advantage in the *Jeremiah* and the *Zuccone* (Figs. 123–125), drawing on the evocative possibilities of drapery, which he had probably already explored for the bronze *St. Louis of Toulouse* (Fig. 129). Jeremiah's heavy and unruly drapery can barely be managed by a prophet removed from reality by his despair and the difficulty of his God-given task. From a distance, this thick, rich cloth reads as an uneasy mantle on an otherwise naked body. The same sense of nakedness, although he has a scant undergarment, is conveyed by the *Zuccone*; his great hand and powerful arm are encumbered by a mass of outsized folds swirling over his shoulder and weighing him down. Such unexpected drapery, unrelated to the body volumes, immediately catches the eye; what then confronts the viewer are heads that seem, in their individuality and eccentricity, to be portraits.

As early as the beginning of the sixteenth century, Antonio Billi identified these two figures as portraits of Giovanni di Barduccio Cherichini and Francesco Soderini; he went so far as to say that the *Zuccone* is 'a likeness, drawn from nature' of Cherichini. It is unlikely, however, that Donatello would have intended the two prophets to be recognized as these two anti-Medicean Florentines. Janson is undoubtedly correct in considering the identification as part of the movement, about 1500, which sought to use significant statuary as political symbol, and which saw the prophets' visual similarities to Roman orators as evidence of republican sympathy; the great weight of material thrown over their shoulders certainly evokes the Roman toga, and the highly individualized faces recall Roman portraiture (see Figs. 106, 125).

A generic connection links ancient art with the Campanile prophets, but Donatello's specific sources have not been found. During the 1420s, he seems to have been very much concerned, whether prompted by Roman portraiture or not, with the uniqueness of the human face and the subtle transitions of the planes that

126. Donatello and Nanni di Bartolo: *Abraham and Isaac*. 1421. Marble, height 188 cm. Florence, Museo dell'Opera del Duomo

define that singularity. About 1425 he was commissioned to do a bronze reliquary bust of San Rossore for the friars of Ognissanti in Florence; the result obviously could not be a portrait of a saint martyred under the Emperor Diocletian, but the qualities of the head have prompted Pope-Hennessy to cite the *San Rossore* as evidence of what Donatello's early portrait style might have been (Fig. 110).[9]

The heads of both the *Jeremiah* and the *Zuccone* have that same sense of individuality, and it is not surprising that their identification as portraits of Soderini and Cherichini persisted into modern art history. Our imagination is captured by Jeremiah's stern, troubled brow, and strangely pouting lower lip; the angle of his neck and shoulders, with chin slightly lowered, gives him an attitude both of meek recoil and determined defiance. The personal conflict imposed on a prophet becomes clear as we focus on an image of a man as full of contradictions as any we might pass on the street. The *Zuccone* carries this turmoil into terror, and seemingly into insanity, with a face whose eyes and mouth are fathomless shadow, and a balding skull that conjures up not just the wisdom of old age, but also, to modern eyes at least, the fanaticism and eccentricity associated with a shaved head. Elaborating on a slightly earlier story, Vasari claims that while Donatello was working on the *Zuccone* he would cry, 'Speak! Speak! or may dysentery seize you!' This anecdote, reflecting the age-old praise that only a lack of breath distinguishes a stone figure from the living, is both a tribute to the compelling power of the statue, and a recognition of Donatello's greatness. Perhaps even more interesting is that the idea is attached to the statue of Habakkuk, the prophet who declared:

> What profiteth the graven image that the maker thereof hath graven it; the molten image, and a teacher of lies, that the maker of his work trusteth therein, to make dumb idols? Woe unto him that saith to the wood, Awake; to the dumb stone; Arise, it shall teach! Behold, it is laid over with gold and silver, and there is no breath at all in the midst of it. (Habakkuk 3: 18–19)

In the mid-1420s Donatello was still near the beginning of his long career, yet he had already faced numerous challenges posed by large figural sculpture. Seemingly determined to push the inherent confrontation between illusion and reality to its limits, he allowed his figures to move in or out of their own space, and his viewer to sympathize, as with the *St. Mark*, or to wonder, as at the Campanile prophets. From the 1430s on, however, his large sculpture completely breaks with tradition and is more or less free-standing, even though the figures on the Padua Altar existed in relationship to an architectural complex, and the positioning of figures such as the bronze *David* (Fig. 134) or *Penitent Magdalene* (Fig. 131) may have determined the viewpoint. To modern notions of sculpture, a free-standing figure seems obvious; even the idea that the bronze *David* marks the revival of the classical bronze free-standing statue makes little impression, since the type is so much a part of the modern experience. For the fifteenth century the intellectual leap involved is extraordinary, but Donatello himself had prepared the way. The free-standing figure is, in many ways, the logical extension of figural sculpture based on a formal command of physical space and the ability to evoke an immediate and strong response from the viewer.

Having set this precedent for Renaissance sculpture, Donatello, toward the end of his career, carried it one step further and created a statue that can truly be called sculpture-in-the-round. The *Judith and Holofernes* has totally abandoned a separate, sculptural space to enter the space of the viewer (Fig. 136). The distinction made here between sculpture-in-the-round and free-standing sculpture is basically in terms of form and the viewer. Complicated as the bronze *David* is, his total pose is comprehensible from any viewpoint; we know the human body so well, there is no guesswork in determining how high the foot will be with the knee at that angle, or

127. *Padua Altar* (as presently mounted) and *Crucifix*. 1446–50 and 1444–9. Padua, Sant' Antonio. (See also Figs. 32, 33, 92, 97, and 101.)

how far the elbow will protrude given the position of the shoulder. *David's* space is defined, yet this does not mean the statue is understood. The viewer must change his viewpoint to be aware of the subtleties of curve against curve, the facial expression, the head of Goliath. The round base gives no indication of a preferred viewpoint – we instinctively view *David* head-on – but it does define the limits of his space.

None of these things can be said of the *Judith and Holofernes*. The two figures rest on a square pillow on a triangular base; the sides of these bases are parallel as we face Judith head-on, yet this view tells least about the grouping and its spatial disposition, and offers the most incentive for the viewer to move: why is neither side of what seems a square base visible? how can Holofernes' foot be hanging there? More than idle curiosity lures the viewer: Judith's drapery curves back from her wrist as she holds Holofernes' hair, which falls in a heavy curve both in front and in back of his shoulder. Once the viewer breaks the frontality even slightly, the band of drapery girdling Judith's thighs keeps the eye moving. Each view is a surprise, each outline so totally different, that there is no logical, visual resting point. It is not simply a desire to know as much as possible about the statue, but a compositional imperative that causes the audience to interact spatially with it. Judith is not only a psychological enigma akin to the Campanile *Prophets* but, through the viewer's movement, she and her victim offer the possibility of change and surprise associated with living beings. Donatello, continuing the concern that had dominated his approach to large-scale figural sculpture throughout his career, finally achieved in the *Judith and Holofernes* a total interweaving of viewer and sculptural space.

His interest in psychological and spatial contact between the work of art and its audience was manifested not simply in works relating directly to the world of the viewer, but in those creating their own environment, notably the high altar for Sant'Antonio, Padua. In 1446 Franceso da Tergola left money to the church of Sant'Antonio to construct a high altar. Donatello seems to have received the contract for the altar in late 1446 and eagerly begun work with a few assistants and a large number of contracted specialists. The complex ultimately entailed numerous bronze and stone reliefs, six life-size bronzes of saints, a bronze Madonna and Child Enthroned, and an architectural framework which is largely unknown. In 1579 the church decided to replace the altar, but to include the Donatello sculpture with new additions; this version was completed in 1582, and was itself renovated in 1591 and 1651. In the nineteenth century, with the intention of restoring the altar to its original condition, another version was erected (Figs. 127, 128); unfortunately it conforms neither to what is known through documents and descriptions of the original, nor to hints given by the sculptures themselves. Although attempts at reconstruction have largely concentrated on the architectural framework, a far more subtle and complicated problem is the relationship of the figures through gesture and posture. The group seems to have been arranged in the manner of a *sacra conversazione* under a canopy, perhaps anticipated in the *Cavalcanti Annunciation* (Fig. 84), and certainly echoed in Mantegna's *San Zeno Altarpiece* in Verona (1456–9). The sense of these sculpted figures creating their own environment, as in a painted *sacra conversazione*, must have been much stronger when they rested on Squarcione's painted floor. The saints do not have bases, so that the sway of *St. Daniel* and *St. Giustina* as they gesture in presentation leaves them forever on the verge of turning toward us, or toward the Enthroned Madonna. They seem capable of being moved in an infinite number of combinations, their relationships, glances, and gestures yielding a forever changing sense of this heavenly assembly.

The interaction of these figures in a three-dimensional space created a narrative with a sense of moment or time; the illusion was no doubt enhanced by the Madonna, who is rising from her throne and grasping the Child under his arms,

seemingly as much to hand him to the viewer as to keep him from sliding down her lap. One by one the saints, Louis of Toulouse, Daniel, Anthony of Padua, Francis, Giustina, Prosdocimus, act as intercessors between us and the Child with discreet gestures and solemn, peaceful, yet curiously mask-like faces; each is delicately poised between motion and stillness, so that even Daniel's heavy dalmatic betrays the sway of his body. The nature of this environment is defined and dominated by the Madonna, whose psychological presence is, in great contrast to Donatello's Florentine statues, a deliberate enigma to the viewer. She rises from a throne of wisdom, ornamented with sphinxes as sides and a relief of Adam and Eve on the back, and inclines her head toward the viewer. Yet her eyes are unseeing, and the gentle youthfulness of her head seems contradicted by the sharp angles of her mantle and the points of her crown of seraphim. Her presence is powerful and intimidating; the viewer accepts her otherworldly state before visually and psychologically entering the more humanly comfortable space of the figures around her. Viewer space and sculptural space are once more interwoven.

128. Rear view of Fig. 127. (See also Fig. 92.)

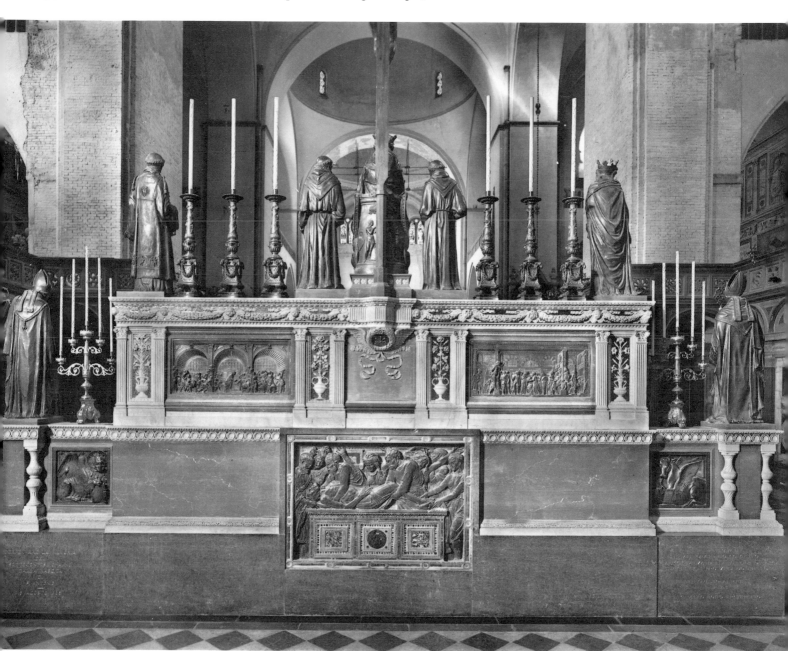

CHAPTER EIGHT

Donatello's Art and the Human Experience

... the sculptor must represent the activities of the soul.
Socrates to the sculptor Cliton; Xenophon, *Memorabilia*, c.355–4 B.C.

A 'historia', then, will move the souls of those who look at it when the men painted there display the motion of their own souls to the highest degree.
Alberti, *On Painting*, 1435/6

Donatello certainly did not lack a feeling for beauty, but beauty had to give way to character whenever character was called into question.
Jakob Burckhardt, *Der Cicerone*, 1855

It is tempting to explain the difference between 'significant form' and 'beauty' – that is to say, the difference between form that provokes our aesthetic emotions and form that does not – by saying that significant form conveys to us an emotion felt by its creator and that beauty conveys nothing.
Clive Bell, *Art*, 1914

Much of the universal and enduring value of Donatello's art lies in the manner in which he interpreted and portrayed character. His narrative solutions are obvious in the reliefs on the San Lorenzo Pulpits, in which he represented a considerable range of emotional responses; the subjects of these panels – the highly charged scenes of the Passion – demand extreme reactions. In other, more subtle subjects Donatello created other, in many ways more complex, psychological states. A twentieth-century analysis of the character and emotional expression of a figure created in the fifteenth century is not only subjective, but obstructed by the constant and undocumented changes in the meaning, and therefore interpretation, of type, pose, gesture, and facial expression. Such an examination is nevertheless important in attempting to understand Donatello's art, since his figures do not seem to be men and women of the distant Renaissance but immediate presences who strongly evoke empathy. Accepting that the twentieth-century viewer's response, clouded by time and cultural change, is probably a diminished version of that of a fifteenth-century Italian, several of Donatello's sculptures seem to present extraordinary personalities: *St. Louis of Toulouse*, the *Penitent Magdalene*, the bronze *David*, *Judith*, and the *Faith* and *Hope* from the Sienese Baptismal Font. With these acknowledged limitations, the following comments are not intended as complete analyses; they are meant to point to the profundity of Donatello's observation and understanding of life, and to describe his ability to represent it.

Among the most enigmatic figures in Donatello's *œuvre* is the *St. Louis of Toulouse*

129. *St. Louis of Toulouse* and tabernacle. *c.* 1422–*c.* 1425. Gilded bronze, with enamel and glass, marble tabernacle, height of figure 266 cm., height of tabernacle 560 cm. Florence, Orsanmichele. (The figure is now in the Museo dell'Opera di Santa Croce. See also Figs. 58–60 and 67.)

for the Parte Guelfa Tabernacle at Orsanmichele (Fig. 129). What is particularly puzzling is that the character suggested by this figure contrasts so sharply with that of Donatello's other saints at Orsanmichele. The *St. Mark* and *St. George* are among the earliest expressions of new Renaissance attitudes; embodying the potential for greatness and the capacity to accomplish significant deeds, they are of the same race as the men in Masaccio's *Tribute Money*, of whom Bernard Berenson once said: 'Whatever they do – simply because it is they – is impressive and important, and every movement, every gesture, is world-changing.'[1] (Fig. 77.) Donatello's *St. Louis of Toulouse* does not live up to this standard, for he conveys neither energy nor purpose. The large scale and overall gilding succeed in creating a strong sense of physical presence, but this effect is undermined by the blank, mask-like expression of the face (Fig. 130), and the voluminous, motionless drapery that covers the body. *St. Louis* is so atypical of both Donatello's work and Renaissance attitudes in general that it is not surprising that this figure is the sole autograph work by Donatello that has been almost consistently criticized since the time of Vasari.

One problem, of course, is that the figure was removed from its original taber-

nacle during Donatello's lifetime. For centuries it was seen only in the wrong context, a niche high on the rough and unfinished façade of Santa Croce.[2] In 1945, when Florentine sculpture was being returned from wartime safe-keeping, the photograph reproduced here was taken while the figure was briefly in its proper setting at Orsanmichele. Like most of the published photographs of the statue it was, unfortunately, not taken from the eye level of a pedestrian, but from an elevated position, and the result is distorted. From this view, for example, the figure does not seem normally proportioned, for the already large head appears even larger and the facial expression, which from below seems mystical and elevated, becomes merely a blank stare. Even the proper view from the street, however, cannot energize the saint. There is no hint of *contrapposto* in his pose, and no suggestion of movement in his stance; his body is smothered in the heavy drapery.

Vasari, who saw the figure only in the Santa Croce niche, expressed his discontent by offering the following story: 'When reproached that this was a clumsy figure, and perhaps the least successful of all his works, [Donatello] replied that he had made it that way on purpose, since the saint had been a clumsy fool to relinquish a kingdom for the sake of becoming a friar.' This interpretation lends some credibility to what could too easily be dismissed as another of Vasari's tales; Donatello may not have made the saint a 'clumsy fool', but his depiction of Louis as a 'clumsy figure' seems to have been 'on purpose'.

St. Louis of Toulouse, the elder son of Charles II, King of Naples and Sicily, was as a young man strongly influenced by the Spiritual Franciscans, an extremist group later condemned as heretical. He chose to abdicate his place in the succession in order to become a Spiritual Franciscan, a move that was permitted by Pope Boniface VIII only on the condition that Louis accept the Bishopric of Toulouse. During his brief tenure as Bishop, Louis wore tattered garments, followed the mendicant practice of begging for alms, and seriously considered renouncing his post. He died in 1297 at the age of twenty-three, and was canonized twenty years later.

The church-authorized accounts of Louis's life, which Donatello would have known, avoided Louis's commitment to poverty and, for obvious reasons, his connections with the heretical Spiritual Franciscans.[3] They stressed his humility, his renunciation of the crown, and his obedience to the Pope. Donatello's meek and quiet *St. Louis of Toulouse*, then, is consistent with the traditional and official view of Louis as one who was humble before authority.

At the same time, however, the voluminous episcopal vestments that weigh Louis down and seem to prevent movement, the oversized and sumptuous mitre, the heavy, richly decorated crosier, all rest uneasily on him, suggesting not just Louis's humility, but the burdensome nature of his official position. This complex and humble personality that gave up a throne renounced not just worldly goods, but also a position of power and authority, subsequently thrust on him again, in a different form, by the Pope. Without knowing the heretical aspects of Louis's devotion, Donatello has subtly dramatized the inner conflict between Louis the friar and Louis the bishop.

Donatello's naturalistically polychromed, wooden figure of the *Penitent Magdalene* (Fig. 131) differs strikingly from the gilded bronze physicality of the *St. Louis*. In character as well, these two are opposites; while Louis seems weighed down by life, the Magdalene's spiritual concentration is vital, energized. She is represented praying, clothed only in her own hair; her usual attributes – skull, cross, and even the familiar ointment jar – have been omitted so that her character and emotional state may be emphasized. The figure is one of Donatello's most powerful works; her concentration on an other-worldly goal is so forceful that the

130. Detail of Fig. 129

131. *Penitent Magdalene*. Late
1430s–1450s. Wood, with
polychromy and gilding, height
188 cm. Florence, Museo dell'Opera
del Duomo

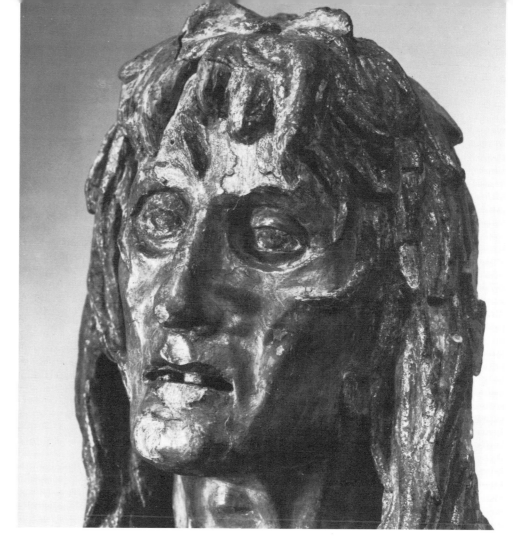

132. Detail of Fig. 131

133. Detail of Fig. 131

observer is drawn into her experience. Although the figure may be physically realistic, it is the Magdalene's fervour that dominates the sculpture's effect.

This is a classic representation of the Magdalene as the great penitent, the single most important example in Christian hagiography of the conversion from a life of flagrant sin to one of repentance and prayer. Traditionally, Mary Magdalene has been identified as the sinner, unnamed in the Bible, who came to Christ while he was dining in the house of Simon the Pharisee. Her sin is not specified, but it was believed that she was a beautiful and wealthy harlot. At Simon's house she washed Christ's feet with her tears, and dried them with her long hair, kissing and anointing them with expensive ointments. When Simon protested, Christ replied that she should be pardoned because of her faith, and then forgave the woman her former life (Luke 7: 36–50). The Bible tells of her part in the Passion, and the Golden Legend of her life after the Resurrection, when she retreated into the wilds of southern France, for thirty years living a life of fasting and penance as a mountain hermit. She discarded her sumptuous garments and, at the climax of her penance, was clothed only in her own long hair. The Magdalene's hair, which plays such a prominent role in Donatello's representation, must thus be seen as a manifold attribute: it is a reminder of her former beauty and sensuality, an emblem of her honouring of Christ and of her repentance, and a symbol of her neglect of worldly things during her life as a hermit saint.

Donatello's representation accords well with the saint's legend, as well as with the text from Proverbs (31:30) read during the Office of St. Mary Magdalene: 'Favour is deceitful and beauty is vain: but a woman that feareth the Lord, she shall be praised.'[4] At first glance the wasted appearance of the figure seems to dominate

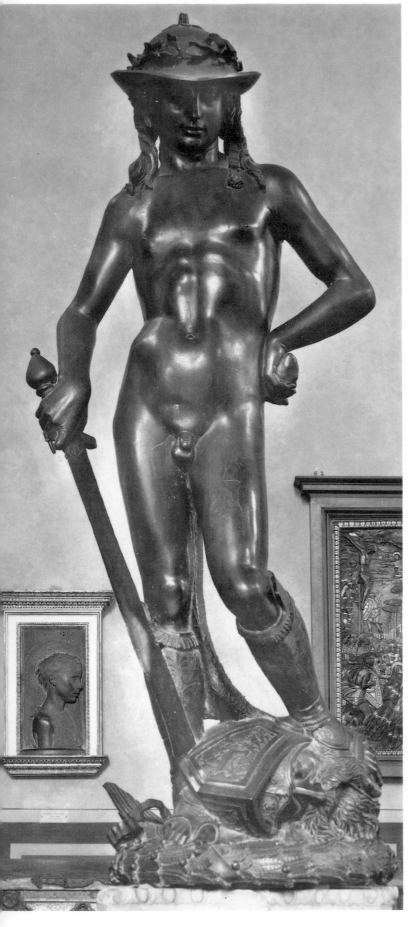
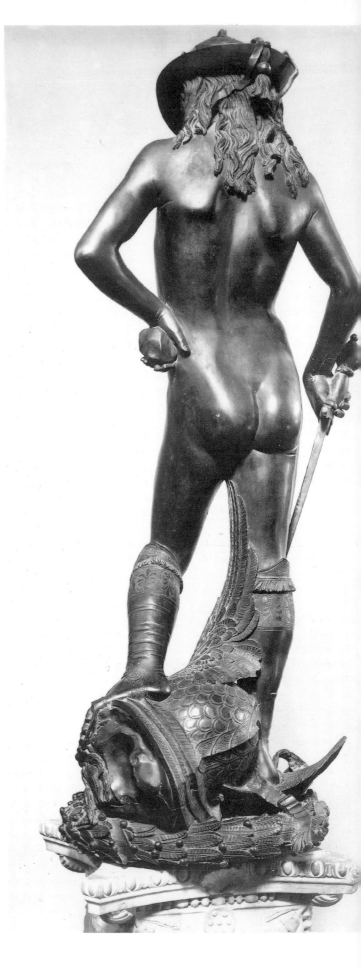

134. *David* (two views).
c.1446–*c*.1460. Bronze, height
158 cm. Florence, Museo Nazionale.
(See also Figs. 50 and 135.)

the representation; it is suggested not only by the abstract verticality of the form, but by such physical details as the bony hands and neck, the flat chest, and the deeply sunken eyes. Donatello's conception, however, also embraces the Magdalene's legendary beauty, manifested in the exquisitely refined bone structure of the cheeks, eye sockets, and nose, the long fine fingers, and the delicately formed ankles and feet (Fig. 132). A memory of her worldliness survives in her pose, which must be ranked among the most beautiful and subtle instances of *contrapposto* in the history of sculpture. A close look at her muscular arms and legs suggests that she is neither as old nor as weak as one first assumes; it is not age or the denial of creature comforts that explains her appearance, it is repentance.

The polychromy of the figure, discovered during restoration after being partly submerged in the Arno flood of 1966, enhances the realism of the carving and modelling. The leather-like skin is a rich and ruddy brown, the result of exposure in the wilderness, and in strong contrast to the auburn hair, streaked with lines of gold that reflect both the naturalistic effect of blond highlights and the aura of sainthood. Her hands approach each other, raised in the traditional attitude of prayer without yet being joined; their lack of resolution implores the observer to join the litany suggested by her parted lips. Her unfocused eyes deny communication with any physical object; her facial expression, in one view in particular, seems uplifted, inspired, even hopeful (Fig. 133). To experience Donatello's *Penitent Magdalene* is to participate in a dramatic, personal encounter.

No less compelling is the bronze *David*, perhaps Donatello's best-known work (Figs. 134, 135, 50). Its fame is in large measure due to its unconventional and unexpected appearance; the victorious hero is but a slight youth who stands relaxed and self-absorbed, his sensuously treated nudity set off by elaborate boots and a

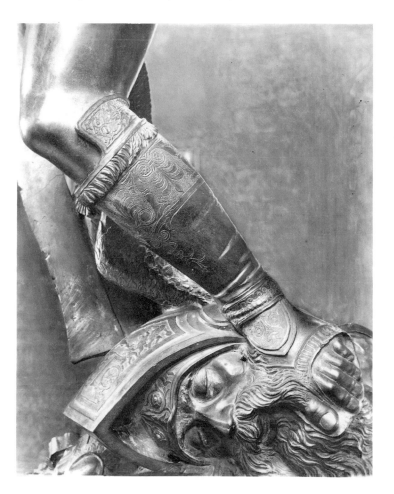

135. Detail of Fig. 134

floppy hat. It is no wonder the *David* is also among Donatello's most controversial works.

But one thing is certain, this is a revolutionary statue in the history of sculpture. To the best of our knowledge, he is the first life-sized free-standing nude figure in over a millennium; surprisingly, there is nothing timid about David's nudity. In fact, the soft, youthful flesh is accentuated by his soft country hat and the tooled leather greaves, as well as by his unstable stance, with one foot on the sweeping wing of Goliath's helmet and the other on the severed head itself. For balance, his pelvis and abdomen are thrown forward and his pose becomes a series of luxurious curves.

The *David's* obvious sensuality results in part from the manner in which strong highlights seem to caress the finely finished bronze, enticing the spectator to touch it to confirm the illusion of smooth and pliant flesh. These highlights are especially dramatic because of the unusually deep, almost black, colour of the bronze. Vasari's comment was: 'This figure is so natural in its vivacity and softness that artists find it hardly possible to believe it was not moulded on the living form.' The inherent naturalism is important, for the bronze *David* conforms neither to a generalized Renaissance ideal, nor to a specific antique type. He is too young, too undeveloped, and a little too soft to meet either of these standards: touches such as the wrinkles below the buttocks and around the armpits, the slightly sagging abdomen, and the low-slung buttocks, underscore the realism. And, although the figure is obviously male, Donatello seems to have suggested female characteristics in the softness of the flesh, the delicacy of the proportions, the slight swell of the stomach, and the choice of a stance that produces a feminine fullness in the line of the right hip and thigh. The androgynous nature of adolescence seems accentuated, while its awkwardness and insecurity are ignored. The bronze *David* may revive the ancient type of the free-standing, life-sized nude, yet there is little about the figure that is antique.

The young David, future king of Israel, is one of the most important heroes of the Old Testament, and Donatello has chosen to represent him after the completion of his heroic act. Standing on Goliath's severed head, he casually holds the giant's great sword; there is a crown of laurel on his hat, and a laurel wreath serves as the sculpture's circular base. In spite of these attributes, critics have long puzzled over what seems to be his essentially unheroic, or even anti-heroic, nature. Yet Donatello's interpretation is not at odds with the biblical text, which explicitly refers to the youthfulness and beauty of Jesse's younger son:

> And Samuel said unto Jesse, 'Are here all thy children?' And he said, 'There remaineth yet the youngest, and, behold, he keepeth the sheep. . . . And he sent and brought him in. Now he was ruddy, and withal of a beautiful countenance, and goodly to look to. (I Samuel 16:11–12.)

> And when the Philistine [Goliath] looked about, and saw David, he disdained him: for he was but a youth, and ruddy, and of a fair countenance. (I Samuel 17:42.)

David's nudity has an oblique basis in the text as well, since I Samuel 17:38–9 tells how he had first put on the armour of Saul and then later removed it, having decided not to wear armour into battle. Even David's non-heroic behaviour and lack of exultation over the defeated enemy may be clarified by the Bible, since before the battle he explained to the Philistines that the victory would not be his:

> 'I come to thee in the name of the Lord of hosts, . . . This day will the Lord deliver thee into mine hand; and I will smite thee, and take thine head from thee; . . . And all this assembly shall know that the Lord saveth not with sword and spear: for the battle is the Lord's, and he will give you into our hands.' (I Samuel 17:45–7.)

Donatello's *David*, then, is not only consistent with the traditional texts, but appropriately emphasizes God's role in the boy's unexpected victory.

This image is more complex than Donatello's earlier marble *David*, where the elevated chin and self-confident posing stress the hero's awareness of his triumph; the early *David* is completely self-centred (Fig. 116). The later bronze figure looks downward, as if musing on his deed. The lowered head suggests humility, the virtue for which David was traditionally a symbol. A recent interpretation by Phillip Fehl has suggested that the meditative quality of Donatello's bronze *David* might be an indication that the sculptor here wanted to incorporate other aspects of David's historical personality. Could this figure represent not merely the youthful hero, but also David as the great musician and poet, author of the Psalms? The laurel on his hat would then allude not only to the Medici, but to the crown of laurel given to poets, and such an interpretation would certainly not be out of place in the circle of the Medici. Even the nudity might be related to David's later life, for when the Ark of the Covenant was returned to Jerusalem, he danced naked in ecstasy.

It is not, however, traditional to represent David as nude, and theories about possible antique or textual references in explanation seem peripheral to the strong response demanded by the sculpture. In fact, if *David* is nude for artistic reasons, as a reference to classical statuary for example, it is odd that the figure has none of the ideal characteristics usually associated with antique sculpture. Yet there is no question that the bronze is handled sensuously, and that it invites both the lingering gaze and a desire to touch; Donatello seems to have intentionally blurred the distinction between the figure's sensuous and sensual natures. In this regard, *David* has been cited as pointing to Donatello's homosexuality and, although such a conclusion is not necessary to explain or understand the figure, it takes into account its strong sensual impact. This sensuality becomes especially important because Donatello has denied the viewer the one sure element of rapport with David: the facial expression tells virtually nothing. The viewer must turn to hints offered by other aspects of the figure, and the nudity cannot be ignored. The possibility that Donatello chose to portray David nude for textual reasons, to emphasize that the triumph was God's and not the boy's, does not negate the statue's sexuality: David does not seem unconscious of himself. His stance is self-assured in its nonchalance; David's foot carelessly rests on the severed head and one wing of the helmet curves up to caress the inside of his thigh. Such a detail is certainly unexpected, but at a distance of nearly five and a half centuries, it is simply a game to guess at its significance. Historical context and the possibilities of interpretation have surely changed, but it seems likely that some of the ambiguities of the bronze *David* must also have been present for a fifteenth-century viewer.

Donatello created an equally complicated hero in *Judith and Holofernes*, based on the apocryphal Book of Judith (Fig. 136). Judith was a rich and beautiful widow from Bethulia, a Jewish city under seige by the Assyrian armies of King Nebuchadnezzar led by Holofernes. By cutting off their water supply, the general intended to 'thirst' the beseiged citizens into submission. In a subtly conceived plot Judith entered the enemy camp and offered Holofernes a scheme for capturing her city; convinced of her sincerity and captivated by her beauty, Holofernes planned a banquet, after which he intended to seduce her. When he succumbed to drunkenness, however, she beheaded him with his own scimitar; her return to Bethulia with his head ended the siege.

Donatello's *Judith and Holofernes* is as intense and thought-provoking as the bronze *David*, and its interpretation no less problematic. Vasari rightly observed that 'one can see the effect of wine and sleep in the expression of Holofernes and the presence of death in his limbs'. Although scholars have sometimes been misled by an irrelevant casting flaw, which becomes too prominent in photographs, the recent

relocation of the sculpture inside the Palazzo Vecchio makes possible a closer examination of the original, which reveals a deep open gash in Holofernes' neck; Judith, then, is represented poised between the two blows mentioned in the text: 'she struck his neck twice with all her might, and severed the head from his body.' (13:8) The murder of the enemy has been accomplished with the first blow; with the second Judith will obtain the grisly trophy to bear home to her people in victory. The composition of the two figures is completely naturalistic: Judith stands on Holofernes' body to prevent it from moving, and braces his neck with her thigh to give the blow of the sword maximum force.

Judith's pose reveals her action but not the moment, so that Janson has referred to her 'ritual gesture'. She seems frozen, fixed in position with sword raised,

136. *Judith and Holofernes* (four views). *c.*1446–*c.*1460. Bronze, with traces of gilding, height 236 cm. Florence, Palazzo Vecchio

137. Detail of Fig. 136

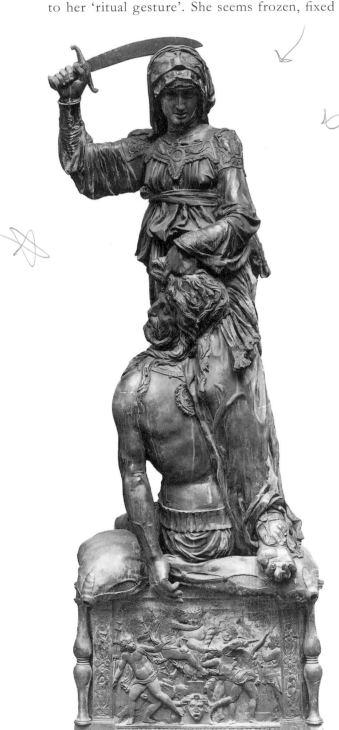

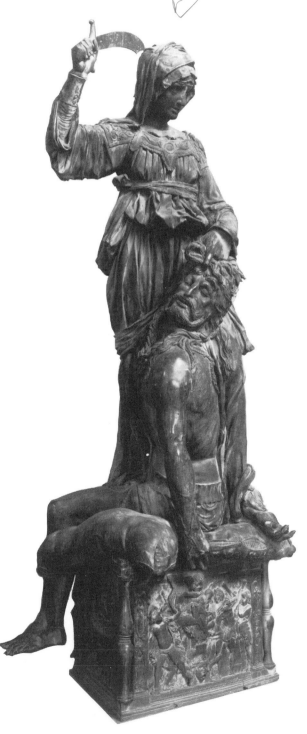

immobilized at the very moment that her well-planned victory is won. Has she suddenly perceived some unexpected meaning or consequence of her action? She has acted in the name of patriotism and self-preservation, and she has saved her people, but to do so she has had to take a life. She has broken the Sixth Commandment: 'Thou shalt not kill.' One cannot imagine a more awesome moment, regardless of justification, and the trauma she must feel is revealed by her open mouth and unfocused stare. Donatello's figure is a testimony to Judith's piety and to her humanity (Fig. 137).

The sense of motivation and psychological intensity that enlivens Donatello's figures is enhanced by, though not dependent on, the viewer's knowing something of their recorded lives; yet two of his most alluring characters are not biblical or

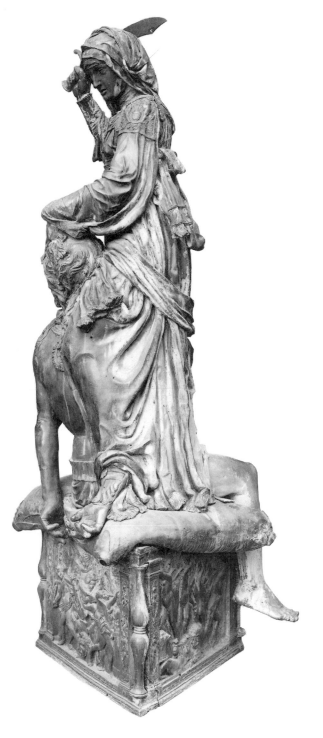

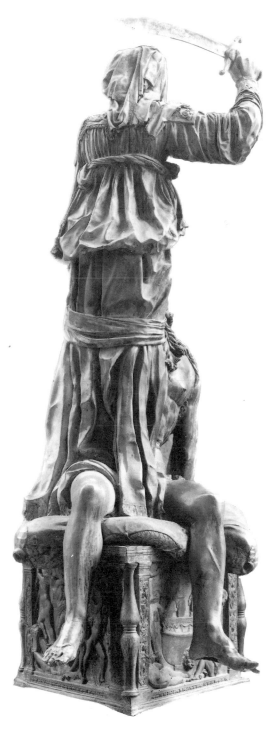

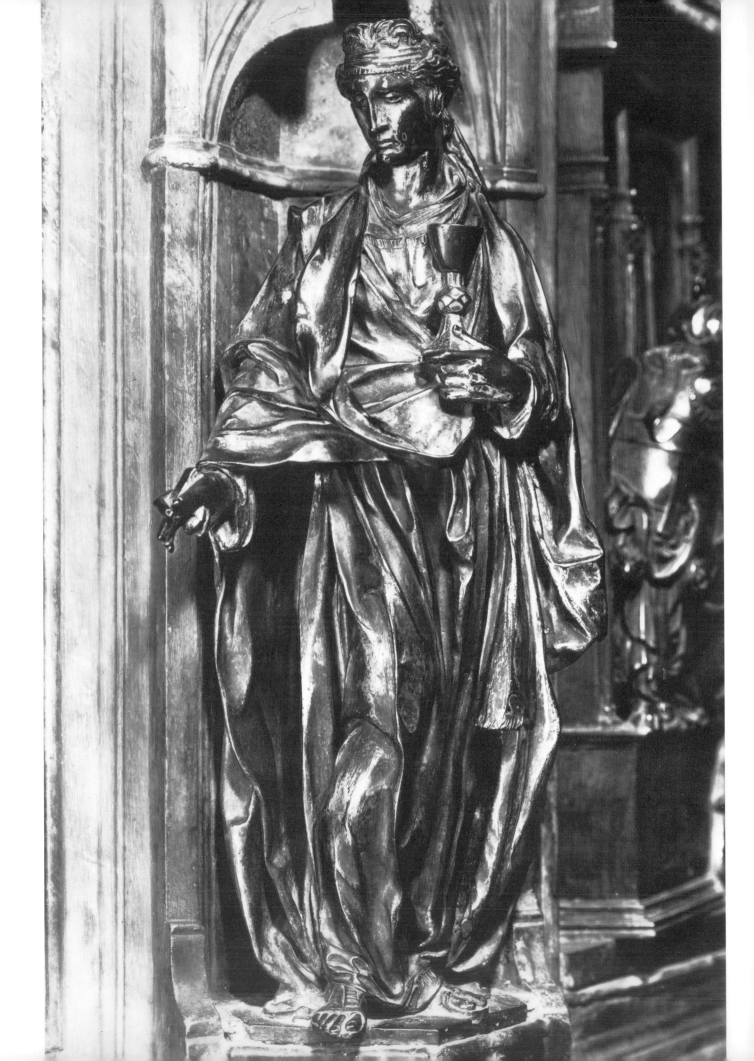

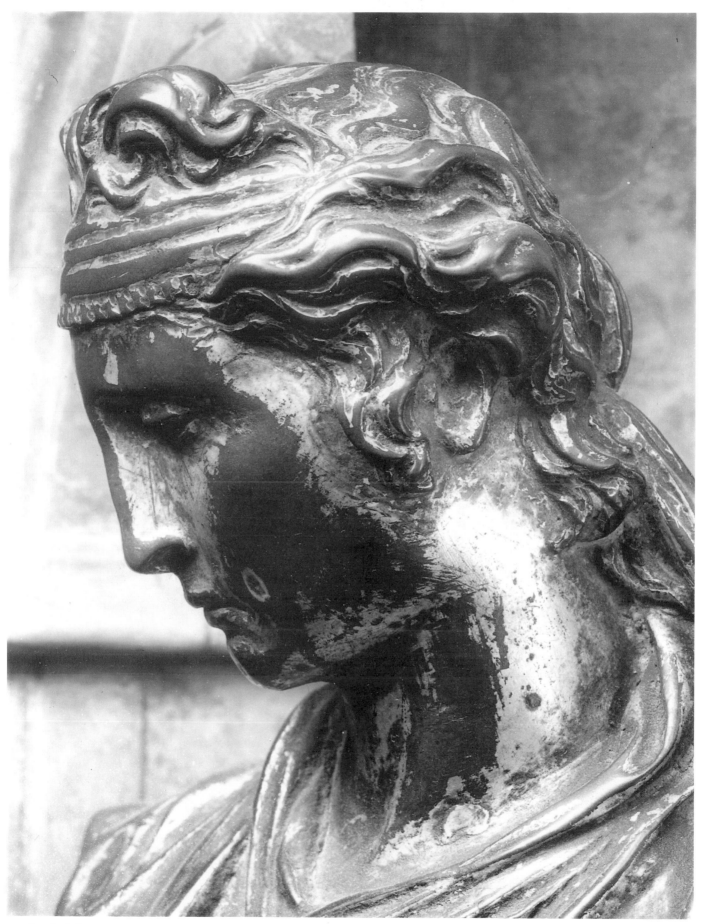

139. Detail of Fig. 138

138. *Faith*, from the Sienese Baptismal Font (Fig. 35). *c*.1427–9. Gilded bronze, height 52 cm.

historical, but allegorical. His earliest female figures in the round are most likely the virtues *Faith* and *Hope* for the Sienese Baptismal Font (Fig. 35; *Hope* is on the far right of the base of the font in this view and *Faith* is in the centre, between two reliefs by Ghiberti). The challenge in representing a virtue is to create a figure that will not only embody a moral position, but also convince errant humanity of its value and convert us to its practice. The danger, as in most allegories, is that the figure will be burdened with attributes and lack emotional life.

Donatello's *Faith* (Figs. 138, 139) holds a chalice, one of her traditional symbols, to her heart; her extended right hand holds the fragment of a second attribute, most likely a cross. These symbols easily identify her as Faith, but it is her character that dominates the representation. She looks downward and inward, and because the observer at the side of the font views the statuette from above, her gaze seems to become even more private. Her pose, a relaxed and beautiful *contrapposto*, is quiet and contained. The meditative seriousness of the figure is strengthened by her stoic expression and the classical beauty of her face. In deliberate contrast to the simple, steadfast nature of her pose and expression, however, is her drapery, which twists and ripples in patterns of inexplicably rich and beautiful movement.

Hope is represented as a different kind of figure and is clearly, therefore, a different kind of virtue (Figs. 140, 141). In contrast to *Faith*'s quiet pose and downturned head, *Hope* seems to be moving outward and upward, aided by her single attribute, a pair of wings. The crown, which in earlier representations was the goal of Hope's movement, is here eliminated.[5] Donatello has provided a more generalized statement about the character of Hope, stressing that the virtue can fulfill her desires through her own volition and activity. Her escape from the Gothic niche into our space seems imminent. As a result of the virtues' low position, *Hope* looks directly up into the face of the viewer. The beginnings of a smile suggest the joy Hope can offer.

Faith and Hope, which were named by St. Paul as two of the three Cardinal Virtues, are not qualities usually associated with Donatello's art, which most often embodies the individual emotion and dramatic moment. Yet in these two figures, despite their delicate scale and decorative function, Donatello's understanding of the breadth and variety of human character and motivation enabled him to express such principles in physical form. He not only captured the character of two distinct virtues, but made them individually beautiful, demonstrating how it is possible to be seduced by virtue.

As the epigraphs to this chapter demonstrate, from the fifth century B.C. to the present century the demand for good sculpture as the expression of human feeling has been consistent, although terminology has changed from the Classical and Renaissance criterion of 'soul' or Jakob Burckhardt's requirement for 'character' to Clive Bell's 'significant form.' Vasari praised this quality in Donatello's sculpture in a variety of contexts and phrases, insisting on his ingenuity – his ability to *conceive* of the work of art – and on his talent – his ability to *express* its conception successfully. At the beginning of the sixteenth century, Pomponius Gauricus also noted the importance of conception to Donatello's art in an anecdote about the Bishop Marco Barbo, who wanted to visit the sculptor's studio to see his abacus, in other words the tool basic to his art and the secret of his creativity. When the bishop arrived Donatello told him, 'You have only to look at me; I have no other abacus;'[6] as the only modern sculptor included in *De sculptura*, Donatello clearly satisfied Gauricus' requirements that a sculptor be universal and make proper use of his imagination. In 1432 an agent of the Medici declared in a letter to a patron of Donatello's that the artist 'has no other possessions than his own hands'.[7] How wrong he was: Donatello had his abacus.

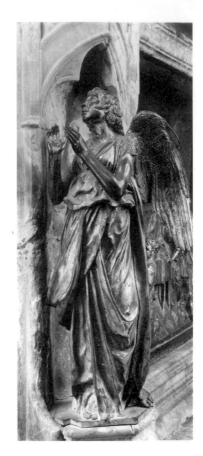

140. *Hope*, from the Sienese Baptismal Font (Fig. 35). *c.*1427–9. Gilded bronze, height 52 cm.

141. Detail of Fig. 140

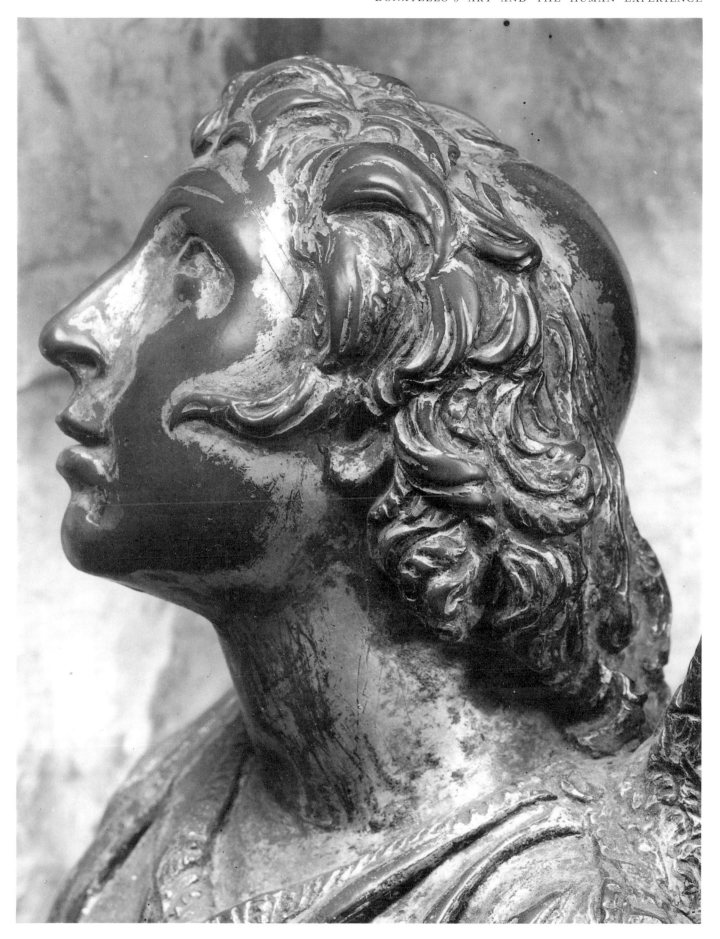

NOTES

Abbreviations used in Notes; full bibliographic references found in Bibliography

AB	= *Art Bulletin*
Hartt	= *Donatello, Prophet of Modern Vision*
Herzner doc.	= 'Regesti donatelliani'
Janson	= *The Sculpture of Donatello*
Krautheimer	= *Lorenzo Ghiberti* (Princeton, 1956)
Mitt. Flor.	= *Mitteilungen des Kunsthistorisches Instituts von Florenz*
Pope-Hennessy	= *Italian Renaissance Sculpture*
Seymour	= *Sculpture in Italy 1400–1500*
Vasari	= *Life of Donato*

Chapter 1

1 All quotations by Vasari, excepting those on Pages 7, 135 (top), 161, 199, 206, and 212, which have been translated by the authors, are from *Lives of the Artists* (trans. George Bull), Harmondsworth, 1981.

2 For recent literature on the San Lorenzo Pulpit reliefs see Becherucci (*I pergami*), Gosebruch, Herzner (*Die Kanzeln* and 'Die Kanzeln'), Huse, Lisner ('Appunti'), Parronchi (*Donatello e il potere*, 211–29), Pfeiffenberger, and Previtali. Parronchi suggests that all the reliefs from both pulpits were intended to be combined to make one huge altar for San Lorenzo; see his reconstruction, 218–19.

Vespasiano da Bisticci, in his life of Cosimo de'Medici, refers to Donatello's four assistants, but does not name them. Vasari repeatedly mentions Bertoldo (di Giovanni) as the pupil who brought the reliefs to completion. A document of 1456 connects Bartolommeo Bellano of Padua with Donatello at that time (Corti and Hartt, 158).

3 A document of 1456, which records both an advance paid to Donatello by an agent of the Medici and the sculptor's expenditures for materials related to bronze casting, may be tied to the execution of these reliefs; see Corti and Hartt, 158.

4 Cosimo's place of burial in a large pier under the crossing of San Lorenzo is indicated by a large inlaid marker and grill in the floor, as well as by inscriptions on the sides of the pier. See Janis Bell Clearfield, 'The Tomb of Cosimo de'Medici in San Lorenzo', *Rutgers Art Review* 2, 1981, 13–30.

5 See the *Ragionamenti* by Vasari, which is published in Gaetano Milanesi's edition of *Le Vite*, Florence, 1906, VIII, 98–9. It was Herzner who first related this passage to the pulpit reliefs ('Die Kanzeln', 155, n. 46); his attention was drawn to it by Ulrich Middeldorf. Herzner believes that a religious crisis experienced by Cosimo led him to abandon his project for a grandiose tomb. On the significance of the free-standing floor tomb at this time, and its infrequent use, see Lightbown, *Donatello and Michelozzo*, 25.

6 As Herzner has pointed out in 'Die Kanzeln', the use of the Resurrection theme between two flanking reliefs to decorate the front of a sarcophagus has a precedent in Tino di Camaino's *Tomb of Cardinal Petroni* (c.1318?; Siena, Duomo).

7 The background horsemen, on the other hand, seem to be additions to Donatello's composition by his followers. Their random position, awkward scale, and illogical nudity support the theory.

8 Frederick Antal, 'The Maenad under the Cross: (2) Some Examples of the Role of the Maenad in Florentine Art of the Later Fifteenth and Sixteenth Centuries', *Journal of the Warburg and Courtauld Institutes* 1, 1937–8, 71–3.

9 Leon Battista Alberti, *On Painting and On Sculpture* (trans. Cecil Grayson), London, 1972, 83. Barasch discusses this in *Gestures of Despair in Medieval and Early Renaissance Art*, New York, 1976, 107–9.

10 Formal sources for the motif have been noted by Janson, who sees a relationship to Sienese Trecento paintings of the Resurrection ('Donatello and the Antique', 88), and by Irving Lavin, who postulates an ancient source taken from Roman sarcophagi illustrating the Death of Meleager ('The Sources of Donatello's Pulpits in San Lorenzo', *AB* 51, 1959, 30, fig. 31).

11 For the typical Florentine representation of the Pentecost see E. Levi, 'Ricostruzione di un affresco perduto di Maso di Banco', *Rivista d'arte* 26, 1950, 193–7, and also the discussion in Millard Meiss, *Painting in Florence and Siena after the Black Death*, Princeton, 1951, 32ff. and *passim*.

12 Meiss, *Painter's Choice*, 63–81.

13 See Creighton Gilbert, 'Last Suppers and their Refectories', in *The Pursuit of Holiness in Late Medieval and Renaissance Religion* (ed. Charles Trinkaus with Heiko A. Oberman), Leiden, 1974, 371–402, and the Interventions to this paper by Clifton Olds and David Wilkins, 403–7. See also David Wilkins, 'The Meaning of Space in Fourteenth-Century Tuscan Painting', in *By Things Seen: Reference and Recognition in Medieval Thought* (ed. David L. Jeffrey), Ottawa, 1979, 109–21.

14 From the *Commentarii*, as translated by Krautheimer, 14.

15 Leon Battista Alberti, *On Painting and On Sculpture* (trans. Cecil Grayson), London, 1972, 79.

Chapter 2

1 Albert Wesselski, *Angelo Polizianos Tagebuch*, Jena, 1929, 118–19.

2 The letter from Alfonso of Aragon is quoted from Pope-Hennessy, 263; for the original text see Herzner doc. 340. For Rinuccini see Gombrich, 1–2. The quotation from the late 1470s is from Gilbert, *Italian Art 1400–1500*, 171.

3 'Donatello, intagliatore (che fu della qualità ch'a ciascuno è noto).' The novella 'Il Grasso legnaiuolo' is attributed to Manetti; see Archille Tartaro and Francesco Tateo, *Il Quattrocento, l'età dell'umanesimo* (La letteratura italiana, storia e testi, ed. Carlo Mascetta, 3, no. 1), Bari, 1971, 220.

4 Translations of anecdotes 1, 2, and 4 from Gilbert, *Italian Art 1400–1500*, 171; 3 and 5 from Janson, *Sculpture of Donatello*, 154 and 85; 6 is a new translation from the original text in Wesselski (see note 1).

5 For the 1401 document see Gai. For Brunelleschi's poem see Janson, 140, and Colin Eisler, 'The Athlete of Virtue: The Iconography of Asceticism', *De Artibus Opuscula XL, Essays in Honor of Erwin Panofsky*, New York, 1961, I, 89. The Italian version of 'Take some wood' is 'Piglia del legno e fanne uno tu', see Giuseppe

Fumagalli, *Chi l'ha detto? Tesoro di citazioni italiane e straniere di origine letteraria e storica, ordinate e annotate da . . .*, 10th edition, Milan, 1968, 695, no. 2188. For the 1458 letter see Lawson, 358 and *passim*. Lawson cites several other letters that reveal the intrigue that could occur when an artist, in this case Donatello, wanted to threaten his current patrons (the Sienese) by trying to obtain work elsewhere (Mantua). Vespasiano da Bisticci, *Vite di uomini illustri del secolo XV* (ed. Paolo d'Ancona and Erhard Aeschlimann), Milan, 1951, 418–19. Rufus G. Mather, 'Donatello debitore oltre la tomba', *Rivista d'arte* 19, 1937, 181–92. According to Harriet Caplow, Donatello's life was 'mobile and debt-ridden' in contrast to the stability demonstrated by his partner Michelozzo ('Sculptors' Partnerships', 152–6).

6 Gene Brucker, *The Society of Renaissance Florence: A Documentary Study*, New York, 1971, 203–26. During the Quattrocento the Ufficiali di Notte (Officials of the Night) began to persecute homosexual lovers, and not just cases of rape as had been the case in the thirteenth century; 'this court was cutting into private affairs, matters of morality which the medieval tribunals (at least in practice) left untouched'. (Samuel Kline Cohn, Jr., *The Laboring Classes in Renaissance Florence*, New York, 1980, 196.)

7 For the painting in the Louvre and its several copies and variants see Pope-Hennessy, *Paolo Uccello*, 2nd. ed., London, 1969, 157–9. On the identifications of the figures in Masaccio and Masolino's fresco see Peter Meller, 'La Cappella Brancacci: Problemi ritrattistici e iconografici', *Acropoli* 1, 1961, 186–227 and 273–312, and Luciano Berti, *Masaccio*, University Park, Pa., 1967, 138 n. 61.

8 For the *Catasto* references see the Mather source cited in note 5. Vasari states in the *Vite* of 1550 that Donatello was born in 1383, while Bartolommeo Fontio, in his *Annales*, reported that Donatello died on 10 December 1466, at the age of 76, giving a birth date of 1390 (Hans Semper, *Donatello, seine Zeit und Schule*, Vienna, 1875, 320). Although it is usually stated that the *Catasto* declaration of 1427 cites Donatello's age as 40, Piero Morselli has verified that the age of 41 cited by Mather is correct (letter, 10 March 1982).

9 This information on Donatello's father is cited from Janson, 'Bardi, Donato', 287–8; for additional information see Maud Cruttwell, *Donatello*, London, 1911, 11. The evidence on the other members of the family is from Donatello's *portate* for the *Catasto*. His sister is mentioned again in a document of 1449; see Herzner doc. 298 bis (mistakenly dated 1499).

10 The signature on the San Lorenzo South Pulpit is accepted as authentic by Hartt (467), but rejected by Janson, who states that it is 'so poor epigraphically that I regard it as posthumous' (202).

11 Wolters, 'Freilegung der Signatur'.

12 Gai.

13 See *Brunelleschi scultore*, 15–22 with bibliography. James Beck has recently suggested that the silver repoussé figure of *Daniel* from the Pistoia Altar might be attributed to the youthful Donatello; see 'Ghiberti giovane'. In a paper presented at the College Art Association meetings in Los Angeles in 1977, Beck also proposed that Donatello might have participated in the execution of Brunelleschi's Competition Relief for the Baptistry Doors.

14 Antonio di Ruccio Manetti, *The Life of Brunelleschi* (ed. Howard Saalman, trans. Catherine Enggass), University Park, Pa., 1970, 52–5.

15 Krautheimer, docs. 28, 31.

16 For a full transcription of the 1406 and 1408 documents and an interpretation see Trachtenberg, 'Donatello's First Work', in which he proposes a figure from the Duomo as a candidate for the documented prophet; the figure is traditional in style and it is difficult to accept this attribution. Both Wundram (*Donatello und Nanni di Banco*) and Poeschke accept the right *Prophet* on the Porta della Mandorla as being by Donatello. Recently Margrit Lisner attributed to Donatello two reliefs on the *ballatoio* of the Duomo ('Die Skulpturen'). She dates the reliefs *c.*1402/5 and *c.*1406/7, and suggests that Donatello was in the employ of Giovanni d'Ambrogio, capomaestro of the Duomo. She also proposes that Donatello may have influenced other heads in the series that are

very antique in inspiration.

17 Frank D. Prager and Gustina Scaglia, *Brunelleschi: Studies of his Technology and Inventions*, Cambridge, Mass., 1970, 30–2.

18 For an introduction to the problems connected with the marble *David* see Janson, 3–7, and Pope-Hennessy, 249–50. There is a documented *David* by Donatello dated 1408–9, which is paired with an *Isaiah* by Nanni di Banco of 1408 in the documents, and another mention of a *David* by Donatello in 1412. Wundram, in his 1968 'Donatello e Nanni di Banco' and 1969 *Donatello und Nanni di Banco*, proposed that the figure in the Museo Nazionale (Fig. 116), which is traditionally associated with the 1408–9 documents, should be connected with the 1412 document. He proposed as Donatello's 1408–9 documented *David* the figure in the Duomo now widely accepted as Nanni di Banco's *Isaiah* (Fig. 117). He substituted another figure as Nanni's work. This controversial theory is still being debated; for opinions see the reviews of Wundram's *Donatello und Nanni di Banco* listed in the Bibliography. Gaborit and Janson did not accept it, but Herzner did in part, proposing in his review that Fig. 117 was an unnamed prophet by Donatello. For recent literature on the *David* see Goldner ('Two Statuettes'), Lisner ('Gedanken' and '*Joshua* und *David*'), Parronchi (*Donatello e il potere*, 27–37), and Marvin Trachtenberg's Review of Gert Kreytenberg, *Der Dom zu Florenz* in *AB* 61, 1979, 131. Lisner, Trachtenberg, and Poeschke do not accept Wundram's reattribution; Goldner, however, does. The most complete examination of the problems of attribution, dating, and iconography related to the marble *David* is Herzner's 'David Florentinus'. In this publication he asserts that Fig. 117 is a representation of Daniel by Donatello. For literature that especially concerns the iconography, interpretation, and political impact of the sculpture, including its transfer to Palazzo della Signoria in 1416, see Levine, '*Tal Cosa*', 2, 28, 230–1; Fehl, 302–3; and Colin Eisler, 'The Athlete of Virtue: The Iconography of Asceticism', *De Artibus Opuscula XL, Essays in Honor of Erwin Panofsky*, New York, 1961, I, 86. Trachtenberg, in 'An Antique Model for Donatello's *Marble David*', unconvincingly proposed an Etruscan statuette as a possible type of antique source for Fig. 116.

Although Janson identifies the wreath *David* wears as amaranth, Poeschke has recently argued that it is ivy (n. 64).

Janson has proposed that the so-called *Martelli David* (Washington, National Gallery) is the documented *David* of 1412; see Janson, pp. 77–86, and, for a summary of the scholarship, Seymour, 234–5, n. 21.

Hertzner's acceptance of Fig. 117 as a work by Donatello led him to identify the two statuettes of *Prophets* that once adorned the portal of the Campanile (now, Museo dell'Opera del Duomo) as Donatello's earliest works ('Zwei Frühwerke Donatellos'). Goldner has attributed these handsome figures to Niccolò Lamberti ('Two Statuettes'), and Brunetti has assigned them to Nanni di Bartolo ('I profeti'). Poeschke dates them later, *c.*1420, and rejects them as works by Donatello.

19 For a discussion of the origins of the competition in Renaissance art see Antje Middeldorf Kosegarten, 'The Origins of Artistic Competitions in Italy', *Lorenzo Ghiberti nel suo tempo; Atti del convegno internazionale di studi* (Florence, 1978), Florence, 1980, I, 167–86.

20 Wundram, *Donatello und Nanni di Banco*. Wundram's chronology was accepted by Janson in his review.

21 The same situation seems to have applied for the *Reliquary Bust of San Rossore* (Fig. 110), for Donatello's tax report in 1427 states: 'Also from the convent and monks of Ognissanti I am owed on account of a bronze half figure of Saint Rossore, on which no bargain has been set. I believe I will get more than thirty florins for it.' (Gilbert, *Italian Art 1400–1500*, 26.)

22 Piero Morselli, 'The Proportions of Ghiberti's *Saint Stephen*: Vitruvius's *De Architectura* and Alberti's *De Statua*,' *AB* 60, 1978, 235–41.

23 Beck, 'Ghiberti giovane', 125–8; the *St. Peter* is accepted as a work by Donatello by Grassi and Poeschke.

24 Wundram dates the tabernacle to 1402 in *Donatello und Nanni di Banco*; this new early dating is accepted by Janson in his review of Wundram.

25 A. Guidotto, 'La "matricola" di Ser Brunellesco orafo', *Prospettiva* no. 9, 1977, 60–1; for Nanni's matriculation see John Pope-Hennessy, *Italian Gothic Sculpture*, 2nd ed., London, 1972, 217.

26 As quoted in Janson, 169.

27 Filelfo, as quoted in Pope-Hennessy, *Luca della Robbia*, 26.

28 See Fader, 24–60, for a discussion of the Florentine *Marzocco*; she also raises the possibility that the lion installed on the platform in front of the Palazzo della Signoria was by Donatello as well. Eve Borsook's reference is from *The Companion Guide to Florence*, rev. ed., London, 1973, 46.

29 The *Prophet* and *Sibyl*, which still decorate the Porta della Mandorla, are exceptional in Donatello's œuvre in that they raise few issues; consequently, there is no recent discussion in the literature of these two handsome, and unfortunately deteriorating, works.

30 For recent literature on the so-called *Pazzi Madonna* see Pope-Hennessy ('Madonna Reliefs') and Rosenauer, *Studien*. Although the relief has been widely accepted as an original by Donatello, Deborah Strom has recently argued that it is a later (perhaps sixteenth-century?) copy after a terracotta or stucco composition by Donatello, which is known in several other versions ('Desiderio and the Madonna Relief'). Her interesting argument is based on: the fact that the marble Madonna reliefs, which were more expensive and seemingly exclusive, were not copied in stucco or terracotta, as was this composition; the unusually large size of the relief; the absence of haloes in the Quattrocento versions; and the flawed perspective of the space box frame and the awkward handling of the Madonna's hands.

31 Paul Schubring, *Donatello* (Klassiker der Kunst), Stuttgart and Berlin, 1922. On the newly discovered Boca Raton *Madonna*, see Pope-Hennessy, 'A Terracotta Madonna'.

32 For Orvieto see Herzner docs. 72, 74; for Ancona see Hans Semper, *Donatello, seine Zeit und Schule*, Vienna, 1875, 279, doc. 48. The statuettes were probably intended to surmount the Baptismal Font; there are surviving Quattrocento examples at Berlin, at the Louvre, and in the Bargello (Museo Nazionale).

33 For recent literature on the Sienese Baptismal Font see Caplow (*Michelozzo*, 396–402), Carli (*Donatello a Siena*), Paoletti (*The Siena Baptismal Font* and 'Donatello and Brunelleschi'), Rosenauer, *Studien*, and Seymour (77–82). In 'Donatello and Brunelleschi' Paoletti makes the unlikely suggestion that the profile head following the violist in the middle ground of the *Feast of Herod* (Fig. 96) is a portrait of Brunelleschi.

34 Gilbert, *Italian Art 1400–1500*, 26–7.

35 Frank D. Prager and Gustina Scaglia, *Brunelleschi: Studies of his Technology and Inventions*, Cambridge, Mass., 1970, 93.

36 Caplow, *Michelozzo*, 44–45.

37 Gilbert, *Italian Art 1400–1500*, 25–6; that Donatello cited his age as 41, not 40, has been verified by Piero Morselli (see n. 8 above). For an analysis of the information from the *Catasto* declarations see David Herlihy and Christiane Klapisch-Zuber, *Les Toscans et leurs familles: Une étude du catasto florentine de 1427*, Paris, 1978.

38 Rufus Graves Mather, 'New Documents on Michelozzo', *AB* 24, 1942, 227–8. The 1427 *Catasto* report of the fourteen-year-old Rinaldo di Giovanni Ghini reports that he was 'in the *bottega* of Donatello and Michelozzo' at this time; Michelozzo wrote his declaration for him (Caplow, *Michelozzo*, 677). The 1428 *Catasto* return of Lapo di Pagno states that his son, Pagno di Lapo, is in the workshop of Donatello and Michelozzo (Herzner doc. 104); Pagno di Lapo appears in many later documents as well. Anne M. Schultz has recently suggested that the young Bernardo Rossellino might have been trained in the workshop of Donatello and Michelozzo (*The Sculpture of Bernardo Rossellino and his Workshop*, Princeton, n.d., 9). For Ghiberti's letter see Herzner doc. 81.

39 James H. Beck, *Masaccio, The Documents*, Locust Valley, N.Y., n.d., nos. XIX, XXIII. For the Pisa documents see Herzner docs. 82, 85, 91; we have, however, accepted the dating of these docu-

ments as given in Janson and followed by Lightbown, rather than that of Herzner.

40 For the most complete and correct transcription of the documents on the *Prato Pulpit* see Morselli, 197–236. For recent literature on the pulpit see Caplow (*Michelozzo*), Guerrieri, Lightbown (*Donatello and Michelozzo*, 230–48), and Marchini ('A proposito del pulpito' and *Il pulpito donatelliano*). On the rapidly deteriorating condition see Franchi. We have followed the analysis of the documents presented by Lightbown, who also discusses the history of the relic and of the previous pulpits. The first contract and the letter quoted here are presented in translation in D. S. Chambers, *Patrons and Artists in the Italian Renaissance*, Columbia, S.C., 1971, 63–6.

The most controversial aspect of the pulpit is the bronze capital, which is documented as being cast by Michelozzo. Both Janson and Pope-Hennessy argue that it was most likely also designed by Michelozzo, but more recent scholarship, supported by the brilliant inventiveness demonstrated in the capital and the use of the putto as a major feature in the design, has supported Donatello as the author of the work; see Poeschke and Summers. Lightbown also supports this view, while suggesting that Michelozzo might have shared in the design (237–8).

41 For Nanni di Miniato's letters see Herzner docs. 106, 124. Poggio Bracciolini's letter is quoted in *Two Renaissance Book Hunters: The Letters of Poggius Bracciolini to Nicolaus de Niccolis* (trans. and ed. Phyllis W. G. Gordan), New York, 1974, letter LXXXIV, 166–7 and 343 n. 7; the letter is usually dated to 23 September 1430, but the year is uncertain. On the antiquities owned by Ghiberti see Krautheimer, 277–93 and 337–52; also *Lorenzo Ghiberti, 'materia e ragionamenti'*, 559–63 with bibliography. For Ciriaco d'Ancona see Gilbert, *Italian Art 1400–1500*, 206–8. On Vespasiano da Bisticci see his *Vite di uomini illustri del secolo XV* (ed. Paolo d'Ancona and Erhard Aeschlimann), Milan, 1951, 418–19.

42 For the letter see Herzner doc. 138; the quotation is from Lightbown, *Donatello and Michelozzo*, I, 235.

43 There is no recent literature on the Crivelli tomb.

For recent literature on the *St. Peter's Tabernacle* see Poeschke and Rosenauer, *Studien*. Poeschke mentions a document, which he finds questionable, that would date the tabernacle to August of 1431 (110 n. 150). Maurice E. Cope has pointed out that Donatello's tabernacle is much more significant than had previously been thought, for it is the first surviving Renaissance example of what became an important new type, a tabernacle for the sacrament (*The Venetian Chapel of the Sacrament in the Sixteenth Century*, New York, 1979, 12ff). This may explain why the sarcophagus is placed frontally and assumes an altar-like position.

44 For recent literature on the *Madonna* in Boston see Caplow, *Michelozzo*, 402–5, who dates the relief closer to 1433/4 (Janson had dated it *c.*1425–8) and tentatively proposes the assistance of Michelozzo. Pope-Hennessy thinks that only the head of the Madonna is by Donatello, although he accepts his authorship of the conception (*Essays*, 54–5, 215 n. 20); he too dates the relief to the mid-1430s (*Study and Criticism*, 77). This is almost certainly the Madonna and Child relief seen by Vasari in the *guardaroba* of Duke Cosimo I. Coolidge suggests that the relief might have been intended for the front of the altar in the Old Sacristy at San Lorenzo, where it would have been seen 'from above and at a fairly sharp angle', and lit 'by diffused light reflected up from a blond stone floor of the kind usual in Brunelleschi's churches'. (See his illustration, no. 14.)

45 See Herzner, 'Donatello und die Sakristei-Türen', for a summary of the history of the Sacristy Doors for the Duomo. Pope-Hennessy in *Luca della Robbia* (68–72, cat. no. 47, 258–61) also reviews the literature; he refutes several of Herzner's assertions.

46 On the complex history of the *Altar of St. Paul* for the Duomo see Pope-Hennessy, *Luca della Robbia*, 31–2, cat. no. 3, 233–4. For the documents see Herzner docs. 236–7. On the choice of Donatello to select materials for the Duomo Choir see Herzner doc. 238.

47 For information on the *Martelli Sarcophagus* see Walter and Elisabeth Paatz, *Die Kirchen von Florenz*, Frankfurt, 1941, II, 503, 572 n. 226. The inscription states that it contains the bones of Niccolò

(1369–*c*.1425) and Fioretta de'Martelli, which were transferred to this coffin from their original burial place in the old church of San Lorenzo; this suggests that the work could only have been conceived when the original basilica was about to be torn down, that is *c*.1440. Paatz dates the work about 1450, but it contains few clues to its period of execution. For information on the Martelli family and its role in Florentine politics – and especially its pro-Medicean stance during the exile of Cosimo de'Medici – see Lauro Martines, 'La famiglia Martelli e un documento sulla vigilia di ritorno dall'esilio di Cosimo dei Medici (1434)', *Archivio storico italiano* 118, 1959, 32ff.

48 Although often accepted in older scholarship, the *Martelli Stemma* has been ignored by contemporary scholars. It was recently rejected by Pope-Hennessy, who stated: 'There is no evidence Donatello was involved in commissions of this type, though he was widely credited in the nineteenth century with the *stemma* of the Martelli, but Desiderio seems to have made something of a specialty of heraldic sculpture. . . .' (*Luca della Robbia*, 57.)

49 See Giuseppe Richa, *Notizie istoriche delle chiese fiorentine . . .*, II, 1755, 230ff, and Walter and Elisabeth Paatz, *Die Kirchen von Florenz*, Frankfurt, 1953, V, 402.

50 For the '*Piagnona*' see Walter and Elisabeth Paatz, *Die Kirchen von Florenz*, Frankfurt, 1952, III, 40 and 75 n. 233. The *terminus ante quem* of 1464 is provided by the inscription mentioning Cosimo de'Medici as the donor; he died in 1464.

51 For recent literature on the Santo *Crucifix* see Marcia B. Hall, 'The *Tramezzo* in Santa Croce, Florence, Reconstructed', *AB* 56, 1974, 336 and ns. 27–9.

52 On the Padua Altar see the documents listed in Herzner's 'Regesti'. The most controversial problem raised by the Altar is the reconstruction of the original architectural setting for the figures and the arrangement of the many reliefs; this is complicated by the fact that Marcantonio Michiel's description (quoted in Janson) does not mention all the surviving works, nor does it clarify the position of the many different pieces mentioned in the comprehensive documentation. For recent attempts to reconstruct the altar see Herzner ('Donatellos "pala over ancona"'), Parronchi ('Per la ricostruzione'), Poeschke, Pope-Hennessy, Sartori ('Documenti', 'Ancora', and *Documenti per la storia dell'arte in Padova*, 87–95); Schroeteler ('Zur Rekonstruktion' and *Zur Rekonstruktion*); and White ('Donatello's High Altar'). Sartori has published some new documentation, which is included in Herzner's 'Regesti'; it has provided new insight into certain aspects of the original appearance of Donatello's work.

For recent literature on problems other than the reconstruction see Busignani, Cessi ('L'altare'), Fiocco ('L'altare', 'Ancora dell'altare', and *Donatello al Santo*), and Gasparotto ('Iconografia antoniana' and 'Sant'Antonio'). On the *Madonna* see Beck, 'Donatello's Black Madonna', and Herzner's response, 'Donatellos Madonna'. On the *Entombment* see Lisner, 'Appunti'.

53 For the Mantua commission see Lawson and Herzner docs. 325–6, 339, 374, 377, 380–3, 385–7. For the Ferrara document see Herzner doc. 331. For the documents on the Modena statue see Herzner docs. 329–38, 341, 343–4, and Rosenberg. As Rosenberg points out, it is not clear whether the monument represented Borso enthroned or on horseback. For Alfonso of Aragon's letter see Herzner doc. 340; for Pope-Hennessy's connection of this reference with the *Gattamelata*, see *Italian Renaissance Sculpture*, p. 263. For Zara, see Vežić.

54 Procacci corrected the incorrect reading of the date of this document; for many years it was thought to read 1443 (pp. 13–14).

55 Foster.

56 Gilbert, *Italian Art 1400–1500*, 171.

57 As quoted in Michael Baxandall, *Giotto and the Orators*, Oxford, 1971, 109.

58 For discussions of Donatello's sojourn in Siena see Carli (*Donatello a Siena*), Herzner ('Donatello in Siena'), and Parronchi (*Donatello e il potere*, 245–67). For the documents see Herzner docs. 354–68, 370–82, 384–90, and 393–4.

59 On the attribution of the *Madonna del Perdono* see Carli (*Donatello a Siena*), Herzner ('Donatello in Siena'), Pope-Hennessy ('Madonna Reliefs' in *Study and Criticism*, 84–5), Seymour (148), and Strom ('Desiderio and the Madonna Relief', 130). All these critics accept the relief as a work designed by Donatello.

60 Lawson.

61 Andrea della Robbia's comment is found in Vasari's *Life of Luca della Robbia*. For new information on the burial place of Donatello, in the crypt at San Lorenzo, see Lightbown, *Donatello and Michelozzo*, II, 327–8.

Chapter 3

1 This summary of Chrysoloras's values is Michael Baxandall's; see his *Giotto and the Orators*, Oxford, 1971, 82–3, for a discussion of the relationship between art and humanist writing. See 51–8 for a discussion of Petrarch.

2 Krautheimer, 372, doc. 52.

3 Gombrich, 3.

4 *Ibid.*, 2; from Ferdinandus Fossius, *Monumenta ad Alamanni Rinuccini vitam contextendam*, Florence, 1791, 43ff.

5 For a discussion of Hercules see Krautheimer, 280, and Ettlinger. For David as a Florentine symbol see Seymour, *Michelangelo's David*, *passim*, and Herzner, 'David Florentinus'. Janson noted the similarities between Donatello's *David* and the fresco by Taddeo Gaddi in the Baroncelli Chapel, Santa Croce.

6 Seymour, 5.

7 For recent literature on the *Marzocco*, see Fader, 24ff.

8 Krautheimer, 5, 256.

9 For a discussion of lions and their medieval and classical antecedents, see Fader (24ff), Hans Kauffmann (*Donatello*, Berlin, 1935, 40), and Luca Landucci (*A Florentine Diary from 1450 to 1516*, New York, 1969, 2).

10 For recent literature on the *Dovizia* see Brunetti, 'Una testa di Donatello', where she proposes that the replacement head now on the body of the late Trecento figure of *Faith* by Jacopo di Piero Guidi on the Loggia dei Lanzi is the surviving head of Donatello's lost *Dovizia*; see also the article by David Wilkins, 'Donatello's Lost *Dovizia* for the Mercato Vecchio: Wealth and Charity as Florentine Civic Virtues', *AB*, 65, 1983, 401–23.

11 For all relevant documents on the *St. Louis of Toulouse* see Janson; also Giovanni Poggi, Leo Planiscig, and Bruno Bearzi, *Donatello, San Ludovico*, New York, 1949. For recent literature see Bearzi ('La tecnica'), Becherucci ('I tre capolavori'), Rosenauer, *Studien* and Caplow (*Michelozzo*, 389–93) on the tabernacle. The photograph for Fig. 129 was taken after World War II, when the statuary was returned to Florence; it was then that the *Louis* was proven to be the original for this tabernacle, since his crozier rests in the plugged hole in its base. On the sources for the tabernacle see Martin Gosebruch, 'Florentinische Kapitelle von Brunelleschi bis zum Tempio Malatestiano und der Eigenstil der Frührenaissance', *Römisches Jahrbuch für Kunstgeschichte* 8, 1958, 110ff.

Rosenauer (*Studien*) has dated the tabernacle to before May 1422, asserting that it was the source for the new classicism of Ghiberti's *St. Matthew* tabernacle (Fig. 30), which was completed by that date. Poeschke agrees with this dating (107 n. 125), but he goes further by suggesting that the project may have been begun as early as late in the second decade (103 n. 84). His arguments are stylistic.

The tabernacle is also attributed to Donatello by Heinrich Klotz in *Die Frühwerke Brunelleschis und die mittelalterliche Tradition*, Berlin, 1970, pl. 159. On the figure see also *L'oreficeria nella Firenze del Quattrocento* (ex. cat., Florence, 1977), 53–7.

12 Leonardo Bruni, 'Panegyric to the City of Florence', *The Earthly Republic: Italian Humanists on Government and Society* (ed. Benjamin G. Kohl and Ronald Witt), n.c., 1978, 171. See George Holmes, *The Florentine Enlightenment 1400–1500*, New York, 1969, 22–6, for a discussion of the history.

13 *Two Memoirs of Renaissance Florence: The Diaries of Buonaccorso Pitti*

and Gregorio Dati (ed. Gene Brucker), New York, 1967, 98–9. The situation is reiterated in a document translated in Gene Brucker, *The Society of Renaissance Florence*, New York, 1971, 88–9 (from the *Consulte e Pratiche*, Archivio di Stato, Florence, 42, fol. 88r.).

14 The Mercanzia commissioned Verrocchio to produce the *Christ and Doubting Thomas*, which is still in the tabernacle. It is interesting to note that the three-faced Trinity in the gable of the tabernacle was not removed when the tabernacle changed hands; this symbol, which also appears prominently over the door of the Palace of the Parte Guelfa, seems to have been associated with republican and Guelph interests. See Edgar Hertlein, *Masaccios Trinität*, Florence, 1979, 205ff. The wreath held by flying putti at the base of the Louis tabernacle now enframes a plain piece of polished marble; perhaps it was in this area that one of the other symbols of the Parte Guelfa – gold keys on a blue field or a red eagle wearing a golden crown and holding a green dragon in his talons – was displayed.

15 For recent literature on the Cossa tomb see Caplow (*Michelozzo*, 98–139), Goldner ('The *Tomb of Tomaso Mocenigo*'), Rosenauer (*Studien*), and Lightbown (*Donatello and Michelozzo*, chapters I and II), where there is a full discussion of the circumstances surrounding the tomb's commission, an attribution of its various parts, and a description of its construction. On the history of Cossa and the Medici, see George Holmes, 'How the Medici became the Pope's Bankers', *Florentine Studies* (ed. Nicolai Rubinstein), London, 1968, 357–80.

16 *Two Memoirs of Renaissance Florence: The Diaries of Buonaccorso Pitti and Gregorio Dati* (ed. Gene Brucker), New York, 1967, 98.

17 George Holmes, 'How the Medici became the Pope's Bankers', *Florentine Studies* (ed. Nicolai Rubinstein), London, 1968, 379–80.

18 Vespasiano da Bisticci, *Vite de uomini illustri del secolo XV*, Milan, 1951, 418.

19 Gombrich, 36.

20 Vespasiano da Bisticci, *Vite de uomini illustri del secolo XV*, Milan 1951, 410.

21 Luca Landucci, *A Florentine Diary from 1450 to 1516*, New York, 1969, 2.

22 Foster.

23 Gombrich, 43–5.

24 For recent literature on the decorations for the Old Sacristy see Rosenauer (*Studien*). Janson argues a *terminus ante quem* of the Doors of 1442 (137); Pope-Hennessy dates the programme between 1437 and 1443 (*Luca della Robbia*, 39). Poeschke asserts a *terminus ante quem* of 1435 (61).

25 For information on the *Cantoria* at San Lorenzo see Walter and Elisabeth Paatz, *Die Kirchen von Florenz*, Frankfurt, 1941, II, 503 and 572 n. 229. Martin Wackernagel suggests that this *Cantoria* was intended to have figural decoration as well (*The World of the Florentine Renaissance Artist*, trans. Alison Luchs, Princeton, 1981, 232).

26 Although the ancient *Marsyas* restored by Donatello for Cosimo de'Medici has been thought to be lost, recent research on the ancient Marsyas replicas by Anne Weis of the University of Pittsburgh suggests that the statue may be the hanging *Marsyas*, inventory no. 201, now in the Uffizi. For a recent discussion of the work see Guido A. Mansuelli, *Galleria degli Uffizi, le sculture*, Rome, 1958, I, 88–90, cat. 57, fig. 56. This figure does not seem to be carved from red marble as has previously been thought; it is white marble with red staining.

27 The bronze *Crucifixion* mentioned by Vasari has often been connected with the relief now in the Museo Nazionale; Janson rejects this work as Donatello's (242–4), but Pope-Hennessy accepts it as an assisted work based on a model by Donatello (*Essays*, 35; 'Medici *Crucifixion*'; and review of Hartt, *Donatello, Prophet of Modern Vision*). Grassi (*Tutta la Scultura*) and Poeschke also accept it. Although immediately inspired by Donatello's works, it is best ascribed to a follower.

Pope-Hennessy has also attributed to Donatello the bronze *Crucifixion* relief in the Camondo Collection at the Louvre; see 'Medici *Crucifixion*' in *Study and Criticism*, 119–20.

28 Isabelle Hyman, *Fifteenth-Century Florentine Studies, the Palazzo*

Medici and a Ledger for the Church of San Lorenzo, New York, 1977, 64–5.

29 Herzner docs. 138, 142, 214; see also doc. 227.

30 E. Müntz, *Les collections des Médici au quinzième siècle*, Paris, 1888, 63–4.

31 For recent literature on the *Judith and Holofernes* see Barelli ('*Judith and Holofernes*'), Bearzi ('La tecnica fusoria'), Corti and Hartt, Fader, Herzner ('Donatello in Siena', 161–81 and 'Die Judith'), Janson ('La signification'), Levine ('*Tal cosa*'), Liess, *Metodo e scienza* (158ff.), Parronchi (*Donatello e il potere*, 237–43), Reid, Schneider ('Donatello and Caravaggio', 'Some Neoplatonic Elements', and 'Response'), Erika Simon ('Der sogennante "*Atys-Amorino*"'), von Erffa, and Alessandro Conti in *Palazzo Vecchio: committenza e collezionismo medicei* (*Firenze e la Toscana dei Medici nell'Europa del Cinquecento*; ex. cat. Florence, 1980), 404.

Laszlo Baransky-Job, in a paper delivered at the College Art Association meetings in 1968 entitled 'The Iconographic and Stylistic Sources of Donatello's *Judith*: The Meaning of the Statue as a Fountain Figure', has tried to relate the iconography to the Turkish Bull of Callixtus III of 1456 and to Hugo of St. Victor's *Allegoriae in Vetus Testamentum*: 'Judith (Church) saved Bethulia, the community of the faithful (in this historic connotation, Constantinople), by killing Holofernes and reopening the channels (the acqueducts of Bethulia in the Biblical story) of Grace, or Truth, and thus she secures the continuous flow of grace into the community of the faithful'.

For a complete review of the literature on the sculpture see Herzner's recent 'Die Judith', in which he argues that the figure was originally intended to be seen in profile. He reviews the iconography of Judith, relating it to that of David, and interprets the sculpture as an allegory of Force and Humility. He proposes that both the Judith group and Donatello's bronze *David* were intended to express the power of the Medici, and that both were originally intended for the Medici Palace.

Corti and Hartt publish a document of 1456, which they connect with the casting of the *Judith*; the agent who makes the payments to Donatello often worked for the Medici, which again supports the idea of Medici patronage. Pope-Hennessy dates the Judith to *c*.1453–5, and accepts the Corti-Hartt document as referring to the casting.

Levine ('*Tal cosa*') argues that the *Judith* is a portrait of Lucrezia Tornabuoni, and Erika Simon interprets the reliefs on the base as representations of Pride and Lust, *superbia* and *luxuria*. Schneider's interpretation of the decapitation theme is single-mindedly Freudian.

While Janson argued that 'Donatello did not conceive the statue in terms of a specific phase of action' (204), Pope-Hennessy interpreted the group as representing a 'literal interpretation of the action'. Barelli agrees with Pope-Hennessy, and Reid has pointed out how exceptional it is that Holofernes is not shown decapitated. The moving of the sculpture inside the Palazzo Vecchio in 1980 has in part resolved the issue, for it is now clear that there is a great open gash in Holofernes' neck that is different from the casting flaw pointed out by Janson; Judith has clearly struck the first of the two blows mentioned in the text, and Holofernes is dead.

The question of whether the statue was fully or only partially gilded (see Janson, 201 n. 4, and Pope-Hennessy, 265) will probably be resolved by a technical examination; for preliminary evidence see *Metodo e scienza*. See below, Chapter 4, n. 38.

Several issues remain unresolved concerning the original placing of the group and its function as a fountain. Isabelle Hyman has noted a poem of about 1455 that mentions a fountain in the garden of the Medici Palace (*Fifteenth Century Florentine Studies, the Palazzo Medici and a Ledger for the Church of San Lorenzo*, New York, 1977, 209–12.) Although the original pedestal was ordered moved to the Palazzo della Signoria in 1495, it is possible that the basin survived in the Medici Palace at least into the sixteenth century, when three separate sources mention a granite vase with marble ornaments by Donatello in use as a fountain at the palace (Peter Murray, *An Index*

of Attributions in Tuscan Sources before Vasari, Florence, 1959, 59). Vasari also mentions that Donatello had made a granite vessel for 'pouring water' that was at the palace. The descriptions seem to indicate that the fountain was of the 'cylix' type defined by Bertha Wiles in *The Fountains of the Florentine Sculptors*, Cambridge, Mass., 1933, 10; a fifteenth-century example of this type of fountain survives at the Pitti Palace, but the Medici arms date the lower part to the period after 1469; the upper basin and figure are sixteenth-century additions.

It is also not certain whether the fountain functioned with four, three or seven spouts. It seems most reasonable that there were only three sources for water, the three openings in the sides of the base (although these are presently closed). The four openings in the corners of the pillow below Holofernes were probably filled with metalwork tassels, which have been lost or have disintegrated with time; note the similar openings in the pillow of Cellini's *Perseus*, which was meant as a counterpart to the *Judith* but which was never intended to be a fountain.

The technical investigations reported in *Metodo e scienze* reveal that the bronze of the triangular base is of a quite different composition than that of the figures, suggesting that the two may not have been made at the same time. This raises the possibility that the figural group once rested on a column, and the base was a later addition.

32 Recent literature on the bronze *David* has concentrated on issues of date, patronage, iconography and interpretation; see Ames-Lewis, Barelli ('Note iconografiche'), Czogalla, Dixon, Doebler, Eisler, Fehl (300–2), Hamme, Hartt ('Art and Freedom'), Herzner ('David Florentinus II' and 'Die Judith'), Janson ('La signification' and 'Donatello and the Antique'), Paoletti ('Bargello *David*'), Parronchi (*Donatello e il potere*, 101–26), Passavant, Rosenauer (*Studien*), Schneider ('Donatello and Caravaggio' and 'Donatello's Bronze *David*'), and Erika Simon ('Der sogennante "Atys-Amorino"'). Patricia A. Leach has recently written a dissertation for Princeton University on the iconography and dating of the bronze *David*.

Janson has proposed Florentine Communal patronage, while Leach favours Cosimo de'Medici, and Ames-Lewis his son, Piero de'Medici, as patron. Pope-Hennessy and Herzner believe that the work was from the beginning intended to adorn the Medici Palace. Janson and Leach both propose an early date of *c.*1428–30, but recent scholarship has tended to return to the post-Paduan dating favoured by Hans Kauffmann (*Donatello*, Berlin, 1935). Pope-Hennessy suggests that the work 'was executed in Florence in the years preceding Donatello's departure, . . . 1440–1442', but he also communicated to us verbally the idea that it might have been executed in Padua in the later 1440s or early 1450s and shipped to Florence. Czogalla favours a date at the beginning of the 1450s, and Seymour would like the work to be post-Paduan. Ames-Lewis thinks it unlikely to have been produced before the late 1450s.

Recently the problem of the original base has been discussed. Fehl states that it was a 'fountain figure' without citing supporting evidence (302) and Ames-Lewis proposes that the pedestal that Vasari ascribes to Desiderio was more probably by Donatello. Passavant has published the ingenious (but unlikely) idea that the *lavabo* now in the Old Sacristy of San Lorenzo preserves the main components of a Medici fountain, which he then proposes as the original base for the *David*; he suggests that the bronze laurel wreath now on the sculpture is a later addition.

Schneider's two articles have over-stressed the idea, first proposed by Janson, that the *David* is an expression of Donatello's homosexuality; Dixon provides a sharp critique of her publications.

The work is in essentially good condition, but it preserves much evidence of the difficulties of the casting process. The second wing of Goliath's helmet either did not cast properly or has been broken off. The soft felt hat worn by David 'is also damaged and may have terminated in a plume' (Pope-Hennessy, 264). Fehl suggests that 'originally it probably had a bunch of real feathers rising above it,

held in the clip which we still see attached to the crown of the hat' (30). The square hole in Goliath's helmet is not a casting error; certainly it once held an extended attribute; see Janson, 'La signification'.

Barelli's article investigates relationships between the *David* and the humanist writers in Florence. Czogalla suggests that the figure combines two themes: David/Goliath and Ganymede/Zeus. Erika Simon's work suggests that Priapus is the putto honoured in the decoration of Goliath's helmet. Parronchi put forward an interpretation of the figural grouping as representing Mercury and Argus; Leach has seconded this theory. Colin Eisler has proposed that the 'nudity of the figure . . . may have been derived from St. John Chrysostom's gymnastic elaboration of a Pauline analogy comparing the body of the Church to the body of Christ', and he goes on to suggest that the figure on its original pedestal 'must have recalled literary descriptions of the monuments erected to triumphant athletes'. ('The Athlete of Virtue: The Iconography of Asceticism', *De Artibus Opuscula XL, Essays in Honor of Erwin Panofsky*, New York, 1961, I, 89.) Doebler relates the *David* to another athlete, Orlando in *As You Like It*.

Paoletti is the only writer who would deny the execution of this, Donatello's most famous figure, to the artist himself. He suggests that the bronze *David* 'is really a cast from the 1463 modello for the buttress figure and that it may even have been made after Donatello's death' (104).

33 Millard Meiss, *Painting in Florence and Siena after the Black Death*, Princeton, 1951, 49, figs. 68–71. The tradition continues into the Quattrocento in Tuscany, as in Sassetta's *St. Francis in Ecstasy* at Villa I Tatti.

34 Other examples include a Florentine plaquette of about 1500 in Washington (see Pope-Hennessy in *Study and Criticism*, 192 and 219 n. 1, for references to this work) and a bronze relief by Donatello's followers Bellano and Riccio in the Santo, Padua. Both figures appear in Botticelli's *History of Lucretia* in the Gardner Museum, Boston, and their victories are paired in the spandrels at one end of Michelangelo's Sistine Ceiling.

35 On the history of the debate over the placing of the *David*, see Levine, '*Tal Cosa*' and 'The Location of Michelangelo's *David*'.

36 Leopold Ettlinger, 'Hercules Florentinus', and *Antonio and Piero Pollaiuolo*, Oxford, 1978. Ames-Lewis notes that '"the defeat of tyrants, the freeing of subject nations, and the restitution of liberty", characteristic clichés of Florentine Republicanism, were, according to Landino in 1475, major achievements of Hercules' (141).

37 Luca Landucci, *A Florentine Diary from 1450 to 1516*, New York, 1969, *passim*.

38 Hartt (210), Paoletti ('Bargello *David*', 107–8 n. 20), Ronald Lightbown (*Sandro Botticelli*, Berkeley and Los Angeles, 1978, I, 80 and 186 n. 14), Levine ('*Tal Cosa*', 76, 110, 120 n. 69), and Ames-Lewis. Levine is incorrect, however, in assuming that Cosimo or his followers actually put some of their enemies to death after the return; see Dale Kent, *The Rise of the Medici*, New York, 1978, *passim*, which is also a good source for a discussion of Cosimo's return via Pistoia to Florence (339).

39 Isabelle Hyman, *Fifteenth-Century Florentine Studies, the Palazzo Medici and a Ledger for the Church of San Lorenzo*, New York, 1977, 188–96, 202–3.

40 Corti and Hartt ('New Documents', 158–9), Pope-Hennessy (265), Hartt (408). For the Lucrezia Tornabuoni reference see Levine, '*Tal Cosa*', 56, 97–9 n. 19. For the history of the Sienese document see Janson, 202–3, and Herzner, 'Donatello in Siena', 161–81; the relatively modest payment for this work suggests that it is unlikely to refer to the *Judith*. Herzner has recently suggested that the document, which explicitly refers to a half-figure, might be related to another subject and another type of object: he proposes a reliquary bust of S. Giulitta ('Die Judith', 161–2 and nn.). For Janson's most recent assertion of Sienese Communal patronage for the *Judith* see 'La signification'.

41 Janson, 'La signification'.

42 For recent literature on the *Gattamelata* see Brunetti ('Una vacchetta'), Fiocco ('La statua equestre'), Janson ('Equestrian Monument'), Parronchi ('Storia'), Sartori ('Il cosidetto bastone' and 'Il donatelliano monumento equestre'), and Schneider ('Some Neoplatonic Elements'). Rina Youngner deserves special thanks for her preliminary research on this topic.

43 E. Müntz, *Les collections des Médicis au quinzième siècle*, Paris, 1888, 64.

44 John Pope-Hennessy, *Paolo Uccello*, London, 1950, 142. There is also a distinctly funerary and more private tradition of monuments, including a free-standing equestrian statue on the *Tomb of Paolo Savelli* (*c*.1408) in the church of the Frari, Venice.

45 Marilyn Perry, 'St. Mark's Trophies: Legend, Superstition, and Archaeology in Renaissance Venice', *Journal of the Warburg and Courtauld Institutes* 40, 1977, 29–30.

46 Gaetano Milanesi, *Le opere di Giorgio Vasari*, Florence, 1906, II, 409 n.

47 *La vita del Beato Ieronimo Savonarola*, Florence, 1937, 130–1.

Chapter 4

1 Quoted from Janson, 'Giovanni Chellini's *Libro* and Donatello', 131.

2 Herzner doc. 173.

3 For information on Donatello as a draughtsman and some additional attributions see Degenhart and Schmitt, Vol. I, part 2, 343–65. The Rennes drawing has recently gained wide acceptance as the only surviving drawing by Donatello; see Eisler, cat. 2. The drawing is from Vasari's *Libro de' Disegni*, but it has lost the 'frame' Vasari drew around each of these prize possessions. Vasari ascribed it to Donatello. It was originally about twice as large, and below the *Massacre* can be discerned an earlier study, a lightly sketched tabernacle enclosing a figure of an angel. On the verso is a drawing of the triumphant David.

4 This problem is discussed by Valentino Martinelli in 'Il non-finito di Donatello'.

5 See Lavin, 'Bozzetti and Modelli', and Pope-Hennessy, *Luca della Robbia*. Cellini reports that Donatello and Michelangelo were similar in their use of models; they either made full-scale models or they worked directly in the stone (Summers, 98).

6 For recent literature on the Victoria and Albert *Lamentation* see Pope-Hennessy (*Catalogue*, 75–6, and 'Some Donatello Problems' in *Essays*, 58–60); he dates the relief to *c*.1440–3. Becherucci in *I pergami* accepts it as intended for the Siena Doors (p. 13). See also Carli, *Donatello a Siena*.

7 A stucco cast of the *Lamentation*, which includes the ground, is in the Museo Bardini; it gives some indication of the effect.

8 Janson, 208.

9 For recent research on the *Coronation of the Virgin* see Walter and Elisabeth Paatz, *Die Kirchen von Florenz*, Frankfurt, 1952, III, 514–15; and *Lorenzo Ghiberti 'materia e ragionamenti'*, 245–50.

10 *Lorenzo Ghiberti 'materia e ragionamenti'*, 581–4.

11 G. Marchini, *Italian Stained Glass Windows*, New York, 1956, 50–1.

12 Alfred Gotthold Meyer, *Donatello*, Leipzig, 1904, 9. For a recent proposal of early work by Donatello as a goldsmith see Chapter 2, n. 13.

13 E. Staley, *The Guilds of Florence*, London, 1906, 269 and, for goldsmiths and the Arte della Seta, 228.

14 Krautheimer, 389, 390, 376, 379, 375, 396, 397.

15 *The Treatises of Benvenuto Cellini on Goldsmithing and Sculpture* (trans. C. R. Ashbee), New York, 1967, 4.

16 Filarete, *Treatise on Architecture* (trans. John R. Spencer), New Haven, 1965, I, 32.

17 Francesco testified in the restitution case against Petruccio da Firenze, the rag dealer, on 10–11 April 1450; see Herzner doc. 324. It could be argued that the Padua documents, such as the one for 1 July 1448, which mentions gold and silver to be applied by Donatello, support the idea that Donatello was required to do, and

did his own goldwork. Since certain casts are more specifically noted as 'by his hand', and since he employed a goldsmith, it seems more likely that he did not execute all the gold and silver work himself.

18 Although the *Madonna* in Cologne was associated with Donatello by Bode, Schubring, and Kauffmann, in the modern literature it has been either ignored or rejected. It was most recently mentioned by Pope-Hennessy in *Catalogue*, 83. William Homisak's research on the Cologne *Madonna* was presented at a symposium at Oberlin College in 1979.

19 Hartt, 9.

20 For recent literature on the *St. John the Evangelist* see Becherucci and Brunetti (I, 262–4), Munman, Rosenauer ('Die Nischen'), and Poeschke, who points out that the figure once held a bronze quill pen in his right hand (p. 100 n. 57, fig. 173).

21 Francesco Bocchi, *Le bellezze di Firenze, ampliate da Giovanni Cinelli*, Florence, 1677, 11, as translated by Janson, 18.

22 From the *Libro di Antonio Billi* (ed. C. Frey), Berlin, 1892, 38–41. Billi's reference is noted by Valentino Martinelli in 'Il non-finito', 182.

23 Giorgio Vasari, *Vasari on Technique* (ed. G. Baldwin Brown, trans. Louisa S. Maclehose), New York, 1960, 152–3.

24 Bernardo Davanzati, *Opere di Tacito*, Padua, 1755, 656; noted in full in English by Janson, 36.

25 Godby. Pope-Hennessy has proposed the *Baptism of Christ* relief on the Font in the Cathedral of Arezzo as Donatello's earliest (*c*.1410–15) *schiacciato* effort ('Some Donatello Problems', in *Essays*, 47–51). Although accepted by Rosenauer (*Studien*, 72ff.), this attribution has been rightly rejected by Covi (Review of *Essays*), Janson, and Poeschke (105 n. 104). For a review of the earlier literature on the relief see Janson, 94.

26 For recent literature on the *Tomb of Cardinal Rainaldo Brancaccio* and the *Assumption* relief see Caplow (*Michelozzo*, 141 95), Lightbown (*Donatello and Michelozzo*, chapters III–V), Martinelli, Morisani, Mormone, and Rosenauer, *Studien*. Lightbown provides the most complete discussion of the tomb's iconography and a thorough reassessment of the quality of the tomb. His attribution of many areas of the monument to Donatello is convincing, especially when related to the fact that many parts are unfinished because of a lack of money after the Cardinal's death.

27 Hartt, 145.

28 *The Treatises of Benvenuto Cellini on Goldsmithing and Sculpture* (trans. C. R. Ashbee), New York, 1967; *Vasari on Technique* (ed. G. Baldwin Brown, trans. Louisa S. Maclehose), New York, 1960. For the most recent discussions of bronze casting and its difficulties see Massimo Leoni, 'Techniques of Casting', in *The Horses of San Marco, Venice*, New York, 1980, 171–7; and *Lorenzo Ghiberti 'materia e ragionamenti'*, 576–84.

29 This composition would then be 4.3% tin. See *Lorenzo Ghiberti 'materia e ragionamenti'*, 576, for a modern analysis of the bronze in Donatello's *Judith* as 8.17% tin, of Ghiberti's *Gates of Paradise* as 2.2% tin, and other Renaissance works with similar fluctuation. It is possible, therefore, that the 500 pounds of copper Andrea had acquired in April were also mixed with this tin. The Arca account books seem to include numerous cumulative entries, so that it is impossible to follow completely the technical expenditures. For further technical information on the *Judith* see *Metodo e scienza*, 158 ff.

30 Bearzi in 'La tecnica fusoria', 100, interprets this document as referring to the five pieces that make up the reliquary.

31 See Chastel, 'Le traité de Gauricus', 291–305.

32 Bearzi, 'La tecnica fusoria', 101–2.

33 The source is Baldinucci, quoting from Ghiberti's lost diaries; see Krautheimer, 73.

34 Krautheimer, 7.

35 Krautheimer, 115, 190–1 n. 4.

36 As quoted in Janson, 79, 209.

37 For recent literature on the Siena *St. John the Baptist* see Carli (*Donatello a Siena*), Herzner ('Donatello in Siena', 161 ff.). The

relevant documents are cited in Herzner, docs. 355, 357, 360 a, b, c. The problematic document of September 1457 refers to a half-length figure, but the name is indecipherable; it could be Giuletta or Guliatte, or Giobatta, as an abbreviated reference to the *John the Baptist*. This seems quite reasonable since the duty was paid on the statue in the same month. For another interpretation, see Chapter 3 n. 40.

38 Bruno Bearzi, 'Considerazioni di tecnica sul S. Ludovico e la Giudetta di Donatello', *Bollettino d'arte* 36, 1951, 119–23, and 'La tecnica fusoria', 102–3. For new information about the technique and the gilding of the *Judith* see *Metodo e scienza*, 158 ff., where it is reported that there is especially good evidence that the scenes on the base were gilded.

39 Ames-Lewis, n. 36.

40 See Bruno Bearzi *et al.*, *Donatello, San Ludovico*, New York, 1949, 27, for a description of fire-gilding. For other discussions on the statue's technique, see n. 38 above.

41 For a brief history of fire-gilding see W. A. Oddy, Licia Borrelli Vlad, and N. D. Meeks, 'The Gilding of Bronze Statues in the Greek and Roman World', *The Horses of San Marco, Venice*, New York, 1980, 182–5.

42 For recent literature on the *Madonna and Child* that Donatello gave to Dr. Chellini see Janson ('Giovanni Chellini's *Libro*'), Lightbown ('Giovanni Chellini'), Pope-Hennessy ('Madonna Reliefs'), and Radcliffe and Avery.

43 Pope-Hennessy, *Luca della Robbia*, 60, 67–8, pl. 90A.

44 For Madonna and Child reliefs in terracotta, stucco, and gilt bronze attributed to Donatello, as well as others that seem to relate to lost originals by Donatello, see Pope-Hennessy's article on the 'Madonna Reliefs' and *Essays*, 60–4; and *Metodo e scienza*, 155 ff. Connoisseurship for these reliefs is complex, and it is complicated by the uncertainty about the Madonna and Child reliefs by Donatello's contemporaries, such as Ghiberti, and slightly later artists, such as Desiderio; for new light on the latter see Strom, 'Desiderio and the Madonna Relief'.

45 *Lorenzo Ghiberti 'materia e ragionamenti'*, 208–11. For other bibliography on terracotta and stucco see Bellosi and Middeldorf.

46 Pope-Hennessy in *Catalogue* (77–8) summarizes the literature on the Victoria and Albert gilt terracotta *Madonna*. He points out that it is modelled, not cast, and suggests a date of *c.*1458, proposing that it may have been executed in Siena. For the 1450 document, see Herzner doc. 326.

47 Vitruvius mentions 'pediments ... ornamented with statues of terracotta ... in the Etruscan fashion' (III.III.5). Pliny the Elder's discussion of a terracotta *acroteria* by the Etruscan artist Vulca is found in *Natural History* 35–157; for more information on Vulca see J. J. Pollitt, *The Art of Rome*, Englewood Cliffs, N.J., 1966, 8–16.

The manner in which the drapery of the putti exposes the form of the genitals might also be related to Etruscan models, e.g. the *Apollo* from Veii at the Museo di Villa Giulia in Rome, but it cannot be demonstrated that Donatello knew examples of this sort; the Veii *Apollo* was only discovered in 1916.

48 *Vasari on Technique* (ed. G. Baldwin Brown, trans. Louisa S. Machlehose), New York, 1960, 170–2.

49 For recent literature on the Venice *St. John the Baptist* see Parronchi (*Donatello e il potere*, 93–9), Strom ('New Chronology' and *Studies*, 8–10, 96–106), and Wolters ('Freilegung'). Strom's dissertation and article provide a good discussion of Donatello's technical innovations in wood sculpture, as well as information about wood sculpture in general and the chronology of Donatello's in particular.

50 For the most important new literature on the *Penitent Magdalene* see Strom, *Studies* (8–10, 106–28) and 'New Chronology', where she dates the work to *c.*1440–43. Other new bibliography includes the *Firenze restaura* catalogue, 61–4, and Huse, 'Beiträge'. Eloise M. Angiola has suggested that the penitential content of the figure is related to the function of the Baptistry, and that the figure may therefore have been commissioned originally for this monument

('"Gates of Paradise" and the Florentine Baptistery', *AB* 55, 1978, 245).

Donatello's *Penitent Magdalene* conforms to a well-known type in Florentine art; the earliest example known to us is the famous Dugento panel representing the saint and scenes from her legend attributed to the so-called Master of the Magdalene (Accademia). There is some evidence that the Penitent Magdalene may have been among the patron saints of Florence, for she appears with the patron saints (Zenobius, John the Baptist, Reparata, and Eugenius and Crescentius) on a panel painted *c.*1300 for the Duomo in Florence; see Evelyn Sandberg-Vavalà, *Studies in the Florentine Churches I: Pre-Renaissance Period*, Florence, 1959, 66, figs. 13a–b.

51 For recent literature on the Santa Croce *Crucifix* see Becherucci ('I tre capolavori'), Bellosi, *Brunelleschi scultore*, Caprara, 'Donatellos Holzkruzifix', Herzner ('Bemerkungen'), Lisner (*Holzkruzifixe*, 54–7, 'Intorno al *Crocifisso*', and 'Zum Frühwerk'), Micheletti, Parronchi (*Donatello e il potere*, 51–85), Strom (*Studies*, 7–8, 87–96), and Taubert. Parronchi tries to reattribute the work to Nanni di Banco. In 'Zum Frühwerk Donatellos' Lisner dates the *Crucifix* to 1408/10. An attribution to Donatello that is sometimes based on the Santa Croce *Crucifix* is the rather mediocre *Man of Sorrows* relief from the apex of the Porta della Mandorla (now in the Museo dell'Opera del Duomo). Lisner has attributed the relief to Donatello in 'Zum Frühwerk Donatellos', while Parronchi gives it, like the Santa Croce *Crucifix*, to Nanni di Banco in *Donatello e il potere*, 51–85. Brunetti denies that it is by either artist ('I profeti'). Poeschke rejects the attribution to Donatello on the basis of quality (102 n. 78). See also Herzner, 'Bemerkungen'.

52 For recent literature on the *Crucifix* from Bosco ai Frati see Becherucci 'I tre capolavori', 37–44; *Firenze restaura*, 50; Lisner *Holzkruzifixe*, 14, 22 ff.; and Parronchi 'Il crocifisso di Bosco' and *Donatello e il potere*, 27–85. It was Parronchi who discovered the work and who first attributed it to Donatello, dating it to 1430. For a recent summary of the literature and opinions see Strom, *Studies*, 128–34, and 'New Chronology'. Strom accepts the attribution to Donatello and dates the work to the later 1430s or early 1440s, relating it to the Medici foundation at Bosco ai Frati. Becherucci and the *Firenze restaura* catalogue also accept the attribution to Donatello, but Lisner attributes the work to Desiderio da Settignano. Strom reports that Pope-Hennessy denies an attribution to either Donatello or Desiderio, while Ulrich Middeldorf was unwilling to attribute the work. Poeschke does not include it in the list of works he attributes to Donatello. Becherucci dates it 1444–9.

53 See K. Jex-Blake, *The Elder Pliny's Chapters on the History of Art*, London, 1896, 13–14; on the Medici inventory see E. Müntz, *Les collections des Medicis au quinzième siècle*, Paris, 1888, 47.

54 See Jex-Blake (preceding note).

Chapter 5

1 Pope-Hennessy, 16.

2 For recent literature on the Victoria and Albert *Ascension, with Christ Giving the Keys to St. Peter* see Pope-Hennessy, 'Donatello's Relief' in *Studies* (37–46) and *Catalogue*, 70–3, cat. no. 61; see also Rosenauer, *Studien*, 86. Pope-Hennessy states that the actual piece of marble is only 36 mm. thick ('Donatello's Relief').

3 The cast shadow reappears in Florentine Renaissance painting in the *Nativity* predella of Gentile da Fabriano's *Strozzi Adoration of the Magi* (1423) and in various paintings by Masaccio, notably the *Pisa Polyptych* of 1426 and the Brancacci Chapel frescoes of about the same time.

4 Pope-Hennessy was the first to suggest this, in 'Donatello's relief', in *Studies*. He summarizes opinions about the relief in *Catalogue*, 72–3. The proposed connection between the relief and the chapel frescoes was dismissed too summarily by Anthony Molho in 'The Brancacci Chapel: Studies in its Iconography and History', *Journal of the Warburg and Courtauld Institutes* 40, 1977, 53 n. 13.

5 Pope-Hennessy, 'Donatello's Relief', in *Studies*, 42–3. The connec-

tion between the mystery play and the relief was first noted by Hans Kauffmann in *Donatello*, Berlin, 1935, 69 ff. Pope-Hennessy points out that Masolino is documented as having repainted the scenery for this play ('Donatello's Relief', 9); the document is dated July 1425 (Molho, 83; see above note). For evidence that Brunelleschi designed the stage machinery for the play see Götz Pochat, 'Brunelleschi and the "Ascension of 1422"', *AB* 60, 1978, 232–4.

6 During the fifteenth century the Carmelites claimed that they were founded by the prophet Elijah and subsequently converted to Christianity by St. Peter; see Molho, 67–8 (note 4 above).

7 Millard Meiss, 'Masaccio and the Early Renaissance: the Circular Plan', in *Painter's Choice*, 72, 74.

8 For recent literature on the Lille *Feast of Herod* see Rosenauer (*Studien*, 75–9).

9 For the most recent discussions of the Brunelleschian linear perspective scheme see John White (*The Birth and Rebirth of Pictorial Space*, New York, 1972), Edgerton, and Martin Kemp ('Science, Non-Science, and Nonsense: the Interpretation of Brunelleschi's Perspective', *Art History* 1, 1978, 143 ff.). For the comments of Brunelleschi's biographer see Antonio di Tuccio Manetti, *The Life of Brunelleschi* (ed. Howard Saalman, trans. Catherine Enggass), University Park, Pa., 1970.

10 Krautheimer, 240.

11 Antonio di Tuccio Manetti, *The Life of Brunelleschi* (ed. Howard Saalman, trans. Catherine Enggass), University Park, Pa., 1970, lines 366–7.

12 Edgerton. A date of *c.*1415–16 for Brunelleschi's panels is accepted by Luigi Vagnetti, 'La posizione di Filippo Brunelleschi nell'invenzione della prospettiva lineare, precisazioni ed aggiornamenti', *Filippo Brunelleschi, la sua opera e il suo tempo*, Florence, 1980, I, 282. Decio Gioseffi asserts that the system is already in use in Masaccio's *San Giovenale Triptych* dated 1422 ('Perspective', *Encyclopedia of World Art*, New York, 1966, XI, col. 204 and pl. 92).

13 For a diagram of the perspective scheme of the Lille *Feast of Herod* see Hellmut Wohl, *The Paintings of Domenico Veneziano*, Oxford, 1980, Fig. 8 and pp. 58–9, n. 31.

14 There is a view from below in Hartt, 59. This same neckless quality may also be noted in the Christ of Masaccio's *Crucifixion* (1426; Naples, Museo di Capodimonte); this panel was the central pinnacle of the *Pisa Polyptych* and, like Donatello's *God the Father*, would have been viewed from below at an acute angle. For a precedent see the left prophet above the *Bardi di Vernio Tomb* in the Chapel of Constantine and St. Sylvester by Maso di Banco (1336–9; Florence, Santa Croce).

15 Whether the recession of loggia and interior are controlled by linear perspective is a controversial issue; for discussion see the Bibliography under Hartt, Pope-Hennessy, Seymour, Edgerton, White, Janson, Rosenauer, *Studien*, and Wundram.

16 For recent literature on the *Tomb of Giovanni Pecci* see Rosenauer *Studien*, 111 ff. The bronze is seriously worn by generations of people walking over the slab, and the enamels which once enlivened the composition have mostly disintegrated. Recently (1980) the ropes that protected the tomb have been removed, and shiny areas of the bronze prove that new damage is occurring. The figure faces an altar, so it is possible that this is its original position. For a sharply angled view of the monument as seen from the feet of the Bishop see Hartt, 163.

Not everyone has appreciated Donatello's illusionism in the Pecci tomb; note these remarks by Richard Krautheimer:

> Donatello represented the deceased ambiguously, half-standing in a niche, but still giving the illusion of half-lying on a pillow, and confronting the beholder with tricks of perspective, such as the position of the feet, the rounded depth of the niche, the base at the bottom, and the scroll-shaped epitaph (p. 152).

For the attribution of another tomb slab to Donatello, the lost *Tomb of Giovanni Catrik* from Santa Croce, which is known in a drawing, see Parronchi, *Donatello e il potere*, 30 ff. Middeldorf has attributed this work to Ghiberti ('Additions to Lorenzo Ghiberti's

Work', *Burlington Magazine* 63, 1961, 72).

The bronze *Tomb of Pope Martin V* at San Giovanni in Laterano, Rome, demonstrates the influence of the illusionistic scheme of the Pecci tomb, but its spatial effects are inconsistent and illogical. This work was rightly rejected from Donatello's œuvre by Janson, but recently the attribution has been reasserted by Poeschke (61 ff.). A newly discovered document reveals that the tomb was sent from Florence to Rome, where it arrived in April of 1445; see A. and D. Esch, 'Die Grabplatte Martins V und andere Importstücke in den römischen Zollregistern der Frührenaissance', *Römisches Jahrbuch für Kunstgeschichte* 17, 1978, 211 ff. Pope-Hennessy also accepts the attribution to Donatello, p. 43.

17 For recent literature on the *Cavalcanti Annunciation* see Becherucci ('I tre capolavori') and Rosenauer (*Studien*, 89 ff.). Harriet Caplow has promised a forthcoming publication that will demonstrate that Michelozzo played an important role in the commission and execution of the *Annunciation* (*Michelozzo*, 407). Deborah Strom has suggested that the work might originally have been completely polychromed (*Studies*, 16); her theory is based on a late nineteenth-century description of the 'cleaning' of the tabernacle, which does refer to extensive coloration:

> L'opera pregevolissima era stata tutta ricoperta di grossa tinta a tempera che celava la finezza della scultura e le lumeggiature a oro; ma in questi ultimi anni venne egregiamente ripulita e restituita allo stato primitivo (il restauro venne egregiamente eseguito dal pittore professore Cosimo Conti). (Arnoldo Cocchi, *Notizie storiche intorno alle antiche imagini di Nostra donna che hanno culto in Firenze*, Florence, 1894, 77).

Since no early author, such as Vasari, mentions this polychromy it seems more likely that it was a later addition. For the original position of the *Annunciation* in the Cavalcanti Chapel, next to the now destroyed *tramezzo* of Santa Croce, see Marcia B. Hall, *Renovation and Counter-Reformation, Vasari and Duke Cosimo in Santa Maria Novella and Santa Croce, 1565–1577*, Oxford, 1979, 131–2.

Like so many of Donatello's works, the *Annunciation* may provide a link between Donatello and the Medici, for Ginevra Cavalcanti was the wife of Lorenzo de'Medici, natural brother of Cosimo, Donatello's friend and patron.

The relationship of Gabriel and Mary in Donatello's *Cavalcanti Annunciation* had a profound influence on later paintings of the Annunciation in Florence; see, for example, those by Fra Filippo Lippi (S. Lorenzo), by Alesso Baldovinetti (San Miniato and Uffizi), and by Botticelli (Uffizi, two versions).

The function of the *Cavalcanti Annunciation* is not clear, but on this question see Rosenauer, 107 ff. It certainly is not the usual altarpiece, for the prominent consoles that support it would only serve to separate it from an altar placed below. It is also higher than the usual altarpiece. The winged wreath below is carved in macigno, but is filled with a piece of highly-polished deep-red marble. It is not certain that this piece of stone is original, and if it is not, the question of the function of an opening in this area must be raised. Given the work's emphasis on the Incarnation, is it possible that there was once a door at this point, and that the work once functioned as an early example of a tabernacle for the sacrament? For the history of this new liturgical form and a discussion of Donatello's role in its early development see Maurice E. Cope, *The Venetian Chapel of the Sacrament in the Sixteenth Century*, New York, 1979.

See also above, Chapter 4, n. 47.

18 Compare, for example, Vasari's description of the background of a lost painting he attributes to Masaccio: 'many columns very finely depicted in perspective ... the building seems gradually to disappear from view' (*Life of Masaccio*). For paintings that demonstrate by contrast the restriction of Donatello's interpretation of the Annunciation, see works by Fra Angelico (Cortona), Lorenzo Monaco (Santa Trinita), Gentile da Fabriano (Strozzi Altarpiece, Uffizi), and Fra Filippo Lippi (San Lorenzo). The severe limitation of Donatello's interpretation of the Annunciation theme in the

Cavalcanti tabernacle renders unlikely Kauffmann's suggestion that the background represents the *porta clausa* (Ezekiel 44:1–3); for a recent championing of this idea, however, see Hartt, 177–8.

19 On 'varietà' see Michael Baxandall, *Painting and Experience in Fifteenth-Century Italy*, Oxford, 1972, 133–5.

20 Filarete, *Treatise on Architecture* (trans. John R. Spencer), New Haven, 1965, I, 306. In making this criticism Filarete has obviously been inspired by Alberti: 'it befits a runner to flail his arms as much as his legs, but a discoursing philosopher should show restraint rather than behave like a fencer' (as quoted in Janson, 136).

21 Nicolas de Prospero, a student at the University of Pittsburgh, drew this textual source to our attention. The Dispute is a rare subject; no examples are listed in George Kaftal, *Iconography of the Saints in Tuscan Painting*, Florence, 1952.

22 John White, *The Birth and Rebirth of Pictorial Space*, New York, 1972, 152.

23 Janson has traced this motif to a Roman relief incorporated into the Arch of Constantine; see 'Donatello and the Antique', 90, fig. 41.

24 Janson reports that the limestone is disfigured by an 'ugly layer of brown paint covering the figures' (187 n. 17); this is chipped, seriously disfiguring the relief. Deborah Strom recently proposed that the figures were originally polychromed (*Studies*, 13).

25 Maurice E. Cope, *The Venetian Chapel of the Sacrament in the Sixteenth Century*, New York, 1979, 31–2.

26 For new bibliography on the *Cantoria* see Becherucci and Brunetti (I, 280–2), Pope-Hennessy (*Luca della Robbia*, 19 ff.), and Rosenauer, *Studien*. The upper entablature was wrongly restored; for a view of the corrected reconstruction by Georg Kauffmann see Janson, fig. 50. Frederick Hartt has correctly pointed out that in the reconstruction the figures were placed too low (198).

Two bronze *Angels with Candlesticks* in the Jacquemart-André Museum in Paris have been attributed to Donatello and his workshop as integral parts of the *Cantoria*; for a summary of the bibliography see LaMoureyre-Gavoty, 'Gli angeli' and *Sculpture italienne*. For the most recent research, and a reasonable attribution to Luca della Robbia, see Pope-Hennessy, *Luca della Robbia*, 257–8.

Donatello's sources for the use of inlaid materials to add colour and texture to the work are unknown, but this idea was current in Italy during the later middle ages; for examples see Edward Hutton, *The Cosmati*, London, 1950. Donatello also used square gold glass mosaic behind the figures on the *Prato Pulpit* (Fig. 103).

For further literature on the *Cantoria* see the following notes.

27 One possible medieval source that might be noted, although it most likely had nothing to do with the evolution of Donatello's *Cantoria*, is the type of small French Gothic tabernacle, carved of ivory, which has representations of narrative scenes behind enframing, free-standing colonnettes. For a fourteenth-century example, now in the Museo Nazionale, see Lamberto Vitali, *Avori gotici francesi* (ex. cat., Milan, 1976), no. 9.

For a discussion of the heightened movement that results from the framing, dependent on an effect known to psychologists as the Poggendorf illusion, see Ernst Gombrich, 'Moment and Movement in Art', *Journal of the Warburg and Courtauld Institutes* 27, 1964, 304–6 (reprinted in *The Image and the Eye*, Oxford, 1982, 59–60).

28 Pope-Hennessy has convincingly argued that the architectural ornament of Luca's *Cantoria* was most likely designed by Brunelleschi, who was at that time 'the dominant voice in the Cathedral' (*Luca della Robbia*, 20–1).

29 Janson and Middeldorf both argue against the idea of a particular iconographic source (Janson, 125; Ulrich Middeldorf, review of Hans Kauffmann's *Donatello* in *AB* 18, 1936, 575 n. 8), but this would seem to be unlikely given the Renaissance attitude toward iconography. Also, the contents of the earliest known documentary reference to Donatello's *Cantoria* has been summarized as follows: 'The *operai* authorize Neri di Gino Capponi . . . to order from Donatello a marble pulpit, to be placed above the door of the second, 'new' sacristy; and to decide upon the *subject*, conditions, price, and delivery date' (as quoted in Janson, 119; our italics).

30 Hans Kauffmann, *Donatello*, Berlin, 1935, 72; Kauffmann's thesis is rejected by Janson and Middeldorf, see the preceding note.

In discussing the iconography of the putti in the *Prato Pulpit* as related to the theme of the Virgin's Assumption, Ronald Lightbown has noted: 'When the ground between the angel putti was filled with gold mosaic, and shone with the golden light of heaven, the symbolism must have been even more obvious.' (*Donatello and Michelozzo*, I, 245.)

For examples of the Assumption or Coronation with music-making and/or dancing putti or angels, see the altarpiece signed by Giotto at Santa Croce; Maso di Banco's panel in Budapest; Andrea da Firenze's oculus in the façade of Santa Maria Novella; and other examples by Fra Angelico (Louvre, Uffizi, Gardner Museum in Boston) and Masolino (Naples, Capodimonte). It is especially interesting in this context to note that such figures are included in Ghiberti's *Assumption and Coronation*, documented to 1404–5, in the oculus of the façade of the Duomo and directly opposite Donatello's *Coronation* (Lorenzo Ghiberti, 'materia e ragionamenti', 144). Note also the musical angels in Nanni di Banco's *Assunta* over the Porta della Mandorla of the Duomo (1414–21). The popularity of the musical angels that accompany the Assumption and Coronation themes in Sienese painting may most likely be traced back to the lost central pinnacle of the *Maesta* by Duccio (1308–11); see H. W. Van Os, *Marias Demut und Verherrlichung in der sienesischen Malerei 1300–1450*, s'Gravenhage, 1969.

The motif of flowers as a symbol for Mary also was important for the ceremonies of consecration for the Cathedral of Florence, on 25 March 1436, with Pope Eugenius IV in attendance. The motet composed for the occasion by the great Flemish musician Guillaume Dufay is entitled 'Nuper rosarum flores'. The Pope had only recently presented the city of Florence with one of the golden roses that were a sign of special papal honour.

31 Pope-Hennessy has proposed Ghiberti as the innovator of pictorial relief (20). For a discussion of the differences between the pictorial relief practices of Ghiberti and Donatello see Krautheimer, 148–53.

32 Janson argues that this figure is a male dinner guest (70), but the anatomy suggests otherwise. That the short-cropped hair was acceptable for a female figure is revealed by the *Annunciate Virgin* in the controversial marble group now in the Museo dell'Opera del Duomo (Becherucci and Brunetti, I, 255–8).

In the mid-thirteenth-century anonymous panel dedicated to St. John the Baptist in the Pinacoteca of Siena, there are only two figures seated at the table in the banqueting scene, Herod and Herodias (Edward B. Garrison, *Italian Romanesque Panel Painting*, Florence, 1949, 143, no. 375).

33 The violist recalls the similar figure in Giotto's Peruzzi Chapel fresco of this subject. Janson has posited that the 'frequent recurrence of figures behind walls, with only their heads and shoulders visible', found on the Column of Trajan in Rome is a likely source for the use of this device by Donatello ('Donatello and the Antique', 90–1).

34 A possible source for Donatello's button-like sun is Gentile da Fabriano's predella panel of the *Flight into Egypt* from the *Strozzi Adoration* (Uffizi). An inspiration for the inclusion of natural phenomena in a work of art might also have come from the reflective background of Brunelleschi's perspective demonstration panel of the Florentine Baptistry:

And he placed burnished silver where the sky had to be represented, that is to say, where the buildings of the painting were free in the air, so that the real air and atmosphere were reflected in it, and thus the clouds seen in the silver were carried along by the wind as it blows. (Antonio di Tuccio Manetti, *The Life of Brunelleschi*, ed. Howard Saalman, trans. Catherine Enggass, University Park, Pa., 1970, 44.)

Chapter 6

1 Gombrich, 122–8.

2 *Ricordi*, Venice, 1554, no. 109, p. 51, as cited by Lord Balcarres in *Donatello*, London, 1903, 90.

3 For the cameo that inspired the relief on Goliath's helmet see Wester and Simon, 31; G. M. A. Richter, *Engraved Gems of the Romans*, London, 1971, 43, no. 164; *Il tesoro di Lorenzo il Magnifico – Le gemme* (ex. cat., Florence, 1972), 45–6, no. 8, pl. VI. The other references to antique sources in this paragraph, and many others in this chapter, are from Janson, *Sculpture of Donatello* and 'Donatello and the Antique'.

4 For recent bibliography see Ames-Lewis and Wester and Simon. Wester accepts the roundels as works by Donatello, *c.*1460. Ames-Lewis says they were perhaps carved in Donatello's workshop *c.*1460 (147).

5 Caplow, *Michelozzo*, II, 550–7.

6 Patricia Rose has recently argued that the *Zuccone's* garment is not a toga but 'the mantle of the double spirit', identifying the figure as Elisha.

7 Beck, 'Donatello's Black Madonna', was refuted by Herzner, 'Donatellos Madonna'.

8 On the revival of Roman style lettering see L. Ullman (*Origins and Development of Humanist Script*, Rome, 1960), Millard Meiss ('Toward a More Comprehensive Renaissance Palaeography', *AB* 52, 1960, 97–112), Dario Covi ('Lettering in Fifteenth Century Florentine Painting', *AB* 55, 1963, 1–17), and Pope-Hennessy *Luca della Robbia*, 229.

9 Of great assistance in research of this sort will be the census of ancient works of art known to Renaissance artists, published in *Renaissance Artists and Antique Sculpture: A Handbook of Sources* by Phyllis Bober and Ruth Rubinstein, London, 1983.

10 See Mario Lopes Pegna, *Firenze dalle origini al medioevo* (2nd ed.), Florence, 1974, 125–8. The two arches that remained in 1776 are illustrated on p. 127. They were impressive in scale, 7.54 m. high, and Borghini wrote in 1808 that he could remember when ten or twelve were still standing.

11 Lisner has attributed to Donatello the design of the *Sarcophagus of Onofrio Strozzi* in the Sacristy of Santa Trinita ('Zur frühen Bildhauer-architektur').

12 The motif of flying putti with a wreath appears quite frequently in Donatello/Michelozzo attributions, such as the door of the Milanese branch of the Medici Bank, now in the Museo Archeologico, Milan. Vasari states that Donatello did a number of chimney-pieces, and in this regard note the impressive mantle in the Pierpont Morgan Library in New York, which has the same motif.

13 In a fourteenth-century manuscript of the *Cronaca* by Giovanni Villani the Baptistry is identified as a Temple of Mars (Rome, Bibl. Apostolica Vaticana L.VIII); see *Mostra di Firenze ai tempi di Dante* (ex. cat., Florence, 1965), no. 2.

14 The obvious exception has been the *Guidoriccio*, attributed to Simone Martini, in the Palazzo Pubblico, Siena. Recent research by Gordon Moran suggests that this, too, is a posthumous memorial; his argument rests on historical evidence, as well as the funereal draping of Guidoriccio's horse.

15 Janson, 161.

16 On the *Regisole* see Ludwig H. Heydenreich, 'Marc Aurel und Regisole', *Festschrift für Erich Meyer*, Hamburg, 1957, 147–58.

17 Hartt, 323.

18 Filarete, *Treatise on Architecture* (trans. John R. Spencer), New Haven, 1965, I, 306. In Gregorio d'Allegretto's *Tomb of Gattamelata* inside the Santo (Fig. 107), the figure wears antique armour modelled, it would seem, on that of Donatello's monument. The contract for this tomb states that the figure should be dressed *all'antica*. (See Janson, 159 n. 14.)

19 Sartori, 'Il cosidetto bastone', 334–5.

20 Parronchi, 'Storia di una "Gatta malata"'.

21 Janson, 159 n. 14.

22 Pope-Hennessy, 'Donatello and the Bronze Statuette'.

23 For recent bibliography on the *Niccolò da Uzzano* see Hatfield, dal Poggetto, Schlegel ('Zu Donatello und Desiderio'), and Schuyler; also Eve Borsook and Johannes Offerhaus, 'Storia e leggende nella Cappella Sassetti in Santa Trinita', *Scritti di storia dell'arte in onore di Ugo Procacci* (ed. Maria G. C. D. dal Poggetto and Paolo dal Poggetto), Milan, 1977, 298–9; see also the same authors' *Francesco Sassetti and Ghirlandaio at Santa Trinita, Florence: History and Legend in a Renaissance Chapel*, Doornspijk, 1981, 40 n. 141. The work is also mentioned by Beck, in his review of *Donatello e il suo tempo*; Schlegel in 'Zu Donatello und Desiderio'; and Parronchi in 'Su "Della Statua" Albertiano', *Paragone* 117, 1959, 26–7. The attribution to Donatello is rejected by Janson, Hatfield, Grassi, dal Poggetto, and Schlegel; it is accepted by Poeschke, Castelfranco, Schuyler, Becherucci ('Donatello'), and Beck. Borsook and Offerhaus question the attribution to Donatello, and identify the subject as Neri di Gino Capponi.

24 John Pope-Hennessy, *The Portrait in the Renaissance*, 74, 77.

25 J. Pohl, *Die Verwendung des Naturabgusses in der italienischen Renaissanceplastik*, Würzburg, 1938, 48 ff.

26 For recent literature on the *San Rossore* see Lavin ('On the Sources') and Moskowitz ('Donatello's Reliquary Bust').

27 For recent literature on the so-called *Atys-Amorino* see: Brown, Grabski ('L'Amor-Pantheos'), Lloyd, Shapiro, and Erika Simon ('Der sogenannte *Atys-Amorino*'). Simon identifies the figure as Priapus. Panofsky's suggestion that the figure represents *Time as a Playful Child Throwing Dice* is found in *Renaissance and Renascences in Western Art*, New York, 1969, 169. In the light of this suggestion, note Amerigo Parrini, *With Dante in Florence* (trans. C. Daniell Tassinari), Florence, n.d., 144–6, who points out that a statuette of a boy holding a sundial inscribed with verses by Beniveni once decorated the Ponte alla Carraia.

The attribute the figure must once have held was gone by 1677 (see Cinelli, quoted in Janson, 143), and may have been made of wood or some material other than bronze.

Chapter 7

1 See Chapter 2, n. 18.

2 For recent literature on the *Joshua* see Janson, 'Giovanni Chellini's *Libro*' and 'Meaning of the Giganti', as well as Seymour, 'Homo magnus et albus' and *Michelangelo's David*.

3 See the literature cited in the previous note. Brunelleschi constructed small platforms or spurs (the general meaning of *sproni*) at the base of each outer rib of the dome, above the drum (Frank D. Prager and Gustina Scaglia, *Brunelleschi, Studies of His Technology and Inventions*, Cambridge, Mass., 1970, 63 n. 37). Statues on these spurs would correspond to the Trecento conception of the Duomo in Andrea da Firenze's fresco. The first record of Brunelleschi's work on the cupola is 1417, but this does not preclude his earlier involvement.

4 For recent literature on the *St. Mark* see Wundram ('Donatello e Nanni di Banco' and *Donatello und Nanni di Banco*), Rosenauer, *Studien*, and Poeschke. Wundram redates the figure to the 1415–20 period, a thesis accepted by Janson (in his review) and by Poeschke, but rejected by Rosenauer.

5 Vasari states that Donatello helped Nanni with the *Quattro Coronati*; this idea has recently been reasserted by Herzner ('Bemerkungen', 93), and accepted by Poeschke (115, n. 197).

6 Although it has been argued that *St. Mark*'s pillow is unprecedented, it may well derive from the pillows placed under the feet of seated figures of the Madonna in Byzantine art. The monumental *Madonna and Child* by Arnolfo di Cambio, which was once placed over the central portal of the Duomo (now in the Museo dell'Opera del Duomo), is a likely precedent.

7 For recent literature on the *St. George*, including the tabernacle and reliefs, see Barash ('Character and Physiognomy'), Macchioni, Beck ('Ghiberti giovane'), Wundram (*Donatello: der heilige Georg*

and *Donatello und Nanni di Banco*), and Rosenauer, *Studien*. Wundram dates the tabernacle to the first years of the Quattrocento and denies the *God the Father* relief to Donatello. Wundram's argument that the *George* must pre-date the *Mark* is accepted by Janson in his review of Wundram's book. Rosenauer accepts all parts of the decoration, including the tabernacle itself, as works by Donatello. Poeschke mistakenly refers to the pedimental figure as a representation of Christ; for a discussion of the manner in which George is riding see Poeschke, 105 n. 107. Beck argues that the document that mentions the 'base' was originally dated 1416, as Milanesi, who discovered it, would be unlikely not to correct the date to modern style; Beck dates the *George* c.1410, arguing that Jacopo della Quercia's *Apostle* in Lucca betrays its influence; the latter is documented to 1413.

Wundram's careful stylistic analysis of the Orsanmichele tabernacles led him to the conclusion that the tabernacle of St. George pre-dates Lamberti's tabernacle for St. Luke, of 1403–6; on this basis he related the George tabernacle to the unspecified tabernacle that in 1402 was decorated by the Laudesi.

8 For recent literature on the Campanile *Prophets* see Becherucci and Brunetti (I, 267 ff.), Goldner ('*Tomb of Tommaso Mocenigo*'), Herzner ('Donatello und Nanni di Banco'), Lisner ('*Joshua und David*'), Rose and Stang. Rose, who provides a useful summary of the more recent literature on this confusing topic, identifies the *Zuccone* as a figure of Elisha. Herzner argues that Fig. 123 should be the last of the prophet series and, therefore, Habakkuk. Brunetti, in 'Aggiunta', proposes that the beardless prophet is a portrait of Brunelleschi.

9 Pope-Hennessy, *Portrait in the Renaissance*, 85.

Chapter 8

1 Bernard Berenson, *The Italian Painters of the Renaissance*, 3rd ed., Oxford, 1980, 50.

2 For a 19th-century photograph of the unfinished façade with the *Louis* in place, see Eugenio Pucci, *Com'era Firenze*, Florence, 1969, 43.

3 On the iconography of St. Louis of Toulouse see Edith Pàsztor (*Per la storia di San Ludovico d'Angiò, 1274–1297*, Rome, 1955), Ferdinando Bologna (*I pittori alla corte Angioina di Napoli, 1266–1414, e un riesame dell'arte nell'età fridericiana*, Rome, 1969), David Wilkins's review of Bologna's book (*AB* 56, 1974, 127–30), and Julian Gardner ('Saint Louis of Toulouse, Robert of Anjou and Simone Martini', *Zeitschrift für Kunstgeschichte* 39, 1976, 12–33).

4 Peter Murray, 'The Continuity of Latinity', *Apollo* n.s. 81, 1965, 300–1.

5 For earlier examples see the representations by Giotto at the Arena Chapel, by Andrea Pisano on the Baptistry Doors, and by Jacopo di Piero Guidi on the Loggia dei Lanzi. The crown is also omitted in the figure of *Hope* on the *Tomb of Baldassare Cossa*, designed by Donatello and executed in the workshop (Fig. 46).

6 Pomponius Gauricus, *De sculptura* (ed. A. Chastel and R. Klein), Geneva, 1969, 64–5; see also the discussion of this anecdote in Summers, 364 ff.

7 Quoted from Lightbown, 235; for the document see Herzner doc. 138 and Lisner, 'Zur frühen Bildhauer-architektur', 119, doc. 28.

BIBLIOGRAPHY

This bibliography includes all works published between 1960 and 1982 that contain information on Donatello or his work; it is intended as a supplement to the bibliographic references found in:

BECHERUCCI, LUISA. 'Donatello'. *Encyclopedia of World Art*. New York, 1961, IV, cols. 427–41.

GRASSI, LUIGI. *All the Sculpture of Donatello*. 2 vols., New York, 1964.

JANSON, H. W. *The Sculpture of Donatello*. 2nd ed., Princeton, 1963.

AMES-LEWIS, FRANCIS. 'Art History or Stilkritik? Donatello's Bronze *David* Reconsidered'. *Art History* 2, 1979, 139–55.

AVERY, CHARLES. *Florentine Renaissance Sculpture*. New York, 1970.

BARASCH, MOSHE. 'Character and Physiognomy: Bocchi on Donatello's *St. George*. A Renaissance Text on Expression in Art'. *Journal of the History of Ideas* 36, 1975, 413–30.

BARELLI, EMMA. '*Judith and Holofernes*: An Extreme Moral Instance; Response to Laurie Schneider's Article'. *Gazette des beaux-arts* 92, 1978, 147–8.

———'Note iconografiche in margine al *Davide* in bronzo di Donatello'. *Italian Studies* 29, 1974, 38–44.

BARO, GENE. 'Giotto and Donatello in their Times'. *Art in America* 54, September 1966, 100 ff.

BEARZI, BRUNO. 'La tecnica fusoria di Donatello'. *Donatello e il suo tempo*. Florence, 1968, 97–105.

BECHERUCCI, LUISA. 'Donatello.' *Encyclopedia of World Art*. New York, 1961, IV, cols. 427–41.

———'Donatello e la pittura'. *Donatello e il suo tempo*. Florence, 1968, 41–58.

———*I pergami di S. Lorenzo*. Florence, 1979.

———'I tre capolavori di Donatello'. *Primo rinascimento in Santa Croce*. Florence, 1968, 37–52.

———and GIULIA BRUNETTI. *Il Museo dell'Opera del Duomo a Firenze*. 2 vols. Florence, 1969.

BECK, JAMES H. 'Donatello's Black Madonna'. *Mitt. Flor.* 14, 1969–70, 456–60.

———'Ghiberti giovane e Donatello giovanissimo'. *Lorenzo Ghiberti nel suo tempo: Atti del Convegno internazionale di studi* (Florence, 1978). Florence, 1980, I, 111–34.

BELLOSI, LUCIANO. 'Ipotesi sull'origine delle terracotte quattrocentesche'. *Jacopo della Quercia fra gotico e rinascimento: Atti del Convegno di studi* (Siena, 1975). Florence, 1977, 163–79.

BERTI, LUCIANO. 'Donatello e Masaccio'. *Antichità viva* 5, 1966, no. 3, 3–12.

BERTINI, ALDO. *Scultura fiorentina del quattrocento e del cinquecento*. Turin, 1965.

BROWN, HOWARD MAYER. 'A Guardian God for a Garden of Music'. *Essays Presented to Myron P. Gilmore* (ed. Sergio Bertelli and Gloria Ramakus). Florence, 1978, II, 372–81.

Brunelleschi scultore (ed. Emma Micheletti and Antonio Paolucci;

exhib. cat., Florence, 1977).

BRUNETTI, GIULIA. 'Un'aggiunta all'iconografia brunelleschiana; ipotesi sul "*profeta imberbe*" di Donatello'. *Filippo Brunelleschi, la sua opera e il suo tempo*. Florence, 1980, 273–7.

———'I profeti sulla Porta del Campanile di S. Maria del Fiore'. *Festschrift Ulrich Middeldorf*. Berlin, 1968, I, 106–11.

———'Riadattamenti e spostamenti di statue fiorentine del primo Quattrocento'. *Donatello e il suo tempo*. Florence, 1968, 277 ff.

———'Su alcune sculture di Orsanmichele'. *Studien zur Toskanischen Kunst: Festschrift L. H. Heydenreich*. Munich, 1964, 29–36.

———'Una testa di Donatello'. *L'arte* n. s. 5, 1969, 81 ff.

———'Una vacchetta segnata A'. *Scritti di storia dell'arte in onore di Ugo Procacci*. Milan, 1977, 228–30.

BUSIGNANI, ALBERTO. *Donatello, l'altare del Santo* (Forma e colore 11). Florence, 1965. Reviewed by Francesco Cessi in *Il Santo* 5, 1965, 189–90.

CACCIARINI, GIANNI. 'Donatello, scultore fiorentino'. *Città di vita* 21, 1966, 145–53.

CAPLOW, HARRIET MCNEAL. *Michelozzo*. 2 vols. New York, 1977.

———'Sculptors' Partnerships in Michelozzo's Florence'. *Studies in the Renaissance* 21, 1974, 145–75.

CAPRARA, O. 'Il crocifisso di Donatello, dopo il restauro'. (Pamphlet) Florence, 1974.

CARLI, ENZO. *Donatello a Siena*. Rome, 1967.

———'Urbano da Cortona e Donatello a Siena'. *Donatello e il suo tempo*. Florence, 1968, 155–62.

CASTELFRANCO, GIORGIO. *Donatello*. Milan, 1963. English translation: London, 1965. Reviewed by Giuseppe Fiocco in *Il Santo* 4, 1964, 111–13; Hanna Kiel in *Pantheon* 22, 1964, 186–7; Angiola Maria Romanini in *AB* 53, 1971, 401–2.

———'Sui rapporti tra Brunelleschi e Donatello'. *Arte antica e moderna* nos. 34–5, 1966, 109–22.

CESSI, FRANCESCO. *Donatello a Padova*. Padua, 1967. Reviewed by Vergilio Gamboso in *Il Santo* 7, 1967, 359–60.

———'L'altare di San Francesco nella basilica del Santo in Padova'. *Il Santo* 4, 1964, 197–201.

CHASTEL, ANDRÉ. 'Le traité de Gauricus et la critique donatellienne'. *Donatello e il suo tempo*. Florence, 1968, 291–305.

CLARK, KENNETH. *The Artist Grows Old*. Cambridge, 1972.

COLE, BRUCE. *Masaccio and the Art of Early Renaissance Florence*. Bloomington, 1980.

COOLIDGE, JOHN. 'Observations on Donatello's *Madonna of the Clouds*'. *Festschrift Klaus Lankheit zum 20. Mai 1973*. Cologne, 1973, 130–1.

CORTI, GINO and FREDERICK HARTT. 'New Documents concerning Donatello, Luca and Andrea della Robbia, Desiderio, Mino, Uccello, Pollaiuolo, Filippo Lippi, Baldovinetti, and others'. *AB* 44, 1962, 155–67.

CZOGALLA, ALBERT. 'David und Ganymedes. Beobachtungen und

Fragen zu Donatellos Bronzeplastik *David und Goliath*'. *Festschrift für Georg Scheja*. Sigmaringen, 1975, 119–27.

DANILOVA, IRINA. 'Sull'interpretazione dell'architettura nei basso-rilievi del Ghiberti e di Donatello'. *Lorenzo Ghiberti nel suo tempo; Atti del Convegno internazionale di studi* (Florence, 1978). Florence, 1980, II, 503–6.

DEGENHART, BERNHARD and ANNEGRITTE SCHMITT. *Corpus der italienischen Zeichnungen 1300–1450*. 4 vols. Berlin, 1968. Reviewed by Enzo Carli in *Antichità viva* 8, 1969, no. 3, 78–80; Kenneth Clark in *Apollo* n. s. 91, 1970, 260–5; Luitpold Dussler in *Pantheon* 27, 1969, 491–3; Julian Gardner in *Burlington Magazine* 114, 1972, 32–4; Konrad Oberhuber in *Informationen Albertina* 2, 1969, no. 3, 6–8; Johan Quirin van Regteren Altena in *Master Drawings* 8, 1970, 396–402; Eberhard Ruhmer, in *Arte veneta* 24, 1970, 268–71; Mario Salmi in *Art Bulletin* 55, 1973, 625–7; Roberto Salvini in *Commentari* 23, 1972, 335–50; Günther Thiem in *Die Weltkunst* 39, 1969, 852; Matthias Winner in *Zeitschrift für Kunstgeschichte* 33, 1970, 340–9.

DIXON, JOHN W., JR. 'The Drama of Donatello's *David*: Re-examination of an "Enigma"'. *Gazette des beaux-arts* 93, 1979, 6–12.

DOEBLER, JOHN. 'Donatello's Enigmatic *David*.' *Journal of European Studies* 4, 1971, 337–40.

Donatello e il suo tempo (*Atti dell' VIII Convegno internazionale di studi sul Rinascimento*; Florence and Padua, 1966). Florence, 1968. Reviewed by James H. Beck in *AB* 52, 1970, 98–100.

'Donatellos Holzkruzifix aus S. Croce nach der Restaurierung'. *Pantheon* 32, 1974, 320.

Dopo Mantegna, Arte a Padova e nel territorio nei secoli XV e XVI (exhib. cat., Padua, 1976). Milan, 1976.

DUNKELMAN, MARTHA L. *Donatello's Influence on Italian Renaissance Painting*. Dissertation, New York University, 1976.

——— 'Donatello's Influence on Mantegna's Early Narrative Scenes'. *AB* 62, 1980, 226–35.

EDGERTON, SAMUEL Y., JR. *The Renaissance Rediscovery of Scientific Perspective*. New York, 1975.

EISLER, COLIN. *Sculptors' Drawings Over Six Centuries* (exhib. cat., New York, 1981).

ETTLINGER, LEOPOLD. 'Hercules Florentinus'. *Mitt. Flor.* 16, 1972, 119–42.

FADER, MARTHA A. *Sculpture in the Piazza della Signoria as Emblem of the Florentine Republic*. Dissertation, University of Michigan, 1977.

FEHL, PHILLIP. 'On the Representation of Character in Renaissance Sculpture'. *Journal of Aesthetics* 31, 1973, 298–305.

FIOCCO, GIUSEPPE. 'L'altare grande di Donatello al Santo'. *Il Santo* 1, 1961, no. 1, 21–36. Reviewed by Lionello Puppi in *Arte veneta* 15, 1961, 278.

——— 'Ancora dell'altare di Donatello al Santo'. *Il Santo* 3, 1963, 345–6.

——— 'Vº Centenario della morte di Donatello'. *Padova e la sua provincia* 12, 1966, no. 4, 42–7.

——— 'Donatello a Padova'. *Fede e arte* 14, 1966, 272–89.

——— *Donatello al Santo*. Padua, 1965. Reviewed by Francesco Cessi in *Il Santo* 5, 1965, 111–12.

——— 'La statua equestre del Gattamelata'. *Il Santo* 1, 1961, no. 3, 300–17.

——— 'Tracce di Donatello a Padova'. *Donatello e il suo tempo*. Florence, 1968, 399–404.

Firenze restaura, guida alla mostra (exhib. cat., Florence, 1972).

FOSTER, PHILIP. 'Donatello Notices in Medici Letters'. *AB* 62, 1980, 148–50.

FRANCHI, ROBERTO, GUGLIELMO GALLI, and CARLO MANGANELLI. 'Researches on the Deterioration of Stonework VI: The Donatello Pulpit'. *Studies in Conservation* 23, 1978, 23–37.

GAETA-BARTELÀ, G. *Donatello*. Florence, n.d.

——— *Donatello, Della Robbia*. Florence, n.d.

GAI, LUCIA. 'Per la cronologia di Donatello: un documento inedito del 1401'. *Mitt. Flor.* 18, 1974, 355–7.

GASPAROTTO, CESIRA. 'Iconografia antoniana: i "miracoli" dell'altare di Donatello'. *Il Santo* 8, 1968, 79–91.

——— 'Sant'Antonio nell'altare maggiore di Donatello al Santo di Padova'. *Il Santo* 15, 1975, no. 3, 339–44.

——— 'Tito Livio in Donatello'. *Atti e memorie dell' Accademia patavina di scienze, lettere ed arti* n. s. 80, 1967–8, no. 3, 125–38.

GAVOTY, FRANÇOISE: see LaMoureyre-Gavoty, Françoise de.

GILBERT, CREIGHTON. *History of Renaissance Art throughout Europe*. Englewood Cliffs, N. J., n.d.

——— *Italian Art 1400–1500* (Sources and Documents in the History of Art). Englewood Cliffs, N. J., 1980.

GODBY, MICHAEL. 'A Note on *Schiacciato*'. *AB* 62, 1980, 635–7.

GOLDBERG, VICTORIA L. 'The *School of Athens* and Donatello'. *Art Quarterly* 34, 1971, 229–37.

GOLDNER, GEORGE. 'The *Tomb of Tommaso Mocenigo* and the Date of Donatello's *Zuccone* and of the *Coscia Tomb*'. *Gazette des beaux-arts* 83, 1974, 187–92.

——— 'Two Statuettes from the Doorway of the Campanile of Florence'. *Mitt. Flor.* 18, 1974, 219–26.

GOMBRICH, E. H. *Norm and Form: Studies in the Art of the Renaissance*. London, 1966.

GOSEBRUCH, MARTIN. 'Osservazioni sui pulpiti di San Lorenzo'. *Donatello e il suo tempo*. Florence, 1968, 369–86.

GRABSKI, J. 'L'*Amor-Pantheos* de Donatello'. *Antologia di belle arti*, Roma, 9–12, 1979, 23–6.

GRASSI, LUIGI. 'Donatello nella critica di Giorgio Vasari'. *Donatello e il suo tempo*. Florence, 1968, 59–68.

——— *Tutta la scultura di Donatello*. Milan, 1963. English translation: *All the Sculpture of Donatello*. 2 vols. New York, 1964.

GREENHALGH, MICHAEL. *Donatello and his Sources*. London, 1982.

GUERRIERI, FRANCESCO. *Donatello e Michelozzo nel Pulpito di Prato*. Florence, 1970.

GVOZDANOVIC, VLADIMIR. 'The "Schiavone" in Vasari's Vita of Brunelleschi'. *Commentari* 27, 1976, 18–32.

HAMME, NANCY STEELE. 'A Study of Donatello's Bronze *David*'. *Apocrypha* 3, 1978, 27–34.

HARTT, FREDERICK. 'Art and Freedom in Quattrocento Florence'. *Essays in Memory of Karl Lehmann; Marsyas Supplement I*. New York, 1964, 118–28.

——— *Donatello, Prophet of Modern Vision*. New York, 1973. Reviewed by H. Conant in *Arts* 48, December 1973, 35–8; John W. Dixon, Jr. in *Art Journal* 36, 1976, no. 1, 76 ff; R. Martin in *National Sculpture Review* 22, 1973–4, no. 4, 22 ff; John Pope-Hennessy in *New York Review of Books* 20, 24 January 1974, 7–9; F. Portela Sandoval in *Goya* 126, 1975, 404.

——— *History of Italian Renaissance Art*. New York, 1969.

——— 'Thoughts on the Statue and the Niche'. *Art Studies for an Editor: 25 Essays in Memory of Milton S. Fox*. New York, 1975, 99–116.

HATFIELD, RAB. 'Sherlock Holmes and the Riddle of the *Niccolò da Uzzano*'. *Essays Presented to Myron P. Gilmore* (ed. Sergio Bertelli and Gloria Ramakus). Florence, 1978, II, 219–38.

HERZNER, VOLKER. 'Bermerkungen zu Nanni di Banco und Donatello'. *Wiener Jahrbuch für Kunstgeschichte* 26, 1973, 74–95.

——— 'David Florentinus: Zum Marmordavid Donatellos im Bargello'. *Jahrbuch der Berliner Museen* 20, 1978, 43–115.

——— 'David Florentinus II: Der Bronze-David Donatellos im Bargello'. *Jahrbuch der Berliner Museen*, 24, 1982, 63–142.

——— 'Donatello in Siena'. *Mitt. Flor.* 15, 1971, 161–86.

——— 'Donatello und die Sakristei-Türen der Florentiner Domes'. *Wiener Jahrbuch für Kunstgeschichte* 29, 1976, 53–64.

——— 'Donatello und Nanni di Banco: Die Prophetenfiguren für die Strebepfeiler des Florentiner Domes'. *Mitt. Flor.* 17, 1973, 1–28.

——— 'Donatellos Madonna vom Paduaner Hochaltar: Eine "Schwarze Madonna"?' *Mitt. Flor.* 16, 1972, 143–52.

——— 'Donatellos "pala over ancona" für den Hochaltar des Santo in Padua; ein Rekonstruktionsversuch'. *Zeitschrift für Kunstgeschichte* 33, 1970, 89–126.

——— 'Die Judith der Medici'. *Zeitschrift für Kunstgeschichte* 43, 1980, 139–80.

——— *Die Kanzeln Donatellos in San Lorenzo*. Dissertation, University

of Vienna, 1969.

—— 'Die Kanzeln Donatellos in San Lorenzo'. *Münchner Jahrbuch der bildenden Kunst* 23, 1972, 101–64.

—— 'Regesti donatelliani'. *Rivista dell'Istituto Nazionale d'Archeologia e Storia dell'Arte* series III, 2, 1979, 169–228.

—— 'Zwei Frühwerke Donatellos: Die Prophetenstatuetten von der Porta des Campanile in Florenz'. *Pantheon* 37, 1979, 27–36.

HLAVÁČEK, LUBOS. 'Poznámka k charakteristiche pohybu v Michelangelových sonach'. *Umèní* 24, 1976, no. 1, 65–73.

HUSE, NORBERT. 'Beiträge zum Spätwerk Donatellos'. *Jahrbuch der Berliner Museen* 10, 1968, 125–50.

JANSON, HORST W. 'Bardi, Donato, detto Donatello'. *Dizionario biografico degli italiani*. Rome, 1964, VI, 287–96.

—— 'Donatello and the Antique'. *Donatello e il suo tempo*. Florence, 1968, 77–96. Reprinted in *Sixteen Studies*. New York, n.d., 303–28.

—— 'The Equestrian Monument from Cangrande della Scala to Peter the Great'. *Aspects of the Renaissance* (ed. Archibald Lewis). Austin, Texas, 1967, 73–85. Reprinted in *Sixteen Studies*. New York, n.d., 157–88.

—— 'Giovanni Chellini's *Libro* and Donatello'. *Studien zur Toskanischen Kunst: Festschrift L. H. Heydenreich*. Munich, 1964, 131–8. Reprinted in *Sixteen Studies*. New York, n.d., 107–16.

—— 'The Image of Man in Renaissance Art: From Donatello to Michelangelo'. *The Renaissance Image of Man and the World* (ed. Bernard O'Kelly). Columbus, Ohio, 1966, 77–103. Reprinted in *Sixteen Studies*. New York, n.d., 117–48.

—— 'The Meaning of the Giganti'. *Il duomo di Milano* (Congresso internazionale, Milan, 1968). Milan, 1969, 61–76. Reprinted in *Sixteen Studies*. New York, n.d., 303–28.

—— 'The Pazzi Evangelists'. *Intuition und Kunstwissenschaft, Festschrift für Hanns Swarzenski*. Berlin, 1973, 439–48.

—— *The Sculpture of Donatello*. 2 vols. Princeton, 1957. 2nd ed: 1 vol. Princeton, 1963. Reviewed by Germain Bazin in *Gazette des beaux-arts* 52, 1958, 105; Wilhelm Boeck in *Zeitschrift für Kunstgeschichte* 21, 1958, 187–93; Kenneth Clark in *Apollo* 68, 1958, 225–7; Ellen R. Driscoll in *Renaissance News* 11, 1958, 259–62; Leopold D. Ettlinger in *Connoisseur* 142, 1958, no. 573, 187–8; Creighton Gilbert in *College Art Journal* 18, 1958, no. 1, 90–2; Alfred Nicholson in *AB* 41, 1959, 203–13; A. Richard Turner in *Renaissance News* 17, 1964, 115–16; Charles Seymour, Jr. in *Art News* 57, 1958, no. 3, 44 ff; Leo Steinberg in *Arts* 32, 1958, no. 9, 41 ff.

—— 'La signification politique du *David* en bronze de Donatello'. *Revue de l'art* 39, 1978, 33–8.

LAMOUREYRE-GAVOTY, FRANÇOISE DE. 'Gli angeli reggicandelabro del Musée Jacquemart-André, Paris'. *Donatello e il suo tempo*. Florence, 1968, 353–9.

—— *Sculpture italienne: Musée Jacquemart-André*. Paris, 1975. Reviewed by Carlo del Bravo in *Antichità viva* 14, 1975, no. 3, 65–6; John Pope-Hennessy in *Apollo* 102, 1975, 474–5; François Souchal in *Les monuments historiques de la France* 1976, no. 1, 67.

LAVIN, IRVING. 'Bozzetti and Modelli: Notes on Sculptural Procedure from the Early Renaissance through Bernini'. *Stil und Überlieferung in der Kunst des Abendlandes (Akten des 21. Internationalen Kongresses für Kunstgeschichte in Bonn)*, Berlin, 1967, III, 193–204.

—— 'On the Sources and Meaning of the Renaissance Portrait Bust'. *Art Quarterly* 33, 1970, 207–26.

LAWSON, JAMES G. 'New Documents on Donatello'. *Mitt. Flor.* 18, 1974, 357–62.

LEVINE, SAUL. *'Tal cosa': Michelangelo's David – Its Form, Site and Political Symbolism*. Dissertation, Columbia University, 1969.

—— 'The Location of Michelangelo's *David*: The Meeting of January 25, 1504'. *AB* 56, 1974, 31–49.

LIEBMANN, MICHAEL. *Donatello* (in Russian). Moscow, 1962.

—— 'Donatello'. *Bildende Kunst* 8, 1966, 409–15.

LIESS, REINHARDT. 'Beobachtungen an der Judith-Holofernes-Gruppe des Donatello'. *Argo: Festschrift für Kurt Badt zum 80. Geburtstag*. Cologne, 1970, 176–205.

LIGHTBOWN, R. W. *Donatello and Michelozzo, An Artistic Partnership and its Patrons in the Early Renaissance*. 2 vols. London, 1980.

Reviewed by Francis Ames-Lewis in *Art History* 4, 1981, 339–44; Cecil H. Clough in *Apollo* 116, 1982, 344–6; Volker Herzner in *Zeitschrift für Kunstgeschichte* 44, 1981, 300–13; H. W. Janson in *The New York Review of Books*, April 2, 1981, 38–40; Anne Markham Schultz in *AB* 64, 1982, 659–61.

—— 'Giovanni Chellini, Donatello, and Antonio Rossellino'. *Burlington Magazine* 104, 1962, 102–4.

—— 'Sculptor and the Architect'. *Connaissance des arts* 347, 1981, 42–7.

LISNER, MARGRIT. 'Appunti sui rilievi della *Deposizione nel sepolcro* e del *Compianto su Cristo morto* di Donatello'. *Scritti di storia dell'arte in onore di Ugo Procacci*. Milan, 1977, I, 247–53.

—— 'Gedanken vor frühen Standbildern des Donatello'. *Kunstgeschichtliche Studien für Kurt Bauch*. Munich, 1967, 77–92.

—— *Holzkruzifixe in Florenz und in der Toskana*. Munich, 1970. Reviewed by Jolán Balogh in *Zeitschrift für Kunstgeschichte* 34, 1971, 300–3; John Pope-Hennessy in *Pantheon* 34, 1976, 78–80.

—— 'Intorno al *Crocifisso* de Donatello in Santa Croce'. *Donatello e il suo tempo*. Florence, 1968, 115–29.

—— '*Joshua* und *David*: Nannis und Donatellos Statuen für den Tribuna-Zyklus des Florentiner Doms'. *Pantheon* 32, 1974, 232–43.

—— 'Die Skulpturen am Laufgang des Florentiner Domes'. *Mitt. Flor.* 21, 1977, 111 ff.

—— 'Zum Frühwerk Donatellos'. *Münchner Jahrbuch der bildenden Kunst* 13, 1962, 63–8.

—— 'Zur frühen Bildhauer-architektur Donatellos'. *Münchner Jahrbuch der bildenden Kunst* 9/10, 1958/9, 72–127.

LLOYD, CHRISTOPHER. 'A *Bronze Cupid* in Oxford and Donatello's "*Atys-Amorino*"'. *Storia dell'arte* 28, 1976, 215–16.

Lorenzo Ghiberti 'materia e ragionamenti' (exhib. cat., Florence, 1978).

MACCHIONI, SILVANA. 'Il *San Giorgio* di Donatello: storia di un processo di musealizzazione'. *Storia dell'arte* 36/7, 1979, 135–56.

MAGGINI, ENRICHETTA. *Le tombe umanistiche fiorentine*. Florence, 1972.

MARCHINI, GIUSEPPE. 'A proposito del pulpito di Donatello'. *Prato – storia e arte* 12, 1971, nos. 30–1, 55–65.

—— 'Calchi donatelliani'. *Festschrift Klaus Lankheit zum 20. Mai 1973*. Cologne, 1973, 132–4.

—— 'Maso di Bartolommeo'. *Donatello e il suo tempo*. Florence, 1968, 235–44.

—— 'Maso di Bartolommeo, aiuto di Donatello'. *Prato – storia e arte* 7, 1966, no. 17, 17–29.

—— *Il pulpito donatelliano del Duomo di Prato*. Prato, 1966.

MARTINELLI, VALENTINO. 'La "compagnia" di Donatello e Michelozzo e la "sepoltura" del Brancacci a Napoli'. *Commentari* 14, 1963, 211–26.

—— 'Il non-finito di Donatello'. *Donatello e il suo tempo*. Florence, 1968, 179–94.

MASINI, M. CECILIA DEL VIVO. 'Intorno a una Madonna inedita della cerchia donatelliana'. *Antichità viva* 15, 1976, no. 5, 22–6.

MEISS, MILLARD. 'Masaccio and the Early Renaissance: the Circular Plan'. *Studies in Western Art: Acts of the Twentieth International Congress of the History of Art*. Princeton, 1963, II, 123–45. Reprinted in *The Painter's Choice: Problems in the Interpretation of Renaissance Art*. New York, 1976, 63–81.

Metodo e scienza: operatività e ricerca nel restauro (exhib. cat., Florence, 1982–3). Florence, 1982.

MICHELETTI, EMMA, *et al. Il crocifisso di Donatello dopo il restauro*. Florence, 1974.

MIDDELDORF, ULRICH. 'Some Florentine Painted Madonna Reliefs'. *Collaboration in Italian Renaissance Art* (ed. Wendy S. Sheard and John T. Paoletti). New Haven, 1978, 99–108.

MORMONE, RAFFAELE. 'Donatello, Michelozzo e il monumento Brancacci'. *Cronache di archeologia e di storia dell'arte* 5, 1966, 121–33.

MORISANI, OTTAVIO. 'Per una rilettura del monumento Brancacci'. *Napoli nobilissima* 4, 1964–5, 3–11.

MORSELLI, PIERO. *Corpus of Tuscan Pulpits, 1400–1550*. Dissertation, University of Pittsburgh, 1978.

MOSKOWITZ, ANITA F. 'Donatello's Reliquary Bust of Saint Rossore'. *AB* 63, 1981, 41–8.

———— 'Observations on Titian's Frescoes and the Narrative Tradition in Padua'. *Marsyas* 17, 1974–5, 95–6.

MUNMAN, ROBERT. 'The Evangelists from the Cathedral of Florence: A Renaissance Arrangement Recovered'. *AB* 62, 1980, 207–17.

MURARO, MICHELANGELO. 'Donatello e Squarcione'. *Donatello e il suo tempo*. Florence, 1968, 389–98.

MUSTARI, LOUIS FRANK. *The Sculptor in the Fourteenth-Century Florentine Opera del Duomo*. Dissertation, University of Iowa, 1975.

NEGRI ARNOLDI, FRANCESCO. 'Sul maestro della *Madonna Piccolomini*'. *Commentari* 14, 1963, 8–16.

PANE, ROBERTO. 'Il tabernacolo donatelliano di S. Maria del Carmine'. *Napoli nobilissima* 10, 1971, 77–87.

PAOLETTI, JOHN T. 'The Bargello *David* and Public Sculpture in Fifteenth-Century Florence'. *Collaboration in Italian Renaissance Art* (ed. Wendy S. Sheard and John T. Paoletti). New Haven, 1978, 99–108.

———— 'Donatello and Brunelleschi: An Early Renaissance Portrait'. *Commentari* 21, 1970, 55–60.

———— *The Siena Baptistry Font: A Study of an Early Renaissance Collaborative Program, 1416–1434*. Dissertation, Yale University, 1967.

PAOLUCCI, ANTONIO. *Donatello* (I maestri della scultura, 31–2). 2 vols. Milan, 1966.

PARRONCHI, ALESSANDRO. 'L'autore del "Crocifisso" di Santa Croce: Nanni di Banco'. *Prospettiva*, 1976, no. 6, 50–5.

———— 'Il crocifisso del Bosco'. *Scritti di storia dell'arte in onore di Mario Salmi*. Rome, 1961–3, II, 233–62.

———— *Donatello e il potere*. Florence, 1980.

———— 'Il naturalismo integrale del primo Quattrocento'. *Rassegna dell'istruzione artistica* 2, 1967, no. 2. Reprinted in *Donatello e il potere*, 27–50.

———— 'Per la ricostruzione dell'altare del Santo'. *Arte antica e moderna* 22, 1963, 109–23. Reprinted in *Donatello e il potere*, 157–85.

———— 'Prospettiva in Donatello e Masaccio'. *Rassegna dell'istruzione artistica* 1, 1966, no. 2, 29–42.

———— 'Il *San Sebastiano* ligneo di Santa Maria del Baraccano'. *Atti e memorie della Accademia Clementina di Bologna* 11, 1974, 59–66. Reprinted in *Donatello e il potere*, 187–209.

———— 'Il soggiorno senese di Donatello del 1457–61'. *Donatello e il suo tempo*. Florence, 1968, 163–77. Reprinted in *Donatello e il potere*, 245–67.

———— 'Storia di una "Gatta malata"'. *Paragone* 157, 1963, 60–8. Reprinted in *Donatello e il potere*, 139–53.

PASSAVANT, GÜNTER. 'Beobachtung am Lavabo von San Lorenzo in Florenz'. *Pantheon* 39, 1981, 33–50.

PFEIFFENBERGER, SELMA. 'Notes on the Iconology of Donatello's *Judgment of Pilate* at S. Lorenzo'. *Renaissance Quarterly* 20, 1967, 437–54.

PLAHTER, U. and L. 'Notes on the Deterioration of Donatello's Marble Figure of *St. Mark* on the Church of San Michele in Florence'. *Studies in Conservation: Journal of the International Institute for the Conservation of Historic Works* 16, 1971, 114–18.

POESCHKE, JOACHIM. *Donatello, Figur und Quadro*. Munich, 1980.

POGGETTO, M. GRAZIA CIARDI DUPRÈ DAL. 'Una nuova proposta per il Niccolò da Uzzano'. *Donatello e il suo tempo*. Florence, 1968, 283–90.

POPE-HENNESSY, JOHN. *Catalogue of Italian Sculpture in the Victoria and Albert Museum*. 2 vols. London, 1964. Reviewed by John Fleming in *Connoisseur* 158, February, 1965, 100–3; Hugh Honour in *Apollo* 80, 1964, 528–9; Olga Raggio in *AB* 50, 1968, 98–105; Charles Seymour, Jr. in *Art News* 64, 1966, 18 ff; François Souchal in *Gazette des beaux-arts* 66, 1965, 123; Otto Wittmann in *Art Quarterly* 27, 1964, 532–4.

———— 'Donatello and the Bronze Statuette'. *Apollo* 105, 1977, 30–3. Reprinted in *The Study and Criticism of Italian Sculpture*, 129–34.

———— *Essays on Italian Sculpture*. London, 1968. Reviewed by Dario Covi in *AB* 52, 1970, 316–18; A. Neumeyer in *Journal of Aesthetics* 28, 1970, 397–8.

———— 'The Evangelist Roundels in the Pazzi Chapel'. *Apollo* 106, 1977, 262–9. Reprinted in *The Study and Criticism of Italian Sculpture*, 106–18.

———— 'The Interaction of Painting and Sculpture in Florence in the Fifteenth Century'. *Journal of the Royal Society of Arts* 117, 1969, 406–24.

———— 'The Italian Plaquette'. *Proceedings of the British Academy* 1, 1964, 63–85. Reprinted in *The Study and Criticism of Italian Sculpture*, 192–222.

———— *Italian Renaissance Sculpture*. 2nd ed. London, 1972.

———— *Luca della Robbia*. Oxford, 1980.

———— 'The Madonna Reliefs of Donatello'. *Apollo* 103, 1976, 172–91. Reprinted in *The Study and Criticism of Italian Sculpture*, 71–105.

———— 'The Medici *Crucifixion* of Donatello'. *Apollo* 101, 1975, 82–7. Reprinted in *The Study and Criticism of Italian Sculpture*, 119–28.

———— *The Portrait in the Renaissance*. New York, 1966.

———— 'Some Donatello Problems'. *Studies in the History of Art Dedicated to William E. Suida on his 80th Birthday*. London, 1959, 47–65. Reprinted in *Essays on Italian Sculpture*, 47–64.

———— *The Study and Criticism of Italian Sculpture*. Princeton, 1980.

———— 'A Terracotta *Madonna* by Donatello'. *Burlington Magazine* 125, 1983, 83–5.

PREVITALI, GIOVANNI. 'Una data per il pulpito di San Lorenzo'. *Paragone* 133, 1961, 48–56.

PROCACCI, UGO. 'L'uso dei documenti negli studi di storia dell'arte e le vicende politiche ed economiche in Firenze durante il primo Quattrocento nel loro rapporto con gli artisti'. *Donatello e il suo tempo*. Florence, 1968, 11–40.

PUPPI, LIONELLO. 'Osservazioni sui riflessi dell'arte di Donatello tra Padova e Ferrara'. *Donatello e il suo tempo*. Florence, 1968, 307–30.

RADCLIFFE, ANTHONY and CHARLES AVERY. 'The Chellini *Madonna* by Donatello'. *Burlington Magazine* 118, 1976, 377–87.

REID, JANE DAVIDSON. 'The True Judith'. *Art Journal* 28, 1969, 376–87.

ROMANINI, ANGIOLA MARIA. 'Donatello e il rinascimento in Alta Italia'. *Donatello e il suo tempo*. Florence, 1968, 215–34.

———— 'Donatello e la "prospettiva"'. *Commentari* 17, 1966, 290–323.

RONCHI, VASCO. 'La prospettiva della Rinascità e le sue origini'. *Donatello e il suo tempo*. Florence, 1968, 131–54.

ROSE, PATRICIA. 'Bears, Baldness and the Double Spirit: the Identity of Donatello's *Zuccone*'. *AB* 63, 1981, 31–41.

ROSENAUER, ARTUR. 'Die Nischen für die Evangelisten figuren an der Florentiner Domfassade'. *Essays presented to Myron P. Gilmore* (ed. Sergio Bertelli and Gloria Ramakus). Florence, 1978, II, 345–52.

———— *Studien zum frühen Donatello: Skulptur im projektiven Raum der Neuzeit*. Vienna, 1975. Reviewed by H. W. Janson in *AB* 59, 1977, 136–9; Joachim Poeschke in *Kunstchronik* 30, 1977, 340–5.

ROSENBERG, CHARLES M. 'Some New Documents Concerning Donatello's Unexecuted Monument to Borso d'Este in Modena'. *Mitt. Flor.* 17, 1973, 149–52.

RUSSOLI, FRANCO. *Il rinascimento* (Scultura italiana, 3). Milan, 1967.

SALMI, MARIO. 'Antico e nuovo in Donatello'. *Donatello e il suo tempo*. Florence, 1968, 1–10.

SARTORI, A. 'Ancora su Donatello e sul suo altare'. *Il Santo* 1, 1961, 337–44.

———— 'Il cosidetto bastone di comando del Gattamelata'. *Il Santo* 1, 1961, 334–7.

———— 'Di nuovo sulle opere donatelliane al Santo'. *Il Santo* 3, 1963, 347–58.

———— *Documenti per la storia dell'arte a Padova*. Vicenza, 1976.

———— 'Documenti riguardanti Donatello e il suo altare di Padova'. *Il Santo* 1, 1961, 37–99. Reviewed by Lionello Puppi in *Arte veneta* 15, 1961, 278.

———— 'Il donatelliano monumento equestre a Erasmo Gattamelata'. *Il Santo* 1, 1961, 318–34.

SCHLEE, ERNST L. 'Die Bekrönungszone des Silberaltars in Pistoia – Zur Florentiner Skulptur um 1400'. *Kunstgeschichtliche Gesellschaft zu Berlin* no. 25, 1976–7, 8–12.

SCHLEGEL, URSULA. 'Problemi intorno al David Martelli'. *Donatello e il suo tempo*. Florence, 1968, 245–58.

———— 'Zu Donatello und Desiderio da Settignano. Beobachtungen

zur physiognomischen Gestaltung im Quattrocento'. *Jahrbuch der Berliner Museen* 9, 1967, 135–55.

SCHNEIDER, LAURIE. 'Donatello and Caravaggio, The Iconography of Decapitation'. *American Imago* 33, 1976, 76–91.

———— 'Donatello's Bronze *David*'. *AB* 55, 1973, 213–16.

———— 'More on Donatello's Bronze *David*'. *Gazette des beaux-arts* 94, 1979, 48.

———— 'Response'. *La Chronique des arts* in *Gazette des beaux-arts* 93, February 1979, 18–19.

———— 'Some Neoplatonic Elements in Donatello's *Gattamelata* and *Judith and Holofernes*'. *Gazette des beaux-arts* 87, 1976, 41–8.

SCHROETELER, HEINZ. 'Zur Rekonstruktion des Donatello-Altars im Santo zu Padua'. *Il Santo* 16, 1976, no. 1, 3–45.

———— *Zur Rekonstruktion des Donatello-Altars im Santo zu Padua*. Dissertation, Ruhr-Universität, Bochum, 1969.

SCHUYLER, JANE. *Florentine Busts: Sculpted Portraiture in the Fifteenth Century*. New York, 1976.

SEYMOUR, CHARLES, JR. 'Homo magnus et albus: The Quattrocento Background for Michelangelo's *David* of 1501–4'. *Stil und Überlieferung in der Kunst des Abendlandes (Akten des 21. Internationalen Kongresses für Kunstgeschichte in Bonn, 1964)*. Berlin, 1967, II, 96–105.

———— *Michelangelo's David: A Search for Identity*. Pittsburgh, 1967.

———— *Sculpture in Italy 1400–1500* (Pelican History of Art). Harmondsworth and Baltimore, 1966.

———— 'Some Aspects of Donatello's Methods of Figure and Space Construction: Relationships with Alberti's *De statua* and *Della pittura*'. *Donatello e il suo tempo*. Florence, 1968, 196–206.

SHAPIRO, MAURICE L. 'Donatello's *Genietto*'. *AB* 45, 1963, 135–42.

SIMON, ERIKA. 'Dionysischer Sarkophag in Princeton'. *Mitteilungen des Deutschen Archaeologischen Institutes, Römische Abteilung* 69, 1962, 136–58.

———— 'Der sogennante *Atys-amorino* des Donatello'. *Donatello e il suo tempo*. Florence, 1968, 331–51.

SIMON, KATHRIN. 'The Dais and the Arcade: Architectural and Pictorial Narrative in Quattrocento Painting and Sculpture'. *Apollo* 81, 1965, 270–8.

STANG, RAGHNA and NIC. 'Donatello e il *Giosuè* per il Campanile di S. Maria del Fiore alla luce dei documenti'. *Acta ad archaeologiam et artium historiam pertinentia, institutum Romanum Norvegiae* 1, 1962, 113–30.

STROM, DEBORAH. 'Desiderio and the Madonna Relief in Quattrocento Florence'. *Pantheon* 40, 1982, 130–5.

———— 'A New Chronology for Donatello's Wooden Sculpture'. *Pantheon* 38, 1980, 239–48.

———— *Studies in Quattrocento Tuscan Wooden Sculpture*. Dissertation, Princeton University, 1979.

SUMMERS, DAVID. *Michelangelo and the Language of Art*. Princeton, 1981.

TAUBERT, G. and J. 'Mittelalterliche Kruzifixe mit schwenkbaren Armen'. *Zeitschrift des deutschen Vereins für Kunstwissenschaft* 23, 1969, 79 121.

THOMAS, ANABEL JANE. *Workshop Procedures of Fifteenth-Century Florentine Artists*. Dissertation, University of London, 1976.

DE TOLNAY, CHARLES. 'Donatello e Michelangelo'. *Donatello e il suo tempo*. Florence, 1968, 259–76.

TRACHTENBERG, MARVIN. 'An Antique Model for Donatello's *Marble David*'. *AB* 50, 1968, 268–9.

———— 'Donatello's First Work'. *Donatello e il suo tempo*. Florence, 1968, 361–7.

VEŽIĆ, PAVUŠA. 'Nadbiskupska palača u Zadru'. *Peristil* 22, 1979, 17–36.

VON ERFFA, HANS MARTIN. 'Judith-Virtus Virtutum-Maria'. *Mitt. Flor.* 14, 1969–70, 460–5.

WACKERNAGEL, MARTIN. *The World of the Florentine Renaissance Artist: Projects and Patrons, Workshop and Art Market* (trans. Alison Luchs). Princeton, 1981.

WEISE, GEORG. 'Donatello e la corrente tardo-gotica degli ultimi decenni del Quattrocento'. *Donatello e il suo tempo*. Florence, 1968, 107–13.

WESTER, URSULA and ERIKA SIMON. 'Die Reliefmedallions im Hofe des Palazzo Medici in Florenz'. *Jahrbuch der Berliner Museen* 7, 1965, 15–91.

WHITE, JOHN. 'Donatello's High Altar in the Santo, Padua: Part I: The Documents and their Implications; Part II: The Reconstruction'. *AB* 51, 1969, 1–14, 119–41. For Correction: see *AB* 51, 1969, 412.

———— 'Paragone: Aspects of the Relationship between Sculpture and Painting'. *Art, Science and History in the Renaissance* (ed. Charles S. Singleton). Baltimore, 1967, 43–109.

WILKINS, DAVID G. 'Donatello's Lost *Dovizia* for the Mercato Vecchio: Wealth and Charity as Florentine Civic Virtues'. *AB* 65, 1983, 401–23.

WOLTERS, WOLFGANG. 'Eine Antikenergänzung aus dem Kreis des Donatello in Venedig'. *Pantheon* 32, 1974, 130–3.

———— 'Due capolavori della cerchia di Donatello a Trogir e a Sibenik'. *Antichita vivà* 7, 1978, no. 1, 11–24.

———— 'Freilegung der Signatur an Donatellos *Johannesstatua* in S. Maria dei Frari'. *Kunstchronik* 27, 1974, 83.

WUNDRAM, MANFRED. *Donatello: der heilige Georg* (Werkmonographien zur bildenden Kunst). Stuttgart, 1967.

———— 'Donatello e Nanni di Banco negli anni 1408–9'. *Donatello e il suo tempo*. Florence, 1968, 69–75.

———— 'Donatello und Ciuffagni'. *Zeitschrift für Kunstgeschichte* 22, 1959, 85–101.

———— *Donatello und Nanni di Banco*. Berlin, 1969. Reviewed by Giorgio Castelfranco in *Bollettino d'arte* 52, 1967, 208; J. R. Gaborit in *Bulletin monumental* 128, 1970, 88–9; Volker Herzner in *Pantheon* 30, 1972, 82–4; L. O. Larsson in *Konsthistorisk Tidskrift* 40, 1971, 58–9; H. W. Janson in *AB* 54, 1972, 546–50; Joachim Poeschke in *Kunstchronik* 24, 1971, 10–23; Artur Rosenauer in *Mitteilungen des Gesellschaft für vergleichende Kunstforschung in Wien* 26, 1974, 28–30.

ZERVAS, DIANE. *Systems of Design and Proportion Used by Ghiberti, Donatello, and Michelozzo in their Large-Scale Sculpture Architectural Ensembles between 1412–1434*. Dissertation, Johns Hopkins University, 1973.